Cinema's Baroque Flesh

Cinema's Baroque Flesh

Film, Phenomenology and the Art of Entanglement

Saige Walton

Amsterdam University Press

Sections of chapter two have previously appeared as a part of "Enfolding Surfaces, Space and Materials: Claire Denis' Neo-Baroque Textures of Sensation" in *Screening the Past* 37 (2013). Sections of the conclusion have appeared as "The Beauty of the Act: Figuring Film and the Delirious Baroque in *Holy Motors*" in *Necsus: European Journal of Media Studies* 3:1 (2014).

Cover illustration: Still from *Trouble Every Day* (2001)

Cover design: Kok Korpershoek, Amsterdam
Lay-out: Crius Group, Hulshout

Amsterdam University Press English-language titles are distributed in the US and Canada by the University of Chicago Press.

ISBN	978 90 8964 951 5
e-ISBN	978 90 4852 849 3
DOI	10.5117/9789089649515
NUR	670

© S. Walton / Amsterdam University Press B.V., Amsterdam 2016

Printed and bound by CPI Group (UK) Ltd, Croydon, CR0 4YY

For L. and Z.

Table of contents

Acknowledgements

This project initially began as a dissertation under the guidance of the excellent Angela Ndalianis in the School of Culture and Communication at the University of Melbourne, Australia. It was Angela who first sparked my love of film, art and all things popular culture as a first-year undergraduate student. Her bold scholarship, interdisciplinary thinking and intellectual generosity are life-long legacies.

I am deeply grateful to both Laura U. Marks and Sean Cubitt for their careful comments and suggestions as readers of what became the book manuscript. Their intellectual rigor not only greatly enriched the revision process but also prompted many new ideas. Thanks also to my commissioning editor Jeroen Sondervan who believed in this project from the first and to all at Amsterdam University Press.

Thanks must go to Pal Ahluwalia who first appointed me to the University of South Australia where I am now based. Thanks in particular to my colleagues in the School of Communication, International Studies and Languages, especially Jodie George, Ian Hutchison, Kit MacFarlane, Clayton MacKenzie, Brad West and the Media Arts team. To Katrina Jaworski and Susan Luckman – wonderful scholars, colleagues and academic gal pals – I owe a special debt of thanks for helping steer me through to publication. I would also like to express my gratitude to the University of South Australia for providing me with a Divisional Research Performance Fund grant that enabled the completion of this book.

There are numerous individuals to whom I owe thanks for their intellectual encouragement of my work and for the debate and refinement of ideas in various conference settings or over more casual drinks and dinners. Special thanks go to the following friends and colleagues: Amelia Barikin; Adam Bartlett; Lauren Bliss; Mel Campbell; Justin Clemens; Felicity Colman; Michael Connor; the Cinema-Thinking network (Gregg Flaxman, Robert Sinnerbrink, Lisa Trahair, James Phillips) and its members; Elena del Río; Natalie Edwards; Ian Gouldstone; Greg Hainge; Alexandra Heller-Nicholas; Christopher Hogarth; Alex Ling; Adrian Martin; Kristy Matheson; Ben McCann; Martyn Pedler; Michael Parry; Mehmet Mehmet; Samuel Harvey; Wendy Haslem; Jane Stadler; Helen Stuckey; David Surman; Fiona Trigg and Brett Tuer.

A special thank you to my family for their love and support: Neil, Dale, Kyla, Liam and Jessica Walton.

Thanks also to Kate Leeson for her invaluable editorial assistance in the preparation of the manuscript and to all the individuals and archives who allowed me to reproduce the beautiful film images and artworks in this book. Particular thanks go to the Alinari Archives, Foundation Prussian Palaces and Gardens and to Jonathan Caouette.

Finally, my thanks must go to Lucio Crispino – last but never least – not least of all for his labor of love with the preparation of the book index.

Introduction

This baroque world is not a concession of mind to nature; for although meaning is
everywhere figurative, it is meaning which is at issue everywhere. This renewal
of the world is also mind's renewal, a rediscovery of that brute mind which,
untamed by any culture, is asked to create culture anew.
– Maurice Merleau-Ponty ('The Philosopher', p. 181; italics mine)

In his book *The Fold: Leibniz and the Baroque,* philosopher Gilles Deleuze
extends the formal and critical reach of the baroque beyond historic con-
fines. Detaching the baroque from its traditional historic, geographic, and
artistic origins in seventeenth-century Europe, Deleuze argues that the
baroque is best understood as a restless trans-historic 'operative function,
a trait. It endlessly produces folds' (*The Fold*, p. 3).[1] If the baroque can be
extended into the twentieth and twenty-first centuries, I ask: What is the
relationship between cinema and the baroque? How might it be figured
and felt in film?

As we shall discover, Deleuze's philosophy of the fold is one possible
means for us to engage with the baroque's vast and complex critical terri-
tory. This book explores the baroque as its own aesthetic category of film,
one that generates its own cinema of the senses. Rather than the fold, it is
in the writings of Maurice Merleau-Ponty that *Cinema's Baroque Flesh: Film,
Phenomenology and the Art of Entanglement* finds its titular inspiration. The
baroque of art and film spurs an aesthetic concretization of what Merleau-
Ponty likes to call 'flesh'. Foregrounding the baroque as a vital undercurrent
of Merleau-Ponty's phenomenological thought, what I name baroque flesh
is a productive site of analysis and it is the main film-philosophical model
by which I approach all of the films examined here.

Like Deleuze's articulation of the baroque-as-fold, Merleau-Ponty also
demonstrates a pliant, embodied, and suitably trans-historic appreciation
of the baroque. In the quotation that begins this book, he gestures towards
the possibility of a 'baroque world' in which its overall 'configurational
meaning [...] is in no way indicated by its "theoretical meaning"' ('The
Philosopher', p. 181). The baroque configuration of the world that he alludes
to in his essay 'The Philosopher and his Shadow' involves ways of seeing
that are not singularly frontal, extroverted, and projective but also mobile,
multiple, and introjective (things are 'flaying our glance with their edges');
it is a world of situated, prismatic, and intrinsically variable dimensions to

our lived experience ('each thing claiming an absolute presence [...] not compossible with the absolute presence of other things'); and it involves the replenishment and regeneration of personal and cultural meaning (this 'renewal of the world is also mind's renewal') ('The Philosopher', p. 181). It is 'meaning which is at issue everywhere' in Merleau-Ponty's baroque world, where meaning must be lived at the literal level of the body as well as in and through the expressive figures and functions that belong to specific artistic and cultural formations ('The Philosopher', p. 181).

Though Merleau-Ponty rarely makes such a direct link between his philosophy and the baroque, it must be noted that he invokes the baroque throughout various essays and in his notes on film.[2] In his dedicated writings on art and aesthetics, however, Merleau-Ponty was predominantly concerned with modernist art and with the impressionist paintings of Cézanne in particular.[3] Cézanne—like other favourites such as Picasso, Klee, and Gris—sought to recreate the sensible properties of objects so that 'the mode of their material existence [...] stand "bleeding" before us' (Merleau-Ponty, World of Perception, p. 93). In Cézanne's paintings of fruit, for instance, we are encouraged to apprehend apples, pears, and oranges through their light-scattered sheen, their different surface shapes and textures rather than through a more optically objective record. For Merleau-Ponty, Cézanne's art valuably thrusts us into 'the world of lived experience' by attempting to 'recapture the feel of perceptual experience itself' (World of Perception, pp. 53–54).[4]

What Merleau-Ponty admired most about Cézanne was his ability to 'portray the world, to change it completely into a spectacle, to make visible how the world touches us' ('Cézanne's Doubt', p. 19). Similarly, in his own writings on art, film, and perception, Merleau-Ponty beautifully captures the intimate feeling and inter-sensory exchange of what phenomenology understands as the lived body, as well as the importance of the lived body in aesthetic experiences.[5] He speaks of 'hot, cold, shrill, or hard colors, of sounds that are clear, sharp, brilliant, rough or mellow, of soft noises and penetrating fragrances' and of how Cézanne once claimed that 'one could see the velvetiness, the hardness, the softness, and even the odor of objects' (Merleau-Ponty, 'The Film', pp. 49–50).[6] Artworks that impose the geometric precision of linear Renaissance perspective or those accounts of art that restructure its subjectively felt impact 'remain at a distance and do not involve the viewer, they are polite company' (World of Perception, pp. 53–54). As we will discover throughout, the baroque is anything but distant or 'polite' company when it comes to forging spatial, emotive, and sensuous connections between bodies. I take it as no coincidence that Merleau-Ponty

once called on the baroque to speak to the embodied relationality and reversibility that is at the heart of his ontology. Whereas Merleau-Ponty often called upon Cézanne as the aesthetic inspiration for his philosophy, it is in Merleau-Ponty that I find a compelling philosophical counterpart for the baroque.

In Merleau-Ponty's work, perception is vitally mobile because the roles of the seer and the seen are reversible ('Eye and Mind', p. 299). Significantly, it was in painting that he first discerned a 'figured philosophy of vision' ('Eye and Mind', p. 299). His famous example of the painter who feels themselves looked at by the objects that they are painting—of the painter who sees the trees but feels that the trees can also 'see' the painter—emblematizes the elemental reversibility of what he calls the 'flesh' ('Eye and Mind', p. 299; Dillon, *MPO*, pp. 153–176).[7] What 'flesh' articulates is an inherent structural reversibility: 'the seer's visibility conditions vision itself [...]. To see is also the possibility of being seen' (Grosz, 'Merleau-Ponty', p. 45). In the scenario of the trees and the painter, then, the philosopher extends to the domain of art the same structural reversibility that he discerns in all our embodied perception. Here, it is important to note that Merleau-Ponty is not imputing a reductive anthropomorphism to the trees such that they are sentiently 'aware' of the painter. Rather, as Elizabeth Grosz points out, his claim is really an ontological one. The 'flesh' speaks to a shared materiality that connects the subject and object of perception; as mutually 'visible, [the] trees and the painter are of the same visibility, the same flesh' ('Merleau-Ponty', p. 45).

Why might Merleau-Ponty have underscored the reversibility of perception with such specific reference to painting? According to phenomenological film scholar Vivian Sobchack, the answer lies in how the 'painter and filmmaker practice a phenomenology of vision' (*Address of the Eye*, p. 91). In her book *The Address of the Eye: A Phenomenology of Film Experience* (1992), Sobchack draws upon Merleau-Ponty to make a polemical call for the importance of phenomenology to film studies. In Sobchack's film-phenomenological schema, cinema is embedded in similar existential structures to that of the human body. In having sense (perception) and making sense (expression), cinema is a medium that 'quite concretely returns us, as viewers and theorists, to our senses' (Sobchack, *Address of the Eye*, p. 13). Here, the ontology of cinema is not approached through questions of its technological make-up (analogue or digital) or its indexical relations with the real. As such, Sobchack does not answer the recurring question of what cinema 'is' in and through its technologies. Instead, she understands cinema as analogous to our own bodies in its enworldedness

and its having and making of sense. Regardless of its particular historic era or its precise technological format, cinema relies on comparable '*modes of embodied existence* (seeing, hearing, physical and reflective movement)' as the main 'vehicle, the "stuff", the substance of its language' (*Address of the Eye* p. 4). For *Cinema's Baroque Flesh*, the very ontology of cinema lends itself to the art of entanglement.

Flesh and its Reversibility

Before I turn to the baroque in more depth, it is necessary to outline some of the other major theoretical influences from film and media studies that have shaped this book. In recent years, topics relating to touch and the senses, to the body, affect, and the emotions have received a considerable amount of attention across the humanities. More specifically, the work of film and new media theorist Laura U. Marks has broken new conceptual ground in prompting scholars to consider how the proximate senses (touch, taste, smell) shape the aesthetics of inter-cultural cinema, art, and experimental film and media. In books such as *The Skin of the Film* and *Touch*, Marks draws on Deleuze, Sobchack, and other thinkers to argue for cinema as a medium of sensuous contact wherein meaning is filtered through a sense of material presence as much as it is through intellectual or narrative signification.

For Marks, spectatorship is best viewed (or, more precisely, experienced) as a bodily, mnemonic, and contagious exchange that occurs between different selves, objects, and others rather than through the mind alone. This exchange is synopsized by her carnally loaded metaphor of the 'skin of the film', whereby 'the circulation of a film among different viewers is like a series of skin contacts that leave mutual traces' (*Skin of the Film*, pp. 121, xii). Marks' considered emphases on the proximate relations that connect film and viewer and on the inter-permeation of touch and vision that can occur therein have influenced my own thoughts as to what a baroque cinema of the senses might involve. In addition, the more explicitly film-phenomenological work of Sobchack and Jennifer M. Barker prompted me to delve more deeply into Merleau-Ponty's philosophy (Barker, *Tactile Eye*).[8] In doing so, I was led to discover the striking but still strikingly neglected parallels that connect his philosophy to the baroque. As we will discover, distanced and disembodied accounts of vision or bodily being cannot be reconciled with baroque flesh. By contrast, Merleau-Ponty's philosophy strongly resonates with the art of entanglement because he

argues for our shared participation in a restless, mobile, and replenishable field of materiality that is known as 'flesh' (Grosz, 'Merleau-Ponty', p. 45).

In his final unfinished work—published posthumously as *The Visible and the Invisible*—Merleau-Ponty outlined his ontology of the 'flesh'. Cut short by the philosopher's death, *The Visible and the Invisible* with its fragmentary working notes can make for a somewhat elliptical read. The text has spurred much debate as to whether or not it marks a radical departure from Merleau-Ponty's earlier phenomenological investigations, as these investigations relied on the intentionality of a subjective consciousness.[9] While this book will not retread these debates, it is useful for us to turn briefly to critics such as M.C. Dillon who have argued for the underlying continuity of Merleau-Ponty's thought as well as an important conceptual shift in his terminology. According to Dillon, the philosopher's intentions remained the same throughout his career: to 'carry Western philosophy beyond the dualism of subject and object' (*MPO*, p. 155). The 'flesh' therefore needs to be understood as a modification of Merleau-Ponty's lifelong interest in embodied being and perception rather than as a wholly new take upon them (*MPO*, p. 85).[10]

For Dillon, there are definite antecedents to *The Visible and the Invisible* that indicate that Merleau-Ponty had been progressively moving towards this later ontology. Let us examine that continuity more closely. In his *Phenomenology of Perception*, Merleau-Ponty encapsulates the subjective and objective dimensions of embodiment through one of his favourite examples—one hand of the body touching the other. The figure of the two hands touching represents our lived capacity to function as both a perceiving subject in the world and as an object of perception. In the example of the two hands touching, each of the hands is felt from within while functioning as a tangible object for the other from without. As Merleau-Ponty is careful to observe, however, whenever I touch one hand to the other these 'two hands are never *simultaneously* in the relationship of touched and touching to each other' (*PP*, p. 106; italics mine).

While my body holds the capacity for touching and for tangible being I cannot experience both of these potentialities at the same time. Whenever I focus on this doubled sensation, either one hand will pass over into the role of the touched object (so that, correspondingly, I cease to touch with it) or *vice versa*. Our intentional focus is therefore forced to move back and forth between the subjective and objective dynamics of embodiment. In *The Visible and the Invisible*, Merleau-Ponty returns to the figure of the two hands touching. This time, however, he explicitly links this doubling of sensation to the ontology of 'flesh'. Reflecting upon the sensible, he

asserts that 'every reflection is after the model of the reflection of the one hand of the body touched' (*VI*, p. 204). The example of two hands touching resurfaces throughout this text and in its working notes (*VI*, pp. 9, 123, 133–134, 147–148, 254, 261). This is because self-touching emblematizes a 'crisscrossing [...] of the touching and the tangible, [as] its own movements incorporate themselves into the universe they interrogate, are recorded on the same map as it' (*VI*, p. 133). This crisscrossing is extended to the relationship between the visual and the visible and to sensibility in general (Merleau-Ponty, *VI*, p. 133).[11]

In his *Phenomenology of Perception*, Merleau-Ponty had couched two hands touching as an alteration of consciousness. In *The Visible and the Invisible*, the figure of two hands touching demonstrates a structural reversibility that belongs to no-one. In this regard, 'flesh' re-directs the haptological implications of Merleau-Ponty's earlier work (and that of his forerunner, Edmund Husserl) towards a different end.[12] Touch becomes Merleau-Ponty's means of establishing an ontological reversibility that is not only appropriate to sight; it is indicative of all sensibility (Derrida, *On Touching*, pp. 162, 185–186). While the concerns of Merleau-Ponty's last work are traceable back to his earlier *Phenomenology of Perception*, his theory of 'flesh' replaces the former 'language of subject–object disjunction' with an ontology that is marked by a sense of material relatedness, of 'communion and reciprocity' (Dillon, *MPO*, p. 150). What 'flesh' rightly insists upon is that all perception is embodied, reciprocal, and reversible. To quote Merleau-Ponty: 'to say that the body is a seer is, curiously enough, not to say anything other than: it is visible' (*VI*, p. 273). Furthermore, if the positions of visual and visible can reverse, then '[t]o have a body is [also] to be looked at (it is not only that), it is to be *visible*' (*VI*, p. 189). For this book, such reversibility is essential to understanding the relevance of Merleau-Ponty's 'flesh' to baroque art and film. Within this critical framework, every visual is at the same time visible, the touching can be touched, the sonic heard, and the sensing also sensed.

At this juncture, we should pause to note that Merleau-Ponty's 'flesh' is not actually reducible to the guise of literal human flesh. While the term boasts a definite carnal resonance, 'flesh' possesses no 'referent' because it is not an identifiable substance as such (Dastur, 'World', p. 34). As Merleau-Ponty himself remarks, 'we do not mean to do anthropology' when we speak of his ontology; 'flesh' pertains to a kind of 'anonymity innate to Myself' though 'one knows that there is no name in traditional philosophy to designate it' (*VI*, pp. 136, 139). Although 'flesh' is not equivalent to actual human flesh, it does still return us to the basic phenomenological understanding of embodiment as it is lived in subjective and objective modalities—albeit

with one crucial difference. Whereas his earlier projects had counteracted the objectification of the body by detailing the body that is subjectively lived, Merleau-Ponty would later unite these twinned components of the subjective and objective under the heading of a basic structural reversibility or what he calls the *chiasm*.

In the chapter entitled 'The Intertwining—The Chiasm', Merleau-Ponty explicitly asserts that 'we do not have to reassemble [the subjective and the objective] into a synthesis'—'they are two aspects of the reversibility which is the ultimate truth' (*VI*, p. 165).[13] Foregrounding the ways in which the objective and the phenomenal body, self and other, or the lived body and its world will continuously 'turn about one another or encroach upon one another', Merleau-Ponty speaks to the inherently reversible nature of subjects and objects (*VI*, p. 117; see also Sobchack, *Carnal Thoughts*, p. 294). 'Flesh' is the name he gives to the manifestation of that reversibility or *chiasm* in embodied, enworlded existence: 'the chiasm is that: the reversibility' (Merleau-Ponty, *VI*, p. 263).

'Flesh' is one of many key terms that get repeated throughout *The Visible and the Invisible.* It appears alongside a number of important others: '*chiasm*', 'wild meaning', 'brute mind', 'brute' or 'savage being', 'fold', 'fabric', 'intertwining', 'divergence', '*écart*' (meaning gap or interval), and 'reversibility'. Seeking to give voice to a mobile and materialist ontology that would 'replace that of transcendental subjectivity [with its notions of] subject, object, meaning', many of these terms make their appearance in Merleau-Ponty's writing for the first time (Merleau-Ponty, *VI*, p. 167). In this regard, Michel de Certeau's commentary on Merleau-Ponty's last text is illuminating and well worth quoting at length. As he remarks, its prose is much like

> a woven fabric, built upon a few recurrent words, which constitute its vibrant 'ramification': Brute, flesh, entrapment, hinge, complicity, engulfing, divergence, horizon, ramification, operative, opening, landscape, spectacle, style, etc. The most insistent of these refrains forms its own network of synonyms. *It provides a lexical figure for the movement of the discourse*: chain, circularity, coexistence, embracing, overlap, enjambment, enlacing, rolling up, intertwining, fabric, filigrane, implication, inextricable, inter-world, inter-section, intersubjectivity, mixture, knot, pre-possession, promiscuity, reciprocity, to reciprocate one another, re-doubling, solidarity, tissue, weft, etc. The recurrence of these words, like successive waves, creates a magic spell of the text, but *they testify above all to that which bewitches it.* The interlacing of these words duplicates

that of the things. In that respect, *the literary structure of the discourse reproduces the 'enlaced' structure of the vision that it describes.* (de Certeau, 'Madness of Vision', pp. 30–31, fn. 4; italics mine)

Through its mobile and materialist language (enlacing, encroaching, intertwining, knot, fabric, fold, and so on), *The Visible and the Invisible* provocatively mimics the very ontology it is engaged in expressing. Similarly, Fred Evans and Leonard Lawlor observe how the *chiasm* deliberately calls up the figure and the action of crisscrossing, as with 'a crosswise arrangement' ('Introduction', p. 17, fn. 2).[14] Dillon, too, understands 'flesh' as an innately reversible structure. He likens the *chiasm* to 'the crossing and turning back on itself of the single thread that emanates from the spider's body when she spins her web. This web-matrix, the whole cloth, the flesh of the world is an interweaving, an elementary knotting' (*MPO*, p. 155). Following on from de Certeau, Evans and Lawlor, and Dillon, then, we can highlight that the key terms of *The Visible and the Invisible* (*chiasm*, intertwining, 'flesh') are evocative of ideas, forms, and figurations of reversibility. That reversibility or *chiasm* is essential to my understanding of baroque flesh and how it manifests itself in film.

A structural intertwining, interlacing, or entanglement between bodies is crucial to the baroque. When I first came across how film scholar, Elena del Río, had glossed Merleau-Ponty's ontology of the 'flesh' as connoting 'the structure of reversibility whereby all things are at the same time active and passive, visual subjects and visible objects, the outside of the inside, the inside of the outside', I could think of no aesthetic that was more invested in and expressive of that reversibility than the baroque ('The Body as Foundation of the Screen', p. 103). Deliberately opening up the internal and external properties of its own form, baroque art and film creates a heightened spatial, emotive, and experiential continuum between bodies. I contend that the formal and the philosophical hallmark of the baroque is its sensuous reversibility, as it enjoins an embodied response. Baroque flesh weds the 'inside' of embodied vision and feeling to the 'outside' of its aesthetic expressions; in turn, it uses the expressive 'outside' of its form to solicit the affective 'inside' of the body before the work. In this book, the notion of baroque flesh makes for an innately sensuous as well as reversible encounter between bodies: the art of entanglement.

As Dillon and del Río both propose it, 'flesh' needs to be situated *adverbially* rather than *substantially* (Dillon, *'Écart'*, p. 25; del Río, 'The Body as Foundation of the Screen', p. 103). Merleau-Ponty himself chose to invoke 'flesh' as something of a primary or even elemental term: 'the concrete

emblem of general manner of being' (*VI*, p. 147). According to Dillon, his use of the term 'manner' here is suggestive of how 'flesh' refers to the structural how of relations rather than to their corporeal make-up ('*Écart*', p. 25). Instead of delimiting 'flesh' to the human or to any specific matter, we need to understand it as the background or material field of possibility against which all discretely embodied and individualized figures emerge and differentiate themselves through the shifting relations of perception. As Alphonso Lingis likewise suggests, 'flesh' only pertains to the literal human 'body inasmuch as it is the visible seer, the audible hearer, the tangible touch—the sensitive sensible: inasmuch as in it is accomplished an equivalence of sensibility and sensible thing' ('Translator's Preface', p. liv).

For Merleau-Ponty, the subject is always implicated in the object of perception and *vice versa*. In his later philosophy, though, both positions co-exist in 'flesh' as the 'shared material exchange that makes possible the reversible exchange or transfer between one and the other' (del Río, 'The Body as Foundation of the Screen', p. 102). As 'flesh' is not a specific substance, its material exchange or transfer can also be extended to aesthetic experience. As structural reversibility, 'flesh' is as apposite to cinema and its range of technological mechanisms (film camera, projector, lenses, cinema screen, celluloid stock, or digitized code) as it is to the human body and its carnal mechanics (skeleton, musculature, neural channels, skin and hair, inner organs, sinews, tendons, and the like) (Sobchack, *Address of the Eye*, p. 220). For Barker, to invoke Merleau-Ponty's 'flesh' for film theory means insisting 'on a spectator [...] who joins the film in the act of making meaning' (Barker, *Tactile Eye*, p. 27). As it speaks to a mobile enjoining or enlacing in-between, 'flesh' can be used to shed light on baroque cinema as well. This is because the baroque is premised upon and often explicitly figures itself as a sensuous doubling or reversibility between bodies.

Defining the Baroque

As both an aesthetic and a critical concept, the 'baroque' is not the cultural phantom of a long distant past.[15] As Timothy Hampton remarks, it has continued to shadow 'ghostlike around much recent thought' ('Introduction', p. 2). In his *Life of Forms in Art* (1934), the French art critic Henri Focillon was amongst the first to comment upon the baroque's potential to reveal 'identical traits existing as constants within the most diverse environments and periods of time' (p. 58). Approaching aesthetic form as subject to trans-historic or cyclical renewal, Focillon pre-empts more contemporary

arguments for the persistence of the baroque into the twentieth and twenty-first centuries.

According to Deleuze, the baroque 'radiates everywhere, at all times' in fields such as mathematics, art, science, philosophy, and costume design (*The Fold*, p. 121; see also Conley, 'Translator's Forward', pp. x–xi). For Deleuze, as for a number of art, film, and cultural critics such as Mieke Bal, Omar Calabrese, Norman M. Klein, Angela Ndalianis, Timothy Murray, and Lois Parkinson Zamora, the baroque is an incredibly elastic phenomenon that radiates out well beyond its inception in seventeenth-century Europe, wherein spectacular cultural productions were harnessed to meet the ends of the church and the absolutist state.[16] In the work of Bal, for example, the baroque is approached as possessing a 'preposterous history' that seeps into the present through its reiterated citation (*Quoting*, p. 1). Although it enjoys historical specificity, the baroque is very much 'molded within our present being' (Bal, *Quoting*, p. 27). Similarly, the cultural historian José Antonio Maravall has intimated that 'one can speak of a baroque at any given time, in any field of human endeavor' (*Culture*, p. 5). Once it is expanded beyond past media traditions as well as along trans-historic and cross-cultural lines, the baroque reveals a startling formal and philosophical endurance.

In her *Neo-Baroque Aesthetics and Contemporary Entertainment*, Angela Ndalianis expertly elucidates how cinema might be especially amenable to a neo-baroque logic that delights in visual illusion, cross-media serialization, and technological display (*Neo-Baroque*, p. 182). While Ndalianis makes a compelling argument for the neo-baroque of contemporary Hollywood and its cross-media entertainments, it must be noted that the very notion of a 'cinematic' baroque remains conceptually fractured.[17] Unlike Ndalianis, there are critics who argue that modernity brought about a revival of the baroque or those who claim an avant-garde or modernist baroque that is typified by European or UK directors such as Peter Greenaway, Derek Jarman, the Brothers Quay, Jan Švankmajer, and Agnès Varda. Some situate the baroque as the progenitor of modernist surrealism while others refer to a 'Hollywood baroque' that is evident in the auteurist flair of studio-era directors like Orson Welles, Douglas Sirk, and Nicholas Ray. Some see the neo-baroque of the late twentieth century as a critical alternative to postmodernism while others argue that the neo-baroque is an exclusively digital phenomenon, evident in the work of new media artists such as Bill Viola. There are those who approach the baroque as an aesthetic of innate artifice that can be linked to pre-cinematic histories of special effects and animation; and those who explore the New World baroque of the Americas, examining how the filmmakers, artists, writers, and intellectuals of this

region have appropriated the European baroque of their ancestry to voice their own postcolonial identities.[18]

And yet, whenever the designation of a 'cinematic' baroque is called upon in film and media studies it tends to be reduced to films that veer towards the visually spectacular. Stephen Calloway, in his book *Baroque, Baroque: Culture of Excess*, illustrates the case in point. Calloway argues that baroque forms re-appeared throughout twentieth-century architecture, interior design, jewellery, *haute couture* fashion, and film. In terms of the latter, he admirably documents the potential for a baroque cinema across the course of film history—invoking directors as varied as Busby Berkeley, Jean Cocteau, Josef von Sternberg, Michael Powell and Emeric Pressburger, Sergei M. Eisenstein, and Federico Fellini. While noting that the baroque is 'more than amplitude of form and swirling movement [...] more than just color and opulence and quality of materials or the simple elaboration of decoration [...] far more than just decorative style', he rarely delves into the entrenched sensuality of the baroque aesthetic nor does he address cinema's capacity to evoke it (*Baroque, Baroque*, pp. 15, 173).

Calloway's baroque cinema relies upon costume, set design, architecture, and *mise-en-scène* yet he never addresses how the sensuality of film movement, colour, texture, materiality, and decoration might harbour meaning in their own right (pp. 15, 173). For Calloway, 'the material of the plot and the action and the overall "feel" of a great many [...] films is undoubtedly baroque, and yet the actual quality of the film-making is straightforwardly banal [...]' (p. 226). He continues that when 'design is so obviously lacking, the term "baroque" [...] seems to be misused as a description of the true style of the film' (p. 226). In this book, by contrast, I take the fact that a film can *feel* baroque—even without extravagant set design, technological displays, or stylistic hyperbole—to indicate that notions of baroque filmmaking need to be extended beyond that of a spectacular, virtuoso, or technologically-driven optic.

Clearly, some parameters are needed for us in approaching this aesthetic. Following on from phenomenological philosophy and from Bal's work on the baroque, I understand the baroque as a fundamentally correlative aesthetic that entangles one body with another.[19] Approaching the baroque as a doubled or correlative structure is suggestive of another crucial formal feature of the baroque: its characteristically 'open' spatiality. In 1915 the Swiss art historian Heinrich Wölfflin first noted that the baroque manifests a quintessentially 'open form' in its expansive depiction of space and in its stylistic attitude towards the frame (*Principles*, p. 124). Similarly, Ndalianis locates one of the foremost principles of baroque and neo-baroque form in its signature 'lack of respect for the limits of the frame' (*Neo-Baroque*,

p. 25). Umberto Eco, too, has argued that the baroque is a proponent of the 'open work' as it enacts 'deliberate move[s] to "open" the work to the free response of the addressee' ('The Poetics', pp. 52–53). Together, Ndalianis and Eco both helpfully indicate how the 'open' topology of the baroque occurs in conjunction with its 'open' attitude towards the participant. For Eco, 'open' works are characterized by a strong sense of physicality and movement, a porous spatiality and an invitation to the participant 'to make the [aesthetic] work together' ('The Poetics', p. 63). As Ndalianis similarly observes (and here we might take special note of her wording), the audience is '[e]ntangled in [the] neo-baroque order [...] (Neo-)baroque form relies on the active engagement of audience members, who are invited to participate' (Neo-Baroque, p. 25; italics mine). The baroque manifests an open stance towards the frame, as if inviting the audience into the space of the representation.

These topological tendencies lead me on to another key definition of the baroque: the baroque as a highly sensuous aesthetic. Despite the predominantly visual nature of most discussion of the baroque, the inter-sensory texturing of perception is essential to historic baroque forms just as embodied vision, movement, and materiality are fundamental to baroque cinema. Of course, baroque flesh will be enacted and experienced differently in its transition from the seventeenth-century arts into film. Here, Ndalianis is once again apposite. As she writes, the 'neo-baroque shares a baroque delight in spectacle and sensory experiences' that combine the visual, auditory, and textual in 'ways that parallel the dynamism of seventeenth-century baroque form' (Neo-Baroque, p. 5). While Ndalianis' neo-baroque has been catalysed by post-sixties shifts in Hollywood, her point remains pertinent to the baroque flesh that concerns this book—the fact that cinema possesses strong sensorial continuity with as well as substantial difference from earlier baroque traditions.[20]

Whereas the historic baroque arts were rendered through painted canvases, architectural frescoes, poetry, rhetoric, music, sculpture, and the play of light and shadow, a cinema of baroque flesh relies on very different technological bases. At the same time, the historically diverse and arguably still emergent technologies of cinema are also transcended by the sensible presence of what Sobchack labels the 'film's body' (Address of the Eye, pp. 164–259).[21] As I discuss more fully in the next chapter, the embodied but non-human concept of the film's body allows us to attend to the likeness that cinema bears with our own bodily being, bearing, and perception, and to the different aesthetic modalities that can inflect cinematic embodiment.

'Good Looking'

In his remarkable book *Downcast Eyes*, Martin Jay has extensively documented how an almost endemic distrust of vision has haunted Western philosophy, whether that distrust has been directed towards images, shadows, mirrors, reflections, or the cinema.[22] Even within current sensuous film scholarship, anti-visualism persists in the way that sight has come to signify a position of inherent optical or ideological mastery as opposed to the affective valuation of touch. Unlike other sensuously oriented film and media scholars, I try not to configure sight as distanced, disembodied, or distrustful in comparison to the other senses. Not only is vision inextricable from the rest of the human sensorium, even the notion of us making eye *contact* with another or with an artistic object can lead us on to moments of revelatory insight and ethically embodied connection (Cataldi, *Emotion*, p. 35).[23]

To redress such takes upon vision, I turn to the media archaeological work of the art and visual cultural historian Barbara Maria Stafford. As Stafford compellingly demonstrates, many contemporary critiques of 'manufactured splendors and ocular falsifications' as well as critiques of vision itself as '[m]ere beholding' stem from the pre-modern period (*Artful Science*, pp. 21, 23). It is no secret that the Enlightenment railed against the flagrantly feeling 'eye' of the baroque. Not only did seventeenth-century arts and culture appeal to 'lying surfaces' but its desire to foreground physicality was regarded with a deep suspicion—the beholder might become all too responsive to the 'perils of tactile color and whorish paint' (Stafford, *Good Looking*, p. 102; see also Stafford, *Artful Science*, p. 21). The anti-visualism of Enlightenment discourse situated vision 'not with Cartesian clarity and rational distinctness, but with Jesuitical delusion and mystical obfuscation in general', thereby damning the sensuous visuality of the baroque as not to be trusted in the new age of reason (Stafford, *Visual Analogy*, p. 14). Such metaphysical inheritance 'prefers the verbal to the visual, the intelligible to the sensible, the text to the picture, and the rigorous articulations of signification to the ambiguities of untutored perception' (Shaviro, *Cinematic Body*, pp. 14–15). It is not surprising that this inheritance is discernable in film theory as well, especially those strains that distrust one taking visual pleasure in or 'being affected and moved by visual forms' (Sobchack, *Address of the Eye*, p. 18).[24]

In the wake of the 'sensual turn of scholarship' that has been steadily gaining sway in the humanities, it seems timely to consider the still highly pressing need to restore what Stafford calls 'good looking' to cinema (Howes,

Sensual Relations, p. xii; *Good Looking*, p. 11). 'Good looking' focuses on embodied intelligence and a faith in visuality as it induces thought-provoking attention (*Good Looking*, p. 11). In bringing together Stafford's call for 'good looking' with the phenomenon of baroque flesh, it is my hope that this book will recuperate a thoughtful visuality for the baroque—typically associated with deceptive, maddening, or chaotic modes of perception—and for film and media studies.[25] I want to harness the longstanding aesthetic, critical, and cultural history of the baroque to develop a model of baroque cinema and of embodied film theory that is simultaneously sensuous, formally structured, and thoughtful in its engagements with the viewer. As it engages the senses, the emotions, and our visual intelligence, the baroque cinema that this book explores demands materialist approaches and flexible frameworks to film that do not just focus on the pre-reflective body (as Barker, *Tactile Eye*, and Sobchack do) or confine cinematic sensation to an aesthetics of the excessive, the abstract, the experimental, or the formless (as recent studies such as those of Martine Beugnet, *Cinema and Sensation*, or Jenny Chamarette, *Phenomenology and the Future of Film* also imply).[26]

This brings me to another overarching concept for this book: the relationship between analogy and the baroque. Made famous by Walter Benjamin's study of the *Trauerspiel* (the German tragic drama or mourning play), the baroque has often been linked with allegory.[27] As Paul de Man explains it, allegory 'names the rhetorical process by which the literary text moves from a phenomenal, world-oriented to a grammatical, language-oriented direction' ('Introduction', p. xxiii). If allegory boasts literary origins (the textual cleverness of making signs assume multiple meanings), then analogy can be considered visual in its origins and just as integral to the experience of baroque flesh.

In her book *Visual Analogy: Consciousness as the Art of Connecting*, Stafford invokes the ancient concept of analogy as 'a general theory of artful invention and as a practice of inter-media communication'; analogy derives from the Greek *analogia* or *ana/logos*, meaning 'according to due ratio' or 'according to the same kind of way' (*Visual Analogy*, p. 8). Reacting against what she perceives as the debilitating emphases on negativity, disjunction, fragmentation, differentiation, and decay brought about by post-structuralism, Stafford laments how we seem to 'possess no language for talking about resemblance, only an exaggerated awareness of difference' (*Visual Analogy*, p. 10).[28] She turns to analogical art, thought, and practice as a weaving together of things, as analogy 'discover[s] the relevant likeness in unlike things' (Stafford, *Good Looking*, p. 203; see also *Visual Analogy*, p. 3). Not only does Stafford identify analogy as at once a visual and a thoughtful

practice, she also maintains that the 'visual arts [are] uniquely suited to provide explanatory power for the nature and function of the analogical procedure' (*Visual Analogy*, p. 3).

Admittedly, Stafford is not concerned with cinema. Nevertheless, her recuperation of analogy as an ongoing visual mode of engaging with the world and with the arts can be extended to film. Furthermore, the kind of perceptual intelligence that she opens up through the lens of the pre-modern is well worth considering for contemporary film studies. This is because analogy prompts 'participatory performance' in the aesthetic experience—a 'mutual sharing in, or partaking of, certain determinable quantitative and qualitative attributes *through a mediating image*' (Stafford, *Visual Analogy*, pp. 3, 10–11; italics mine). The visual component of analogy and its 'fundamentally participatory mode of perception' are especially well suited to my analyses of baroque flesh, as it draws our attention to a mutually shared sensuality between bodies (Stafford, *Visual Analogy*, pp. 23, 58).

According to art historian John Rupert Martin, the historic baroque arts lent 'new force and meaning to received truths by translating them from the realm of the general and abstract into that of immediate, sensuous and concrete experience' (*Baroque*, p. 132). Similarly, Stafford locates analogy as 'a demonstrative or evidentiary practice—*putting the visible into relationship with the invisible* and manifesting the effect of that momentary union' (*Visual Analogy*, pp. 23–24; italics mine). As an analogical art, the seventeenth-century baroque brought 'invisible' concepts into visibility, lending theoretical and intellectual 'abstractions' concrete forms. It rendered the intensity of subjective feeling in Counter-Reformation scenes of martyrdom, death, ecstasy, and the divine or the growing awareness of infinity in terms that were sensuously intelligible to the beholder. As Christine Buci-Glucksmann asserts, the baroque typically founds 'meaning on matter and not on concept' (*Baroque Reason*, p. 140). Such a 'materialization or "corporealization" of the invisible' accounts for the heightened function that the image accrues in baroque art (Buci-Glucksmann, *Baroque Reason*, pp. 140–141). Not content with abstractions, the baroque weaves connectivity and connection between bodies, signs, and phenomena. Seemingly 'unrepresentable' concepts are endowed with visual and tangible form in the arts, soliciting the sensuous perception of their beholder.

As Stafford puts it, analogy 'has the virtue of making distant peoples, other periods, and even diverse contemporary contexts part of our own world' (*Visual Analogy*, p. 51). As an age-old concept, it is analogical thought that allows the design of this book to proceed by providing us with great

conceptual 'opportunities to travel back into history, to spring forward in time, to leap across continents' (Stafford, *Visual Analogy*, p. 11). By way of analogy, what follows will draw attention to the correspondences and the differences that exist between the historic baroque and a baroque cinema, between cinema and our own embodied being, attempting to weave together imaginative and analogous connections between phenomena along the way.

A Cinema of Baroque Flesh

This brings us to the organization of this book. Each chapter is structured by particular themes, figures, feelings, and forms of the baroque—long-standing media archaeological motifs that can be traced back to the art, architecture, literature, poetry, historic treatises, and collecting practices of the seventeenth century. Throughout, I offer the reader close analyses of historic baroque artworks and/or cultural practices that I consider along-side my examples of a baroque cinema of the senses. To be sure, my film selections are expansive: they move from early cinema and silent slapstick through to contemporary European filmmaking; they rove between past and present Hollywood; ranging from the costumed bio-picture to digital documentary and jostling 'art' film alongside science fiction and horror. While my selections are expansive, they are not without careful considera-tion. They span film history, different national cinemas, and genres so as not to restrict baroque flesh to any one format or period of cinema. In bringing together the past and present of the baroque, I like to think of my film analyses as dynamic thought experiments in what a baroque cinema of the senses might involve and how it is experienced—readers should feel free to pause and add their own. For this book, baroque flesh lies latent within and is amenable to the ontological dynamics of cinema itself. A baroque cinema emerges when film enacts or reprises recognizably baroque figures, forms, and motifs, modes of perception, physicality, and feeling. Each chapter will endeavour to draw out the sensuous significance of the historic and cinematic baroque by considering its appeals to our different sense fields and to our analogical intelligence.

Chapter 1 establishes the main critical, contextual, and film-philosophical frameworks for my model of baroque flesh. By way of the philosophy of Merleau-Ponty, I identify the baroque as a doubled or correlative structure and as the aesthetics of reversibility. I argue for the relevance of film-phenomenology to the baroque and I mobilize Sobchack's striking concept

of the 'film's body' to deepen our understanding of baroque incarnations of that body (*Address of the Eye*, pp. 164–259). Following on from a discussion of baroque vision and painting the 'flesh' in seventeenth-century art, I examine the importance of vision, self-reflexivity, and gesture for the baroque. Contrasting two films that resonate with the baroque in different ways—the Hollywood science fiction/noir *Strange Days* (Kathryn Bigelow, 1995) and the European thriller *Caché* (Michael Haneke, 2005)—I argue that baroque cinema involves a self-reflexive layering of vision that also foregrounds experiences of perceptual flux.

Chapter 2 undertakes a substantial fleshing out of baroque vision and form. Bringing together Merleau-Ponty with the sensuous history of the baroque and the senses in film theory, I argue that baroque flesh resonates with an important decorative and conceptual motif for the baroque: the knot. Through a detailed examination of Gian Lorenzo Bernini's *Ecstasy of St. Teresa of Avila* (Cornaro Chapel, Rome, 1647–1652) amongst other historic baroque artworks, this chapter contextualizes the seventeenth-century *bel composto* (the beautiful whole) and early modern appeals to the 'passions' of the soul as crucial historic precedents for a baroque cinema. Chapter 2 delves into the flow between space, movement, and emotion for a cinema of baroque flesh. Concentrating on the brutally charged work of the contemporary French filmmaker Claire Denis and her film *Trouble Every Day* (2001), I argue that baroque 'excess' needs to be understood in more precise spatial, emotive, and inter-sensory terms. Denis' baroque is linked to sensuous assault as well as absorption, such that we are spatially and also emotionally immersed 'in' a cinema of the passions.

Chapter 3 develops the analogical world view of the baroque by focusing on the copy and the contact of baroque poetic language. Here I argue for baroque flesh as an intertwining of the figural with the literal, of language with experience, and of skin with signification. Reading the silent slapstick comedies of Buster Keaton through baroque poetics, I argue that the analogical witticisms of Keaton also belong to a baroque cinema. Keaton's films reprise both the copy and contact of baroque poetics by creating ingenious and surface-driven connections between bodies, signs, and worldly phenomena. Chapter 3 then turns to the history of the French absolutist court of Versailles to establish the baroque as a surface-based aesthetic that privileges the skin and different material textures. I argue that baroque sensibility persists in the affectively luxurious and surface-driven textures of Sofia Coppola's *Marie Antoinette* (2006).

Chapter 4 returns to Merleau-Ponty's figure of the two hands touching to develop a baroque haptics of the cinema. In the wake of Deleuze's own

mobilizations of the art historian Aloïs Riegl, together with Deleuzian-inflected studies of art and film such as those of Marks, discussions of the haptic in film theory have often relied upon Riegl.[29] While continuing to draw on Riegl, Deleuze, and Marks, this chapter brings the 'flesh' together with art historical studies of the baroque and with the work of Benjamin to propose a baroque haptics that is inclusive of figuration, depth, and signification. Using Jonathan Caouette's digital documentary *Tarnation* (2003) as my main case study, I examine how the design of baroque haptics moves between surface and depth and in and through shifting masses of detail. Connecting the digital assemblage of *Tarnation* to the collecting traditions of the seventeenth century, the baroque habit of perceiving and thinking by way of analogy again emerges here. Building on Stafford's work, I try to demonstrate that baroque analogy is as tactile and textural in its engagements with the world as it is visual.

The notion of a trans-historic baroque and its cinematic incarnation have provided the very impetus for this book. Together, Merleau-Ponty's philosophy, Sobchack and Barker's film-phenomenology, and the work of sensuous film scholars such as Marks and del Río have provided its film-philosophical foundation, inspiring me to take a closer look, get a better feel, and listen to the sensuous murmurings of the body in terms of what might constitute an appropriately baroque cinema of the senses. Harnessing the strengths of film-phenomenological as well as detailed formal description, what follows will attend to the always two-sided exchange that occurs between film and viewer by examining what happens to my flesh as it engages with, recedes from, or is riled up by the baroque. This is not to imply that baroque cinema is particular to my flesh; rather, my use of close description strives to capture and to continue to document what Sobchack has valuably established as 'our common sensuous experience of the movies' (*Carnal Thoughts*, p. 65). While this common sensuality might be experienced by differently situated viewers in ways that are not fully described here, it is also not beyond a film-phenomenological nor an aesthetic thematization such as I undertake. By concentrating on the particular embodied manner by which a specific film or artwork engages me, I have been better able to identify and reflect upon the different embodied experiences of the baroque that can occur in cinema while still remaining committed to historicizing and contextualizing its sensuous significance. The art of entanglement is longstanding, while baroque flesh finds new life, sensuous form, and signification in cinema.

1. Flesh, Cinema and the Baroque: The Aesthetics of Reversibility

> If we can show that the flesh is an ultimate notion, that it is not the union or compound of two substances, but thinkable by itself, if there is a relation of the visible with itself that traverses me and constitutes me as a seer, this circle which I do not form, which forms me, this coiling over of the visible upon the visible can traverse, animate other bodies as well as my own.
> – Maurice Merleau-Ponty (*VI*, p. 140)

> [A]bove all it is the [...] provocative quality of the gesture which is baroque.
> – Walter Benjamin (*The Origin*, p. 183)

For Merleau-Ponty, any 'philosophy of perception which aspires to learn to see the world once more [...] will restore painting and the arts in general to their rightful place' (*World of Perception*, pp. 93–94). By establishing the ontological structures and conditions that underpin baroque flesh, this chapter will give us pause to consider why this aesthetic is so amenable to film. While turning perception 'inside out' to make it sensible to others could be considered through alternative aesthetic models, reversibility bears a very special relationship to the baroque. As I argue it, in baroque flesh we find the aesthetic expression of much of what Merleau-Ponty has to tell us about embodied being and perception.

Just as 'flesh' speaks to shared but not coincident relations, the baroque of art and film hinges upon doubling and reversibility. Baroque flesh is embedded in a structural circularity: 'every perception is doubled with a counter-perception [...] an act with two faces' as Merleau-Ponty writes (*VI*, p. 264). In starting to explore the relationship between cinema and the baroque more closely, this chapter will establish the baroque as its own phenomenology of vision: mobile, multiple, prismatic, and highly theatrical. By way of *Strange Days* and *Caché*, I argue that a baroque 'way of seeing' manifests itself in film through perceptual flux and through a self-reflexive gesturing towards the viewer, towards the medium, and towards what Sobchack calls the 'film's body' (Klein, *Vatican to Vegas,* p. 12; Sobchack, *Address of the Eye*, pp. 164–259).

Bringing this chapter to a close necessitates a shift from the visual to the visible, as I consider what Walter Benjamin calls the 'provocative quality

of the gesture' of the baroque (*The Origin*, p. 183). Baroque art has long thrived upon frontal modes of address through its use of bodily gesture and intimate 'facing' effects. Baroque 'facing' similarly occurs in film when self-reflexivity combines with the feeling of audio-visual proximity. As I will detail, baroque 'facing' in film is not a modernist address towards the viewer. Attaching the baroque to critical notions of *deixis* (a rhetorical term meaning to 'point out' or 'pointing'), I argue that baroque cinema courts a sense of bodily closeness that occurs alongside our awareness of its artifice (Stewart, *Poetry*, p. 150). The feeling of *deixis* fosters a dialogical relationship between film and viewer, 'pointing at the viewer' in a manner that acknowledges a shared embodiment (Bal, *Quoting*, p. 138).

Baroque Vision and Painting the Flesh

Given its traditional association with cultures of overt, luxurious display and with revelry in illusion, splendour, intricate ornamentation, and decoration, it seems almost redundant to observe that the baroque boasts a heightened connection with vision. In his book *Sade, Fourier, Loyola*, Roland Barthes identifies that the seventeenth century introduced a new cultural re-alignment of the senses. The historic baroque brought with it the diminishing importance of sound: we 'have a reversal: the eye becomes the prime organ of perception (Baroque, art of the thing seen, attests to it)' (Barthes, *Sade*, p. 65).

The ocular displays of the historic baroque have been well captured, with scholars such as Martin Jay suggesting that the baroque introduced a veritable 'overloading of the visual apparatus' (Jay, *Downcast Eyes*, p. 47; Jay, 'The Rise', p. 418). During the seventeenth century pictures were re-produced and disseminated on a quasi-industrial scale (Braider, *Baroque Self-Invention*, p. 42).[1] Thanks to the invention of the printing press during the fifteenth century, print culture and the baroque appetite for vision combined to spawn nascent and highly visual mass entertainments. Amidst the proliferation of plays, novels, biblical texts, printed books, street music, pamphlets, ballads, almanacs, as well as books of scientific secrets and natural magic, the written word was infused with appeals to the eye (Ndalianis, *Neo-Baroque*, p. 45).[2] Popular labyrinth poems that were composed in Latin, Spanish, or Portuguese created a profusion of written paths for the reader to follow. These poems could be read across multiple trajectories (left to right, up and down, diagonally, or even in spirals) and were known for striking displays of creative calligraphy and printing (Hatherly, 'Reading Paths',

p. 52). Similarly, baroque novels detail their protagonists being absorbed in activities that are primarily scopic in nature. They contain detailed accounts of arts and entertainments such as automata, cabinets, paintings, emblems, sculptures, columns, ceilings, ballets, galleries, devices, portraits, inscriptions, sonnets, and ballets (Murray, 'Philosophical Antibodies', p. 155).

The mapping of new strangely exciting worlds (celestial space, exotic continents, and the body) flooded the market with illustrations of animal and human anatomies as well as the theatres in which they were dissected. Woodcuts showed flora, fauna, and artefacts newly discovered in the colonies of the New World, alongside images of the physiognomies, the social mores, and dress of colonial subjects (Braider, *Baroque Self-Invention,* pp. 42–43). Paintings, drawings, and prints were concerned with 'scenes and objects drawn from every field of human interest, every sphere of human activity and every corner of the globe' (Braider, *Baroque Self-Invention,* p. 42). Their imagery consisted of portraits, genre scenes, and still lives, landscapes, maps, and pictures in the *vanitas* and *memento mori* traditions. The historic baroque age witnessed pictures of notable buildings and diagrams of complex machinery; rampant emblems, engravings of coins, medallions, and the ruins of ancient monuments or sites; 'histories' drawn from the Bible, classical mythology, and epic poetry and the depiction of sieges, battles, coronations, dynastic marriages, and public executions (pp. 42–43). The fervour with which the historic baroque produced and consumed visual experience has been described as tantamount to a kind of optical mania. For Christine Buci-Glucksmann, the 'madness of vision' that typifies the baroque binds vision and lunacy together as the twinned faces of its overwhelmingly scopic drive (*La folie,* p. 73; translation mine; Braider, *Baroque Self-Invention,* p. 8).[3]

Above and beyond the circulation of print imagery and painting, the historic baroque produced a slew of visual enchantments for the eye (Kitson, *Age of Baroque,* p. 38). An opulent sensibility pervaded painting, theatre, and the 'visual extravagances' of seventeenth-century opera (Braider, *Baroque Self-Invention,* p. 8; Klein, *Vatican to Vegas,* p. 57). The baroque compulsion to see can be evidenced by the general baroque delight in visual intrigues and optical ingenuity of all kinds as well as the sheer range of visual experiences on offer in emergent scientific technologies and in the arts: telescopes, microscopes, lenses, prisms, camera obscura, and magic lanterns (Stafford, 'Revealing Technologies'). Invested in perspectival trickery of all kinds, the baroque experimentation with and warping of perspective was practised in everything: landscape gardening, *trompe l'oeil* paintings, and anamorphic imagery; large-scale forms of decoration such as staggering *quadratura* or

quadri riportati perspectival effects on vaults, domes, and ceilings; and portable entertainments such as mobile peep shows and perspectival boxes.[4]

The famous Jesuit experiments with catoptrics and prism-like devices coupled visual curiosity with revelry in special effects. The machine of multiple mirrors that is said to have belonged to the great polymath Athanasius Kircher, for example, is said to have contained a portrait of Pope Alexander VII at its centre. As the machine turned, the mirrors combined to produce not one but what must have seemed like an almost infinite number of refracted images of the Pope (Findlen, *Possessing Nature*, pp. 46–47).[5] In fact, seventeenth-century Europeans were obsessed with mirrors especially concave or convex mirrors that deliberately distorted the image or the multi-faceted surface of the *sorcière* (witch's mirror) that could multiply reflections into a bewitchingly slivered series (Jay, *Downcast Eyes*, p. 48; Stafford, *Visual Analogy*, pp. 125–126). Such mirrors can be read as a potent analogy for historic baroque culture: its taste for *mise-en-abyme* or multiple and doubled enframings; the replication of its own media within the space of the representation; its themes of dream and illusion or illusion and reality; and a love of ghosts, twins, and doublings of all shapes and forms (Braider, *Baroque Self-Invention*, p. 8). Given that the baroque has been associated with a rampant and manic desire to see, is it any wonder that Barthes synopsizes the baroque as the 'art of the thing seen'? (*Sade*, p. 65). An overt fascination with vision is also staged within the space of baroque representation. That fascination persists in baroque cinema, as we will later discover.

What is too little emphasised in the common critical association of the baroque with vision is how the 'baroque habit of seeing double' actually addresses its participant as a commensurately visual and visible being (Stafford, *Visual Analogy*, p. 129). In other words, what the baroque instigates is a doubled 'drama of *reciprocal* seeing' (Zamora, *Inordinate Eye*, p. 35; italics mine; see also Buci-Glucksmann, *La folie*, pp. 73, 85–86). Taking our cues from Merleau-Ponty, we could say that the baroque will-to-see has its structural reverse—the corresponding 'baroque desire and compulsion to be seen' (Saisselin, *The Enlightenment*, p. 34). According to Giancarlo Maiorino, historic 'baroque art called for involvement' because it cultivated 'bilateral relationships' (*Cornucopian Mind*, p. 99). Similarly, the art historian Rudolf Wittkower notes that the saints and martyrs of baroque art are seen in heightened bodily states 'of devotion and ecstasy, and in this exalted frame of mind they may see visions to which the beholder becomes a party' (*Art and Architecture*, p. 42). In baroque hagiographies, especially, the beholder is configured as a vital participant in the 'visionary

experience' (Wittkower, *Art and Architecture*, p. 42). Although he does not name it as such, correlation typifies baroque art for Wittkower. By way of a 'dual vision', the 'beholder is stimulated to participate actively in the supra-natural manifestations of the [...] art rather than to look at it "from outside"' (p. 140). Supported by its highly sensorial subject matter, light, composition, and gestural expression, nothing is 'left undone to draw the beholder into the orbit of the work of art' (p. 140). Such bilateral relationships and dual visions lend artistic form to Merleau-Ponty's *chiasm* of the 'flesh'. Following on from his 'reciprocal distinctions' between the seeing and the seen, we can better understand how baroque organizations of vision are not depicted as fixed but as always 'innumerable and changing' (de Certeau, 'Madness of Vision', p. 25).

Cinema's Baroque Flesh: Film, Phenomenology and the Art of Entanglement is not alone in identifying resonant points of connection between the 'flesh' and the baroque. Alphonso Lingis aptly describes *The Visible and the Invisible* as a '"baroque" proliferation of generating axes for visibility' ('Translator's Preface', p. liii). Michel de Certeau connects *The Visible and the Invisible* with 'a contradictory, quasi-baroque style' that combines 'the constituting "no" of the "for-itself" with the "yes" of "being-in-the-world"' ('Madness of Vision', pp. 25–26). More recently, art historian Christopher Braider has remarked that seventeenth-century baroque painting contains figures looking out 'to the position we ourselves occupy as beholders in a space outside of yet continuous with that of the image' (*Baroque Self-Invention*, p. 61). The frontal looks that populate baroque art are suggestive of the 'power to look back' at the beholder (p. 61). For Braider, these frontal looks are a reminder of Merleau-Ponty's 'reciprocal and *chiastic* structure of vision itself. [... Each] object, however eyeless and inanimate, returns our gaze as a reflex of that conscious presence to things by which we grant them visibility' (p. 61).

More so than these critics, it is the French philosopher Christine Buci-Glucksmann who has most forcefully argued for a connection between Merleau-Ponty's later philosophy and the baroque. Her book, *La folie du voir: De l'esthetique Baroque* (The Madness of Vision: On Baroque Aesthetics), gleans its title directly from *The Visible and the Invisible* and from de Certeau's essay on this text, discussed above and in the introduction.[6] For Buci-Glucksmann, as for this book, 'flesh' finds representative form in the baroque (*La folie*, pp. 85–86). Following on from Merleau-Ponty, Buci-Glucksmann asserts that all 'Being is to be seen' and that, '[a]s in the baroque, the aesthetic [experience] is the paradigm of every ontology of "Being" in decline, in flight, in retreat, that from which announces the great

symbolic matrices of the Gaze' (*La folie*, pp. 72–73, 85; translation mine). Given its demand for 'seeing in perspective, Being becomes a system of many entries', such that the baroque is typified by a 'plural vision' (*La folie*, pp. 72–73; translation mine). Through its ready embrace of mobility and multi-perspectivism, the baroque foregrounds the play of many shifting gazes and a 'multi-faceted vision' (Buci-Glucksmann, 'Baroque Eye', p. 32). Furthermore, she likens baroque vision to seventeenth-century poetic language. Although we will examine baroque language more closely in Chapter 3, it is worth noting how baroque language encourages the proliferation of meaning just as baroque vision fosters the proliferation of many possible points of view (*Baroque Reason*, p. 139; *La folie*, p. 134; Jay, 'The Rise', p. 322).

While adopting Buci-Glucksmann to further our understanding of the baroque, I would urge a word of caution. Unlike this study, Buci-Glucksmann does not consider the existence of a baroque cinema and she tends to delimit the broader sensuous connections between the baroque and Merleau-Ponty to the singular realm of vision.[7] She articulates a dialectics of seeing and gazing that, as Deleuze affirms, only allows for the existence of an optical bond or correlation (*The Fold*, p. 33). Nevertheless, she does invoke Merleau-Ponty to convey the imbrication of viewer and viewed that is so endemic to baroque form (Jay, 'The Rise', p. 317). In addition, she refers to a particular seventeenth-century artwork—Diego Velázquez's *Las Meninas* (The Prado, Madrid, 1656)—as indicative of baroque vision and representation.

Velázquez's *Las Meninas* has fascinated art historians, cultural critics, film theorists, and philosophers alike.[8] The culmination of Velázquez's career as artist and courtier to King Philip IV of Spain, the cast of characters and the setting of the work can be ascertained with relatively little trouble. Velázquez's earliest biographer, Antonio Palomino, gives us an accurate description of both the scene of the painting and its people as early as 1724.[9] Velázquez certainly paid much attention to capturing authentic details for *Las Meninas*: the principle setting of the work (inside the prince's chamber) corresponds with the 1686 inventory of the Alcázar palace, right down to the reproduction of various Rubens in the background, while most of the painting's characters can be identified as real-life personages.[10] As Jonathan Brown comments, Velázquez 'first of all used a real setting with real people which automatically triggered the response of recognition in his contemporaries' (*Velázquez*, p. 258). And yet, despite its assured air of verisimilitude, precisely what the painting represents and even the techniques behind its construction have been hotly contested.

At its most basic, the artwork represents the painting of a portrait inside an artist's studio. It is set inside a large room, the right-hand side of which is

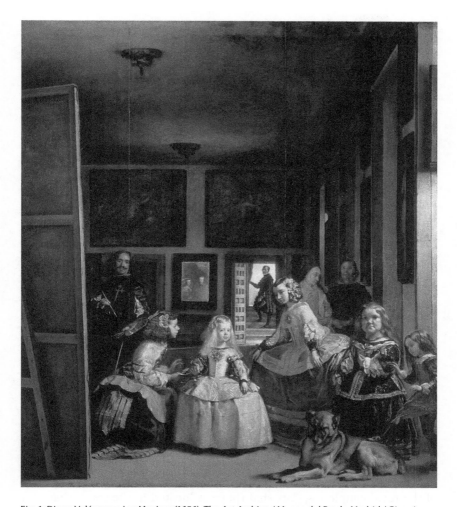

Fig. 1: Diego Velázquez, *Las Meninas* (1656). The Art Archive / Museo del Prado Madrid / Gianni Dagli Orti.

cut through with windows. Our view of the left side of this room is blocked by the edge of a large canvas, which can only be seen from the rear. Standing just back from the hidden canvas is Velázquez, a self-portrait of the artist that depicts him as poised with his palette and paintbrushes in hand. He pauses from his task to look out, portrait-like, from the actual canvas that is *Las Meninas*. In the rough centre of the painting is a richly dressed little girl. A consummate baroque artist with 'an eye [...] attuned to appearance', Velázquez conveys to us the delicately embroidered and zigzagging patterns of her dress (Wölfflin, *Principles*, p. 47). This is the Infanta Margarita María,

daughter of King Philip IV and Queen Mariana of Spain. Accompanied by two maids of honour, the Infanta is looking directly outwards, as if posing for her portrait. On her left side is María Agustina Sarimenta, who kneels to offer a cup of water to the princess. On her right side is Isabel de Velasco, inclining towards the Infanta even as she directs her glance away. Her attention is caught by an event happening *outside* the space of what is visible.

Two of the known court dwarves, Mari Bárbola and Nicolas Pertusato, stand in the right corner of the painting. Once again, Mari's gaze is directed outwards towards an unseen event while Nicolas places his foot on a sleeping dog at their feet. Two other court attendants are seen behind the dwarves: these are a female chaperone, the widow Marcela de Ulloa, who turns to address an unidentified companion (a *guardadamas* or bodyguard). His attention is focused elsewhere, beyond the limits of the canvas (Brown, *Images and Ideas*, p. 88). In the rear of the painting, Velázquez's use of perspective renders an open door, a corridor, and a flight of stairs visible. A man stands out on the stairs (most likely José Nieto, head of the queen's tapestry works) as a dark silhouette against the flood of light (Schmitter, 'Picturing Power', p. 256). Although it is not certain whether Nieto is about to enter the room, his presence draws no attention from any of the painted figures and his own look is also directed outwards. In the background of *Las Meninas* are a dimly lit series of paintings that adorn the walls of its room and are supposed to be by the artist Rubens, including *Minerva Punishing Arachne* and *Apollo's Victory Over Marsyas* (Schmitter, 'Picturing Power', p. 256).

Despite its array of human figures, it is the luminous rectangle on the left of the far walls that catches the eye—drawing our attention towards a distant mirror. This mirror reflects the image of the Spanish king and queen, standing beneath a red drapery. Arranged frontally, the reflection of the royal couple suggests that they are located in the space that is *in front* of the representational canvas within the painting. Most readings of *Las Meninas* suggest that it is the king and queen who are the focus of suspended attention. It is they towards whom the characters look, either because their intrusion has interrupted the painting of a group portrait or because what the painted Velázquez is working on is a portrait of the royal couple (Brown, *Images and Ideas*, p. 91). *Las Meninas* gives us the impression that the viewer inhabits the same space as the king and queen and that, together, we have attracted the attention of the various looks of the painting. Velázquez creates a heightened spatial, visual, and embodied continuum between the artwork and its beholder so that 'two worlds interlock, physically and psychically' (Martin, *Baroque*, pp. 168–170). In this regard, *Las Meninas* is very much a baroque painting.

As the surface of its representational canvas cannot be seen, we cannot determine whether the mirror reflects a portion of the painted canvas or whether it holds an image of the 'real' king and queen. According to art historian Svetlana Alpers, the composition makes for an 'intrinsically puzzling' artwork (*Art of Describing*, p. 248, fn. 69, 70). Rather than offering a conclusive interpretation, *Las Meninas* is best understood through the baroque appetite for enigmas as these resist 'unraveling to reveal a transparent meaning' (Jay, 'The Rise', p. 322). Studying the relationship between enigmatic forms and the baroque, Mario Perniola has observed that baroque 'painting de-realizes the given, and for the natural substitutes the enigmatic and the contrived. [...] The gaze is drawn deep into [its] enigmatic depths, indeed into the infinite; the play of light and shadow evade every law, and dissonances are deliberately sought out' (*Enigmas*, p. 93).

Perniola's description of the 'enigmatic' baroque painting is congruent with the interpretive enigma of *Las Meninas*. Its images weave in and through the 'real', the 'reflected', and the 'represented' to incorporate pictured bodies as well as doubly removed pictures or mirrored reflections of bodies. Given its built-in ambiguity, this artwork has been taken to mean everything from Velázquez-the-artist invoking the activity (and nobility) of painting to a post-structuralist icon for the nature of representation itself (Tweedie, 'Moving Forces', p. 36; Schmitter, 'Picturing Power', p. 257; Alpers, 'Interpretation', p. 33; Lambert, *Return of the Baroque*, pp. 79–81; Foucault, *Order of Things*, pp. 3–16).[11] The one aspect that has united discussion of *Las Meninas* is the fact that most critics agree that the painting offers us a meta-account of its own operation (Schmitter, 'Picturing Power', p. 257). For Lois Parkinson Zamora, 'Velázquez paints himself painting himself, a circle of self-representation that includes the monarchs he ostensibly paints' (*Inordinate Eye*, p. 171). As Mieke Bal similarly observes, *Las Meninas* 'is self-reflexive in the most obvious senses: it is a painting about painting' (*Reading*, p. 260). As a painting about painting, the self-reflexive gestures that *Las Meninas* makes towards the beholder and towards its own production can be readily reconciled with the rampant doubling of form and vision that typifies the baroque.

Of particular interest to this chapter, however, is the *chiasm* of vision that Velázquez so forcefully evokes. It is the *chiasm* of vision in this painting that allows for its conflicting interpretations. Pinning down a singular interpretation to *Las Meninas* is to ignore its baroque destabilizations of vision and meaning. As Martin Kemp observes, perhaps '[n]o painting was ever more concerned with "looking"—on the part of the painter, the figures in the painting and the spectator' (*Science of Art*, p. 88). Kemp is correct in identifying the importance of looking in *Las Meninas*—for the viewer before

it, the bodies contained therein, and the painter who enables it. However, I hesitate to embrace his synopsis fully because it places too much emphasis on the singular act of looking. In its attempt to unhinge fixed perceptual roles, the baroque vision of this painting instigates a movement between the inside and the outside of the work.

Through a complex layering of vision, *Las Meninas* configures perception as in flux. It is the mobility of perception—the reversibility of the seeing and the seen—that catalyses the enigmatic qualities of the painting. The looking is correlated with the looked at and these perceptual roles are capable of renewal and reversal. The painting itself is organized around a heightened theatrical scenario such that the beholder *outside* the picture is acknowledged and gestured towards as being seen. *Las Meninas*, in turn, 'acknowledges [its own] state of being-seen' as well (Alpers, 'Interpretation', p. 32). As Buci-Glucksmann nicely describes it, the structural dynamic of the baroque means that artistic 'objects lose their stable and enclosed identity' and will 'gravitate around us "as stars"', enfolding us into a *shared* aesthetic vision that occurs across real/representational bodies (*La folie*, pp. 85–86; translation mine).

As is consistent with the porous spatiality of the baroque, *Las Meninas* 'opens' the space of artwork and beholder to forge a heightened continuum between them (Eco, 'The Poetics'; Ndalianis, *Neo-Baroque*, p. 25; Maravall, *Culture*, p. 75). Furthermore, it is known to be one of the largest of Velázquez's paintings, measuring ten and a half feet by nine feet wide (Brown, *Velázquez*, p. 96). The sheer dimensions of the painting render its characters life-size—an approximate match for our own viewing body, an effect that is still maintained by the contemporary hanging of the work at the Prado. Insofar as the actual frame of the painting intersects a room whose ceiling, floor, and window bays all extend outwards, appearing to incorporate the body of the beholder, the beholder is strongly encouraged to engage with the painting in physical, spatial, and optical terms. In many respects, the painting is all about the artistic role and function of framing: literal frames appear on the walls of the room, in the mirror, the windows, in the doorway, and as the edges of the unseen canvas. Nevertheless, in its fluid perceptual exchange between the 'inside' and the 'outside' of the work, *Las Meninas* remains a decidedly un-framed experience. Yoking the 'inside' of the representation to the 'outside' space of the viewer, it erodes the boundaries that divide internal from external elements by performing a baroque collapse of the frame (Ndalianis, *Neo-Baroque*, p. 152; Deleuze, *The Fold*, p. 123). This spatial effect is only achieved through the perceptual instability of artwork and beholder.

Alpers also picks up on the embodied impact of *Las Meninas*, aptly re-
marking that it is 'not only intended for the viewer's eyes [...] given the great
size of the canvas, it is also intended for the viewer's body' ('Interpretation',
p. 31). If *Las Meninas* is endowed with an arresting physical presence, this
is because it hinges on recurring trademarks of baroque art: face-to-face
looks and the use of bodily gestures that are directed out from the canvas
to foreground 'the fact that we are looked at by those at whom we are look-
ing' (Alpers, 'Interpretation' 31). The gaze of the painted Velázquez, Nieto,
the Infanta, and most of her entourage are directed outwards—not only
towards the king and queen of their representational realm but also towards
us. As Merleau-Ponty comments, in a quotation that can be extended to this
artwork, 'our eyes are no longer the subjects of vision; they have joined the
number of things seen' (*VI*, p. 29). Based upon the shared, reversible grounds
of vision, *Las Meninas* plays upon an embodied continuity between the
beholder and its represented scene/seen. The series of looks that emanate
from the canvas rely upon a complementary vision. To adopt Merleau-
Ponty's words for this painting's baroque effect, we could say that here
vision becomes '*doubled with a complementary vision or with another vision:
myself seen from without, such as another would see me*, installed in the midst
of the visible, occupied in considering it from a certain spot' (*VI*, p. 134;
italics mine). It is towards our eyes and our body (beyond the perimeters of
the representation) that the painted figures turn—encroaching upon and
observing the 'space from which they are observed: gaze encounters gaze'
(Schmitter, 'Picturing Power', p. 257).

In his book *The Order of Things*, Michel Foucault famously aligns *Las
Meninas* with the 'classical' model of representation. This is an episteme of
knowledge that Foucault extends from the late sixteenth to the nineteenth
century whereby interpretation ceases to move in and through resemblance
(Foucault, *Order of Things*, p. 16; Tweedie, 'Moving Forces', p. 35; Alpers, *Art
of Describing*, p. 79). For Foucault, *Las Meninas* is 'the representation as it
were, of Classical Representation, and the definition of the space it opens
up to us' (p. 16). Although Foucault does not use the term 'baroque', the
concept pervades his descriptions of the artwork. Recalling the *chiasm* of
vision, Foucault asserts that *Las Meninas* is a painting in which '[n]o gaze
is stable' for 'the observer and observed take part in a ceaseless exchange'
(pp. 4–5). The 'looks that pass across it are not those of a distant visitor',
he adds, for 'what all the figures in the picture are looking at are the two
figures to whose eyes they too present a scene to be observed. *The entire
picture is looking out at a scene for which it is itself a scene*' (pp. 12, 14; italics
mine).

Foucault's analyses are reminiscent of Merleau-Ponty as well, although he never mentions the latter. At the outset of his essay, Foucault describes the viewing of *Las Meninas* as 'a matter of pure reciprocity: we are looking at a picture in which the painter is in turn looking out at us. [...] eyes catching one another's glance, *direct looks superimposing themselves upon one another as they cross*' (p. 4; italics mine). If this were not material enough for a reading of baroque flesh, he then goes on to suggest how the 'subject and object, the spectator and the model, *reverse their roles to infinity*. [...] we do not know who we are, or what we are doing. *Seen or seeing?*' (p. 5; italics mine). Despite these intriguing descriptions, Foucault diverges from the 'flesh' of Merleau-Ponty by aligning *Las Meninas* with 'classical' representation. As Alpers insists, the absence of the subject-viewer is essential to Foucault's 'classical' model. However, his emphasis on absence does not cohere well with this painting's motif of visual reciprocity (Alpers, 'Interpretation', p. 36).

For me, Foucault elides the baroque vision of *Las Meninas* in order to demonstrate a fundamental negativity at the heart of its viewing: 'our gaze disappears' within 'a whole complex network of uncertainties, exchanges, and feints' (*Order of Things*, p. 4). A considerable burden is placed upon the mirror of the painting as a kind of screen that ties his 'classical' model of representation together. For Foucault, the mirror is the exact site/sight at which the roles of artist, spectator, and model/subject congregate. It represents a 'superimposition of the model's gaze as it is being painted, of the spectator's as he contemplates the painting, and of the painter's as he is composing his picture (not the one represented, but the one in front of us which we are discussing)' as 'the starting point that makes the representation possible' (pp. 14–15). Insofar as the beholder must inhabit the 'essential void' of this painting and of 'classical' representation in general, Foucault argues that the presence of the beholder is usurped or effaced by the image of the sovereign (the king and queen) that appears in the mirror (p. 16). It is the sovereign eye that is the real and rightful owner of the painting's masterful view.

If we pursue Foucault's 'classical' interpretation of *Las Meninas*, there is 'a necessary disappearance' of the beholder; this 'very subject [...] has been elided' (Foucault, *Order of Things*, p. 16). The disappearance of the beholder from the mirror where their image should appear (*if* the spectator/artist/ model did converge) exposes the 'classical' model of representation as an ideological construction that must be viewed from an ideal vantage point. This vantage point is that of the 'sovereign beholder who stands before the picture and for whose eyes everything is meant' (Perez, *Material Ghost*,

p. 301). The promise of such a view depends on the distance/absence of the actual beholder. If we assume this point of view, it is always in the borrowed clothes of the sovereign and an inherent deception.

In light of the baroque organization of this painting, I have to disagree. Foucault curbs a baroque mobility of vision by concentrating on the sovereign authority that is reflected in the mirror. As film theorist Gilberto Perez suggests, *Las Meninas* makes explicit its own function as 'a stage [that is] meant for the eyes of a spectator who stands outside it' (*Material Ghost*, p. 302). Furthermore, by 'making explicit the picture stage of classical representation, *Las Meninas* at the same time makes a breach in it, breaks through its boundaries and *opens it in our direction*' (p. 302; italics mine). By deliberately opening itself up in our direction, the painting can justly be interpreted as baroque. Most importantly, the mirror of the painting is *not* the vanishing point of this work.[12] Far from serving as an index of truth or as the reflection of an ideal viewing point, as Foucault claims, I want to project another critical premise on the mirror of *Las Meninas* for it functions as a baroque mirror that distorts, multiplies, and prolongs its reflections. It is not intended to yield a transparent image or fixed interpretation.[13]

What the mirror of *Las Meninas* reflects is a baroque correlation between bodies. For Bal, what is really at stake in analysing the mirror of *Las Meninas* is the issue of *self*-reflection. Self-reflection requires the beholder to think about which self is at stake in interpretation: that of the work, the interpreter, or both? For Bal, 'self-reflection needs to risk the viewer's entanglement within the work and thus must endorse the reflection of/ on both selves. This is suggested by the ambiguity of the word "reflection", meaning both mirroring and thinking' (*Reading*, p. 258). Unlike Foucault's reading, then, we might say that though artist, spectator, and model(s) meet on the shared grounds of vision in *Las Meninas* they do not coincide there. Rather, we are entangled. If we recall Merleau-Ponty's words at the beginning of this book we might add how the art of entanglement involves other selves, bodies, or things 'flaying our glance with their edges, each thing claiming an absolute presence [that is] not compossible with the absolute presence of other things' ('The Philosopher', p. 181).

Foucault detects only lack, distance, negativity, and deception in *Las Meninas* by reading the painting as a pre-determined and already won battle of looking. By contrast, I would approach the painting as an instance of baroque visuality/representation and as a work that resonates with the 'flesh'. As Merleau-Ponty insists, 'to see is no longer simply to nihilate', for in the ontology of the 'flesh' we instead 'catch sight of a complicity' (*VI*, p. 76). Such a complicity or commensurability between looks is integral to

Las Meninas. As Laura Marks observes, there is a 'continuum between the actuality of the world and the production of signs about that world' that can duly be extended to art or film such as when we see the gleaming knife in *Lulu* (Pabst, 1929) and we instinctively flinch (*Touch*, p. 115).[14] Similarly, when the members of the Spanish court face frontally, with many of them looking out towards me, I cannot help myself in reorienting my own stance to match the inclined postures of the Infanta and her maid, Isabel, whether the degree of bodily responsiveness occurs through a slight tilting of the head, a move in closer to the work, or a sympathetic adjustment of the shoulders.[15] The turning of my body inwards, towards a painting that so openly gestures outwards and looks towards me, suggests that *Las Meninas* is invested in the art of entanglement and not a dualistic battle of perception.

In phenomenological interpretation, of course, all aesthetic experiences will be correlated with their viewer or beholder. Nevertheless, the theoretical premise of this book is that the correlative effects of baroque flesh are especially pronounced. As Buci-Glucksmann writes, the 'baroque itself is inscribed within the structure of representation that we find in Velázquez's *Las Meninas*: the visible refers us to a reverse side, to an invisible that is at once present and absent' (*Baroque Reason*, p. 135). Our viewing bodies, always existentially present for us, might be invisible within the space of the representation but this is not to say that they are not physically implicated within it.[16] *Las Meninas* demands a mutual exchange of space, body, and vision. So directly does this painting address me, and so responsive am I in reciprocating it, that it cannot be equated with the kind of perceptual negativity that marks Foucault's 'classical' model. If anything, *Las Meninas* 'represents attention so sharply that the viewer, strongly implicated, needs to divert attention from him/herself', even if only momentarily, to realize that the royal couple are also the addressee of its frontal look (Bal, *Reading*, p. 278).

To clarify: we have spent some time with *Las Meninas* to consider how its correlation between bodies is indicative of historic baroque art. This is a painting that revels in the baroque instability of vision and of meaning. As evidenced by *Las Meninas*, even ascertaining the 'subject' and 'object' of perception can be difficult in the aesthetics of reversibility as its artworks portray '*the Baroque self* [*as*] *both surveyor and seen*' (Zamora, *Inordinate Eye*, p. 171; italics mine). Let us also remember the philosophy of the 'flesh' as the structure of reversibility whereby all things are visual subjects *and* visual objects, active *and* passive, the *outside* of the inside and the *inside* of the outside (del Río, 'The Body as Foundation of the Screen', p. 103; Dillon, '*Écart*', p. 15). Consonant with the 'flesh', the baroque renders visual subjects

and visual objects, inside and outside, and states of activity and passivity as intertwined and reversible. In a 'baroque play with point of view, the continuum between inside and outside [...] makes the separation between [...] self and other untenable [...] point of view is mobile and mutual' (Bal, *Quoting*, pp. 163–164). Within this compositional circularity, the seeing and the seen will meet, entangle, and reverse.

Baroque Flesh

Doubled or reversible sensations recur throughout Merleau-Ponty's work. As I detailed in the introduction, self-touching is the means by which Merleau-Ponty frames shifting relations of sensibility. The reversibility of the two hands touching is just as present within a handshake, an embrace, or by looking at another (Johnson, 'Introduction', p. xxii; Merleau-Ponty, *VI*, p. 271; Merleau-Ponty, 'The Philosopher', p. 168).[17] When it comes to perception, we interact with other bodies 'whom we see and see us seeing' (Merleau-Ponty, *VI*, p. 9). By calling attention to the doubled nature of the lived body as a turning about of perceptual roles, Merleau-Ponty's philosophy suggests that 'subject' and 'object' cannot be locked down. In these terms, there is an innate reciprocity between perceiver and perceived, self and other, and the lived body and its world that is played out through the crisscrossing of and renewal of the 'flesh'. 'It is never a matter of anything but co-perception', Merleau-Ponty tells us, for 'I see that this man over there sees, as I touch my left hand while it is touching my right' ('The Philosopher', p. 170). As embodied, enworlded beings, we are always of the 'flesh'—each a particular variant of the elemental structure that sustains and unites us. In a lovely turn of phrase, this vitalist philosophy asks: 'Where are we to put the limit between the body and the world, since the world is flesh?' (Merleau-Ponty, *VI*, p. 138).

For this book, the baroque aesthetics of reversibility finds its philosophical equivalent in the 'flesh'. Tropes of doubling or a doubling of sensation are especially prominent in *The Visible and the Invisible*. As Galen A. Johnson points out, all of Merleau-Ponty's 'metaphors and images for the one element that he named "flesh" are cases of doubling: inside and outside, obverse and reverse, left and right, a hand in a glove, two leaves, two laps overlapping, a two-sided strait' ('Introduction', p. xxvi). In his chapter 'The Intertwining—The Chiasm' alone, Merleau-Ponty makes reference to two systems or the two halves of an orange, applied to one another (*VI*, p. 133); two maps or a complementary vision (p. 134); a double belongingness to the order of the

'subject' and 'object' (p. 137); two circles, two vortexes, or two spheres, with their edges overlapping (p. 138); two mirrors facing one another (p. 139); the 'secret blackness of milk' that is described by the poet Paul Valéry, which can only be accessed 'through its whiteness' (p. 150); the doubling up or 'folding back' of 'our flesh as in the flesh of things' (p. 152); the look that refers back to itself (p. 154), and, of course, the *chiasm* of the 'flesh' whose reversibility he designates as 'the ultimate truth' (p. 155). Even in the incomplete 'Working Notes', Merleau-Ponty couches 'flesh' as doubling and as reversibility: obverse and reverse; inside and outside; a doubled representation; 'two caverns, two openness, two stages where something will take place' (*VI*, pp. 262–263). Imagine, the philosopher says, the finger of a glove that is turned inside out: the inside of the glove reciprocally constitutes the outside but I can still feel through either side (p. 263).

In the quotation that begins this chapter, Merleau-Ponty alludes to the 'flesh' as a perceptual circularity that 'traverses me and constitutes me as a seer' (*VI*, p. 140). He makes it clear that this coiling up of perception does not occur in isolation. Highly pertinent to the baroque is the fact that Merleau-Ponty locates the 'flesh' as a common ontology: 'this coiling up of the visible upon the visible can traverse, *animate other bodies as well as my own*', which includes, for this book, the bodies of the cinema (*VI*, p. 140; italics mine). Similarly, in her film-phenomenological work Vivian Sobchack has argued that 'two bodies and two addresses must be acknowledged as the necessary condition of the film experience' (*Address of the Eye*, p. 125). I will return to Sobchack's productive understanding of the film-as-body for the baroque in the next section. For now, let us stay with Merleau-Ponty in order to develop a workable definition of baroque flesh.

Consider, says Merleau-Ponty, how 'flesh' signals a 'coiling up of the visible and the universal over a certain visible wherein it is redoubled and inscribed' (*VI*, p. 114). The philosopher could easily be describing the baroque as it deliberately courts a doubling of vision and of sensation between bodies. This 'coiling over of the visible upon the seeing body, of the tangible upon the touching body' and the sensing upon the sensible is what I call baroque flesh (*VI*, p. 146). In baroque art and film, there is a coiling up of the universal (the visual, the tactile, and the sensible) over a certain visible (the baroque expression). That coiling up is re-doubled by the visual, tactile, and sensuous perceptions of another. Regardless of whether the aesthetics of reversibility occurs between artwork and beholder or film and viewer, there will always be a 'reciprocal insertion and intertwining of the one in the other' in the feeling of baroque flesh (Merleau-Ponty, *VI*, p. 138).

In helping us to solidify the formal and conceptual connections between 'flesh' and the baroque, Mieke Bal's approach to the baroque is incredibly useful. In her book *Quoting Caravaggio: Contemporary Art, Preposterous History*, Bal reprises the notion of entanglement that she hinted at in her discussion of *Las Meninas*. She adopts entanglement, or what she calls a 'shared entanglement', as the most appropriate way of imagining a baroque conjunction of bodies (Bal, *Quoting*, p. 30). In and of itself, the figure of entanglement is a nice insistence on the importance that embodied vision, movement, and materiality accrue in the baroque, as it demands the feeling, vision and thought of the beholder, film viewer, or 'subject within the material experience' to complete it (Bal, *Quoting*, p. 30). Like me, Bal understands the baroque as a *'correlativist'* aesthetic, whereby 'the primary characteristic of baroque point-of-view is that the subject becomes vulnerable to the impact of the object' (*Quoting*, pp. 30, 28). Correlativism means that artwork and beholder and film and viewer complement each other. In this light, the art of entanglement entails a mutual 'process of meaning-production'; as Bal continues, it is this dialogic *'process, not the object alone, [that] is the object of analysis according to baroque point-of-view'* (Bal, *Quoting*, p. 36; italics mine).

As it gives itself over to a correlation between bodies, Bal cautions that any 'historical view of the Baroque' must also abandon 'the firm distinction between subject and object' (*Quoting*, p. 28). Such is the intention of this book. From within the alternative philosophical context of psychoanalysis, Jacques Lacan discusses the baroque as a doubled, mobile, and correlative aesthetic. As he notes: 'someone recently noticed, I am situated [...] who situates me? Is it him or is it me? [...] I am situated essentially on the side of the baroque' (*On Feminine Sexuality*, p. 106). In her discussion of baroque perception, Bal maintains that baroque '[o]bjects seen are thus enfolded with the subject in a shared entanglement' but that '[what] is specifically baroque about this view is the point of view of two mobile positions' (*Quoting*, pp. 29–30). In this book I take very seriously Bal's allusions to entanglement for the baroque and a baroque cinema—all the more so because entanglement evokes the crisscrossing or *chiasmic* structure of the 'flesh'. As with the characteristically 'dual vision' of the historic baroque arts, baroque cinema relies upon the art of entanglement to achieve its effects (Wittkower, *Art and Architecture*, p. 140).

Having defined the formal and the philosophical hallmark of the baroque as the aesthetics of reversibility—as a doubled and correlative structure— we are better placed to explore how baroque cinema reverberates with film-phenomenological approaches. Phenomenological film theory understands

all perception as involving an object of vision, an act of vision, and a subject of vision, all existing in 'dynamic and transitive correlation' (Sobchack, *Address of the Eye*, p. 49). In her *The Address of the Eye: A Phenomenology of Film Experience*, Sobchack mobilizes Merleau-Ponty as 'a way of seeing the film experience freshly' (p. 49). Both Merleau-Ponty and Sobchack urge us to approach subject and object, body and world, artwork and beholder, or film and viewer through an embodied dialectics of reciprocity and reversibility (Sobchack, *Address of the Eye*, pp. 173, 118–119). Expanding on Sobchack's now seminal work, I would argue that Merleau-Ponty not only allows us a way to see film anew but to see film and phenomenological film theory *baroquely*.

By way of the *chiasm*, Merleau-Ponty tells us that

> we do not have to choose between a philosophy that installs itself in the world or in the other and a philosophy that installs itself 'in us' [...] our own experience *is* this turning round that installs us far indeed from 'ourselves', in the other, in the things [...] we situate ourselves in ourselves *and* in the things, in ourselves *and* in the other, at the point where, by a sort of *chiasm*, we become the others and we become the world. (*VI*, pp. 159–160)

Extending Merleau-Ponty, Jennifer Barker synopsizes phenomenological film analysis as always arising from this turning about of film and viewer, along an axis that itself constitutes a rich object of study (*Tactile Eye*, p. 18). I am also pursuing this entanglement or intertwining between bodies for an understanding of baroque cinema. Merleau-Ponty's 'flesh' provides us with a cogent philosophical framework for the baroque as it involves an essential circularity or 'turning about' of perception (*VI*, p. 160). It is my argument in this book that 'flesh' finds an especially charged realization in baroque cinema—the sensuous, spatial, and emotive implications of which I will detail in subsequent chapters. For now, let us take note of how correlation, proximity, and the experience of a perceptual circularity are amongst the defining features of baroque flesh.

Analogous Embodiments: The Film's Body

In his one sustained essay on cinema, 'The Film and the New Psychology', Merleau-Ponty points out that the task of phenomenology is to describe the 'inherence of the self in the world and in others, [...] an attempt to make us *see* the bond between subject and world, subject and others, rather than to

explain it' ('The Film', p. 58).[18] Interestingly, he cites cinema as 'peculiarly suited to make manifest the union of mind and body, mind and world, and the expression of one in the other' ('The Film', p. 58). Just as Merleau-Ponty once suggested that 'the philosopher and the moviemaker share a certain way of being, a certain view of the world' in which '[w]hat is inside is also outside', Sobchack's film-phenomenology turns perception 'inside out' ('The Film', p. 59). For Sobchack, film 'poses the same questions about seeing and being in the world that are posed to the [...] philosopher' and the representational 'what' of that which we see on-screen 'cannot be severed from existential connection with *the being who sees being*' (Sobchack, *Address of the Eye*, p. 57).

In *The Address of the Eye*, Sobchack invokes the phenomenological concept of the lived body to argue that perception and its expression constitute 'the *unity* of meaningful experience' at the cinema (pp. 40–41). In these terms, she radically contests the objectification of vision that has dominated past and present film theory. Instead, film-phenomenology understands both human and filmic vision 'as a dynamic system of commutation that is lived as the inherent reversibility of perception and expression, of the visual and the visible' (Sobchack, 'Active Eye', p. 21). Subjective perception (what Sobchack calls our viewing-view) is reversible as objective expression. That is, every internal perception 'expresses vision, makes its perception perceptible to other seeing body-subjects' in an objective dimension, as a viewed-view that is available to others ('Active Eye', pp. 21–22). This situation is no less the case for cinema.[19] Just as the lived body is at once perceptive and expressive, cinema enacts a reversible performance of the visual and the visible (Sobchack, *Address of the Eye*, p. 13). Existentially finite, film perceives, inhabits, and moves through the world from the vantage point of its own situated locale. At the same time, it objectively expresses its perceptions of that world to us. For Sobchack, it is the reversible grounds of vision that make for the locus of cinema's common intelligibility. Film-maker, film, and spectator alike can all be considered as viewers viewing, dynamically engaged in the perception of expression (the visual) and the expression of perception (the visible). Because 'the embodied structure and modes of being of a film are like those of filmmaker and spectator, the film has capacity and competence to signify, to not only *have* sense but also to *make* sense' (Sobchack, *Address of the Eye*, pp. 5–6).

Sobchack's film-phenomenology can readily be affiliated with the doubled or correlative structure of baroque flesh. In her terms, in the 'visual dialogue' that is cinema, both film and viewer will 'dialectically [address] each other's vision' as both visual subjects and visible objects of

perception (*Address of the Eye*, p. 173). Together, film and viewer enact the titular concept of Sobchack's 'address of the eye'. This address 'demands two lived-bodies for its realization—as that subjective dialogue of vision that we too often reify as the objective cinematic "text"' (Sobchack, *Address of the Eye*, p. 262). In detaching the medium from its doubled address, Sobchack makes the powerful argument that film theory has, traditionally, approached cinema as a one-way street. Dividing film and viewer into two self-contained visual, spatial, or semiotic centres, cinematic meaning has been conceived as being produced up 'there' onscreen or down 'there' in theoretical (and, often, wanly embodied) notions of spectatorship. As a result, it has delimited cinematic spectatorship and the making of sense and its significance to a viewing subject (the spectator) who is encountering film as a statically viewed object (Sobchack, *Address of the Eye*, p. 15).[20]

By relegating film to the status of visual object or by denying the correlative structure of the film experience, Sobchack claims that the 'exchange and reversibility of perception and expression (both in and as the film and spectator) are suppressed, *as are the intrasubjective and intersubjective foundations of cinematic communication*' in many strains of film theory (*Address of the Eye*, p. 15; italics mine).[21] If cinema is only conceived as being witnessed by or as duping its viewer (as it is in the various frame, window, and mirror metaphors of film theory) then any possibility of a shared making of meaning is elided, as is the sense of affinity that relates film and viewer to a world and to each other (Marks, *Skin of the Film*, pp. 149–150).

By contrast, Sobchack frames cinema as a privileged medium because of its phenomenological doubling of the viewer's body. 'More than any other medium of human communication, the moving picture makes itself sensuously and sensibly manifest as the expression of experience by experience', she writes, thus 'as a symbolic form of human communication, the cinema is like no other' (Sobchack, *Address of the Eye*, pp. 3, 5). Sobchack, together with the resurgence of phenomenological scholarship that has followed in her wake, understands cinema as an extension of our embodied and enworlded existence that uses similar modes of sensory experience (intentional movement, spatio-temporal location, seeing, hearing, and movement) for its expression (Sobchack, *Address of the Eye*, pp. 4–5). In these terms, every film 'is an act of seeing that makes itself seen, an act of hearing that makes itself heard, an act of physical and reflective movement that makes itself reflexively felt and understood' (Sobchack, *Address of the Eye*, pp. 3–4).

Heretofore, I have largely discussed the 'flesh' as an ontological reversibility. It is now time to draw attention to how difference is lodged

within its reversibility—that what 'flesh' articulates is not self-sameness but non-coincidence. As Merleau-Ponty's proponents observe, 'flesh' is inclusive of difference and alterity.[22] As Cathryn Vasseleu remarks, even Merleau-Ponty's example of the two hands of the body touching suggests 'a subjectivity which is internally divergent with itself' (*Textures of Light*, p. 26). Merleau-Ponty chose to frame his later ontology through this example because it allows 'for the inscription of difference within the same' (Vasseleu, *Textures of Light*, p. 26).[23] Within the 'flesh', the touching is not exactly the touched, the seeing never precisely the seen, nor the sensing the same as the sensible. While 'flesh' is the common structure that binds lived body and world together and allows perceptual roles to reverse, it is also the inauguration of a non-coincidence.

Throughout *The Visible and the Invisible*, Merleau-Ponty seems well aware of this non-coincidence. In fact, he is at pains to emphasise that there can be an intertwining but not a conflation. As he writes, there 'is no coinciding of the seer with the visible. But each borrows from the other, takes from or encroaches upon the other, intersects with the other, is in *chiasm* with the other' (Merleau-Ponty, *VI*, p. 261). The asymptotic nature of the 'flesh' is captured by the various metaphors and terms that are used to describe it: dehiscence, divergence or *écart*, coiling, folding, inter-calculated leaves, fission or the inside-out of a glove, where differences exist between two sides (Grosz, 'Merleau-Ponty', pp. 45–46; Dillon, *MPO*, p. 157; Merleau-Ponty, *VI*, p. 157). In a particularly lucid and helpful analogy, Galen A. Johnson likens the 'flesh' to a mirror ('Introduction', p. xxviii). Imagine, he says, that it might be possible to arrive at a reversibility that is without pure symmetry, as in a set of 'mirror images where there is reversibility with difference' ('Introduction', p. xxviii). Merleau-Ponty's 'flesh' implies a general manner, structure, or style of being that is given over to the vicissitudes of reversibility. As Dillon maintains, Merleau-Ponty's 'flesh' rejects coincidence in favour of 'identity-within-difference' (*MPO*, p. 159).

The embodied exchange between film and viewer is suggestive of just such an identity-within-difference. Upon considering film's relation to the technologies that enable it (the film camera, the projector, the screen, and so on), Sobchack proposes that cinema can be deemed a *body* in its own right (*Address of the Eye*, p. 203). The concept of the 'film's body' that she proposes recalls the non-coincidence of the 'flesh' (Sobchack, *Address of the Eye*, pp. 164–259). Here, it is important to realize that Sobchack is not imputing a human subjectivity or sentience to film. Rather, as with Merleau-Ponty's painter-and-trees example that I discussed in the introduction, she is arguing for similar modes of being that ontologically connect film

and viewer (see Grosz, 'Merleau-Ponty', p. 45). Once it is configured as a sensing and a sensible being, film is no more reducible to its technological make-up than we are to our own anatomy. While we could break down the material specifics of the human and the film's body, even the most rigorous of physiological or technological categorizations cannot capture 'the *existentially transcendent function of the body*, the body as *lived-body*' (Sobchack, *Address of the Eye*, p. 220).

It is because of the reversibility of perception and expression that we can assert the film's body as a lived body—in the sense that film-phenomenology understands it. Sobchack is particular on this point. She is definitely *not* arguing that the film's body is a human one. However, we could not say that how we experience the technological perceptions and expressions of the film's body is inanimate, either. Rather, a film is 'experienced and understood for what it is: a visible and centered visual activity coming into being in significant relation to the objects, the worlds and the others it intentionally takes up and expresses in embodied vision' (Sobchack, *Address of the Eye*, p. 171). To recall Dillon and del Río on the philosophy of the 'flesh', we might say that while the film's body is substantially different to ours we are adverbially simpatico. As with our own embodied existence in the world, film is a viewing, sensing, and experiencing subject as well as being visible and sensible for others. With the 'camera its perceptive organ, the projector its expressive organ, the screen its discrete and material occupation of worldly space', the film's body can be considered a lived body (Sobchack, *Address of the Eye*, p. 299). It is synoptically enabled by its (inhuman) mechanisms just as our bodies provide us with the (human) means of fulfilling the perceptive/expressive structures of lived-body experience (Sobchack, *Address of the Eye*, p. 299).

In the terms of this book, the doubled address of the eye is what makes cinema *ontologically* hospitable to the baroque—especially if we factor in the longstanding tendency of the baroque to foreground highly theatrical shifts between the seeing and the seen. Similarly, Sobchack's film-phenomenology invokes a 'double embodiment and double situation in—and as—the specific relations of vision that constitute the film experience' (*Address of the Eye*, p. 23). Insofar as it involves doubled embodiment and a doubled address of the eye—or, more precisely, a doubled address of the body as we will see in later chapters—there is no better framework by which to accommodate a baroque cinema of the senses than a film-phenomenology that is inflected by the 'flesh'. A coiling up of the visual upon the visible, the touching upon the tangible, and the sensible upon the sensible is absolutely essential to a cinema of

baroque flesh, wherein at least two bodies intertwine and *chiasm* in the mutuality of their having sense and making it (Sobchack, *Address of the Eye*, p. 13).

As I detailed in the introduction, the baroque is an art of analogy that makes visible the invisible by channelling 'abstractions' in and through the body. Its historic quest to image or imagine the unseen; to be within and beyond the edges of our own skin attempted to materialize and sensuously display an enigma that escapes words (Stafford, *Visual Analogy*, p. 24). Herein we uncover another reason why the baroque might be at home within the medium of cinema. Like the baroque, cinema constitutes another art of analogy that brings the invisible into visibility. Given the mutually embodied structures of film and viewer, Sobchack argues that 'film makes sense by virtue of its very ontology. [...] film is given to us and taken up by us as perception turned literally inside out and toward us as expression' (*Address of the Eye*, p. 12). Just as the historic baroque harnessed the art of analogy to bring its participant into up-close-and-personal encounters with the invisible or the abstract, cinema is enabled by its own existentially familiar connections. In Sobchack's schema, film and viewer inhabit an analogous existence: 'Perceptive, [film] has the capacity for experience; and expressive, it has the ability to signify' (*Address of the Eye*, p. 11). In these terms, both film and viewer are analogous beings even though our bodies differ in material kind (pp. 164–259). If the figures and forms of baroque flesh persist in film, it may well be because cinema is an analogous medium that turns the 'invisible' of subjective perception and of interior feeling inside out.

At this point, I must acknowledge the fact that Merleau-Ponty himself resisted invoking 'analogy' as such. His resistance can be attributed to the common critical association of analogy with purely mental or rhetorical endeavours or what Merleau-Ponty calls 'reasoning by analogy' (*PP*, p. 410).[24] This intellectual reasoning is very different to how I employ analogy or 'good looking' in this book, as it involves an art of incarnational effects, thoughtful visuality, and participatory perception. As with the visual analogy of 'good looking', descriptions of affinity, resemblance, and bodily sympathy loom large in Merleau-Ponty's thought. As Leonard Lawlor points out, Merleau-Ponty's philosophy is grounded in the perception of 'immediate analogy' and 'bodily mimicries [that] are based in a resemblance' ('End of Phenomenology', p. 28). Lawlor is correct for Merleau-Ponty speaks to an immediate, analogous, and sensuous reciprocity between bodies—the kind of reciprocity that is deliberately staged, figured within, and cultivated by baroque flesh.[25]

Immediate analogy can be traced back to the 'Other Selves and the Human World' chapter of *Phenomenology of Perception*. There, Merleau-Ponty describes how, just as *'the parts of my body together comprise a system, so my body and the other's are one whole, two sides of one and the same phenomenon'* (*PP*, p. 412; italics mine). At the same time as I live and I feel my own body from within, I know that it has another visible and sensible side for others. If only we can recognize how 'I experience this inhering of my consciousness in its body and its world', Merleau-Ponty asserts, then 'the perception of other people and the plurality of consciousnesses no longer present any difficulty' (*PP*, pp. 408–409).

This is where the philosopher's connections to film-phenomenology and to the baroque begin to take on fascinating implications, especially in terms of harnessing immediate analogy for a baroque cinema. As David Michael Levin maintains, Merleau-Ponty's philosophy is a fundamentally inter-subjective one insofar as he conceives vision and being through a 'communicative inter-subjectivity' ('Visions of Narcissism', p. 54). For Merleau-Ponty, the 'origin of structures of mutual recognition' is anchored in the shared 'nature of the sensorimotor body, the body of perception' (Levin, 'Visions of Narcissism', p. 49). Situating vision as 'part of a communal world [where] others are experienced originally as animate organisms like myself', Merleau-Ponty's thought is a 'phenomenology of inter-subjectivity' (Dillon, *MPO*, pp. 114–115).

In the paragraph that I quoted above, Merleau-Ponty posits that a 'system' of relations is enacted whenever one body encounters another in the world. This 'system' of relations is at the core of how we perceive and understand others, and appears throughout his work on being and on perception.[26] This 'system' also testifies to how immediate analogy informs his take on inter-subjectivity. Dillon, too, points out the analogical undertones of Merleau-Ponty's philosophy.[27] In fact, Merleau-Ponty goes so far as to fasten on what Husserl once called 'analogical apperception' or 'pairing' to convey the mutual recognition that occurs between two embodied subjects (Dillon, *MPO*, p. 116).[28] Merleau-Ponty couches one body encountering another as like the phenomenon of coupling—as he tells us this 'term is anything but a metaphor' (Merleau-Ponty, 'The Child's', p. 118). Merleau-Ponty's descriptions of immediate analogy or bodily mimicry take place in reciprocal and decidedly inter-subjective terms. As such, immediate analogy can be helpfully used to frame aesthetic relations as well. An analogical coupling or pairing is highly relevant to the art of entanglement. To appropriate Merleau-Ponty's words for a baroque cinema and its intertwining of film and viewer, we might assert that we are not dealing with 'two images side

by side of someone [...] but *one sole image in which we are both involved* [...]
each the reverse of the other' (*VI*, p. 83; italics mine).

If Merleau-Ponty understands inter-subjectivity as a relational 'system',
it is a system that is grounded in the same kind of visual or immediate
analogy that I ascribe to baroque flesh. In his essay 'The Child's Relations
with Others', the philosopher discusses inter-subjectivity as a 'system of four
terms' ('The Child's', p. 115). Consistent with 'the sociality of our embodi-
ment and the embodiment of our sociality', the four-term system that he
outlines understands embodiment as always lived 'in and through [our]
social interactions' (Levin, 'Visions of Narcissism', pp. 48, 63). As Sobchack
asserts, the four-term system 'inaugurates the person as both individual
and social, as both privately and publicly available' (*Address of the Eye*,
p. 126). Of particular interest to this book is Sobchack's appropriation of
Merleau-Ponty's four-term system to demonstrate how we interact with the
film's body at the cinema. Building on her discussion, I will then establish
the importance of analogy and the inter-subjective in a baroque cinema.

Upon encountering another embodied subject, Merleau-Ponty argues
that a four-term system is brought into play. The first of these terms is
'myself, my "psyche"', a psyche that he takes care to distinguish from tra-
ditional accounts; here, the psyche is not closed off to others but conveyed
through the purposeful exterior of the body (Merleau-Ponty, 'The Child's',
pp. 113–115). The second term is what he calls our 'introceptive image'; the
image of my body that I garner from within by experiencing it through
proprioception (weight, movement, balance, and so on) (Merleau-Ponty,
'The Child's', p. 115). Together, these are two internally lived aspects that
make up the subjective being of *'one-self'* (Sobchack, *Address of the Eye*,
p. 125). In the third and fourth terms of the system—the terms that pertain
to another body—the perception of another through immediate analogy is
posited. The third term is what the philosopher labels the 'visual body'; this
is another's visible body that is seen by me (Merleau-Ponty, 'The Child's',
p. 115).

At this point, the inference of a visual analogy between my embodied
self and another is what completes the four-term system. As Merleau-Ponty
states: 'the visual image of the other is interpreted by the notion I myself
have of my own body'; as another body who is similar to (but not identical
with) me ('The Child's', p. 118). The fourth and final term of this relational
system is 'the "psyche" of another, the other's feeling of his own existence' as
it is internally lived (Merleau-Ponty, 'The Child's', p. 115). While it is true that
I have no direct access to that consciousness, I can infer or reconstitute it
through sympathetic recognition. Through the perception of an immediate

analogy that exists between us, I can assume that that body possesses a similarly animate consciousness that is or might be like mine. To quote Merleau-Ponty, behind 'the body whose gestures and characteristic utterances I witness, I project, so to speak, what I myself feel of my own body [...] I transfer to the other the intimate experience I have of my own body' ('The Child's', p. 115).

Intriguingly, Merleau-Ponty's four-person system corresponds with Stafford's arguments for the innately visual and participatory nature of analogy. For Stafford, it is through analogical 'intuition or beholding that we come to know what is innate. *Insight allows us to infer the ontological and phenomenological likeness binding seemingly unrelated structures*' (*Visual Analogy*, p. 89; italics mine). For this book, what is most compelling about Merleau-Ponty's account of inter-subjectivity is how it speaks to 'good looking' or a kind of visual analogy between bodies that can be recuperated for cinema. I discern this visual mode of intelligence in Sobchack's film-phenomenology as well, as it understands cinema as a mutually embodied encounter between film and viewer. Lest the connections between analogy, coupling, and pairing be missed, Sobchack herself explicitly asserts that 'film presents an analogue of [our] own existence as embodied and significant' (*Address of the Eye*, p. 143). It is because of immediate analogy that her concept of the film's body is premised on 'film's seeing as the seeing of another who is *like* myself, but *not* myself' (*Address of the Eye*, p. 136).

Sobchack reprises Merleau-Ponty's four-term system to convey cinema as a similarly inter-subjective event. However, she makes one very significant adjustment to the four terms. While my 'psyche' and the introceptive image of my own body remain constant in the cinema, the last two terms undergo a reversal: whereas 'the other seeing person's "visual body" is visible to me in our encounter with the world and each other, the film's "visual body" is *usually invisible to me*' (Sobchack, *Address of the Eye*, p. 138; italics mine). While the technological substance of the film's body is often invisible to me, its perceptions and its expressions are not. Rather, these are directly experienced as the film's intentional agency, its subjective vision, its motion, its gestural conduct and sense of feeling.[29] What I see and experience as the film is its vision 'given to me as it is lived in the relation "myself, my psyche" and "introceptive image"' (Sobchack, *Address of the Eye*, p. 138). Instead of inferring a 'psyche' or subjectivity to the visible body of another, I analogically infer that film has an enabling body. This (technological) body grounds the subjective perceptions and expressions that a film presents to me. What we encounter here is the film's body as a lived body that makes subjective perception and states of feeling visible to us. This truth can only

be 'discovered through the functions that make *its existence in the world analogous to our own*' (Sobchack, *Address of the Eye*, p. 219; italics mine).

To recap: my approach to cinema as an analogous medium is not an argument for self-sameness—the film's body is a lived body, not a human one. Similarly, my encounter with another in the world initiates the analogous perception of their body as *like* my own but that immediate analogy does not ever erase the differences between us. While baroque flesh strives for an entanglement or correlation between bodies, it still does not conflate them. Likewise, Merleau-Ponty does not urge coincidence but a non-coincident reversibility. Given the identity-within-difference of the 'flesh', it is clear that he was ultimately concerned with voicing a familiarity or reciprocity between bodies rather than their collapse. Insofar as 'what I see [...] is in close correspondence with what the other sees', there is a sense of affinity and analogy to the 'flesh' (Merleau-Ponty, *VI*, p. 10). That said, there is never a complete fusion or self-sameness to its ontology: 'I never rejoin the other's lived experience' and live it as they do, Merleau-Ponty states, for it is only 'in the world that we rejoin one another' (*VI*, p. 10).

In bringing this section to a close, I would submit that what connects Merleau-Ponty, film-phenomenology, and the baroque together is their shared interest in analogous rather than coincident embodiments. Analogy is the end-point of the critical nexus that I have been steadily working towards throughout this chapter. Merleau-Ponty's thought, the baroque, and the cinema all turn upon embodied reciprocity and a doubling of sensation. With baroque flesh as our focus, the concept of the film's body in place, and the 'flesh' as our film-philosophical guide, we can begin to explore the possibilities of a baroque cinema.

Baroque Vision and Cinema

A high-pitched whirring is heard, followed by a computer read-out of the date and time against a black screen: 1:06:27 am 30 Dec 1999. The clock is counting. Within its first few seconds, Kathryn Bigelow's *Strange Days* has already evoked its cinematic past by referring to the pseudo-documentary titles that begin *Psycho* (Hitchcock, 1960): Phoenix, Arizona, Friday, December the Eleventh, Two Forty-Three pm. The bravura displays of vision and spatial traversal that follow also refer back to and outperform the opening of *Psycho*, especially in terms of how its camera glides down from the upper heights of the city to peer voyeuristically into the small window of an apartment block below. 'Are you ready?' an unidentified voice asks; 'Yeah,

boot it' another answers. The close-up of a human eye appears, blinking a few times before it closes. Another allusion is now set in motion, this time to another cult horror film that is equally obsessed with vision: *Peeping Tom* (Powell, 1960), with its opening image of an arrow piercing a target that is followed by an extreme close-up of a human eye. Combined, these images function as an emblem for the film's central preoccupation with voyeurism, with psychic and physical wounding, and with painful modes of vision; a conjunction that similarly informs *Strange Days*.[30]

Nevertheless, the eye that begins *Strange Days* is followed by an abrupt pixilation of the image. The first thing we see when the pixilation stabilizes is some kind of recording deck that is held up into a shared line of sight ('I'm recording!'). The high-pitched sound beginning the film belongs to this device. What ensues is an action-filled, hyper-kinetic, fluid, and seemingly unbroken long take in which we find ourselves thrust into the first person point of view of a burglar undertaking a robbery. In itself, this shift is not remarkable as we are familiar with cinema weaving in and out of the different points of view of its on-screen characters. What is unusual about *Strange Days* is how its highly mobile and fluid camera is no longer just a film camera—it assumes the technological mantle, double, or guide of the 'super conducting quantum interference device' (SQUID) and disperses its shared vision across the bodies of multiple participants.

We place a ski mask over our heads and someone hands us a gun. Vision is expressed as nervous, jerky, and agitated; we are running on adrenaline. We move quickly through the back of a restaurant. Our point of view gets turned, up, down, and around, accompanied by the faint whirring sounds of the SQUID in the background. We threaten the owners and the patrons, waving our gun at them. We grab money from the register and make a break for it ('Run, man, run!'). We turn to leave but the cops are closing in. We flee up the stairs, ripping the mask over the camera/SQUID. Alongside the sound of ragged breathing, we hit the roof and we are trapped. We look down at the pavement, several stories down. No choice: we jump. In a reprisal of *Vertigo* (Hitchcock, 1958), we hang suspended for a moment on the adjacent rooftop. This time around, we fall, screaming as we plummet to the ground. With an audible electronic buzz, the image explodes into shards of bright colours and static. Ostensibly, 'we' have died. Only then does *Strange Days* cut to reveal the character of Lenny Nero to us in an abandoned workshop, ripping the SQUID off his head and groaning as if the wind has been physically knocked out of his lungs. The film's initial close-up of an eye belongs to Lenny, who has also taken part in the 'enlaced structure of vision' that the SQUID so overtly represents (de Certeau, 'Madness of Vision', pp. 30–31, fn. 4).

In his underutilized 1934 essay 'What is Baroque?', German art historian Erwin Panofsky highlights how the historic baroque introduced a new age of self-awareness into the arts (p. 45). For Panofsky, the baroque is characterized by a subjective intensification of feeling that gets coupled with the theatrical display of highly emotional states. As I detail more closely in the next chapter, the historic baroque arts embraced the emotions and 'a new sphere of highly subjective sensations' at the same time as they expressed their own 'intense consciousness of an underlying dualism' (Panofsky, 'What is Baroque?' pp. 38, 45). Zamora agrees, asserting that an abiding baroque theme is 'the self, and the self's consciousness of itself' (*Inordinate Eye*, p. 170). Panofsky reproves how 'the feeling of Baroque figures' has been received as 'lacking genuineness and sincerity' because its 'figures displayed their theatrical poses' and often 'reveled in their own sensations'; in his terms, it is a mistake to assume that historic baroque art 'did not mean' its feeling ('What is Baroque?', p. 75). As he argues it, the baroque is invested in genuine feeling even as it expresses a self-conscious or self-aware aesthetic. He continues: the 'feeling of Baroque people is [...] perfectly genuine [...]. They not only feel, but are also aware of their own feelings. While their hearts are quivering with emotion, their consciousness stands aloof and "knows"' (Panofsky, 'What is Baroque?', p. 75). Reconciling dualistic separations of mind from body and consciousness from feeling, the baroque presents self-consciousness alongside sensation as an essential part of its overall aesthetic.

Given the coupling of self-reflexivity with sensation that I want to stake out for baroque flesh and for a baroque cinema, I should clarify what might appear to be a contradiction between the baroque and the pre-reflective 'flesh' that guides Merleau-Ponty.[31] If we factor in how the historic baroque traditionally conceived the self and self-reflexivity, it might seem paradoxical for me to extend the pre-reflective 'flesh' to the self-conscious aesthetics of the baroque (Zamora, *Inordinate Eye*, p. 171). Despite Merleau-Ponty's concern with pre-reflective being, I would maintain this is not a paradox at all. The ontology of the 'flesh' is commensurate with baroque aesthetics and with its *self*-reflexivity. As I have established, *The Visible and the Invisible* contains numerous instances of reversal and a doubling of sensation. Furthermore, there are intimations by Merleau-Ponty that we can reflect on the 'flesh'. As Dillon notes, there is a strong recurrence of the reflexive voice throughout Merleau-Ponty's descriptions of 'flesh': 'There is vision, touch, when a certain visual, a certain tangible, turns back upon the whole of the visible, the whole of the tangible, of which it is a part' (Dillon, *MPO*, p. 165; see also Merleau-Ponty, *VI*, p. 139). The turning back of perception

upon the whole of which it is a part (and its breaking through to conscious-
ness) echoes the baroque intertwining of sensation with self-reflexivity.
The difference between Merleau-Ponty's 'flesh' and the baroque is that
the latter figures ontological reversibility in aesthetic terms. That is, the
baroque is a calculated aesthetic that depends on the art of entanglement
to achieve its effects. The pre-reflective 'flesh' of Merleau-Ponty and the
self-consciousness of baroque flesh is not a contradiction. If 'flesh' is a
general manner of being that exists prior to our consciousness of it, then
it is something that can also be consciously reflected upon or figured in
baroque art and film.

In coming to grips with the vicissitudes of cinematic embodiment, it may
be useful to consider the film's body as a continuation of the anonymous
organization of being and perception that is discussed by Merleau-Ponty, as
Jennifer Barker has done. That is, it is fruitful to approach the perceptions
and expressions of the film's body as a (cinematic) being that is grounded in
a pre-reflective embodiment that exists prior to its self-conscious identifica-
tion (*Tactile Eye*, pp. 4–12). As Barker and Sobchack both assert, film is first
of all an anonymous, pre-personal being and the truth of its having a body
need not depend upon its reflection upon nor consciousness of that body
(Barker, *Tactile Eye*; Sobchack, *Address of the Eye*, pp. 135, 199). While Barker
provides brief examples such as *Rear Window* (Alfred Hitchcock, 1954) of how
a film can reflect on itself as a perceiving subject, her film-phenomenology
is largely concerned with pre-reflective cinematic embodiments such that
reflection is understood as an 'after-the-fact distancing' from the sensuous
immediacy of the image (*Tactile Eye*, pp. 164, 8).

Unlike Sobchack or Barker's film-phenomenology, in this book I am
concerned with establishing a specifically baroque cinema of the senses.
As such, we have different sets of questions to ponder: what makes for a
baroque address of the eye? How might the film's body take on baroque
incarnations? Though Sobchack is not at all concerned with the baroque,
she does intimate that even a self-reflexive cinema will still be founded
on the pre-reflective embodiments of the film's body. As she writes, an
'anonymously lived cinematic subjectivity [...] provides the ground upon
which *a self-conscious cinema can figure as a reflection upon and interroga-
tion of the nature and function of its own being*' (*Address of the Eye*, p. 135;
italics mine). To adapt Sobchack for my model of baroque flesh, we might
say that the film's body is the necessary (and usually anonymous) grounds
against which the forms and figurations of baroque cinema stand out. For
baroque flesh, there must be a body or an embodied self to reflect upon, at
the same time as it gives rise to genuine states of feeling.

In baroque cinema, the anonymity of the film's body cedes to self-reflexive display as it reflects upon its own perception and expressions. Such reflections might be concerned with cinema's past, with a doubling of form or with the nature of its own being. Unlike the pre-reflective embodiments that concern Sobchack and Barker, baroque cinema self-consciously gestures towards the (technological) body that enables film and its history to come into being. As Sobchack admits, the film's body 'need not (although it can) reflect upon and reflect the technology that enables its perception and expression' (*Address of the Eye*, p. 218). Such reflections are entirely apposite to baroque flesh. After all, as Bal points out, historic baroque forms will often replace 'narrative representation with a narrative *of* representation' (*Quoting*, p. 43). That state of affairs arguably persists within the baroque of the cinema so let us examine its reflection and reflexivity more closely in *Strange Days*.

Part neo-noir and part science fiction film, *Strange Days* is set on the brink of the new millennium in a racially torn Los Angeles. The film's science-fictional premise revolves around the illegal technology of the SQUID. SQUID is an electronic, wire-based media that can play back virtual and immersive experiences in three-dimensional space with full sensory surround. Its recorded clips are transmitted directly from one consciousness into another and are 'pure and uncut, straight from the cerebral cortex', as Lenny Nero says. Lenny, a former cop, peddles these recordings and happens to be addicted to re-living the happier times of his past through them. After Lenny is sent a particularly nasty 'blackjack' or snuff clip, he becomes caught up in a larger maze of death and deception that includes a plotline about racist corruption in the Los Angeles Police Department. Thrust into the role of the reluctant detective, Lenny enlists the aid of his best friend, Mace. His growing dependence on Mace (physically, emotionally, ethically) becomes the means of his quiet redemption.

According to Laura Rascaroli, Kathryn Bigelow's cinema 'is essentially a discourse on vision' ('Steel in the Gaze', p. 232). This statement certainly rings true of *Strange Days*. From its outset, the film sets itself up as concerned with the subject of human as well as cinematic vision. For the SQUID sequences, a special Steadicam camera was built to replicate and enhance the agility of the human eye (this helmet camera was attached to the head of the camera operator, enabling them to pull remote-focus on the run) (Rascaroli, 'Steel in the Gaze', p. 237; Shaviro, 'Straight', p. 161). Allusions to seeing abound: from the titular naming of the murder victim, Iris, to the fact that her killer is colour-blind or the drawn set of eyes that adorn one of Lenny's old SQUID clips. The club where Faith, Lenny's ex-girlfriend,

sings is called The Retinal Fetish, where banks of television monitors run old film noir clips on a loop. As Steven Shaviro points out, '[v]isual clutter is everywhere' ('Straight', p. 171). Such crowding is evident in the film's chaotic, vibrant, and undulating *mise-en-scène*; in the jostle and crush of traffic, police, and people; in the pulsating lights of its interiors, exteriors, and the neon wash of the city streets; in the maze of alcoves, dance floors, and overhanging spaces inside the club; in glimpses of television sets or answering machine monitors as well as huge video screen projections or swathes of confetti, crowds, and fireworks during the film's finale on New Year's Eve (Shaviro, 'Straight', p. 171).

In his book *The Cinema Effect*, Sean Cubitt has also singled out *Strange Days* as an instance of contemporary baroque filmmaking or what he dubs the 'Hollywood baroque' (p. 220). Cubitt's baroque contains a number of distinct formal features: self-referentiality; the urge to artifice, 'heavily singled at every turn'; a pronounced sense of movement and spatialization; and a deliberate solicitation of the 'rapt attention of the viewer' (*Cinema Effect*, pp. 222, 236). *Strange Days* demonstrates many of these features, including the use of allusion to other films that foreground vision (*Peeping Tom, Psycho, Vertigo*) as well as to genres that are concerned with bearing witness to violence such as horror and noir. For Cubitt, the Hollywood baroque is a spectacular contemporary phenomenon brought about through the rise of digital special effects and corporate capitalism to situate the audience 'in place to savor the ingenuity of the artifice in which they have been caged' (*Cinema Effect*, p. 228). In this book, by contrast, baroque cinema is a continuation of prior relays between the seeing and the seen that have long been inherent to baroque forms. Furthermore, *Strange Days* not only expresses the reversibility of vision but it self-consciously reflects upon cinema itself. Vision becomes intertwined with self-reflexivity and with sensation in a suitably baroque manner.

For me, it is this film's self-reflexive imbrication of viewer and viewed that makes it a telling instance of baroque cinema. The science-fictional technology of the SQUID also lends form to the 'flesh', wherein 'every perception is doubled with a counter perception [...] seeing-being seen, perceiving-being perceived circularity' (*VI*, pp. 264–265). Often, we cannot ascertain who is the 'subject' and 'object' of perception in *Strange Days* because the vision of the SQUID is distributed across multiple bodies at the same time. In the SQUID's representational enlacing of vision, perceptual roles can be easily flipped. In the adrenaline-pumping opening scene, perception is dispersed across the film's body, the SQUID recorder (the burglar), the SQUID playback-spectator (Lenny), and the viewer, all of whom function

as visual and visible beings at the same time. Overlaying vision across so many participants, the vision that the SQUID of *Strange Days* represents is the *chiasm* of baroque vision—it is heavily theatricalized, prismatic, unstable, mobile, and reversible.

Reflecting upon the perceptual conditions that make cinema possible, *Strange Days* also reveals to us the impossibility of making the film's body entirely visible to us. As Sobchack observes, even when we see an enabling technology such as the film camera within the space of the representation, it will only be present in the scene as a partially dissected part of the film's body (*Address of the Eye*, p. 222). The second that the technologies behind cinema are revealed on-screen (whether these are microphones, a glitching DVD disc, or a faulty film projector), they are thereby reconfigured as 'objects of perception' rather than the visual subject of perception that is cinema (Sobchack, *Address of the Eye*, p. 222). Just as you cannot normally see the flesh-and-blood intricacies of the human body as it is lived from without, we cannot see the technological intricacies of the film's body as it is lived from within. Because it is a visible/sensible entity turned inside out, the totality of the film's body cannot ever be shown to us. What we see, feel, and experience instead is cinema's 'material body lived introceptively' (Sobchack, *Address of the Eye*, p. 223).

If film's material body cannot be made visible to us within the very 'perception that [...] itself is generating and expressing', how does *Strange Days* reflect upon cinema and its embodiment? Our answer lies in the SQUID. Lenny sells SQUID to his clients as 'not like TV, only better. This is life. It's a piece of somebody's life'. The SQUID is indeed life, a piece of somebody's life, and that life belongs to a body with whom we are already familiar—the film's body as it 'makes itself sensuously and sensibly manifest as the expression of experience by experience' (Sobchack, *Address of the Eye*, p. 3). Throughout, it is clear that SQUID is a science-fictional extension or doubling of film itself. In this regard, it functions as a representational double for the film's body that *can* be made visible to us.

Like cinema, the SQUID clips turn perception inside out as a 'direct' experience that is visible, for sale, and accessible to more than just a single consciousness. Re-activating the 'baroque habit of seeing double', SQUID makes visible the likeness of cinema to our own bodies (Stafford, *Visual Analogy*, p. 129). In an appropriate reversal, the technological device even gets grafted back onto the ontological dynamics of a human embodiment. Drawing on Sobchack and others, I have been arguing that the film's body is analogous to but not the same as the human body. *Strange Days* utilizes the human body as analogous to but not the same as its own representational

double for the cinema. In its recording mode, the SQUID conjoins with the eyes, body, and cerebral cortex of its wearer as a kind of camera; in its playback mode, it uses the retina of its wearer as both a projector and a screen (Sobchack, *Address of the Eye*, p. 206). The basic ontological structures of perception and expression that are inherent to human and cinematic embodiment remain, despite being recast as a science-fictional technology.

According to Merleau-Ponty, the 'seer is caught up in what he sees, it is still himself he sees: there is a fundamental narcissism [to] all vision' (*VI*, p. 139). Re-doubling the dynamics of human and cinematic embodiment, SQUID underscores the basic perceptual narcissism of all cinema. He 'who sees cannot possess the visible unless he is possessed by it, unless he is of it', as Merleau-Ponty puts it, in words that parallel Sobchack's own account of the doubled address of the eye (*VI*, pp. 134–135). At one point, Lenny instructs Mace that she will have to close her eyes when playing back the SQUID—otherwise, she will experience its overlap with her own body too immediately and then 'see double'. As an imagined technology, SQUID literalizes the seeing double that is shared between the film's body and our own. As Bal writes of the baroque, self-reflection often focuses 'on the making of representation itself' so that point of view 'seems to bite its own tail: it becomes a point-of-view on "point-of-view"' (*Quoting*, p. 28). Adopting a fictional point of view on the embodied point of view that is cinema, *Strange Days* demonstrates a baroque delight in exposing its own mediation.

And yet, the only way that this film can make cinematic being visible to us is to channel its basic ontological functions into the SQUID. In doing so, the normally invisible or anonymous film's body gives way to the kind of self-reflexive display that belongs to baroque representation. The historic baroque gave rise to an incredibly self-reflexive turn in the arts—from mirrors that reflect other mirrors, novels that invaginate themselves, or the use of frames containing additional frames. For example, mirrors used within the interior of baroque paintings work to 'digest' and to replicate the scene that has been painted (Merleau-Ponty, 'Eye and Mind', p. 300; Alpers, *Art of Describing*, p. 179).[32] Baroque artists and authors will often voice the labour and savvy of their own artistry by parading the different formal possibilities of their chosen medium; they include a 'doubling' of that medium within the space of the representation or allude to their own creative presence through the inclusion of textual inscriptions, mirrors, or self-portraits, such as with the painted Velázquez of *Las Meninas* or the art of Michelangelo Merisi da Caravaggio (Alpers, *Art of Describing*, pp. 178–179; Varriano, *Caravaggio*). According to Buci-Glucksmann, seventeenth-century 'theatre now knows

itself to be theatre' such that we witness new overt stagings of theatre about theatre (*Baroque Reason*, p. 71).[33] One particularly extravagant instance of this theatrical doubling occurred when Bernini adopted the play-within-a-play conceit. Around 1637–1638, Bernini staged a comedy that confronted his (real) audience with duplicate actors, a duplicate theatre, and a duplicate audience as well. At the beginning of the play, the audience saw an actor reciting a prologue. Behind him, they saw the rear of another actor who was facing another audience and also delivering a prologue. A curtain was raised between two actors and two sets of audiences and the play began. At its end, 'the curtain dropped, and the audience saw the other audience leaving the other theatre in splendid coaches by the light of torches and the moon shining through clouds' (Lavin, *Bernini*, pp. 150–151).

Baroque portraitists portray the portrayal, and painters foreground different stages of completion in their work, teasing us with the completion of canvases that we cannot fully see (Vermeer, Velázquez). Poems rewrite themselves (Marino); the poet Lope de Vega writes sonnets on the composition of sonnets; there are promises and fears of books and essays yet to come (Montaigne). The Spanish novelist, Miguel Cervantes, writes prologues about writing prologues as narration itself becomes narrated (Maiorino, *Cornucopian Mind*, pp. 93, 120; Maravall, *Culture*, p. 200). This doubling or folding over of baroque form upon itself can also be extended to its sensuous preoccupation with different material surfaces and textures, as fabrics, draperies, tresses, costumes, and skin intricately fold back on themselves in baroque art to intimate unexplored, hidden depths (Conley, 'Translator's Foreword', pp. xi–xii).

As well as doubling its own form, the baroque will express the aesthetics of reversibility through its foregrounding of perceptual instability. The *chiasm* of perception is played out through the prominent inclusion of doubled audiences, spectators, or 'witnessing' figures within the artwork (Bernini, Caravaggio, Velázquez), paralleling the presence of the beholder. Actors will suddenly turn into the spectators of plays-within-plays such as in *Hamlet*; fictitious characters become the readers of the very stories that are written about them or they encounter other fictitious characters purporting to inhabit the same space as the reader, such as in Cervantes. In the plays of Shakespeare, characters promise to tell each other the story that they have just heard (Ndalianis, *Neo-Baroque*, p. 219; Maiorino, *Cornucopian Mind*, pp. 105, 120; Askew, 'Caravaggio', pp. 248–269). A rampant self-reflexivity towards the self and towards its own media; doublings and duplications of form within the space of the representation; reversals or inversions of aesthetic and perceptual roles (reader and writer or viewer and viewed) as

well as doublings or divisions of the self mark the historic baroque arts and a baroque cinema (Zamora, *Inordinate Eye*, p. 171).

As Buci-Glucksmann states, in the baroque, there are 'several layers, circle of circles, ball of balls, book of books, cinema of cinemas' ('Baroque Eye', p. 38). Self-involved and formally cannibalistic, baroque flesh will often stage a layering of representation as well as a *chiasmatic* layering of vision. Such representational layering can be traced back to the use of alternate frames, maps, or mirrors in artworks like Johannes Vermeer's *The Art of Painting* (Kunsthistorisches Museum, Vienna, c. 1666); the prominence of other paintings or media housed inside historic paintings such as Jan Brueghel's *The Sense of Sight* (1618); and the play-within-a-play structures of Shakespeare like *A Midsummer Night's Dream*. Such self-reflexivity continues in the conjoining of self-consciousness with perceptual flux in *Strange Days*, especially in terms of its allusions to films within films.

The film's dense layering of vision and representation is especially evident in the scene of Iris' rape and murder. Here, the entanglements of baroque vision take on a dark turn of events. The shared vision of Iris' suffering is multiply dispersed across the film's body, the viewer, Lenny (the SQUID play-back spectator), Iris, and her killer. Directly referring back to the horror of *Psycho* and *Peeping Tom*, Iris' death also takes place in a bathroom and her point of view vacillates with that of her killer. But whereas the female victims of *Peeping Tom* were forced to watch their own faces as they died—their fear reflected back at them, through a mirror attached to the killer's film camera—in *Strange Days*, the killer literally 'jacks' Iris into the electronic SQUID deck. He then attaches its headset to her so that she is forced to feel her own victimization through his eyes, alongside her killer's excitement. While this scene is incredibly disturbing in its implications, it is also one of the few SQUID sequences in the film that is interrupted by the use of editing, such that it moves between the 'clip' of Iris and her killer as well as Lenny's horrified reaction, albeit to a death that has already occurred.

While this scene pursues a visual entanglement, it clearly indicates how its shared vision is not experienced in the same way. To recall the baroque world of Merleau-Ponty, each participant possesses 'an absolute presence [...] not compossible with the absolute presence' of the others ('The Philosopher', p. 181). As with my earlier discussion of *Las Meninas*, bodies meet upon the shared grounds of vision but they are not coincident there ('The Philosopher', p. 181). In *Strange Days*, each point of view yields different experiential implications. When the film's body assumes the guise of the

SQUID, its vision becomes pixilated; there is a noticeable shift in colour and the sound of electronic feedback. In the scene mentioned above, Iris suffers her own death at the same time as she must suffer a 'mediated' version of it through both her killer and the SQUID. Like the viewer, Lenny shares with us the SQUID vision of Iris and her killer while experiencing his own disgust and revulsion as he becomes nauseated. As viewers, we bear witness to the SQUID clip, to Lenny's reactions and experience our own varying responses to the scene. Whatever our reaction to Iris' death might be (cringing, closing our eyes, or leaning back), we are unable to alter the diegetic outcome. However we express our vision and bodily reaction to this scene, however much we find ourselves caught up in its shared vision(s) (or not), our bodies are not ever fused; they are artfully entangled. This is because the film's body always 'lives its perception without the volition—if within the vision—of the spectator' (Sobchack, *Address of the Eye*, p. 167).

While the baroque perceptions of *Strange Days* are shared across multiple bodies, they are not at all experienced in the same way. Even in scenes of an explicitly intertwined vision, we encounter the non-coincidence of the 'flesh'. In addition, a layering of vision combines with a layering of representation to create a highly self-reflexive comment on the history of violence in cinema. In the rape and murder scene, Iris is configured as the camera that perceives the horrors being done to her and the screen upon which those horrors are also projected. Crucially, the 'clip' ends with an extreme close-up of Iris' eye as it bears the reflection of her masked killer before it suddenly bursts into pixelation. This close-up reprises *Psycho*, yet again, and the close-up of Marion Crane's eye that famously concludes her death. Contra claims that *Strange Days* displays a misogynistic objectification of women, this scene deliberately literalizes the sadistic connotations of the 'gaze' in film theory.[34] Considering the film's obvious debt to the genres of horror and noir, it functions as a pointed comment on the female spectator being forced to witness her own torture and victimization on-screen—an interpretation driven home by the killer framing Iris' face with his hands, as if he were composing a film shot.[35]

Unlike *Strange Days*, Michael Haneke's *Caché* turns upon a never resolved perceptual mystery and the elusive visibility of the film's body. Otherwise known as *Hidden*, the title and content of this film cohere well with the enigmatic tendencies of the baroque. *Caché* centres on the Laurent family home where Georges and his wife Anne live, with their young son Pierrot. The Laurents are disturbed by the arrival of an anonymous video—a tape recording of the entrance to their house. Throughout the film, more tapes begin to surface that are wrapped in childishly scrawled, eerie

drawings that include the figure of a boy spitting blood and a decapitated chicken. Footage of Georges' childhood home appears, hinting that the tapes might somehow be connected to the past. The tapes and drawings trigger in Georges memories of forgotten episodes from his childhood. These memories centre on an Algerian orphan, Majid, whose parents once worked for Georges' family. After Majid's parents failed to return from the 17 October 1961 demonstration—a massacre in which more than a hundred pro-Independence Algerians were killed by French police and dumped into the Seine—Georges' parents had planned to adopt Majid. Through its re-playing of the tapes, snatches of conversation, and flashbacks (or, possibly, dreams), *Caché* unravels how young Georges grew increasingly jealous and resentful of Majid. Young Georges 'told lies' to his parents to be rid of him. He alleged that the orphan was coughing up blood, later cajoling Majid to cut the head off the family rooster before accusing Majid of threatening him. When Georges tracks down a middle-aged Majid, Majid (and later Majid's son) deny any involvement in the sent tapes. It is not the lies of a 6-year-old child that concern *Caché* so much as Georges' adult refusal to recognize and accept his own culpability in the circumstances of Majid—a refusal of guilt that echoes the hushing up of the 1961 atrocity by France.[36]

Caché opens with the distant establishing shot of a house façade and quiet street in Paris. Miniscule, almost indecipherable title credits slowly appear across the frame. The scene is tranquil. It is early morning with the faint sound of birds chirping. The camera, noticeably, does not move. The only action of the scene takes place inside the frame: a pedestrian passes by the house, a woman exits the front door of the house and a cyclist rides towards us. Over two minutes into the film and an alternative point of view or counter-shot has yet to emerge. This prolonged, unedited, and completely static shot, seemingly devoid of any narrative impetus, quickly becomes infused with the banal. 'Well?' an off-screen male voice asks. 'Nothing', a woman answers. A car drives by. 'Where was it?' the man questions again. 'In a plastic bag on the porch', she replies. We cut to a view of the same house in twilight. A man (Georges) crosses the street, staring up the appropriately named *Rue des Iris*: 'He must have been there [...] How come I didn't see him?' he muses, wondering where to locate the source of the filming.

When we return to our initial view of the house, visible tracking marks now run across the surface of the image and we can hear the sounds of a tape fast-forwarding. The tracking marks halt and we see Georges leaving the house, earlier that day. As with *Strange Days*, the opening of *Caché* calls attention to a sequence that is literally in the process of being re-viewed—not only by us but by the film's protagonists as well—and to the

Fig. 2: Look Harder: Baroque Vision in *Caché* (2005). Sony Pictures/The Kobal Collection.

body of the cinema that enables that viewing, whereby its images are quite overtly marked out as being technologically 'mediated'. Doubling our own function as the spectators of *Caché*, Georges and Anne rewind, pause and replay the tapes throughout, searching them for clues as to the identity, location, and intentions of their stalker. Similarly, *Caché* elicits puzzled, curious modes of vision from us, too, as we scrutinize its reticent images for clues, trying to glean details from them about who or 'what is being watched, when, and by whom' (Mecchia, 'The Children', p. 136). The fact that we have to labour to read even the title credits is suggestive of '[s]ecrecy, concealment and [the] blocked or obstructed vision' that dominates the film, as well as the keen and searching vision that it demands from us in turn (Saxton, 'Secrets and Revelations', p. 5). In a later scene, for instance, Georges almost collides with a young bicyclist. Anne plays peacemaker to their heated argument, asserting to Georges that 'you weren't looking [...] we weren't looking'. *Caché* itself, however, urges us to pay attention as viewers and to look harder for this film does not readily divulge its secrets. It ends just as mysteriously as it began with an extended, static, and distant view of the entrance to Pierrot's school.

The final sequence could well be another 'tape', although the chatting children seem to display no awareness of being filmed. Given the wide expanse of the shot, the crowding of the children on the school steps, and the sounds of their overlapping but indecipherable conversations, it is easy enough to miss a small but crucial exchange. It is only with scrutiny—the aforementioned curious gaze that the furtiveness of the film prompts from

us—that 'hidden' details become apparent, details that the film resists signalling out in close-up. On the left of the frame, almost lost amongst the crowd, Pierrot and Majid's son meet and inaudibly converse. After they depart, the camera does not alter its intentional focus from the school's steps as the credits roll. Discerning the exchange between the two boys does not bring us any closer to interpretive resolution. Instead, it prompts more unanswered questions because there has been no suggestion in the film that Majid's son and Pierrot even know each other. Are they accomplices in the tapes? Will the younger generation heal the trauma of its elders? The scene opens up multiple possibilities.

As Giuseppina Mecchia observes, 'ambiguity is essential to the political, narrative and affective economy of *Caché*' ('The Children', p. 132). Such ambiguity stems from its baroque plurality of vision and of meaning. Let us return to the film's opening, previously described. After the film cuts back to Georges and Anne in front of their television with their remote, we realize that the initial establishing shot of the house may not have been an establishing shot at all. We have either been watching a close-up of the same screen that Georges and Anne are watching or we were temporarily located outside, alongside the hidden filming source. Reversing our view of the outside of the house that we have been watching to the inside of the house being watched, *Caché* lends cinematic credence to the 'Baroque self [as] both surveyor and seen' (Zamora, *Inordinate Eye*, p. 171). From its outset, the film implicates us in its baroque reversals and enigmas of vision. As Buci-Glucksmann remarks, here everything 'is before our eyes, yet the centre remains unfixable, like in Borromini's elliptical, spiraling structures' ('Baroque Eye', p. 37). Similarly, perceptual roles become so unfixed in *Caché* that the question of 'who else, besides us, might be looking and why' becomes a pressing one (Saxton, 'Secrets and Revelations', p. 7). By way of the tapes, we share the vision of the surveyor but we also share in the point of view of the seen (Georges and Anne). Throughout, it remains uncertain whether we watch the tapes as they are being filmed or as they are being re-watched by those under surveillance. As it oscillates between the visual and the visible, the film re-plays a baroque aesthetics of reversibility through the circulation of the tapes.

As a result, the 'plural vision' of *Caché* also spawns an interpretive multiplicity that is entirely in accordance with baroque flesh (Buci-Glucksmann, *La folie*, pp. 72–73). The film's mystery arises from the ambiguity of precisely *whose* vision we are engaged by and whether or not that vision can be verified. In this regard, the visual organization of the film mimics its own narrative investigation as to what constitutes the past and the present. In the

baroque, 'interpretive multiplicity' comes to the fore because it expresses the many different 'points-of-view [to be] taken' and the many different 'angles from which the world is viewed' (Buci-Glucksmann, 'Baroque Eye', p. 38). Confounding vision and interpretive meaning throughout, *Caché* reprises the logic of baroque perspectivism. Its circularity of vision generates rather than forecloses enigmas and opens up multiple perspectives upon the 'truth'. The ambiguity that infuses this film is compounded by its use of the taped footage: not only does the frame of *Caché* coincide with the frame of its tapes, the entire film is shot in high-definition digital video so to unsettle any obvious distinction between media (Saxton, 'Secrets and Revelations', pp. 8, 14). Likewise, the recurrence of fixed long shots mimics the taped footage, just as the austerity of the tapes echoes the cinematic style of *Caché*. Due to the film's repeated views of the Laurent home, we cannot determine if we are watching a narrative scene or if we are re-watching surveillance footage. Often, only the appearance of the tracking marks cues us into the fact that we have actually been watching one of the 'taped' images.

According to Buci-Glucksmann, the baroque confuses 'the spectacle and the real, the actual and the virtual' in its theatrical 'arrangement of seeing spectators' whereby the visual or painted scene incorporates all 'spectators both [as] seen and seeing' ('Baroque Eye', pp. 31–32). As if Haneke's film were not already complicated enough, *Caché* pursues other appropriately baroque expressions such as the 'indiscernability of imaginary and real, [or] life and spectacle' (Buci-Glucksmann, 'Baroque Eye', p. 25). After the drawings appear, another layer of complexity is added to the film; we become privy to glimpses of a darkened house where a young boy crouches against a windowpane, wiping blood from his mouth. These images are fragments of Georges' dreams or memories of his childhood time with Majid, which begin to coalesce into more sustained sequences. Yet again, these glimpses of the past foster further interpretive instability. Is Georges remembering Majid correctly? Or are his recollections or dreams tainted by a desire to assuage his own guilt? It is impossible for us to verify the 'truth' of vision in *Caché* because 'every image becomes suspect' through convoluted intersections of the personal and the political, media, memory, and history (Saxton, 'Secrets and Revelations', p. 14). By confusing the videotape footage with the rest of the film and by interspersing Georges' memories or nightmares of the past with the present, *Caché* plays upon shifts between the 'real', the 'mediated', the 'remembered', or the 'imaginary', confounding their distinction. By way of its baroque 'multi-faceted vision' and 'interpretive multiplicity' the film is able to lend commensurate form to the conflicting versions of the 'truth',

which is its central theme and ethical preoccupation (Buci-Glucksmann, 'Baroque Eye', pp. 32, 38).

For me, *Caché* is no less baroque in its gestures towards cinema than *Strange Days* is though it manifests its self-reflexivity in a different manner. Georges is at a complete loss as to where to locate his hidden surveyor: as he states, 'It'll remain a mystery'. His words prove partially correct for the source of the tapes is never clearly identified. The mystery of *Caché* is so entrenched in the 'enigmatic look' of the source of the recordings that its source is never made visible (Saxton, 'Secrets and Revelations', p. 7). One interpretation that has been offered is that the recorder of the tapes is none other than Haneke, as the director who relentlessly stalks his characters into giving up their secrets. Surely, it is Haneke-the-filmmaker who is the real 'hidden presence who observes, films and [...] directs the action from beyond the frame' and the real source of the tapes (Saxton, 'Secrets and Revelations', p. 7)? By contrast, I would offer an alternative explanation that is commensurate with the film's baroque self-reflexivity.

As Sobchack maintains, film is discretely embodied. It enjoys its own uniquely embodied existence that is separate to the director behind the film and the viewer before it (Sobchack, *Address of the Eye*, p. 9). *Caché* bears witness to this claim—the truth of how the subjectivity of the director or the creative forces behind a film are only ever experienced by us indirectly. These bodies have all been 'remediated' by way of various cinematic technologies to become the perceptions and expressions of the film itself (Sobchack, *Address of the Eye*, p. 22).[37] As Libby Saxton astutely observes, the tapes in *Caché* are all shot from purposely baffling or 'impossible angles' (from on high, within nooks and crannies, flat against the wall), even as they suggest that the camera *should* be visible to its subject ('Secrets and Revelations', p. 11). By way of the tapes, *Caché* makes explicit how cinematic vision is not the same as that of the director nor any other human body; rather, it belongs to a discrete and technologically enabled 'I'/eye.

Caché self-reflexively calls our attention to how this 'I'/eye is not equivalent to the film's various characters, its director, or its viewer. Nevertheless, I think we can locate a baroque body behind the tapes. This happens to be the same body through which all vision in *Caché* is channelled—the film's body. Its vision is not that of Haneke or one of the film's characters for no human body could undertake vision at such impossible angles nor could a human achieve the perfect rigidity of vision that marks the tapes. Similarly, the vision of the film's body is not the same as our own as we attempt to unravel the mysteries of *Caché*. As Sobchack suggests, when the film's body 'comes into being through projection, the film becomes. As it has being on

the screen, the film behaves. It *lives* its *own* perceptive and intentional life before us as well as for us' (*Address of the Eye*, p. 216).

Caché is reluctant to provide its viewers with any clear-cut resolution. Rather, it employs a shifting and oblivious vision to keep a 'plurality of competing readings in play' (Saxton, 'Secrets and Revelations', p. 13). Prior to the film's conclusion on the schoolyard steps and following what looks like yet another 'taped' excerpt, Georges climbs into bed. The scene that follows features an extreme long shot of the courtyard of his childhood home. Like the opening, the atmosphere appears subdued, with chickens flocking about the sunny courtyard. A car pulls up and we watch a young Majid being escorted from the house. He tries to run but is chased down, forcibly placed in the car and taken away. Is this the 'real' and painful truth of the past or its distorted view through the present? Is this sequence a flashback or a dream? *Caché* never offers us a definitive version of what took place between the young Georges and Majid. Indeed, the vision of the film's body never seems to differentiate between fact or fiction, videotape or film, past or present, history, dream, or memory. As with the baroque art of analogy, *Caché* brings the invisible into visibility—the question of guilt or innocence on the part of Georges and Majid; a lost childhood; events that have long been hidden, effaced, or deliberately forgotten in the passing of personal and political history. The film leaves it up to the viewer and their own searching vision to decide. In the midst of its baroque destabilization of vision and meaning, the adult denial of guilt by Georges ('Why should I feel responsible?') is the only certainty that the film provides.

Up to this point, I have been associating both *Strange Days* and *Caché* with the flux of perception and meaning inherent to baroque forms. Visually, however, it might appear as if the baroque flesh of these films bears very little in common. On this front, cultural historian José Antonio Maravall proves instructive. As he notes, baroque artists and authors 'could allow themselves to be carried away by exuberance or could hold to a severe simplicity. [...] To appear baroque [...] *abundance or simplicity* [*must*] *take place in the extreme*' (Maravall, *Culture*, p. 210; italics mine). Vision in *Strange Days* is fevered and visceral; it expresses frenetic modes of vision that are tied to a shared sense of movement in and through space. A bodily emphasis on movement is typical of the genre film experiments of Kathryn Bigelow, a director who is known for her incredibly dynamic, fluid camera; breakneck editing; her use of subjective point-of-view shots or shooting at a zero distance such that the camera stays close to the human bodies it films, enhancing our physical involvement in a scene (Rascaroli, 'Steel in the Gaze', pp. 233, 237). Vision in Bigelow's cinema is forged out of the fires

of action and movement, working 'towards a reduction of the distance between the human eye [of the viewer] and the camera's eye' (Rascaroli, 'Steel in the Gaze', p. 237). Similarly, a privileging of space and movement is typical of Cubitt's Hollywood baroque. As he details it, time cedes to space in the Hollywood baroque as its 'narrative and stylistics have been subordinated to [an] exploration of the world of the film' (*Cinema Effect*, p. 224). Expressive of Hollywood baroque mobility, the SQUID/Steadicam sequences of *Strange Days* reveal that kinesthetic lures of spatialization can 'take over from narrative the job of managing the film's dynamics' (*Cinema Effect*, p. 224).

As Steven Shaviro aptly observes, the opening of *Strange Days* is 'all speed, violence and nervous tension' and the energetic modes of vision that it establishes here likewise characterize our viewing of the SQUID throughout ('Straight', p. 161). If the moment of immersion into SQUID elicits an audible gasp of shock and a physical shudder from one of Lenny's SQUID clients, his reaction only rehearses, re-stages, and hyperbolizes our own embodied response to the physicality of vision in *Strange Days*. Despite the film's recurring motifs of vision, we do not feel the adrenaline, fright, or tension of the SQUID with just our eyes. In Cubitt's Hollywood baroque, the mobile exploration of various cinematic worlds is never 'entirely embodied in the [film's] protagonist but tends to gather in the space around them' (*Cinema Effect*, p. 227). Throughout *Strange Days*, an inter-sensory spatialization of the image often occurs. As Shaviro comments, its SQUID sequences are really 'tactile, or haptic, more than they are merely visual. The subjective camera doesn't just look at a scene. It moves actively through space. It gets jostled, it stops and starts, and it pans and tilts. It lurches forwards and back' ('Straight', p. 164).

Vision, in *Caché*, involves a totally different aesthetic and affective register because it is filtered through Haneke's cinema of icy distance. Here, vision is coupled with effects of physical and film formal restraint. It is austere and ascetic in its radically pared down images, its muted colours, and its lack of close-ups. Vision is cold ('glacial' is a term often applied to Haneke), replete with overly long takes and minimal film editing (Frey, 'Michael Haneke'). *Caché* is entrenched in bleak vision; its vision occurs at an extreme distance or in utter stasis. And yet, while the film's body is detached and oblivious to the tragic events that it witnesses, *Caché* is certainly not experienced as distant at the level of our own viewing bodies. For instance, the confusion between the surveillance footage and the rest of the film is physically unnerving. As viewers, we lose our spatial bearings in relation to the image through the film's recurring reversals of the visual and the

visible. Alternatively, we might consider the rhythmic shock that comes of unexpected shots of a young Majid, staring out at us and coughing up blood. The close-up decapitation of the rooster in *Caché* also elicits an audible gasp from me, prompting visceral unease as the animal's blood splashes into Majid's eye; my queasiness is compounded further by the pronounced sounds of the dead rooster's still-flapping wings. As the 'nightmare' vision of Majid moves closer, widening his mouth towards the camera and towards us, *Caché* figures how we can become very literally and affectively absorbed into a film (an idea that I will return to in more depth in Chapter 2).

Let us also consider the physical and ethical horror that occurs when the adult Majid takes out a knife in his apartment. He silently slits his throat in front of Georges, spraying his blood against the white expanse of a wall (a tragedy presaged by the drawings that were sent to the Laurents). As Brigitte Peucker comments, Haneke stages viewing situations that she likens to a conjunction of cold image with hot affect such that we are 'provoked, [feel] irritated, on the defensive and in a situation of conflict' in his cinema (*Material Image*, p. 132). Rather than intellectually removing us from the scene, *Caché* arouses bodily and emotive attachments from us that temper its icy vision and the coldness with which Georges treats the adult Majid and his family. If anything, we emote or empathise all the more in response to this film because its vision is so coolly remote. Through a baroque aesthetics of reversibility, we corporeally participate in and complete its coupling of cold image with hot affect (Maravall, *Culture*, p. 75; Peucker, *Material Image*, p. 132). While *Strange Days* and *Caché* can be conceived, respectively, as cinematic vision that is birthed by way of fire or by ice, both films can be aligned with baroque flesh.[38] As Perniola observes, 'extremely hot and extremely cold emotive tonalities [are] at the centre of the Baroque experience' (*Enigmas*, p. 97). In either extreme, baroque cinema will always carve out a proximately embodied experience for its viewer.

Summation: Face to Face—Feeling Baroque *Deixis*

With the art and film examples discussed in mind, we can note that baroque flesh is not only concerned with vision. Phenomenology asserts that subjective perception has its flip side as external and visible expression. Through the manifold ways in which we carry ourselves in the world our embodied 'being gestures' (Sobchack, *Address of the Eye*, p. 41). Gesture is the reverse of the baroque fascination with vision and we can trace the privileging of gesture in historic baroque art, where the pronounced use of gesture

'makes contact with our world' (Martin, *Baroque*, p. 158). Similarly, Zamora has observed how 'theatrical personages in Baroque art and sculpture [...] reach out towards the viewer with gestures that seem to represent [a baroque] desire for connectivity and connection' (*Inordinate Eye*, p. 255). In the art of Caravaggio, for example, baskets or stools are painted as if they are perched on the very edges of the frame—the gestural address of these objects urge us to grab them lest they fall at our feet. Alternatively, the heightened bodily gestures of Caravaggio's paintings seem to thrust through the very surface of the canvas and reach into our viewing space, as with the hand that points towards us in his *Supper at Emmaus* (National Gallery, London, 1601). Caravaggio was renowned for using gesture to enhance the 'confrontational nature of his pictorial spaces', enticing the beholder to engage with the painting as if it were an extension of their own space (Varriano, *Caravaggio*, pp. 35, 38).[39]

It is for good reason, then, that Benjamin latched onto gesture and the 'provocative quality' of the gesture as a baroque trait (*The Origin*, p. 183). This is because gesture hastens frontal or face-to-face modes of address that are crucial to baroque flesh. According to Susan Stewart, 'face-to-face forms' harbour the capacity for 'changing or moving us' by way of the 'profound intimacy and affect' that they engender (*Poetry*, p. 146). Appropriately, she goes on to connect face-to-face forms with the baroque. She argues that baroque frontal address, 'regardless of [its] media, bring[s] forward a desire to touch, [our] compulsion to be in proximity to the material of the work' (Stewart, *Poetry*, p. 161). Self-reflexively gesturing towards the cinema itself and towards the viewer, the baroque flesh of cinema prompts a face-to-face address between film and viewer that can be likened to the proximate effects of 'facing'.[40] As has been detailed in art history and in film theory, 'facing' renders the surface of a painting or film akin to a front that resists spatial closure. This spurs an intensification of feeling in relation to the image while the effect of 'facing' also foregrounds the latent capacity of an artwork, object, or film to *return* our look (Fried, *Absorption*, p. 158; Deleuze, *Cinema 1*, p. 90). In Deleuze's discussion of the affection-image, for instance, the effect of 'facing' or *visagéification* is associated with the technique of the close-up and with the physical presence of an *inanimate* object (a clock, a knife, a kettle): it 'stares at us [...] even if it does not resemble a face' (Deleuze, *Cinema 1*, p. 90; Marks, *Skin of the Film*, p. 94; Beugnet, *Cinema and Sensation*, p. 109).[41]

In my view, the film's body can adopt a face-to-face mode of address even without the use of close-ups and whilst still not possessing a human face as such. One instance lies in the transference of baroque forms and figurations

in cinema. As Buci-Glucksmann also reminds us, from the presence of 'angels, [and] from baroque putti to [...] tragic creatures, it is actually "the eye which looks at us"' in baroque art (*Baroque Reason*, pp. 59–60). As I have also demonstrated, the baroque flesh of the cinema also reprises a reciprocity or layering of vision and self-reflexive doublings of the medium. While the cinematic baroque is technologically distinct from its historic predecessors, the fact remains that it is predicated on a remarkably similar correlation or contact between bodies. If the baroque can truly be characterized as a face-to-face aesthetic, as Susan Stewart suggests, then the baroque 'facing' of the cinema can intertwine its self-reflexive or provocative gestures with the feeling of audio-visual proximity (*Poetry*, p. 146; see also Benjamin, *The Origin*, p. 183).

In closing this chapter, it has now become necessary to extract the highly self-reflexive entanglements of baroque flesh from a modernist framework. In his book *The Vatican to Vegas: A History of Special Effects*, Norman M. Klein also helpfully distinguishes between modernist forms of self-reflexivity and 'Baroque Artifice' (p. 40). For Klein, the baroque stages sensuously 'scripted spaces' (p. 40). Significantly, he connects historic baroque spaces (and their merger of nature and artifice) to film by way of a 'common heritage' (p. 274). That common heritage is predicated upon both self-reflexive and sensuous exchange with the audience.

Two important points can be noted here that will serve us well throughout this book. Firstly, the common heritage Klein identifies involves an 'elaborated, direct address' that 'lures the audience into a scripted space imagined on-screen'; it incorporates the viewer as a vital participant as the 'audience [is] winked at, treated as an insider' (Klein, *Vatican to Vegas*, pp. 274–275). Whether it was achieved through costumed masques and theatre, or optical, painted, sculptural, and architectural illusions, Klein asserts that the baroque aesthetic has 'never required a fourth wall, not in 1650' and not in its cinematic incarnation, either (p. 249). Secondly, this common heritage can help us to distinguish what I call baroque flesh from a modernist sensibility. As Klein asserts of historic baroque ceilings, churches, palaces, and the like, 'Baroque "magic" as of 1647—the occult laboratory, the tools of theatrical illusion—was *never* modernist, definitely not' (*Vatican to Vegas*, p. 31). Similarly, Peter Wollen has picked up important experiential discrepancies between the baroque and modernism. As he argues it, modernism often 'shunned intense emotion and prized literalness' when it came to exposing its own form ('Baroque', p. 11). By contrast, the baroque seeks to be endlessly 'dramatic, not only in the sense of striving for spectacular effects, but also in *acknowledging*

its own fictiveness and in expressing intense emotion' (Wollen, 'Baroque', p. 11; italics mine).

As I have argued in this chapter, baroque flesh enacts a fittingly face-to-face dynamic by self-reflexively gesturing towards its own form and towards the viewer. Here, affect exists alongside artifice because the audiences' 'sensing [of] the fake' is 'considered a glory' (Klein, *Vatican to Vegas*, p. 31). In this regard, it does not pursue a modernist sensibility so much as a 'Baroque form of narrative' in which nature and artifice merge while still courting our embodied response (Klein, *Vatican to Vegas*, p. 247). Contemplating its own perceptions and expressions or foregrounding the film's body that enables it, baroque cinema stirs 'a sensory echo' in you such that you 'suddenly notice the strings of the marionette' and 'sense that this could not be real' (Klein, *Vatican to Vegas*, p. 249).

This is where the concept of *deixis* might assume a special critical force in accounting for the sensation and self-reflexivity of the baroque. *Deixis* derives from linguistics (meaning 'to show forth, point, display, bring to light, hail, exhibit, reveal, to greet by means of words or form') and the 'orientational' features of language, as they have specific contextual reference points in time, space, and between speakers (Stewart, *Poetry*, p. 150). Both Stewart and Bal mobilize *deixis* to capture the feeling of a correlative relationship (I/you) between bodies (Stewart, *Poetry*, p. 150; Bal, *Quoting*, pp. 151–153). For Stewart, *deixis* resonates with any presentational or face-to-face aesthetic. Here, we must attend to the 'specific time and space of apprehension, the mutuality, reciprocity, or non-reciprocity of relations between positions and perspectives' (*Poetry*, p. 156). *Deixis* is an affective concept that is wedded to the experiential 'thisness' of an artwork or film, as it emerges in space and time and in and through bodily relations (Stewart, *Poetry*, p. 154).

Significantly, both Stewart and Bal connect *deixis* to the baroque. In baroque art and film, bodies address or 'face' each other in charged corporeal encounters that play upon the acknowledgment of a shared physicality. In this 'traffic of images between inside and out', writes Bal, the beholder or viewer is addressed by deictic gestures and 'sends back, so to speak, the images that enter it from without [...] this time accompanied by [their own] affective "commentary" or "feeling"' (*Quoting*, p. 152). Furthermore, as Bal and Stewart are careful to point out, feeling *deixis* does not take place in purely visual terms. As Stewart insists, *deixis* always involves more than a visual dimension as it elicits our apprehension of forms by way of 'touch or motion' (*Poetry*, p. 150). According to Bal, feeling *deixis* is placed 'within', 'on', and 'at' the site of the lived body; it is inclusive of its 'proprioceptive basis

[...] the muscular as well as the space around the body, the space within which it "fits" as within a skin' (*Quoting*, p. 152). I consider *deixis* to be highly appropriate for gauging the self-reflexive and the sensuous experiences of baroque flesh—as the 'now' of its address, the 'here' of the space in which it occurs, the 'I' of the speaker/artwork/film's body, and the 'you' of the listener/beholder/viewer (Stewart, *Poetry*, pp. 146–154).

In this chapter I have established the film-philosophical frameworks of my model of baroque flesh and I have considered the importance that vision, self-reflexivity, gesture, and 'facing' hold for a baroque cinema. The next chapter will extend upon the corporeal nature of *deixis* by examining how we *feel* baroque spatiality and the 'passions' at the cinema. Given that the ontology of the 'flesh' has provided the critical inspiration for this book, it is fitting to conclude with Merleau-Ponty. As he tells us, the reversibility 'that defines the flesh exists in other fields; *it is even incomparably more agile there and capable of weaving relations between bodies* that [...] pass definitively beyond the circle of the visible' (Merleau-Ponty, *VI*, p. 144; italics mine). My remaining chapters will pursue that sensuous inter-weaving further by examining the differently embodied entanglements of a baroque cinema.

2. Knots of Sensation: Co-Extensive Space and a Cinema of the Passions

The baroque propitiates emotive participants, it empties them, it excites them,
it tunes and sharpens the fleeting perceptions.
Sensual, it accepts the immediate givens of consciousness,
it likes voluptuous immersions, to be possessed and overflowed.
– Saúl Yurkiévich ('Baroque Fusions', p. 112)

What makes the weight, the thickness, the flesh of each color, of each sound, of
each tactile texture [...] is the fact that he who grasps them feels himself emerge
from them by a sort of coiling up or redoubling, fundamentally homogenous
with them; he feels that he is the sensible itself coming to itself and that in return
the sensible is in his eyes as it were his double or an extension of his own flesh.
– Maurice Merlaeu-Ponty (*VI*, pp. 113-114)

This chapter fleshes out my vision of baroque flesh by examining how the baroque knots sensation together with a deliberate breaching of borders, frames, and surfaces. To adopt a neologism of Sobchack, in this chapter I will examine how baroque cinema is porous in its spatiality and 'cinesthetic' in its texturing of sensation (*Carnal Thoughts*, p. 67). Not only does this concept endow the film's body with a deeper and more luscious sensuality than has heretofore been described, it helps establish how cinema 'uses our dominant senses of vision and hearing to speak comprehensibly to our senses', and how we as viewers 'do not only experience any movie through only our eyes' (Sobchack, *Carnal Thoughts*, pp. 67, 63). A cinema of baroque flesh is not limited to sight and sound, although it is channelled and expressed through those senses.

For Sobchack, cinesthesia speaks to the doubled embodiment and doubled spatiality of cinema such that the viewer feels themselves to be 'ambiguously located both "here" off-screen and "there" onscreen' (*Carnal Thoughts*, p. 72). This doubled spatiality accords well with the baroque. Following on from Eco, Ndalianis, and others, we have already identified one of the defining features of the baroque to be its enduringly 'open' attitude towards the viewer and towards the representational frame of the work. Historically, baroque art harnessed bodily gestures, direct looks, and face-to-face frontal positioning as well as various perspectival techniques, illusionistic optics,

and *trompe l'oeil* effects in its ceiling, dome, and vault decorations to effect what Ndalianis calls a perceptual 'collapse of the frame' (*Neo-Baroque*, p. 28). Such strategies appealed to a strong sense of physical presence on the part of the beholder in order to achieve the effect known as co-extensive space. Co-extensive space enacts a spatial push towards or pulling of the viewer into the depths of the image. Here, the 'distinction between the viewer's space and pictorial space, between represented and real' space is eroded through a heightened sense of movement, experiences of sensuous assault, or a materialist absorption (Zamora, *Inordinate Eye*, pp. 247–249).

In connecting the real with the representational, the baroque strives for a spatialized and sensuous correlation between bodies. This chapter will explore how a knotting together of space and of sensation is reprised in a baroque cinema of the senses. The baroque potential of film is enabled by its doubled spatiality and its doubled embodiment, as the film's body intertwines with our own. Rather than pitting the 'classical' separation of film and viewer against a post-classical or neo-baroque collapse of the frame, then, this chapter locates that doubled address as being indispensable to the activation of baroque flesh in film. In other words, a baroque spatiality is ontologically inherent to cinema. Let me provide a brief but guiding example. As Gilberto Perez writes: 'the moment that [the] Lumière's arriving train came at those spectators who got out of the way, the movies have broken through [the frame] and *opened up in our direction the space of representation*' (*Material Ghost*, p. 302; italics mine). The telling of the course of film history has often begun with the Lumière's famous *Arrival of a Train at La Ciotat* (1896) screening at the Grand Café in Paris, and with the purportedly terrified bodies of early audiences in its Salon Indien.[1] While it remains doubtful that the first audiences did actually run from this screening, fleeing in fear from the image of a train that threatened to burst forth, it is noteworthy that primary reports speak of an 'excitement bordering on terror' (Gunning, 'An Aesthetic', p. 121). For me, what this early encounter with the moving image underscores is the inaugural potential of film to instigate a powerful agitation or physical excitation of the body. That physicality is coupled with palpable impressions of a spatial rupturing or rushing outwards from the screen, into the space of the viewer.

And yet, there exists another more obscure story that demonstrates an alternative kind of spatiality to how audiences experienced the new medium. That story is equally telling of cinema's baroque potential. As film historian Tom Gunning has detailed, one of the utmost fascinations of early cinema is with the display of movement and with the film camera's ability to mobilize or explore space. Hence we witness a slew of early films shot from a variety

of moving vehicles (aerial balloons, subway cars, trains, street cars, gondolas, boats) as well as the enormous popularity of the travelogue genre at the time (Gunning, 'An Unseen Energy', p. 362).[2] A contemporaneous reviewer of a Biograph film (shot from a moving train) evocatively described its effect as:

> The way in which [an] unseen energy swallows up space and flings itself into the distances [...]. A sensation is produced [...] One holds his breath instinctively as he is swept along in the rush of the phantom cars. His attention is held almost with the vise of a fate. (Reviewer, *New York Mail and Express*, qtd. in Gunning, 'An Unseen Energy', p. 363).

Rather than an assault outwards by the image, what this quotation suggests is a spatiality that absorbs the energy of the image inwards. Rather than the image and its content appearing to breach the screen, audiences felt as if they were being engulfed into or swallowed up by the sensuous depths of cinema. This early encounter persists in our feeling of a very real sense of movement into or alongside the moving image ('an unseen energy swallows up space'); in our feeling that we are kinesthetically swept up in cinema's mobile path or else captivated and absorbed by its embodied sense of space and presence (we catch our breath; our attention is held). To recall Sobchack, we might say that from the beginnings of film the viewer has cinesthetically existed as both 'here' off-screen and 'there' on-screen. For this book, it is this 'open' and sensuous spatiality that makes cinema such a fitting vehicle for baroque flesh.

An intertwining of space with the emotions and with sensation is indispensable to baroque flesh. In what follows, I employ the writings of Merleau-Ponty, film-phenomenology, and embodied film theory to argue for the inter-sensory diffusion of human as well as cinematic perception. In terms of the historic baroque, I seek to develop the innate sensuality of baroque forms by foregrounding the knotting of space and sensation that occurred in the art of Bernini and the seventeenth-century *bel composto* (the 'beautiful whole') in the arts (Lavin, *Bernini*, p. 6). The *bel composto* makes for an important historic precedent to baroque cinema. The baroque has long desired to arouse intense feelings or emotional states in the beholder, feelings that can be connected back to what were once understood as the so-called 'passions' of the soul. As it involves us feeling excesses of space as well as excesses of emotion, baroque cinema can rightly be conceptualized as a cinema of the passions.

Given that the baroque has often been deemed an excessive or extremist aesthetic, this chapter has necessitated a return to the unwieldy subject of 'excess' in film theory. While the study of excess in film theory has often

grappled with subjectivity and with questions of materiality, little attention has been paid to excess as a feeling of space. To redress this gap, I establish a model of baroque cinema that can be understood in precise spatial and emotional terms: that is, the 'deeper' an emotive experience is felt then the more likely it is to be experienced as an immersive spatial location (Cataldi, *Emotion*, p. 27). Baroque flesh prompts us to feel that we are spatially immersed 'in' deeply emotive states: we reel back 'in' horror or 'in' disgust; we find ourselves absorbed 'in' the beauty or the melancholy of images and sounds; and we experience ourselves as being 'in' an ecstatic state, residing as 'here' off-screen and 'there' on-screen. Rather than dismissing excess as beyond language or aligning it with the chaotic and non-systematic domain of the body and its sensations, baroque cinema involves a set of definite formal and experiential effects that turn upon excesses of feeling and excesses of space.

Finally, this chapter will examine how the baroque stages 'conflict between antagonistic forces' and moves between pleasure and pain (Panofsky, 'What is Baroque?', p. 38). To that end, I concentrate my analyses on a film that is appropriately concerned with the extremes of feeling and with affective movements between pleasure and pain: Claire Denis' moody and atmospheric art/horror hybrid, *Trouble Every Day*. To my mind this film is entirely befitting of a cinema of the passions, as it fosters mobile and highly emotive transformations between cruelty, love, death, eroticism, ecstasy, and poetic lyricism. Of particular interest to us, however, is how Denis' materialist aesthetic in this film also spurs linkages between the audio-visual expressions of the cinema and immanent expressions of flesh, fabric, and materiality in ways that resonate with the baroque and its texturing of sensation. By looking to the historic art of Caravaggio, I seek to connect this film to a cruel baroque in the cinema, especially in terms of its inter-sensory breaching of borders, frames, bodies, and material surfaces. In its sensuous assaults and its sensuous absorptions, *Trouble Every Day* provides us with yet another incarnation of the 'flesh' in baroque cinema, where activity reverses with passivity while the inside can become the outside just as outsides open up to reveal the depths of their insides (del Río, 'The Body as Foundation of the Screen', p. 103).

Synaesthesia, Phenomenology, and the Senses

In the classical ordering of the senses that stems from Aristotle, the notion of five senses was first introduced as a hierarchical system. In Aristotle's *De Anima*, vision and hearing are considered the most valuable senses because

of their association with the intellect and philosophical contemplation. They are followed by smell, taste, and touch, in that order. Taste and touch are deemed the lowliest senses because these are the senses found in all animals and are necessary for 'animate' rather than well being (Jütte, *A History*, pp. 54–71; Stewart, *Poetry*, pp. 20–21).[3]

Despite his lifelong interest in perception, Merleau-Ponty sought to level the cultural construction of the senses that elevated sight above the other faculties. While vision is obviously an important sense for this philosopher, he does not isolate the eye from the rest of the sensorium. As Cathryn Vasseleu observes, Merleau-Ponty's account of vision 'inhabits a space which is tactile as well as visual' and it is 'resistant to a unified [...] or panoptic point of view' (*Textures of Light*, p. 21). Not only did his writing emphasise the diffusion between vision and touch, it argued for a thorough imbrication of the senses. For Merleau-Ponty, our perception is 'not a sum of visual, tactile and audible givens: I perceive in a total way with my whole being; I grasp a unique structure of the thing, a unique way of being, which speaks to all my senses at once' ('The Film', pp. 49–50). The blurring of clearly demarcated borders between the senses is a pre-reflective and general determinant of perception. It is not an exceptional case such as when the blind 'see' the colour of sound or when the use of drugs induces a vividly synaesthetic and conscious experience.[4]

In *Phenomenology of Perception*, Merleau-Ponty critiques empiricist and intellectualist approaches to perception. The empiricist take on perception is grounded in observation, assuming that sensation is produced from the impact of outside stimuli on a passive sensorium. Intellectualism is built upon speculation. It depends on an absolute subject who constitutes the world that it perceives from the privileged vantage point of its own interiority (Jay, *Downcast Eyes*, pp. 307–308). Both traditions construe the world 'as a spectacle to be observed from afar by a disembodied mind' (Jay, *Downcast Eyes*, p. 308). Whereas empiricism turns the subject into an object, no different from all other objects in the world, intellectualism treats perception as the effect of conscious thought and judgement, achieved by cognitive subjects (Jay, *Downcast Eyes*, p. 308). Merleau-Ponty's philosophy, by contrast, characteristically disrupts ontological divisions between the lived body and its world or the subject and object of perception. With regards to perception, he sought to 'rediscover, as anterior to the ideas of subject and object [...] that primordial layer at which both things and ideas come into being' (Merleau-Ponty, *PP*, p. 255).

For Merleau-Ponty, 'I must be particularly careful not to begin by defining the senses; *I must instead resume contact with the sensory life which I live*

from within' (*PP*, p. 255; italics mine). That renewal of sensory life occurs through what he calls the primary layer of embodied experience. In brief, the notion of the primary layer adheres to the pre-reflective commonality of perception in phenomenology. In the primary layer, there is a 'natural unity' to our sensory experience that 'precedes its division among the separate senses' (Merleau-Ponty, *PP*, p. 264). The cross-modality of the senses is quite a complex affair in these terms. Each of the senses encounters the world through its own unique point of access. However, each sense also contributes to the integrated totality of perception through the lived core of the body. In this synoptic bodily schema, each of the senses has the potential to 'spill' from one modality into another.

In re-considering embodied perception as a synergistic unity, Merleau-Ponty situates the senses as co-extensive with each other—akin to the baroque topology of the knot. In his book *Neo-Baroque: A Sign of the Times*, Omar Calabrese identifies the knot and the labyrinth as two 'profoundly baroque' figures (p. 131). According to Calabrese, these two figures are 'destined to emerge from a specific historical period, because they can be interpreted as signs of a more universal, metahistorical baroque' (*Neo-Baroque*, p. 132). Here, I will concentrate only on the sensuous affiliations of the baroque with the knot, as the relationship between the baroque and the labyrinth has been extensively discussed.[5] In defining the baroque through its correlativism, Mieke Bal has also invoked the figure of the knot (*Quoting*, p. 30). While Bal identified an inherent reciprocity and mobility to baroque point of view, the art of entanglement is not bounded by vision. In fact, the historical baroque's veneration of sensuous entanglement can be emblematized by its attention to the mobile and textured expression of curves, whorls, knots, folds, waves, and shells that appear in its ornamental decoration (Bal, *Quoting*, pp. 140–141).[6] As Wölfflin observes, baroque art is invested in the 'illusion of movement' and forms that will 'approach, entwine, fuse' (*Principles*, p. 66). Both the baroque generally and a baroque cinema of the senses in particular are grounded in the art of entanglement, as it appeals to embodied vision, movement, and materiality, as well as an overt texturing of sensation.

Consider the architecture of Francesco Borromini—a figure whom Jacques Lacan has closely associated with the metaphor of the knot.[7] In Borromini, intricate geometries, architectural detailing, and ornamentation combine in designs that are both complex and dynamic (Rowland, 'Architecture of Love', p. 156). In Borromini's façade of *S. Carlo alle Quattro Fontane* (Rome, 1665–1667), the lower wall undulates in a sinuous curve and advances in the centre to compel our attention. The architectural rhythm of

the lower story (concave-convex-concave) is altered at the upper level where all three bays are concave. Borromini carefully places a cylindrical aedicule or shrine in the centre bay to give us the appearance of a forward thrust to the building that geometrically echoes the floor below (Martin, *Baroque*, p. 190). Unlike his contemporary and reputed rival Bernini (who sought to merge architecture, sculpture, and painting), the architect Borromini kept every line of his geometries intact. As Ingrid D. Rowland writes, with Borromini, 'a molding is always a molding, an angel an angel, a curve a curve' ('Architecture of Love', p. 150). While Borromini's architectural forms never break their integrity, he still manages to convey the lively impression of movement and energy through his tightly controlled use of geometry (p. 150). Employing complex curves, Borromini's architecture could bend 'flat walls into curved space [...] warping arches in three dimensions so that they bend in and out as well as over' (Rowland, 'Architecture of Love', p. 158). What connects Borromini to the baroque passion for knots is his investment in 'figures of complexity' alongside 'another characteristic of the knot [...] that of [its] being a *metaphor of movement*' (Calabrese, *Neo-Baroque*, pp. 132–133). In the mathematics of knots, a single thread can produce a series of knots, becoming more and more convoluted with the addition of extra threads. Borromini presents us with architectural façades that are also premised on mobile complexity. Just as intricate knots can potentially be untied, so do Borromini's façades 'unfold' in space and time by curving inwards, outwards, and back and forth (Calabrese, *Neo-Baroque*, pp. 133, 142).[8]

A recurring leitmotif of baroque aesthetics, the knot provides us with an apt figure by which to understand inter-sensory perception. Merleau-Ponty's take on perception is, from the first, innately synaesthetic and knot-like—the senses are as inextricable from each other as they are from the lived body that anchors the sensorium. Alerting us to the materiality in which all vision is embedded, I can think of no more lovely a description of the 'knotted' correspondence between the senses than Merleau-Ponty's. As he writes, our vision 'sees the hardness and brittleness of glass' and when that substance breaks its 'tinkling sound' is 'conveyed by the visible glass' (*PP*, pp. 266–267). Through the materiality of perception, one can see 'the springiness of steel, the ductility of red-hot steel, the hardness of a plane blade, the softness of shavings'; the 'form of a fold in linen or cotton shows us the resilience or dryness of the fiber, the coldness or warmth of the material' and we can discern the 'weight of a block of cast iron which sinks in the sand, the fluidity of water, [and] the viscosity of syrup' (Merleau-Ponty, *PP*, pp. 266–267).

Such a texturing of perception is highly relevant to Denis' *Trouble Every Day*, as we will later discover. Until then, however, let us take note of how

philosopher Michel Serres has underscored a sensuous knotting of perception. Instead of positing a hierarchy to the senses or a horizontal ordering (with the senses sitting adjacent to each other like separate countries on a map), the knot is suggestive of how our perceptions of the world are 'knotted' or clumped together and capable of mobile extension and renewal (Howes, *Empire of the Senses*, p. 9; Connor, 'Michel Serres', p. 323). For Serres, the tying and untying of a knot mimics the actions of the senses themselves as they engage with the world and vary in their formation or their inflection. To quote Serres: the 'sensible, in general, holds together all senses, all directions, like a knot or general intersection [...] the sensible knots up in the knot, the sensible in which the body never persists in the same plane' (qtd. in Connor, 'Michel Serres', p. 329).

Delimiting our embodied perception to the singular component of vision is as alien to how we experience the world as deliberately watching it through one eye. Opening up the eyes and the lived body to its knotted perceptions, Merleau-Ponty prompts us to consider how '*the senses interact in perception as the two eyes collaborate in vision*' (*PP*, pp. 271–272; italics mine). In his book *The Absent Body*, phenomenologist Drew Leder goes one step further by 'opening' up the different sensory locales of the body. As Leder details, the lived body is the site of a constant exchange between the outer surface, the inner depths, and bodily bearing, all of which contribute to the totality of our embodied perception and its make-up (p. 30). In these terms, the 'surface body' (where through the skin and the 'sensorimotor surface of the body' we 'first engage the world') naturally intertwines with and depends upon the healthy functioning of our 'corporeal depths' (Leder, *Absent Body*, pp. 11, 36). The sensory depths of perception belong to our 'recessive body': the invisible sensations of our inner organs and the proprioceptive sense of our muscular position, balance, weight, and movement (pp. 11, 36, 39). Together, these locales make up the normally inconspicuous or anonymous internal sensations of our 'bone and guts' (p. 36).

Because the senses are pre-reflectively experienced as an overall unity, Merleau-Ponty reasons that they will actively communicate with one another without us forcing them to do so. According to phenomenology, the bracketing of our embodied perception into discrete modes is the result of conscious reflection. Because our senses are predisposed to work 'naturally' in relation to one another, their cross-modal interaction is often experienced as unremarkable. The very fact that we might be oblivious to inter-sensory transfer gives us room to pause. 'My body is a ready-made system of equivalents and transpositions from one sense to another', insists Merleau-Ponty, for the senses 'translate each other without any need of an

interpreter, and are mutually comprehensible without the intervention of any idea' (*PP*, p. 273). On this front Sobchack is apposite. As she points out, our bodies are 'so habituated to the[ir] constant cross-modal translations' that these are 'transparent to us *except in their most extreme experiences*' (*Carnal Thoughts*, p. 70; italics mine).

Extremist experiences of the senses abound in the phenomenon known as medical synaesthesia—that rare condition in which one sensory modality will *involuntarily* ricochet into another so that sounds, smells, and tastes assume distinct colours, shapes, and so forth. While such sensory melding is elicited by external stimuli it cannot be conjured at will. In the most common form of synaesthesia, coloured hearing, the sounds of music and speech trigger a vivid visual overflow of coloured shapes, patterns, movements, and shifting variations in hue (Cytowic, *Man Who Tasted Shapes*, p. 59; Cytowic, 'Synaesthesia'). According to the psycho-neurologist Richard E. Cytowic, only one person in about every 25,000 people is a 'true' or medical synaesthete; their experiences endure throughout their lifetime but are highly individuated ('Synaesthesia'). For instance, Cytowic refers to case studies in which people are able to taste words, with one woman revealing that his name, Richard, 'tastes like a chocolate bar [...] warm and melting on my tongue' ('Synaesthesia'). Even amongst those who share the same type of synaesthesia, there is no guarantee of an obvious similarity in their experiences. For some, the musical sound of a trumpet is scarlet while for others it might be pure yellow, yellow-red, or blue-green (Cytowic, *Man Who Tasted Shapes*, p. 59). In Cytowic's other case studies, a woman by the name of 'Victoria' can smell and hear colours. Strychnine, for her, possesses a gloriously rich pink smell that is the exact same colour as the smell of angel food cake. In Cytowic's main case study, a man dubbed 'Michael' is able to taste shapes. The acidic taste of citrus, for Michael, has a 'pointy' taste; spearmint tastes like vast rows of 'smooth, cold glass columns' and sugar yields a 'round' taste (*Man Who Tasted Shapes*, pp. 139, 48).

Instead of dismissing synaesthesia as a subjective condition that is resistant to clinical analysis or regarding it as the phantom of an over-productive or artistic imagination, Cytowic demonstrates that synaesthesia is not merely an idea. It is an immediate, direct, and very real experience for the synaesthete that can be felt, touched, tasted, and smelled.[9] Clinical synaesthesia is palpably sensed rather than perceived with the 'mind's eye' (Cytowic, *Man Who Tasted Shapes*, p. 176; 'Synaesthesia'). When 'Michael' tastes shapes, he experiences a striking set of tactile perceptions that are either localized in one area or that permeate his entire body. 'Michael' 'felt some shapes, like points, throughout his entire body. Others, like the spheres

of sweet savories, he felt only in his hands. Many shapes were somewhere in between, felt in his hands, face and shoulders [he was] *grasping the shape, fingering its texture, or sensing its weight and temperature'* (*Man Who Tasted Shapes*, pp. 65–66; italics mine). This is where the psycho-physiological case studies of Cytowic and others begin to support Merleau-Ponty's stance on the naturally synaesthetic qualities that inhere in all of our embodied perception (Merleau-Ponty, *PP*, p. 236).[10]

Cytowic himself lists a number of physiological truths to clinical synaesthesia. The condition usually works in one direction. Sight, for instance, may induce touch but touch fail to set off visual perceptions. The additive result is that two or more of the senses are combined without each losing their specificity. Synaesthetes are prone to detailed sensory recall (there are strong links between synaesthesia and a photographic memory or, at least, a heightened memory); and the condition is also hereditary, predominating amongst women (Cytowic, *Man Who Tasted Shapes*, pp. 76–79; 'Synaesthesia'). Because clinical synaesthesia triggers actual physical sensations, Cytowic argues that it has associations with the limbic section of the brain (the part of the brain that deals with emotion and with memory). The hippocampus, for example, is necessary to many altered states of consciousness that are similar to medical synaesthesia (drug-induced perception, sensory deprivation, limbic epilepsy, and responses during the electrical stimulation of the brain), all of which suggests that there might be certain 'elemental perceptual qualities' (Cytowic, 'Synaesthesia').

Like 'Michael', synaesthetes do not encounter complex scenes. However, they see or feel basic shapes, finger textual qualities, and can taste common flavours. They see blobs, grids, cross-hatchings, lines, spirals, lattice, or geometric shapes; they feel rough, smooth, or prickly textures and can taste the salty, sweet, or metallic. Cytowic conjectures that it '*may be that the simple elements of synaesthesia are really the building blocks of more complex perceptions'* (*Man Who Tasted Shapes*, p. 121; italics mine). Affirming Merleau-Ponty's notion of a primary layer to embodied perception where the senses are transposable, Cytowic affirms that medical or clinical synaesthesia involves 'the conscious awareness of [the] normally holistic process of perception' ('Synaesthesia').

Cinesthesia and the *Bel Composto*

Even the term 'synaesthesia' conjures up the knotting of sensation that is so privileged by baroque flesh. Synaesthesia etymologically derives from

the Greek terms *syn* ('together') and *aesthesis* ('perception' or 'sensation') (Cytowic, 'Synaesthesia'; Stafford, *Good Looking*, p. 52). Just as Merleau-Ponty invoked a naturally synaesthetic unity of the senses, the historic baroque pursued a 'total art or a unity of the arts' in which baroque effects were not restricted to the visual but diffusively spread out across the sensorium (Deleuze, *The Fold*, p. 123). There is no doubt that the seventeenth century sponsored luscious 'enchantment[s] for the eye'—as is evidenced by its heady techniques of visual illusionism in palazzos, ceiling paintings, chapels, and churches (Kitson, *Age of Baroque*, p. 38). Yet, even superbly ornate interiors juxtaposed cool temperatures of mottled marble against the warmth of gilt-carved wood, while the baroque revelry in texture was present in the luxurious furnishings, fabrics, and rich tapestries that adorned rooms (Kitson, *Age of Baroque*, p. 38).

Art historian Giancarlo Maiorino supports my inter-sensory approach to the baroque. He suggests that the historic baroque was deeply invested in 'intersense analogies of synaesthesia' because of its desire to unify the arts: 'sculpture borrowed from dance and theatre' just as 'architecture became pictorial (Borromini's *Cappella Spada*, 1662, San Gerolamo della Carità, Rome; Pietro da Cortona's ceiling in Palazzo Barberini, 1633–1639, Rome)' (*Cornucopian Mind*, p. 108). Consider how sculpture, architecture, and the theatrical merge in a tangle of marble, amber, and gold in Bernini's *Baldacchino* (Saint Peter's Basilica, Rome, 1624–1633). The *Baldacchino* can justly be described as a sumptuous 'feast' for the eyes. Its place at the heart of Saint Peter's in Rome brought together sights, tastes, sounds, and smells through the clustering of architectural and sculptural design with religious pageantry, the pungent odours of incense, choral chants, organ music, and the reading of books and sermons (Maiorino, *Cornucopian Mind*, p. 108).[11]

The integration of architectural motifs with figure sculpture and painting led to a complex interplay of forms in seventeenth-century altarpieces, while theatrical works such as those of Calderón and Lope de Vega anchored their scenic centres in paintings of scared images (Maiorino, *Cornucopian Mind*, p. 110). Thanks to mechanical advances in stage machinery and design, seventeenth-century theatre became an era of 'special-effects' plays that recreated mythological marvels, miracles, and cosmological journeys before captivated audiences (Norman, 'Theatrical Baroque', p. 1). The English masque or costumed-ball-as-theatre tradition eagerly adapted the Italian appetite for mechanical stage effects after 1605, which called for both elaborate playwriting and architecture in tandem (Klein, *Vatican to Vegas*, p. 67). As Norman M. Klein points out, the masque functioned as an 'architectonic story' (*Vatican to Vegas*, p. 89). As it was executed by figures

like the English court architect Inigo Jones, it emphasised very speedy disap-
pearances, scenic transformations, and rapid-fire curtain changes. This
veritable 'montage of effects gave the masques their [sense of] presence—*a
multiple of media and narratives sharing the same moment*' (Klein, *Vatican
to Vegas*, p. 89; italics mine). A sensory spectacle to behold, the masques
integrated poetry, painting, music, and dance: their 'turning' scenes played
out on a revolving stage; painted plaster flats (wings) moved on grooves;
mobile sound effects were used (brewing storms, thunder and lightning)
as well as transitions in illumination that could abandon day for night or
night for day; chariots and their wheels hurtled by, alongside an array of
'many devices that flew, and most of all, accelerated perspective' (Maiorino,
Cornucopian Mind, p. 108; Maravall, *Culture*, p. 236; Klein, *Vatican to Vegas*,
p. 67). It is little wonder that theatre was considered one of the pre-eminent
art forms of the time.[12] Premised on an assimilation of artistic and sensible
elements, theatre combined 'the arts of the mimic, the painter, the musician,
the set designer, and the machinist [...] to assault the senses' (Maravall,
Culture, p. 286). For the baroque age, the play was the thing and the stage
a means of bringing together the arts with the audience into a unified and
wondrously sensual spectacle (Maiorino, *Cornucopian Mind*, p. 108).

Such interrelations between the arts once prompted the Catalonian phi-
losopher and art critic Eugenio d'Ors to write that, 'in epochs with Baroque
tendencies, the architect becomes a sculpture, sculpture paints, painting
and poetry take on music's dynamic tones' (qtd. in Zamora, *Inordinate Eye*,
p. 127). For d'Ors, the baroque is an aesthetic of 'proliferating elements' such
that 'mathematics, music, painting, architecture, sculpture, and literature
themselves become morphological elements that generate and extend the
signifying capacities of one another' (qtd. in Zamora, *Inordinate Eye*, p. 127). In
deliberately prolonging or extending one art form into another, the historic
baroque made its appeals to the body and not just the eye of the beholder.
Painting moves beyond the bounds of the frame and is realized in sculpture;
sculpture escapes its form to spill out into surrounding architecture. And
while architecture might seem to re-discover a frame in external façades,
those façades merged with the cityscape to establish interlocking relations
with new developing urban centres (Deleuze, *The Fold*, p. 123).

'From one end of the chain to the other', as Gilles Deleuze points out, the
baroque 'painter has become an urban designer' (*The Fold*, p. 123). Like d'Ors,
Deleuze argues that the baroque is a mobile proliferation or extension of
elements through its fostering of intermedial relations between the arts. As
he suggests, the baroque began 'the prodigious development of a continuity
in the arts, in breadth or in extension: an interlocking of frames of which

each is exceeded by the matter that moves through it' (*The Fold*, p. 123).[13] The matter that moves through the arts involves the materialist expressions of the artwork and its inter-sensory appeals to the body of the beholder. Overtly addressed by as well as correlated with the artwork, the baroque seeks to attain a total 'unity of the arts as "performance", and to draw the spectator into this very performance' by way of its knots of sensation (Deleuze, *The Fold*, p. 123).

Artistic darling of the powerful Barberini family in Rome, artist Gian Lorenzo Bernini was one of the main proponents of the seventeenth-century appeal to the senses in the arts. His work typifies Deleuze's comments about the baroque continuity of the arts, spanning across and attempting to merge architecture, sculpture, painting, and theatre. Just as the age was celebrating the artist as at once a poet, painter, composer, orator, preacher, concertmaster, and stage director, Bernini's artistry manifested itself in the form of churches, bridges, chapels, sculptures, fountains, parades, festivals, plays, operas, and colonnades, making of Rome an 'outdoor *Gesamtkunstwerk* whose construction spanned the artist's lifetime' (Maiorino, *Cornucopian Mind*, p. 113). So astounded was the English writer and diarist John Evelyn by Bernini's artistic scope that he described him as nothing less than a 'Sculptor, Architect, Painter and Poet'. During his visit to Rome in 1644, Evelyn noted that, shortly before his arrival, Bernini had given a 'Publique Opera [...] wherein he painted the scenes, cut the statues, invented the Engines, composed the Musique, writ the Comedy and built the Theatre all himselfe' (qtd. in Maiorino, *Cornucopian Mind*, p. 113).[14]

Bernini's formidable artistry aside, the inter-sensory, spatial, and intermedial implications of his work are my real concern here. Recall, once again, the topology of the knot as a potent emblem of baroque complexity, sensuality, and movement. The knot is a figure that is intricately interwoven but one that can be united and re-tied, anew, into different formations. Not only does the knot resonate with Merleau-Ponty's position on the mobile boundaries between the senses, it provides us with a figuration for baroque 'border crossing' in general (Ndalianis, *Neo-Baroque*, p. 198). As such, let us consider the knotting of sensation and space that occurs in one of Bernini's most well-known works, *The Ecstasy of St. Teresa of Avila* (Cornaro Chapel, Santa Maria della Vittoria, Rome, 1647–1652). Founder of the reformed order of the Carmelites, Teresa of Ávila (Teresa of Jesus) was born in Spain in 1515 (Classen, *Color of Angels*, p. 39). The saint was known for having mystical raptures in which she was tormented by the Devil and pierced by God's love. Teresa recounted her ecstatic communion with God in her autobiography (in which she construes the dart of God's love as piercing her spirit, heart

and entrails) and it is also the subject of the Cornaro Chapel (Classen, *Color of Angels*, p. 39; Zamora, *Inordinate Eye*, p. 178; Lavin, *Bernini*, p. 84).[15]

As is consistent with the art of analogy, Bernini's goal was to build the 'chapel as an earthly analogue for heaven' (Lavin, *Bernini*, p. 82). Martin concurs, pointing out how he brings the 'limitless and incomprehensible into the realm of the visible and tangible' by yoking Teresa's mystical transverberation to the human (*Baroque*, p. 104). Bernini took 'the most intimate and personal kind of experience' (the saint's transverberation and the subjective feeling of ecstasy) and 'deliberately made of it a public spectacle' in which the beholder could participate, by way of the senses (Lavin, *Bernini*, p. 4).

As Deleuze thoughtfully remarks of Bernini, 'his is not an art of structures but of textures' (*The Fold*, p. 122). Deleuze's claim is supported by a close examination of *Teresa*. As is typical of baroque flesh, the embodied expressivity of the artwork here coils up upon and becomes entangled with the sensuality of our own embodied perception. The work itself is concerned with a state of religious ecstasy ('ecstasy' derives from the Greek *ek-stasis*, meaning 'displacement' or to stand out of place, but it more commonly refers to a passionate state of 'overpowering emotion', to bodily transport or 'intense feeling').[16] Not only does Teresa's ecstasy call up baroque conjunctions of pleasure with pain or a movement between these states, that ecstasy is primarily conveyed through the sensuous expressivity of texture—evident in flame-like folds, rippling fabrics, and the soft flesh of the saint. In addition, Bernini harnesses the tactility of light in both real and representational terms, giving us the impression of defying matter, weight, and gravity through his use of a suspended sculpture. The artwork is also endowed with a strong sense of kinesthetic energy and movement, achieved through the rendering of Teresa's body and the painted clouds and angels that spill out from the vault into the space of the chapel below. As Ndalianis observes, *Teresa* elicits the movement of the beholder's eye as well, as our eyes have to move between two- and three-dimensional media and perceive the divergent materials of gilt, chromatic marble, and stucco, as well as uses of painting and architecture (*Neo-Baroque*, pp. 216–217).

The dark framing columns of the altarpiece stand in stark chromatic contrast to the two polished white sculptural figures. Placed against a set of fanning gilt rods, a sculptured angel descends to earth. With one hand, he gently lifts the hem of Teresa's robe and with the other hand he prepares to pierce her heart with a golden arrow—the spear that set Teresa 'completely afire with a great love for God' to quote the Spanish saint herself (qtd. in Lavin, *Bernini*, p. 107). The entire event 'is raised on a cloud; and the subject

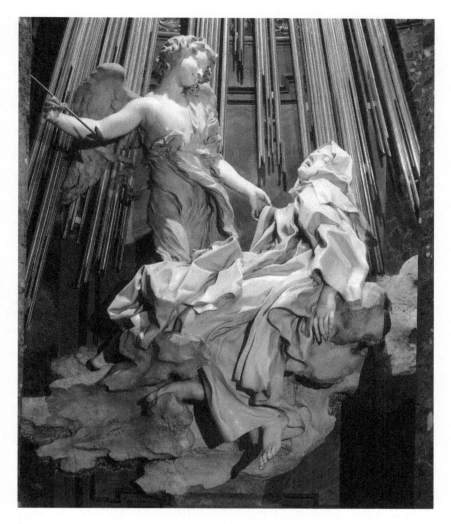

Fig. 3: Gian Lorenzo Bernini, *The Ecstasy of St. Teresa of Avila* (1647–1652). The Art Archive / DeA Picture Library.

is given a sensual, one may say erotic, content it never had before' (Lavin, *Bernini*, p. 113).[17] Teresa is presented in a limp state of bodily collapse while the mid-section of her torso undergoes violent spasms. Bernini granted far greater precedence to the corporeality of Teresa's ecstatic vision than had previous artists. Here, I am reminded of Lacan's comment that the baroque involves a 'regulating of the soul [through] corporeal radioscopy' (*On Feminine Sexuality*, p. 116). In other words, the baroque brings into visible, tangible, and sensible terms what might otherwise remain an

invisible 'abstraction' (the soul, the divine, the subjective feeling of ec-
stasy). It performs a corporeal radioscopy on the 'unrepresentable' to forge
proximate encounters. The heightened physicality of *Teresa* is all the more
remarkable because the only parts of the saint's body that can be seen are
her hands, face, and feet. Her eyes are closed, her mouth slightly open;
her face is a serenely calm expanse in comparison to the agitated folds of
drapery that erupt from her torso or the curling of her foot or her fingers,
which appear on the verge of twitching. Both angel and saint defy gravity.
They float, mid-air, on a seemingly weightless cloud that Bernini has carved
from a hardened, solid block of marble. Light, texture, and movement are
all crucial to wedding this heavenly scene with our earthly sphere (Lavin,
Bernini, p. 101).

As Martin observes, light for the historic baroque was a 'visible manifes-
tation of the supernatural' (*Baroque*, p. 226). Seventeenth-century observ-
ers did not conceive light as a purely visible effect. Pre-modern Europeans
believed that the eyes perceived by issuing rays that touched, mingled, or
made contact with the objects to which they were directed (Classen, *Worlds
of Sense*, p. 2). Similarly, Vasseleu in her book *Textures of Light* explores the
historic and philosophical connections between light, vision, and touch.
She argues that light can implicate touch in vision in ways that contradict
the standardized differentiation of the senses. When light makes contact
with the eye, the objectivity of distance and space that is usually associated
with vision is given over to the subjective immediacy of touch. Through
the embodied experience of light, sight melds with touch. Light hitting
the eye is experienced in tactile terms, prompting 'feelings such as being
penetrated, dazzlement, ecstasy and pain' (Vasseleu, *Textures of Light*,
p. 12).

In *Teresa*, light figuratively becomes touch as both saint and beholder
make contact with the divine. The tactility of light is also expressed in literal
terms as the 'divine' rays of light of Bernini's painted skies transform into
metallic rods surrounding Teresa and the angel. At the same time, Bernini
conceals a window (originally glazed yellow) behind a pediment so that
natural atmospheric light suffuses the golden rays, lending further credence
to the idea of heavenly light taking on tangible form (Wittkower, *Art and
Architecture*, p. 157). The use of a gilt fan also reveals material extensions to
the immaterial rays above (Lavin, *Bernini*, p. 105). Rebounding between an-
tinomies of stone and light, that which resists pressure (marble) is conjoined
with that which is least resistant to pressure (light) in Bernini's sensuous
rendering of the saint's ecstasy (Stewart, *Poetry*, p. 190). As a result, 'stone
is made weightless and light given material form, [as if] the earth might be

swept out from beneath us and we might aim through space toward heaven' and actually touch the divine (Stewart, *Poetry*, p. 190).

As with the feeling of *deixis*, Bernini foregrounds the 'here' and 'now' of the artwork and he relies upon the body of the beholder to complete its perceptual circularity. This fact is underscored by the relief sculptures that are set into the sides of the chapel where members of the Cornaro family sit in theatre-style boxes and share the same space as the beholder (Ndalianis, *Neo-Baroque*, p. 219). These figures 'appear not as abstract busts sunk in the wall but as real people in living relationships with each other and with the world around them' (Lavin, *Bernini*, p. 93). Consistent with the doublings of baroque vision, the Cornaro figures are also spectatorial doubles of the beholder. Intriguingly, however, none of these figures is actually looking at Teresa: in one pair of the effigies, one figure speaks while the other listens; in the other, one figure lifts his finger towards the vault while the other nods in assent (Lavin, *Bernini*, p. 101). Similarly, none of the busts express amazement, passionate transport, or surprise at the events in the altarpiece. Instead, Bernini leaves it up to the beholder to bear witness to Teresa's ecstasy. Because Bernini conceived the ecstasy of Teresa as an embodied 'state of being', the artwork takes on a strong sense of temporal 'happening' and physical presence because it unfolds in our 'real' space (Lavin, *Bernini*, p. 109, 139). As Lavin points out, Teresa's 'transverberation becomes the point of contact between earth and heaven, between matter and spirit' (p. 113). Not only does Bernini's artwork conjoin earth with heaven, matter with spirit, stone with light, and touch with vision, his rendition of Teresa's ecstasy also functions as the sensuous meeting point between the bodies of the artwork and that of its beholder.

According to Filippo Baldinucci, Bernini's biographer and his contemporary, it was 'common knowledge that [Bernini] was the first who undertook to unite architecture, sculpture, and painting in such a way that they together make a beautiful whole' (qtd. in Wittkower, *Art and Architecture*, p. 161). The seventeenth-century unification of the arts (sculpture, architecture, painting, theatre) and its merger of two- and three-dimensional forms had a specific name: the *bel composto* or the beautiful union of many media (Lavin, *Bernini*, p. 13; Ndalianis, *Neo-Baroque*, p. 216). In the *bel composto*, the borders between media and the senses become fluid, as do the borders between artwork and beholder. As Panofsky observes, 'tension between the two-dimensional surface and three-dimensional space' is utilized as a means of 'subjective intensification' so as to encourage our sensual participation in the aesthetic scene ('What is Baroque?', pp. 45, 51). Similarly, Rudolf Wittkower notes how Bernini's 'fusion of all the arts' enhances the

beholder's emotional participation in the scene: 'when all the barriers are down, art and life, real existence and apparition, melt into one' (*Art and Architecture*, p. 161).

As with Merleau-Ponty's primary layer of perception, the *bel composto* did not seek to collapse the differences between media but to make them a holistic totality. What unites Merleau-Ponty with the *bel composto* is the interrelation between parts (media, the senses) that achieve a greater sensuous whole (the *bel composto*, embodied perception). As Merleau-Ponty explicitly states, 'the unity and diversity of the senses are truths of the same order' (*PP*, p. 257). His claim could easily be extended to the *bel composto*. Bernini's trademark was his relation of two- and three-dimensional media to one another (Lavin, *Bernini*, p. 7). Such connectivity between the arts is well captured by the idea of what Bernini called *i contrapposti* (an interaction that achieves an overall unity) (Lavin, *Bernini*, p. 10).[18] Interrelations between the arts and between the senses create the embodied entanglements of *Teresa*. Painting, art, and architecture maintain their differences at the same time as they 'surpass their own limits, transcending one into another' (Careri qtd. in Ndalianis, *Neo-Baroque*, p. 216). Intermedial movement triggers a corresponding series of sensory responses in the viewer whose 'viewpoint leaps from medium to medium, leaving him or her to marvel at the textural effects and the motion of matter that Bernini creates' (Ndalianis, *Neo-Baroque*, p. 217). Building on Ndalianis' description of the work as a sensuous assault, I would claim that what Bernini's work expresses and engenders is a knotting of the senses in the beholder. Although it is realized in and through the eye, *Teresa* solicits a full-bodied appreciation of its materiality, light, texture, weight, matter, movement, and touch. Its quintessentially baroque concern is to express and elicit our embodied perception. It creates the overall unity of the *bel composto* so as to sensuously 'engulf the spectator in it' (Lavin, *Bernini*, p. 155).

Merleau-Ponty would hold that vision is part and parcel of the synoptic and synergistic unity that is the lived body; that vision must be lived in constant communication and exchange with the other senses. By extension, film-phenomenology refuses 'to abstract vision from its existential and embodied motility' (Sobchack, 'Active Eye', p. 21). For film scholars such as Laura Marks, cinema is nothing less than a 'multisensory' event (*Skin of the Film*, p. 213). Marks' approach is informed by the material sway that memory can assume, especially in the writing of philosophers such as Henri Bergson, Deleuze and Gaston Bachelard.[19] Because memory is loaded with multiple senses, Marks argues that cinema can activate a 'memory that necessarily involves all the senses' because it elicits the accumulated,

acculturated, and always embodied memories of its viewer (*Skin of the Film*, p. 22). Synaesthetically, cinema invokes senses that it cannot 'literally' represent (touch, smell, and taste) because it 'appeals to contact—to embodied knowledge [...] in order to recreate memories', whereby viewers will complete the moving image by mnemonically 'trawling through their own circuits of sense memory' (Marks, *Skin of the Film*, pp. 129, 213).

Following in the stead of Sobchack and Marks, Martine Beugnet in her book *Cinema and Sensation: French Film and the Art of Transgression* also identifies a series of 'sensual correspondences' as occurring between film and viewer (p. 71). For Beugnet, rich uses of 'framing, camera movement, light and contrast, the grain of the image and the mix of different film stocks', together with 'variations in sound and visual intensities' can extend the audio-visual expressions of cinema into the realm of 'touch, smell and taste' (p. 74). Similarly, in her book *The Material Image: Art and the Real in Film*, Brigitte Peucker argues that cinema possesses the 'immediacy of lived experience; it produces somatic responses in its spectator, responses that promote continuity between the moving image and the embodied observer' (p. 5).[20]

Informed by newly revived phenomenological as well as film-philosophical approaches, the work of scholars such as Sobchack, Marks, Beugnet, Peucker, and others have initiated new waves of robust and sensuously substantial approaches to contemporary film theory. Nevertheless, embodied understandings of film and film spectatorship are by no means new. Nor should a cinema of the senses be cordoned off to the contemporary—as if film and film theory has just discovered its own embodied potential because it has been catalysed to do so through the emergence of specific film movements, the influence of certain philosophers, or the convergence of recent socio-economic, historic, or technological forces.[21] In counterpoint, one need only think back to the sensuality of vision that infuses the work of early modern cinema theorists such as Walter Benjamin. Always alive to the potential tactility of perception, Benjamin once likened the physicality of film to Dadaist art (it hits 'the spectator like a bullet [...] thus acquiring a tactile quality'); he argues that there is a 'primarily tactile' demand in film, whereby it 'assail[s] the spectator' through constant transitions in place and focus ('Work of Art', p. 240). Sergei M. Eisenstein, too, understood how a film could appeal to the inter-sensory qualities of both human and cinematic perception. He argued for cinema's reverberation between the senses to be matched by a complementary commitment on our own behalf to expand our vocabulary beyond the senses of vision and sound when describing it.[22] In his essay 'The Filmic Fourth Dimension', Eisenstein implores us to

consider how film can create a 'totally physiological sensation': 'For the musical overtone (a throb) it is not strictly fitting to say: "I hear". Nor for the visual overtone: "I see". *For both, a new uniform formula must enter our vocabulary: "I feel"'* (p. 71; italics mine).

Current emphases on the corporeality of the cinema are evident in earlier periods of film theory—in Benjamin and Eisenstein, together with the writings of Béla Balász, Jean Epstein, Dziga Vertov, and Siegfried Kracauer to name but a few (Peucker, *Material Image*, pp. 2–6; Kracauer, *Theory of Film*). While recent film scholarship has been returning with renewed vigour to the sensuous interests of its forerunners, the capacity of cinema to arouse us to meaning physically has always been present. As Sobchack points out, *all* films will 'engage the sense-making potential of our bodies, as well as our minds—albeit to different ratios (or rationalities)' (*Carnal Thoughts*, p. 62, fn. 39). In this regard, the burgeoning of embodied film theory would do well to attend to the many different aesthetic modalities of cinematic sensation. Such is the aim of this book. While all baroque flesh solicits our embodied perception, a baroque cinema of the senses only comes into being when it also activates specific sets of figures and forms.

The proclivity of the spectator towards the sensual dynamics of the cinema is what Sobchack names the '*cinesthetic subject*' (*Carnal Thoughts*, p. 67). She derives this cinematic neologism from the conjunction of two specific conditions: synaesthesia and coenaesthesia (p. 67). Synaesthesia is a phenomenon with which we are already familiar. Coenaesthesia refers to the potential to feel one's sensorial being in its entirety, with particular reference to 'the open sensual condition of the child at birth' (p. 69). Young children, especially, are said to experience a greater horizontalization of the senses because they have not yet become attuned to an *acculturated* sensorium in which vision is often considered the most privileged sense (p. 69).[23] Coenaesthesia also suggests that inter-sensory perception is a natural component of childhood and that, while sensory interplay might diminish with age or be shaped by different cultural regulations of the senses, it never totally disappears (Barker, 'Tactile Eye', p. 81). For Sobchack, one such instance lies in the cinesthetic. Through the sensuous density of cinema, 'we do not have to be clinically diagnosed synaesthetes or very young children' to challenge the commonly assumed separation of the senses (*Carnal Thoughts*, p. 69).

As a knotting of sensation is pivotal to baroque flesh, the burgeoning of embodied film theory can be productively meshed with studies of a baroque cinema. According to Ndalianis, when 'discussing the neo-baroque,

we also need to consider an experience that engages the sensorium' (*Neo-Baroque*, p. 204). While Ndalianis is concerned with neo-baroque effects that literally engage the body (the vertiginous motion of contemporary theme park attractions with their sprays of mist, simulated fire and smoke, rumbling sound, and so on), I am interested in the *chiasmic* intertwining of the literal with the figural that occurs in a baroque cinema of the senses (Ndalianis, *Neo-Baroque*, pp.251-256). As Sobchack writes, as cinesthetic subjects, our real or literal experience of cinema is bound up with its figural sensuality (Sobchack, *Carnal Thoughts*, p. 73). In this regard, the concept of the cinesthetic speaks to how we can feel ourselves to be ambiguously located both 'here' and 'there' at the cinema. For this book, the cinesthetic is highly appropriate to how we experience the literal and figural sensuality of a baroque cinema, especially as it conjoins inter-sensory knotting with the excitation of the emotions and spatialized immersion.

A Passionate Baroque: Emotion, Excess, and Co-Extensive Space

While largely concerned with Lacanian-inflected readings of a baroque 'gaze', Buci-Glucksmann does acknowledge the corporeality of its vision.[24] Drawing upon Richard Alewyn, for example, she comments that 'baroque illusion is always conscious and intentional: it refuses to seduce the soul or even to deceive reason; *it wishes to seduce the senses*' (qtd. in Buci-Glucksmann, *Baroque Reason*, p. 104; italics mine). It is Wölfflin, however, who helps me best frame my remaining concerns for this chapter. Writing of the seventeenth-century baroque, Wölfflin observes how the 'relationship of the individual to the world has changed, and a new domain of feeling has opened' (*Principles*, p. 10). The new domain of feeling that he associates with the baroque involves efforts to overwhelm the beholder sensually. For Wölfflin, the baroque is an art of '[e]motion and movement at all costs' (*Principles*, p. 10).

This section and the analysis of *Trouble Every Day* that concludes this chapter will examine how we experience the baroque in film as a cinema of the *passions*. I underscore the passions here because baroque flesh enacts the extremes of feeling and grand-scale emotions such as ecstasy, love, horror, and mourning. It is not interested in what Sianne Ngai classifies as the 'minor' affects, as these are experienced as less intentional or temporally sustainable feelings (*Ugly Feelings*, pp. 6–7).[25] In the quotation that heads this chapter, Saúl Yurkiévich draws attention to the baroque pursuit of the excitement and the intensity of feeling. As he maintains, the baroque 'likes

voluptuous immersions, to be possessed and overflowed' ('Baroque Fusions', p. 112). As such, the baroque flesh of art and film enacts the extremes of the passions—a pre-modern but nonetheless still relevant concept that I will return to shortly. Wölfflin agrees, asserting that the baroque typically 'wants to carry us away with the force of its impact, immediate and overwhelming. It gives us not a generally enhanced vitality but excitement, ecstasy, intoxication' (*Renaissance*, p. 38). As it relies on excesses of feeling and excesses of space, the baroque intertwines states of activity with states of passivity, lending us an aesthetic concretization to the ontology of the 'flesh'.

Historically, the seventeenth-century baroque has been identified as harnessing the life of the senses for spiritual and ideological purpose. According to José Antonio Maravall and Martin Jay, the baroque age exerted calculated techniques of 'sensual seduction' upon the populace (*Culture*, pp. 57–78; *Downcast Eyes*, p. 46). From the tumultuous scientific, New World, and astronomical discoveries of the age to the encroaching threat of Protestantism or the maintenance of absolutism, the various cultural and ideological factors that led to the rise of the European baroque have already been comprehensively documented.[26] In studying the history and persistence of baroque flesh, I am primarily interested in the recurring association of the baroque with sensation, emotion, and space. Maravall, for one, points us towards this quintessentially baroque coupling of (aesthetic) motion with the emotions.

And that 'was the question: to move' he states of the baroque age (Maravall, *Culture*, p. 220). Seventeenth-century Europe found its answer to that question through highly emotive appeals to the beholder (*Culture*, p. 220). Quoting Jean de La Taille on the French baroque, Maravall maintains that the baroque 'proceed[s] "by moving and wondrously pricking the affections of each one"' so that the beholder is fundamentally moved at the level of the body (qtd. in Maravall, *Culture*, p. 68). Citing the ancient Horatian-Aristotelian tradition of *delectare-docere-movere* (meaning delight, teach, move) in the arts, Maravall also describes how the historic baroque was to change the inflection of that tradition.[27] Instead of the intellectualist nature of *docere* or teaching, the baroque invested in the art of moving. For the Renaissance, art was for the purpose of 'teaching and moving'; the baroque chose to emphasise art as emotion and as movement (*Culture*, p. 77). Less a pure intellectualist endeavour than a sensuously intelligent one, the baroque spurs movement in its participants through the arousal of their feeling flesh.

The historic baroque made no secret of its fascination with depictions of strong emotive states and an untrammelled sensuality in the arts.

According to John Rupert Martin, the baroque is dedicated to and expressive of 'extreme states of feeling' (*Baroque*, p. 13). He goes so far as to suggest that the seventeenth century instigated newly graphic forms of flesh-and-blood-realism (p. 54). Calling on 'the experience of the senses to give reality to the [aesthetic] scenes to be contemplated', the historic baroque sought to stir the senses and the emotions of the beholder (Martin, *Baroque*, p. 54). The depiction and solicitation of extremes of feeling gave rise to 'profound changes in the representation of the visionary experience' (Zamora, *Inordinate Eye*, p. 175). Spiritual subjects such as ecstasy and rapture scenes or portraits of death, suffering, and martyrdom were coupled with a newly heightened sense of corporeal presence. The once pristine flesh of the divine, the limitless, or the intangible was brought firmly back down to earth so that such theological or immaterial 'abstractions' could be made 'accessible to the faithful as beings of flesh and blood' in visible, tangible, and sensually concrete terms (Martin, *Baroque*, p. 54). Saints were now portrayed with dirty feet, their physicality tethered to the terrestrial plane.

Without question, the historic baroque invitation to participate in the artwork corporeally was bound up with Counter-Reformation discourse. Its religious tenets included that the pious could 'discover God in the body, the senses, and the physical world' (Zamora, *Inordinate Eye*, p. 27). This attitude differs markedly from Protestant Reformation practice as it preferred the word over images and an intellectualist apprehension that was detached from appeals to bodily perception.[28] The deliberate turn to the senses on the part of the Counter-Reformation can be vividly demonstrated through the writings of St. Ignatius of Loyola (founder of the Jesuit Order, whose teachings were to influence Bernini greatly). His *Spiritual Exercises* were first published in Latin in 1548.[29] In his meditations on sin and the life, passion, resurrection, and ascension of Christ, Loyola invoked the bodily sense fields so that the faithful might attain a far more intensely physical experience of the subjects he proposed for contemplation. In Loyola, touch, taste, sound, and smell were all brought into play. Consider the first week of the exercises devoted to the end result of sin: here, St. Ignatius asks the contemplator 'to see the flames of Hell, to smell the sulphur and stench, to hear the shrieks of sufferers, to taste the bitterness of their tears and feel their remorse' (Wittkower, *Art and Architecture*, p. 24). According to Wittkower, the *Spiritual Exercises* met with unparalleled success during the baroque age precisely because of its evocation of the senses (p. 139). Aspirations towards piety, coupled with the sensuous depiction of feeling on earth or in the movement towards heaven, accounts for the corporeal density of historic baroque art.[30]

In her book *The Inordinate Eye*, Lois Parkinson Zamora has also discussed how seventeenth-century art made its overtures, first and foremost, to 'the senses and the emotions of the viewer' (p. 30). It was believed that if the artwork was to inspire any kind of devotion, then it should 'provoke a combination of empathy and imagination' in the mind alongside 'an internal, personal response' within the beholder (Zamora, *Inordinate Eye*, p. 30). Flesh, blood, and feeling were the principal means of 'bringing the beholder into mystical communion with [an otherwise] disembodied divinity' (p. 35). Inviting its beholder to share in the physicality of feelings of passion, mourning, suffering, bloodied martyrdom, penitence, or in the urge to transcendence, Zamora maintains that the historic baroque 'call to *visualize the invisible, and to visualize oneself doing so, led viewers to an increasingly self-conscious relationship with the physical bodies of Christ, the Virgin, and the martyred saints and with their own sensory experience*' (*Inordinate Eye*, p. 30; italics mine). Zamora's claims about baroque art coupling sensation with self-reflexivity mirror my claims for a baroque cinema of the senses. Furthermore, she affirms my claims for the baroque as an art of analogy that forges analogical connections in order to 'visualize the invisible' (*Inordinate Eye*, p. 35). Seventeenth-century baroque art relies on an embodied sense of recognition or likeness between bodies, regardless of whether or not those bodies belong to a divine or an earthly plane. In this context, Zamora goes so far as to state that 'explicit physical depiction is, in many ways, a Baroque invention' (*Inordinate Eye*, p. 30). For seventeenth-century Europeans, it was only by way of the body, the senses, and the extremes of feeling that the art of analogy could occur.

Given its extremes of feeling, space, and form, it is not surprising to find that the baroque of art and film has often been affiliated with tropes of 'excess'. Panofsky, for instance, once commented that 'the first idea that comes to our mind when the word *Baroque* is heard is the idea of a lordly racket'; a racket that manifests itself as 'unbridled movement, overwhelming richness in color and composition, theatrical effects produced by a free play of light and shade, and [an] indiscriminate mixture of materials and techniques' ('What is Baroque?', pp. 21–24). When the term 'baroque' is applied to cinema, it usually functions as a metonym for excess—a stand-in for the stylistic verve of idiosyncratic directors and/or ideas of formal extravagance. As Ndalianis explains it, the 'baroque' in film and media studies remains tied to 'connotations of something's being beyond the norm or a quality that is in excess of the norm' (*Neo-Baroque*, p. 9). In this regard, the term baroque has been loosely applied as 'a formal quality that flows "freely" and "excessively" through particular films' (Ndalianis, *Neo-Baroque*, p. 9).

If the baroque is an aesthetic designation that has been haphazardly applied to cinema, it may be because of its affiliations with excess and because ideas of excess have been critically slippery in film theory. To date, excess has been equated with the overstatement of film style or it has been associated with the stylistic and narrative patterns of particular film genres like melodrama. It has been viewed as endemic to film narrative or it has been seen as inherently anti-narrative; it has been rejected by film critics or it has been embraced by them, as a subversive and self-reflexive strategy by which uses of film style disrupt the ideological illusions of the cinema.[31] Interestingly, the two aspects that seem to have united the discussion of excess in film theory are its connections to the sensual or material components of cinema and the fact that those very components have been seen as being resistant to language (Grindon, 'Role of Spectacle', p. 40).

The connections between cinematic excess, sensuality, and their resistance to analysis was set in motion by Roland Barthes' famous essay 'The Third Meaning'. Barthes is one of the more corporeally alert semioticians whose work also possesses baroque leanings, as I will explore further in Chapter 3. In this essay, however, he attends to the sensuality of the image by invoking its excess at the same time as he forecloses its discussion. As Leger Grindon glosses it, Barthes perpetuates 'the enigma of excess by sealing it off from critical dialogue' ('Role of Spectacle', p. 40). Contemplating a series of film stills from the first instalment of *Ivan the Terrible* (Eisenstein, 1944) and *Battleship Potemkin* (Eisenstein, 1925), Barthes' essay describes how he finds himself captivated by the different material elements of these images—by the textures of caked make-up on the courtiers' faces (one 'thick and emphatic' and the other 'smooth'); by a wan complexion; by a hairstyle or the specific angle at which a kerchief is worn ('Third Meaning', pp. 42–49). For Barthes, such elements can be deemed excessive because they are extraneous to any obvious narrative or symbolic meaning. They 'exceed the copy of the referential motif [...] [they] cannot be identified with [...] dramatic meaning' ('Third Meaning', p. 43). Excess is linked to the material details of the image, such that Barthes finds he 'cannot detach [himself] from the image' so he must read or 'receive (probably straight off in fact) a third meaning, errant yet evident and persistent' (p. 42). Throughout, Barthes hints at an immediate sensuous recognition or mimeticism between his own body and the image. He cannot detach from the image because he is already bound up with its material significance. He intimates as much by suggesting that his encounter with the image involves processes of 'poetic' apprehension (with apprehension connoting both mental understanding as well as the act of physical seizure or arrest).[32] Analogy is brought into play as

well, for Barthes asserts that the third meaning 'carries a certain emotion' to it, whereby 'no more than a hank of hair [...] can be the *expression* of grief' pp. 51, 49).

While Barthes latches onto the sensuous apprehension of excess he also consigns its meaning to obscurity. The 'third meaning, the one which appears "in excess", as a supplement my intellection cannot quite absorb' is 'both persistent and fugitive, apparent and evasive' (Barthes, 'Third Meaning', p. 44). While Barthes rightly picks up on the embodied resonance of excess and even hints at it as the 'essence' of the filmic, he reduces excess to ineffability by placing it beyond critical analysis (p. 58). The third meaning depends upon the lived body but those bodily perceptions and expressions are said to evade language. For Barthes, the third meaning is called '*the obtuse meaning*' and '*we cannot describe the obtuse meaning*' (p. 55; italics mine).

The purported antagonisms between the sensuality of excess and its theoretical expression are then later re-staged by Kristin Thompson in her essay, 'The Concept of Cinematic Excess'. Re-visiting Barthes' third meaning alongside her own reading of *Ivan the Terrible*, Thompson's discussion of cinematic excess is implicitly sensual at the same time as she couches excess as fundamentally chaotic. For Thompson, excess initiates a 'conflict between the *materiality* of a film and the unifying structures within it' (p. 132). Here, unification is implicitly understood as belonging to narrative rather than residing in film style. Like Barthes, Thompson positions excess as anti-narrative (p. 135). And yet, her own descriptions of *Ivan the Terrible* abound with meaning as she calls our attention to the rich textures, colours, and shapes of its costumes, to lush furs and brocades, to its rhythmic chiming of bells, small shifts in space, the broken rhythms of its acting styles or its mismatches of *mise-en-scène* and film cuts (Thompson, 'The Concept', pp. 136–137). Contra Thompson, I would suggest that these elements are rife with meaning and with unity rather than chaos, if they are approached through the sensuous significance that is our embodied perception. The materiality of the image or that of cinematic excess need not be beyond analysis as both Barthes and Thompson imply. Rather than perpetuating cinematic schisms between the sensual 'chaos' of excess and the disembodiment of narrative 'order'—a schism that many current articulations of embodied film theory still seem to ascribe to—we would do better to consider how these forces might intertwine with or inform one another.[33]

According to Thompson, the 'systematic analysis [of cinematic excess] is impossible' ('The Concept', p. 140). She does, however, admit that a focus on

the materiality of film is a means of us perceptually reinvigorating it (p. 140). Attending to excess enables a 'different way of watching and listening' and, we might add, *feeling* a film (p. 140). Such a focus is entirely appropriate to the study of a baroque cinema of the senses. Paralleling the discussion of excess in film theory, Jay and others have associated the baroque with a 'denarrativisation of the ocular' (Jay, *Downcast Eyes*, p. 51; Ndalianis, *Neo-Baroque*, p. 221). In this light, the baroque has been conceived as the prioritization of visual spectacle over narration. I would posit, instead, that the art of entanglement is the primary mode of narration in baroque cinema, especially as it involves a correlation or connection between bodies. Instead of scholars continuing to divide the textual from the textural, or the material and the sensational from the domain of narrative, we need to consider how feeling can be a significant form of storytelling in its own right just as narrative or genre-based cinema is by no means disembodied.[34]

The problem for Barthes and for Thompson is that cinematic excess and its sensuality is haunted by a certain degree of subjectivism. To quote Barthes: 'I am not certain whether my reading of this third meaning is justified—if it can be generalized' ('Third Meaning', p. 43). Thompson follows suit in her belief that cinematic excess eludes more 'rigorous' modes of analysis: 'a discussion of the qualities of the visual figure seems doomed to a certain subjectivity. We may not agree that the texture of Efronsinia's has a "heavy, ugly dullness"' (Thompson, 'The Concept', p. 134). As a caveat, she adds that 'the fact that we can agree it has *some* texture opens the possibility of analysis' (p. 134). Unlike Barthes and Thompson, I have no qualms about fusing my flesh to the baroque. Because this book is inspired by Merleau-Ponty's philosophy and by film-phenomenology, how I experience a film and how it presents itself to me comprises its whole correlative structure of analysis.

What Barthes and Thompson see as delimiting, I approach as a useful means of restoring a fuller sense of embodiment to notions of a baroque cinema. According to Jay, baroque images are 'liberated from storytelling' (*Downcast Eyes*, p. 51). By contrast, my model of a baroque cinema of the senses indicates that 'the mind is necessarily embodied and the senses themselves mindful', 'that a focus on perceptual life is not a matter of losing our minds but of coming to our senses' (Howes, *Empire of the Senses*, p. 7). If the baroque has its own stories to tell, their significance lies in an embodied intelligence as well as the passionate density of our feeling flesh.

As such, the sensual excesses of baroque flesh are not without formal or experiential structure. On this front, Linda Williams' discussion of film excess is instructive. In her essay 'Film Bodies: Gender, Genre, and Excess',

Williams sought to redress the then critical neglect of what she calls the 'body genres' of horror, melodrama, and pornography ('Film Bodies', p. 3). These 'sensational' body genres are united by their corporeal excesses in which 'heavy doses of sex, violence and emotion are dismissed by one faction or the other as having no reason for existence beyond their power to excite' (Williams, 'Film Bodies', p. 3). For Williams, these genres all involve the spectacle of an on-screen body that is ecstatically 'beside' itself with uncontrollable physical spasms, inarticulate convulsions, and cries of fear, sadness, and sexual pleasure. Usually, it is the female body that functions as the primary embodiment of fear, pleasure, and pain, and the female body that serves as the physically moved as well as the physically moving. In horror, melodrama, and pornography, the feeling of proximate physicality in relation to the moving image is at its peak. At the same time as the female body undergoes fiercely visceral tremors on-screen, our off-screen bodies are encouraged to mimic those carnal responses in kind through screaming, weeping, and orgasm (Williams, 'Film Bodies', pp. 4–6). For Williams, one reason that body genres have been freighted with the lower end of the cultural spectrum lies in how they (ideally, if not always in fact) generate a mimetic exchange between film and viewer—an exchange that genders excess as 'female' ('Film Bodies', p. 4).

Williams' article remains seminal in that it was amongst the first to examine filmic sensuality as a definite source of meaning in and of itself. She identifies, very precisely, what had seemed to trouble film theory until recently—that the embodied relationship between film and viewer is the grounds upon which all cinematic signification derives and that both are entwined in the production of meaning. With a keen eye and ear, she treats the physicality of body genres in serious semiotic terms. In doing so, she discovers how corporeal excesses in film can boast particular formal patterns. Each genre possesses temporally metered structures of sensation and bodily response: horror is experienced as arriving 'too early!' for the audience as well as the victim (we scream), melodrama is experienced as 'too late!' (we weep, as do the film characters), while pornography choreographs an 'on time!' connection between on and off-screen bodies, so that sexual pleasure occurs simultaneously (Williams, 'Film Bodies', pp. 9–11). Whereas Thompson argues that excess 'forms no specific patterns' ('The Concept', p. 132), the value of Williams' essay for me lies in its recognition that 'excess may itself be organized as a system' (Williams, 'Film Bodies', p. 3). Instead of collapsing film excess into the unintelligible or consigning it to sensory chaos, I understand a baroque cinema as endowed with its own formal and experiential system. In closing this section, let me establish the recurring

patterns of excess that belong to the baroque and a baroque cinema as excesses of feeling and excesses of space.

Benjamin's account of the German baroque theatre is once again pertinent, as he insists that overt displays of feeling assume pride of place. More specifically, he suggests that 'the representation of the actions, the means of the dramatic performance' is 'subordinated to the emotions' (*The Origin*, p. 99). Significantly, he goes on to attach the baroque privileging of emotion to the pre-modern concept of the 'passions'. In the *Trauerspiel*, action cedes to sequences of overt emotional display. In baroque theatre, the 'passions wildly succeed each other' to present 'the exaltations of the passion[s] ever more compellingly and ever more drastically' (Benjamin, *The Origin*, pp. 99–100).

Today, the 'passions' have become interchangeable with feeling in the extreme. As Richard Meyer demonstrates, however, there is a long and complicated cultural history to the passions.[35] The concept is suggestive of 'ungovernable impulses and overwhelming emotions' that have 'variously described states of passivity, extreme suffering, and loss of control in the face of overwhelming impulses' (Meyer, 'Introduction', p. 1). As Ngai observes, grand-scale and all-consuming passions such as love, sorrow, lust, anger, and fear have been central to the philosophical discourse of the emotions since the time of Aristotle (*Ugly Feelings*, p. 6). During the seventeenth century, the passions of the soul became a central concept for the European baroque. The passions were both expressed by the artwork and physically experienced by the beholder. As Martin details it, the 'portrayal of the inner life of man [...] suddenly came to the fore' and a broad 'preoccupation with the "passions of the soul"' can be traced across the period (*Baroque*, pp. 73, 13). As Maravall documents, politicians trivialized the subject of the passions while various religious orders sought, alternatively, to harness it (such as the Jesuit Sénault who published *De l'usage des passions* (The Use of the Passions) in 1641) (*Culture*, p. 66). The passions even received a type of scientific sanction in 1649 with the publication of René Descartes' *Treatise on the Passions of the Soul* whereby the passions came to be broadly understood as 'things we undergo, not things we do' (Martin, *Baroque*, p. 88; see also Hoffman, *Essays on Descartes*, p. 179).[36] Strongly influenced by Descartes, philosopher Baruch Spinoza significantly developed this definition of the passions in his *The Ethics* (1677), where he discussed the passions as a state that harboured the potential to move from passivity towards the bodily activity of the affects.[37]

Alongside the passions that are endemic to baroque form are its excesses of space. Past and present scholars alike have underscored the specific spatial organization of baroque aesthetics. As I have detailed, that spatial

organization involves an open and mobile attitude towards its own form. Wölfflin, for instance, contrasts the closed composition with the baroque 'style of the open form', as it 'everywhere points out beyond itself' (*Principles*, p. 124). In pointing out beyond itself, the baroque deliberately points towards and is inclusive of its audience. In this regard, it was Wölfflin who first picked up on how the baroque impresses upon us an agility of movement and an open attitude towards the frame that moves in two directions—as a spatial movement out towards us and as a movement that pulls us inwards. As he writes, baroque spatiality is oriented 'essentially in the direction of forwards and backwards' (Wölfflin, *Principles*, p. 15). It gives us the 'illusion of physical relief' as 'objects seem to project or recede in space' (Wölfflin, *Renaissance*, p. 31). The spatial dynamics of this forward and backward thrust are part of the sensory impetus to movement that guides baroque flesh. Similarly, Henri Focillon has picked up the baroque desire to become space in all directions. Through its urge to movement and its breaching of the frame, Focillon writes that baroque forms 'proliferate like some vegetable monstrosity. [...] *they tend to invade space in every direction, to perforate it, to become one with all its possibilities.* This mastery of space is pure delight to them' (*Life of Forms*, p. 58; italics mine).[38] Such a restless, open attitude towards the frame and its mobile push-and-pull effects can be demonstrated by a brief examination of the illusionistic ceiling tradition.

Illusionistic ceiling painting was one the foremost signatures of baroque art. Its effects were not unprecedented in Renaissance decoration—most notably, in the works of Correggio—however, it was not until the seventeenth century that the illusionistic ceiling became popular as a painting technique.[39] Ndalianis notes that subject matter and scale became monumental in scope, 'to an extent not previously experienced' and that the historic baroque took 'the illusion of the extension of real, architectural space into the fictive space of the painted representation to new limits' (*Neo-Baroque*, p. 90). Particular to the baroque ceiling is a trajectory of movement that appears to plunge out from or recede into the image (Huddleston, 'Baroque Space', p. 14). Baroque spatiality sensuously assaults the beholder or else it cultivates their absorption into the aesthetic scene by fostering 'the illusion that the image is as real as the beholder' (Huddleston, 'Baroque Space', p. 14). Baroque art pulls our attention into the depth and density of the scene or it appears to push through its own material surfaces, reaching into our own viewing space.

In the illusionistic ceiling tradition, ceiling paintings will lavishly strain against and test the limits of their own entablature. Their scenes

are 'crowded and massive and make us fear that the filling will burst out of the frame', as painted or sculpted figures wantonly cross the borders of the architectural frame, spilling out into the space of the beholder below (Wölfflin, *Renaissance*, p. 56; Wittkower, *Art and Architecture*, p. 252). Alternatively, the ceilings present us with the illusion of an 'unlimited space continuum', drawing us into what appears to be an ever widening or dilating space as architecture itself seems to extend 'infinitely into the heavens' (Wittkower, *Art and Architecture*, p. 252; Ndalianis, *Neo-Baroque*, p. 160). In Pietro da Cortona's *The Glorification of Urban VIII* (Palazzo Barberini, Rome, 1633–1639) or Andrea Pozzo's *Allegory of the Missionary Work of the Jesuit Order* (*The Glorification of St. Ignatius*) (Church of St. Ignatius, Rome, 1691–1694) the structure of the ceiling appears to dissolve into the ethereal illusion of heavenly scenes (Hagerman-Young and Wilks, 'Theatre of the World', p. 40).[40] Here, we are perceptually drawn into the illusion of vast or unending spaces—where figures spill out or thrust through the surface—or else the work avoids the suggestion of corners, lines, and boundaries, so much so that the edges of the frame are hidden altogether. In either tradition (sometimes, both at the same time), the baroque 'puts the emphasis on the material and either omits the frame altogether or makes it seem inadequate to contain the bulging mass it encloses' (Wölfflin, *Renaissance*, pp. 54–55).

The topographical effects of the baroque have been picked up in art history, within philosophy, and within film studies as a collapse between real and fictive space and as a merger between the internal and external elements of its own form. As Martin writes, the baroque aim 'is to break down the barrier between the work of art and the real world'; its method of achieving that aim is 'to conceive of the subject represented as existing in a space coextensive with that of the observer' (*Baroque*, p. 155). Baroque art intentionally correlates the 'inside' of the aesthetic plane with the 'outside' experiential plane, merging real and fictive space to incorporate the beholder 'as an active participant' in the work (Martin, *Baroque*, p. 14). As Deleuze points out, 'matter tends to flow out of the frame, as it often does in *trompe l'oeil* compositions, where it extends forward horizontally' (*The Fold*, p. 123). As I argue in this book, the baroque can be understood through the aesthetics of reversibility. In its doubled or correlative structure, baroque flesh hinges upon contact and connection between bodies. The sensuous yoking together of bodies and the inside and the outside of the aesthetic experience continues to be the hallmark of baroque cinema. This heightened sensory and spatial continuum is what Martin dubs 'co-extensive space' within the historic baroque; what

Ndalianis invokes as the perceptual 'collapse of the representational frame' in neo-baroque film and media; what Klein refers to as animation-in-real space; and what I identified as the feeling of *deixis* at the close of Chapter 1 (*Baroque*, pp. 155–156; *Neo-Baroque*, p. 152; *Vatican to Vegas*, p. 249).[41]

Merleau-Ponty has also discussed the mutual inflection of spatiality with sensation. As the philosopher writes, 'I find in the sensible a certain rhythm of existence is put forward—abduction or adduction—and that, following up this hint [...] *I am brought into relation with an external being, whether it be in order to open myself to it or to shut myself off from it*' (Merleau-Ponty, *PP*, p. 248; italics mine). In French, the term *sens* (sense) contains multiple meanings including spatial direction and orientation as well as sensation and meaning; an association that Merleau-Ponty himself seems to be well aware of.[42] Baroque flesh intertwines spatiality with sensation to further experiences of the passions. Although he does not develop its sensuality, Calabrese also indicates the importance of a feeling of space in baroque and neo-baroque aesthetics. For Calabrese, representational excess brings about its spatial organization, as excess of content works to alter the 'actual structure of its container because it requires an excess in spatial terms as well. One of the formal constants in neo-baroque containers is excess' (*Neo-Baroque*, p. 62). Representational excesses of content such as the depiction of emotional extremes is experienced in spatial terms that confuse the inside and the outside of the work, encouraging us to feel ourselves immersed 'in' the passions.

Discussing neo-baroque film and media, Ndalianis intriguingly writes that this aesthetic conjures up 'sensorial models of perception that lose the sense of one centre. Rather, the centre is now to be found in the position of the spectator' (*Neo-Baroque*, p. 152). From a film-phenomenological perspective, a baroque cinema of the senses might be even more dynamic than she suggests as neither film nor viewer can be said to function as its singular centre. Rather, as Sobchack maintains, cinema always involves *two* bodies, *two* occupied spaces or situations, and *two* addresses of vision (*Address of the Eye*, p. 23). Furthermore, the fact that the film's body uses 'the visible, audible, kinetic aspects of sensible experience to make sense visibly, audibly, haptically' for itself as well as for us only enhances the baroque penchant for the sensual in film (Sobchack, *Address of the Eye*, p. 9). In Denis' passionately embodied *Trouble Every Day*, a baroque intertwining of space, emotion, and sensation pervades graphic scenes of death, desire, and eroticism as well as an affective atmospherics of the beautiful, anxious quietude, and waiting.

Assault and Absorption: Cruel Baroque

Whether coming together with another body in the world through the shared space and flesh of desire or being driven apart through personal and socio-political circumstance, the sensuous significance of bodies (their gestures, postures, habits and rituals, and their languid or energetic movements) make for the stuff and substance of Denis' filmmaking.[43] Judith Mayne concurs, summarizing her cinema as one 'in which bodies move through landscapes of present and past, and through the pleasure and pain of contact with others' (*Claire Denis*, p. 129). In what follows, I approach *Trouble Every Day* as a *deeply* baroque film. My emphasis on depth, as it involves passionate feeling and a breaking of the surface, is crucial to understanding this film's baroque flesh.

Interestingly, French film scholars such as Beugnet and Douglas Morrey have also commented on the 'baroque sensuality' of this film (Beugnet, *Cinema and Sensation*, p. 44; Morrey, 'Textures of Terror'). Unlike my approach, though, Beugnet filters the film's baroque elements through Georges Bataille-related readings of excess, chaos, and the *informe* (p. 44). As she describes it, Denis' film draws the viewer into 'sensation-filled-audio-visual-chaos' and scenes of 'baroque audio-visual excess' that blur the borders between the figurative and the abstract, pulling us towards the irrational (pp. 33, 40). While excess is certainly commensurate with baroque aesthetics, the baroque flesh of this film cannot be reconciled with a mode of cinema that veers towards 'the formless' (p. 107).

As I have demonstrated, a baroque cinema is not formless or chaotic but endowed with its own readily comprehensible set of formal and experiential structures. Invoking Denis' awareness of the horror genre alongside her privileging of texture, materiality, the surface, and sensation, Morrey's interpretation lies closer to mine.[44] That being said, his analyses concentrate on the film's 'material horrors' rather than its movement between pleasure and pain or its evocative reprisals of baroque forms throughout (Morrey, 'Textures of Terror', p.7). To fully grasp *Trouble Every Day* as an instance of baroque cinema, we must engage with its total 'affective vocabulary', with its texturing of sensation and with its reversals between the inside and the outside and the surface and depth (Martin, *Baroque*, p. 73).

In the baroque, the emotions run high so as 'to *expand the range of sensual experience and to deepen and intensify the interpretation of feelings*' (Martin, *Baroque*, p. 73; italics mine). That depth and intensity of feeling persists in *Trouble Every Day*, as does a characteristically baroque rupturing of borders, frames, and surfaces, and a vacillation between pleasure and pain. This

feeling of emotive extremes is channelled into a cinesthetic and highly textural exchange. As Adrian Martin comments, 'the bedrock of Denis' cinema is the flesh' as her films are 'switched on to *the sensual chemistry or alchemy of two bodies sharing the same space*, the chemical attraction of two "flesh landscapes" in the flash of desire' that can bring about situations of 'trouble, disquiet, [and] perversity' ('Ticket to Ride'; italics mine). Such sensual chemistry or alchemy need not only pertain to film characters. *Trouble Every Day* commingles the bodies of film and viewer to shatter the frame through extremes of pain (love and blood lust, murderous delirium) or erode it through extremes of pleasure (eroticism, melancholy, beauty).

Trouble Every Day inter-cuts between two different sets of lovers to reveal their past and present connections. Léo Semeneau, a radical French scientist, spends his time looking after and hoping to cure his wife Coré who suffers from a mysterious, unnamed disease. The 'trouble' with Coré stems from her fatal sexual urges. She is compelled to hunt for men, biting her lovers to death during lovemaking and then devouring them. An American doctor, Shane Brown, is in the early stages of the affliction. Journeying to Paris on his honeymoon with his new bride, June, Shane attempts to seek out answers from Léo only to find that the scientific community has shunned the French doctor. Throughout the course of the film, Shane becomes more and more distressed by his illness and increasingly predatory towards women. We later learn that the disease that Coré and Shane share was contracted in Guyana, where Léo and Shane once worked together and Shane and Coré once desired one another. At some point in their past, Shane also stole, experimented with, and profited from Léo's research.

After Shane and Coré meet, she deliberately sets the house alight and is wilfully burned alive (her only line of dialogue in this film is 'I want to die'). The roles of Shane and Coré then reverse, with Shane seeking out his first female lover/victim in the basement of his hotel. After mauling and murdering the young hotel chambermaid to whom he has been drawn, Shane appears to be at ease. He takes a shower in the hotel honeymoon suite: 'I feel good', he embraces June and they agree to go home.

The film concludes with a small-scale, textural portent of events yet to come—evident in a single drop of blood running down the plastic folds of the shower curtain. The imagery of blood mixing with water and commercial plastic intimates that this film's horror can never be washed away; its regenerative loops of desire and bloodshed are likely to repeat and can ultimately be blamed on white capitalistic greed as their source. In a similar manner, the film's final image also suggests that its trouble will repeat every day (Nancy, 'Icons of Fury', p. 7). As the couple embrace, the film holds on a

Fig. 4: Regenerative loops of desire and bloodshed close *Trouble Every Day* (2001). CLT-UFA, Rezo Films/The Kobal Collection.

close-up of June's eyes just long enough to register their slight contraction. Framed against her set of vibrantly bright-red gloves (a chromatic stand-in for Shane's own recently bloodied hands), June's flicker of uncertainty as she holds her husband is the last image of the film before it enigmatically fades to black. Seen in this light, there is no cure for Shane and no end to this film's coupling of pain and pleasure, death and desire, the erotic and the elegiac.

As Mayne writes, *Trouble Every Day* is invested in 'the connection between desire and violence, and desire is, quite literally, a deadly force in the film' (*Claire Denis*, p. 113). Concretizing these connections, the film starts with a kiss. Before the title credits appear, we peer into the dimly lit backseat of a car where two lovers kiss. This is one of the few kisses of this film that is not hungry for blood. It does not later open into a bite and become a kiss of bleeding flesh and we will not encounter these anonymous lovers again (Nancy, 'Icons of Fury', p. 1; Scholz and Surma, 'Exceeding the Limits', p. 11). The couple seems oblivious to all but the press of their own bodies. As their lips touch, the sombre musical score of the Tindersticks sets in: 'Look into my eyes/you see trouble everyday/ It's inside of me [...] I get on the inside of you', sings the lead.

Given the imagery of the kissing couple alongside suggestions of close bodily warmth and cosiness within the car, the atmospherics of the opening

scene appear serene. And yet, there are glimmers of something more sinister at work. As Mayne notes, there is a 'pervasive sense of anxiety, of something about to happen, of a disturbance in our fields of sound and vision' throughout *Trouble Every Day*, where space, sound, and vision 'pulsates' and '[c]alm and tranquility are underscored by a sense of foreboding' (*Claire Denis*, p. 110). In his book *The Cinematic Body*, Steven Shaviro remarks on how anxiety can be quite palpably experienced in film through a 'churning of the stomach, *a throbbing of the arteries*, a tension distending the skull' (p. 149; italics mine). Building on Shaviro, we might say that anxiety is also embedded into the perceptions and expressions of the film's body here. For instance, the couple's preoccupation with each other hints that the gaze of the film is where it is not wanted, as if the vision of the camera were preying upon the couple as it will stalk the hotel chambermaid Christelle later on. Recalling Shaviro's comments about anxiety as a churning, throbbing, or tension, the deep bass of the film's score throbs and pulsates and is sonically reminiscent of the throb of a heartbeat or streams of blood rushing beneath the surface of the skin/image.

Though the faces of the couple are difficult to discern in the darkness, the intentional focus of the film keeps drifting back to the woman's neck. It traces its vision across her soft flesh, just as her lover's fingers do. Although this film never explicitly mentions the words 'monster', 'vampire', or 'cannibal', allusions to horror abound as with this subtle focus on the skin of the woman's neck. In *Trouble Every Day*, anxious feeling is everywhere because kisses harbour the potential to bite. As it moves between a continuum of desire and violence and sex and death, I find that this film gets 'on the inside' of me and I get 'on the inside' of it through a baroque breaching of borders, frames, and surfaces (Bal, *Quoting*, p. 27).

In her book *Surface: Matters of Aesthetics, Materiality and Media*, Giuliana Bruno has argued for an alternative genealogy of film by way of the screen as both a site of materiality and embodied expressivity. For Bruno, the materiality of an image manifests on its surface such that the surface of the cinematic image/screen is 'not superficial but a substantial place of relational transformation that has [a sense of] texture and depth' (*Surface*, p. 104). Though her objects of study are often non-figurative and not specifically concerned with the baroque, her arguments for the surface of the image/screen as both textured and evocative of perceptual, spatial, and affective depth complement my own understanding of baroque flesh. The reasons why the baroque of art and film makes for such a surface-driven and highly textured aesthetic will be clarified further in Chapter 3.

Against the sound of swelling violins, the opening scene of *Trouble Every Day* cedes to a long sequence of black that is suggestive of a flat surface and voluminous shadows. The images and sounds of water that follow similarly alternate between effects of surface and depth, the two- and the three-dimensional. A series of soft dissolves and gradual revelations of scale reorient this imagery as the waters of the Seine, lapping beneath the bridges of Paris. As it first subsumes the screen in close-up, however, the moving waters of the Seine are made to resemble nothing so much as a ream of rippling fabric. This evocation of texture is heightened by the filmic interplay of light and shadow. The streetlights of Paris at dawn cast dappled effects across the surface of the water and create deep furrows of purplish shadow. From the first, the film calls up notions of a moving textile. Rather than presenting us with the substance and materiality of water, the image/screen takes on the qualities of a moving fabric—replete with surface patterning and texture, as well as a strong sense of depth, tactility, and motion. Subtle transitions between surface and depth and an emphasis on gradual movement in representational content (fades to black, flowing water, and clouds drifting across the sky) also convey supple movement.

As our view of Paris and its signature bridges disappears, the title credits rise and fall out of the darkness as if they are moving out of submerged depths. Tinged mauve and black (colours that can be connected to the vampiric time-keeping of dawn and dusk), the credits evoke sensuous impressions of the water-as-fabric and as worldly material. The credits appear visibly animated, stirred into swells of movement by unseen energies below. Alongside suggestions of anterior contours to the image that boast depths yet to be probed, the eye is simultaneously drawn to the surface of the screen. The image/screen takes on a mutable and highly textured appearance, functioning as a moving site of materiality in its own right.

In her considered attention to the screen as a sensuous site of texture and materiality, Bruno evocatively describes how the image/screen can be perceived as being 'layered like cloth' such that it takes on properties of 'volume and becomes a space of real dimension' (*Surface*, p. 4). Fabrications of the image recur throughout *Trouble Every Day* (Walton, 'Enfolding Surfaces'). Chiaroscuro lighting effects and engulfing shadows darken and obscure the film's representational content, while sculpting the impression of unplumbed material depths. The contours of on-screen bodies appear lost to the materiality of their surrounding environments. The hunched over body of Coré, for instance, seems to disappear into the landscape of the hunting grounds, while the blacks, blues, and grey of Shane's costuming echo the surrounding urban architecture, the dull metallic sheen of the

airplane and the ultimately fatal space or grave of the hotel basement. Such techniques are indicative of Denis' privileging of the material and her consistently 'non-hierarchical visual register, in which human beings seem to have no greater claim to the image than other elements of the décor' (Morrey, 'Open Wounds', pp. 12–13).

Together with its privileging of materiality, there is much baroque sense and significance to be had from this film. According to Ashley Montagu, 'every kind of cutaneous stimulation that is not intended to be injurious is characterized by an erotic component' (*Touching*, p. 156). Baroque flesh is invested in injurious and erotic stimulation. In a lovely comment, Renu Bora has observed that our physical attraction to another when we develop a 'crush' can evoke feelings of 'texture, like crushed velvet or crushed foil. My surface gets all uneven, my underneath shows through [...]. It's like "being" crushed material, but also like wearing it, alternately slippery and itchy' (Bora, 'Outing Texture', p. 94). Bora's insightful comments on the texturing of a 'crush' can be extended to the textural violence and the textural eroticism of *Trouble Every Day*. Even the term 'crush' hints at a latent potential for violence, signalling the ways in which materials become altered through forceful or cruel physical acts (Bora, 'Outing Texture', p. 94). In the baroque flesh of this film, painful and pleasurable contact with its images and sounds shape us into 'crushed' materials that are expressive of textures of love and what Morrey calls textures of terror ('Textures of Terror', p. 1).

As Susan Stewart argues, many tactile or textural qualities can be apprehended by the sense of sight: qualities of 'roughness and smoothness; sticky things that remain in contact with the skin and slippery things that move readily across it; qualities of wetness and dampness and dryness in relation to each other; heaviness and lightness, hardness and softness' (*Poetry*, pp. 163–164). This situation is doubly the case in cinema given the mutual embodiments of film and viewer. As Sobchack asserts, the vision of the film's body is one that 'understands materiality. The film's vision [...] perceives and expresses the "sense" of fabrics like velvet or the roughness of tree bark or the yielding softness of human flesh' (*Address of the Eye*, p. 133).

Let me establish the textures of *Trouble Every Day* as not only expressive of materiality but a baroque texturing of sensation. In an echo of the film's opening, we are introduced to Shane and June through the window of an airplane. This couple is similarly absorbed with each other as Shane is seen placing his mouth over the soft, white flesh of June's upturned wrist and arm. Recalling the merger of pleasure and pain in baroque art, this scene gives way to Shane's retreat to the bathroom and to his fantasies of

a bloodied yet blissful June. The image of a hand suddenly appears, feeling its way across a fabric that is slippery and sodden with blood before disappearing into the shadows. In the still and dimly lit setting of Shane's vision, the limp body of June appears coated in blood and partially covered by a bed sheet. The connection between this disturbing vision and the kiss that preceded it is affirmed as the camera moves into a close-up on June's mouth. Death, violence, and eroticism are intricately folded into each other to recall the necrophilic tendencies of the baroque where life and death are perpetually on the point of crossing over and beautiful draperies can also serve as shrouds (Bal, *Quoting*, p. 51).

Like the rich textural rendering of flesh, folds, fabric, and drapery that are one of the key artistic signatures of baroque art, the film's body in *Trouble Every Day* is preoccupied with texture throughout. In the sequence of Shane's fantasy, the disturbing nature of his vision is rendered through the perceptual immediacy of its textures. The vibrant red of freshly drawn blood stands out against the surrounding darkness, while sticking to the surface of June's skin and soaking into the cloth. In close-up, the film traces its embodied vision down June's immobile flesh, inviting us to apprehend the heaviness of the wet and blood-soaked fabric that clings to her. It continues down June's body, enraptured by its surface contours. Pursuing its own mobile and materialist path, it traverses June's body in close-up to reveal varying surface patterns in the blood that coats her like a second skin: a light splattering here, a denser coagulation over there. The camera continues its journey downwards, showing us how individual streams of blood join together, flowing like a river down the crease of June's spine.

What is so remarkable about this sequence is how explicitly it re-works the textural and iconographic heritage of the baroque for the purposes of Denis' sensuous cinema. Flesh, fabric, blood, and bodily comportment conjoin to recall the enwrapped and enshrouded saints and martyrs who populate historic baroque art, as well as their different sacred and sacrificial poses. The depiction of June on her side, her front and her back, with her eyes alternately open and closed, calls to mind baroque artworks such as Stefano Maderno's sculpture of the martyrdom of Saint Cecilia (1600), where Cecilia is positioned on her side, her face and body completely covered by a sculpted shroud. The intermediality of Shane's vision is enhanced by the film's soundscape as it shifts from the low drone of the airplane to the whistling of wind bringing with it the suggestions of an enclosed tomb.

Eventually, the vision of the film comes to rest on the multiple folds of scarlet fabric that cover June's lower back and legs. Here, it is as if the film's body had gathered together its material vision with the folds of Bernini's

marble sculptures, the vibrant and bloodied wounds of Caravaggio's art and the iconography of enfolded shrouds. Effects of perceived surface and depth combine through a heightening of texture. As with Bruno's argument for how materiality manifests itself on the surface of the image such that the image/screen can take on a sense of depth and volume, we are dealing with a highly layered and fabricated composition. The materiality of the image/screen comes to the fore, expressing all the micro-indentations and textural creases that appear in the surface of the cloth and small-scale variations across June's skin (*Surface*, p. 3). At the same time, the darkness that surrounds June, enveloping the background, creates the impression of peering into an infinite depth—much like the deep shadows that appear amongst the red folds of fabric. As with the art of Caravaggio, to whom I shall return, our embodied perception is tugged between the depths of perspective, bodily depths, and the materiality of the surface. The conjunction of surface with depth also lends the depiction of the fabric a strong sculptural quality, as if its deep textural folds were actually three-dimensional. Only a sudden, intrusive knock on the bathroom door can call a halt to the textural revelry of Shane's bloodied vision.

Not only does *Trouble Every Day* enact a baroque texturing of sensation, its graphic flesh-and-blood realism reprises the sensibility of what we might call a cruel baroque in cinema. After all, it is not only Shane and Coré who need to bite and break the skin. The film's body, too, is cruel in its breaching of borders and surfaces, revelling in spectacles of pain and presenting us with a textural horror that 'sticks' to the skin (Beugnet, *Cinema and Sensation*, p. 41). In baroque flesh, the kiss can taste of ashes. As Buci-Glucksmann observes, baroque '"excessive" form [...] links together Eros and Thanatos' to conjure up 'the "bitter taste" of love and the madness of death' (*Baroque Reason*, pp. 144, 147). She goes so far as to cite the gestures of '[s]*eeing, touching, cutting, kissing, eating*' as belonging to an 'extremist baroque somatology' that strains against formal and physical borders and 'infringes codes by overturning their limits' (Buci-Glucksmann, *Baroque Reason*, pp. 146, 153). Through spectacles of pain, suffering and tragedy, the 'living body turns into its opposite' (Buci-Glucksmann, *Baroque Reason*, pp. 146, 157). The baroque reverses the life and the liveliness of the flesh into the death of martyrdom or else it eroticizes the corpse/skeleton, coupling death with love.

As Benjamin, Zamora, and Maravall all attest, cruelty ran rife through the historic baroque arts. According to Maravall, the broad fascination with funeral representation was the outcome of 'making a studied penetration into the structure of existence, to whose essence inexorably belonged the

final step of death' (*Culture*, p. 65). The emergence of a cruel baroque was spurred by the extensive imagining and imagery of death, pain, and suffering; so much so that Maravall asserts that 'one can consider the image of the human cadaver as a baroque theme' in its own right (*Culture*, p. 65). In his study of the *Trauerspiel*, Benjamin notes that depictions of torture and 'scenes of cruelty and anguish' gave rise to a 'theatre of cruelty' in which 'the corpse becomes quite simply the pre-eminent emblematic property' (*The Origin*, pp. 216–218). Given the popularity of martyrdom scenes, Zamora comments that stories 'of suffering saints long precede the seventeenth-century, but the wide-spread depiction of their suffering does not' (*Inordinate Eye*, p. 177). The latent cruelty of baroque flesh '*glorifies the body in all its visceral aberrations*. We recognize St. Lucy by her eyes, which she carries on a platter, St. Agatha by her breasts, similarly detached and displayed, and St. Apollonia by her teeth, extracted by the Romans who tortured and martyred her' (Zamora, *Inordinate Eye*, p. 177; italics mine).

Let me ground this cruel baroque and its visceral aberrations in an artwork that resonates with the assaultive rupturing of bodies and surfaces in Denis' *Trouble Every Day*—Caravaggio's *The Incredulity of St. Thomas* or *Doubting Thomas* (Sanssouci, Potsdam, Germany, 1601–1602).

Doubting Thomas is a cruel artwork that testifies to the 'essentially phenomenological view of reality' that Caravaggio brought to the depiction of bodily violence and violent martyrdom in his art (Varriano, *Caravaggio*, p. 60). As is indicative of the baroque art of analogy, in his paintings Caravaggio endeavoured to make sensuous contact with the beholder. He evoked the *chiasm* of vision through his inclusion of direct eye contact so that the abstraction of divine and/or human suffering was transformed into a 'face to face [encounter] with the supernatural' (Wittkower, *Art and Architecture*, p. 56).[45] In *Doubting Thomas*, by contrast, the gaze of all of its figures is directed towards Christ's wound. Its visceral force stems not from eye contact but from its intimations of bodily and spatial depth.

Here, co-extensive space is achieved through a privileging of the surface. The 'open' surface of the representational body and that of the artwork create the tactile impression that one could reach in and touch its partially hidden depths. *Doubting Thomas* is emblematic of what Bal calls the 'skin-deep' sensibility of the baroque (*Quoting*, pp. 27, 31). The work appeals to lures of skin, flesh, and materiality at the same as it takes a gory delight or pleasure in rupturing surfaces. A series of 'openings' appear across the surface of the painting, in the form of Jesus' slightly open mouth; his fingers, captured mid-movement into the darkened creases of cloth; the rent in the shoulder of Thomas' garment; and of course the bloodied site of the

Fig. 5: Michelangelo Merisi da Caravaggio, *The Incredulity of St. Thomas* (1601-1602). Foundation Prussian Palaces and Gardens, Berlin-Brandenburg.

wound, where Thomas' finger is poised to penetrate the skin (Bal, *Quoting*, p. 37). As the 'wound opens up the space of the representation to the real', the work strives to make embodied contact with its beholder by making use of its flesh-and-blood realism as well as spatial effects that provide further perceptions of depth (Stewart, *Poetry*, pp. 159–160, 184). The figure of Doubting Thomas must *feel* that the dead can live, just as Caravaggio makes us feel the presence of the open wound in his art.

As is typical of the horror genre, conceptual as well as physical borders are continuously breached in *Trouble Every Day* (Creed, *Monstrous-Feminine*, pp. 10–11). Kisses turn into bites. Caresses lead to a cutting or tearing of the skin. Paris, the traditional site of heterosexual romance, is made to look like Victorian London and the haunt of Jack the Ripper. Alternatively, urban Paris resembles the wilderness of a savannah, where Coré crouches like an animal in stems of grass chewing her prey. According to Benjamin, there is a horror 'that stirs deep in man [...] an obscure awareness that in him something lives so akin to the animal that it might be recognized' ('One-Way Street', p. 66). The horror of becoming animal is a central concern for this film. Not only does Denis pointedly reference the cinematic past of *Cat People* (Tourneur, 1942), her savvy casting of the leads plays upon the

ravenous mouth of Coré (Béatrice Dalle) and the strikingly lupine look of Shane (Vincent Gallo). Often, the film's body also assumes the sinuous and winding movements or gestures of a felid animal such as with its predatory following of the chambermaid as it insistently returns to the sleek nape of Christelle's neck (a source of intentional fascination for the film as much as for the character of Shane). Later, Shane will drag the murdered body of the chambermaid across the floor like an animal carcass while the vision of the film's body peeks from around a corner. Guiltily, it seems to have retreated from its formerly proximate view of Shane's cannibalistic oral sex upon the maid and the cruelty of its own up close, impassive vision as it conveyed to us the gradual flushing of her skin with pain. In *Cat People*, the danger of the troubled Irena is texturally expressed by the renting of scratch marks into the fabrics of a sofa, a towel, or bathrobe, thereby intimating what her nails might do to a human face (Newman, *Cat People*, p. 56). The monstrous lovers of *Trouble Every Day* quite literally break the skin before us. In its cruel baroque rupturing of borders and of bodily surfaces, the film reaches skin-deep to 'crush' its viewer through a series of highly visceral and textural assaults.

Given the co-extensive space that I am extending to baroque cinema, it is well worth quoting philosopher Jean-Luc Nancy and his own flesh-filled meditations on this film. For Nancy, Denis' film 'is made entirely on and about the skin. Literally: exposed skin. [...] Not only is the skin present in the image in extreme close-ups [...]. It is also the image itself, the film, its skin, that caresses and ravishes and tears' ('Icons of Fury', p. 4). While Nancy is playing on the doubled meanings of film/skin in French (*pellicule*), I think we can take his words quite literally in terms of how we experience the depth-full effects of *Trouble Every Day*.

Consider the scene in which Coré seduces and then murders a neighbour-hood boy. As Coré and the boy begin their tryst, the vision of the film concentrates on the huge indentation of a bellybutton; valleys of skin and bone; stretches of light and dark shades of body hair; and various markings that pocket the surface of the skin. The film's extremely tight, up close, and material vision presents us with unfolding and almost uncomfortable topographies of flesh meeting flesh. The familiar scale and surface of the body are rendered strange and re-configured as a vast dermal 'landscape or a constellation of planets' (Beugnet, *Cinema and Sensation*, p. 45). Coré runs her hands up and down the boy's torso and neck and their mouths find each other in the darkness. The once gentle strains of the Tindersticks' score transform to become more and more ominous. Its repetitive beat begins to take on the qualities of a ticking timepiece, anxiously counting down to

the eruption of the shocking and horrendous bites. Pleasurable sounds of sex give way to gurgled screams as we watch Coré begin to bite at the boy's chin. His agonized screams overwhelm the soundtrack, intermingling with Coré's own agonized cries at her inability to control internal tides of blood lust. Unrelentingly, the vision of the film's body stays close to the murder to show us the cruel orality of Coré biting at and pulling flesh from her lover's face and then feeding from his chin. His screams turn into strangled yelps that are thick and garbled with his own blood. Pleasure and pain combine in a baroque paroxysm of death and desire as Coré continues to bite, to kiss, to lick, nip, and nuzzle her dying lover/victim.

In Caravaggio's art, darkened chasms of the body such as gaping mouths or wounds 'insist upon the force of the surface' (Panagia, 'The Effects of Viewing', p.10, 4). Similarly, sensuous effects of perceiving surface and depth combine in this scene. Because of its formal, emotive, and experiential foundations in the baroque I hesitate to read the graphic extremes of *Trouble Every Day* as 'formless' or expressive of the 'element of chaos, which destabilizes vision' (Beugnet, *Cinema and Sensation*, pp. 107, 46). While uncomfortably proximate, invested in an aesthetics of the material and noticeably dark—moving in and out of visibility like the undulating tonalities of a baroque drapery—this scene is not experienced as abstraction. The faces of Coré and her lover/victim are visible, if obscure, partially framed or hidden behind hair. The film's body also insistently returns its focus, throughout, to a tight close-up on their mouths, such that we see these mouths becoming progressively bloodied, torn, and gaping open. This motif of the bloodied or biting mouth re-surfaces throughout: in the bite mark that appears on June's shoulder or the shocking imagery of Shane's open, bleeding mouth, as it emerges into view after his killing of Christelle. As Bal observes, what the baroque establishes is 'a relationship between subject and object'; through its doubled or correlative structure, the baroque then 'goes back to that subject again, *a subject that is changed by that movement*' (*Quoting*, p. 28; italics mine). Similarly, when bodies commingle in *Trouble Every Day*, we experience such change as co-extensive space. Rather than formlessness or chaos, material surfaces give way to larger and more depth-full tearings of the image or screen that are incredibly difficult to untangle oneself from.

The film's reliance on the imagery of representational bodies-in-touch (kissing, killing, biting, loving, caressing, strangling) not only continues Denis' interest in 'the pleasure and pain of contact with others'; it self-reflexively recalls the iconographies of a cruel baroque (Mayne, *Claire Denis*, p. 129). Just as the kisser wants to bite in *Trouble Every Day*, the film's

evocations of touch desire to 'split, break or tear the skin [...] the skin is here to be broken and explored, under as well as on its surface' (Morrey, 'Open Wounds', p. 17).[46] Through its rupturing, breaching, and tearing of borders and surfaces—the surfaces of the skin and of the film frame—the texturing and feeling horror runs 'deep' here. In a striking parallel to Caravaggio's painting *Doubting Thomas*, Coré opens up a fold of flesh that she has recently torn from her victim's body. Placing her fingers inside the wound, she probes its innermost reaches. As Nancy asserts, the film's murder scenes revel in 'a bitten, broken screen' that is akin to the bi-directional movement of a co-extensive space ('Icons of Fury', p. 6). Sounds and images tear 'forwards [...] toward us, but also backwards, toward a background that is all the deeper and more distant for being contained within the image, on the surface or the skin of the image' (Nancy, 'Icons of Fury', p. 6).

In these terms, it is not only the character of Coré who probes the innermost recesses of the flesh. Through its cinesthetic evocation of bites and of wounds, *Trouble Every Day* reaches into the depths of our viewing bodies to stir the visceral and recessive sensations of the 'bone and guts' (Leder, *Absent Body*, p. 36). In a very real sense, this film gets on the 'inside' of me as I feel its wounds right down to my stomach. At the same time as my limbs tense up, my body shifts with discomfort and I often have to look away. As Steven Shaviro remarks of our bodily engagements with horror, the 'jolts and spasms that run through my body at the sight of all this gore, threaten to tear me apart as well' (*Cinematic Body*, p. 103). Such is the visceral impact of the cruel baroque in *Trouble Every Day*. In its graphic breaking of the skin and its film-phenomenological breaking of the frame, *Trouble Every Day* sensuously assaults me and it changes me by immersing me 'in' the depths of horror, disgust, and revulsion (Cataldi, *Emotion*, p. 27).[47]

And yet, even as this film bites and wounds us, the film's body can beckon us to move into the frame in more texturally vital, seductive, and gently affective ways. This is because it solicits our sensuous absorption 'in' the cinesthetic depths of the image. Such absorptions are instigated by the very first images and sounds of *Trouble Every Day* where we are courted by the gentle meeting of the lover's skin/lips, the velvety darkness of the image, faint flecks of lilac light, and the rhythmic pulsations of the soundtrack. By way of its baroque reliance on texture and materiality, together with the knotting of space and sensation that recurs throughout, we are affectively absorbed 'in' the frame through the exquisite beauty as well as the melancholic weight of the composition.[48]

As Benjamin suggests, mourning and melancholy can be identified as pre-eminent states of baroque feeling. Discussing the *Trauerspiel*, he

observes that 'these are not so much plays which cause mourning as plays through which mournfulness finds satisfaction: plays for the mournful' (Benjamin, *The Origin*, pp. 118–119). We can identify a similar gravitational sadness at work throughout *Trouble Every Day* that is another testament to its baroque correlation between bodies. According to Benjamin, mourning involves a 'motorial reaction to a concretely structured world'; thus it is through the 'motorial attitude' of my flesh that I am absorbed 'in' the feeling of melancholy (*The Origin*, p. 139). For me, some of the most seductive, melancholic, and poignant instances of this film lie in its repeated, rhythmical movements down the hotel corridors, as the camera trails after Christelle to the forlorn music of the Tindersticks' 'Maid's Theme' and concentrates its vision on the back of her neck.

According to Benjamin, the mournful manifests itself in the baroque as an attitude and aura of 'pensiveness': the 'natural affinity of pensiveness [is] for gravity. In the latter it recognizes its rhythm' (*The Origin*, p. 140). The aforementioned corridor scenes are imbued with a palpable sense of mourning and gravitational pull whereby I am encouraged to feel the weight of the heavy metal cart, bumping against the maid's legs, or her awkward dragging of the luggage across the carpet. Similarly, the rhythmical return to and focus on the maid's neck pensively pulls the feeling of the film downwards—foretelling Christelle's sure and imminent death.

Much of the beauty of *Trouble Every Day* and my sensuous absorption 'in' this film stems from its baroque preoccupation with the 'textures of the material world' (Morrey, 'Textures of Terror', p. 3). Whether attending to the rippling waters of the Seine, the soft fuzz of Coré's blue suede shoe, or the glistening of fresh blood on grass, the vision of the film's body is imbued with a strong sense of materiality. Throughout, I find that I move willingly into the frame because of the arresting lure of an array of material details: the eroticized images of skin brushing against skin; a bright green scarf, suddenly lost to the breeze of a cold grey sky; the touching collection of small soaps and jams that the maid pockets on her rounds; or how the glint of a silver ring stand outs against the coarseness of pubic hair. Such absorptions 'in' the frame are only possible through the embodied and emotive linkages that can occur between film and viewer and because cinema itself is a sensing and a sensible entity. Watching any film, of course, 'we can see the seeing as well as the seen, hear the hearing as well as the heard, and feel the movement as well as the moved' (Sobchack, *Address of the Eye*, p. 10). *Trouble Every Day*, however, combines its texturing of sensation with co-extensive space and the feeling of passionate extremes to form a cinema of baroque flesh.

Unlike other critical interpretations, I would argue that *Trouble Every Day* is a horror film, though it does not parody the genre (Beugnet, *Cinema and Sensation*, p. 37; Nancy, 'Icons of Fury', p. 4). If anything, Denis fully inhabits horror by getting 'under' its skin and burrowing deep into matter to explore the material textures of death and desire. If *Trouble Every Day* is a horror film that does not overtly act like one, it still subtly repeats, varies, and consolidates the history of cinematic horror (Morrey, 'Textures of Terror', p. 3). The 'carnivorous breed' of the vampire and their bloodied kiss is reactivated by the figure of Coré raising her coat to the sky, gasping at the cold breeze in a pointed allusion to *Nosferatu* (Murnau, 1922) (the 'cold can bite, or acid, or flames', just as hard as a vampire's love can: Nancy, 'Icons of Fury', p. 1). As I have also indicated, the film often evokes the horror of becoming animal in *Cat People* through its attention to slashed fabrics and bedding or Coré's panther-like gestures, such as when she sleepily sprawls on the bed. At one point, Shane impersonates the figures of Frankenstein and Count Orlok during a visit to the cathedral of Notre-Dame. He appears zombie-like for much of Denis' film until his horrific feast upon Christelle's flesh enlivens him.

Locked up in her house and peering out through its bars, Coré recalls the literary Gothic tradition of the 'mad woman' in the attic, while the film's circular movements through the hotel corridors evokes the rhythmic, motorial horror of *The Shining* (Kubrick, 1980) (Morrey, 'Textures of Terror', p. 5). As is typical of a baroque cinema of the senses, self-reflexivity combines with the sway of sensation. By turns pleasurable and horrifying, expressive of textures of love as well as the textures of terror, *Trouble Every Day* is imbued with a deeply baroque sensibility. Here, 'the death's head and the corpse prowl around', though they can just as easily give way to an 'ecstatic and mystical theatre of love' and to the 'pure lyricism' of images and sounds (Buci-Glucksmann, *Baroque Reason*, p. 136).

Summation: Beside Oneself

According to Merleau-Ponty, the *chiasm* indicates how 'every relation with being is *simultaneously* a taking and being taken, the hold is held, it is *inscribed* and inscribed in the same being that it takes hold of' (*VI*, p. 266). His words are appropriate, as always, to baroque aesthetics. As it ambiguously intertwines activity (a taking) and passivity (being taken), such sensuous reversibility is essential to baroque cinema. As I have detailed, in the baroque, co-extensive space enacts a spatial push towards or a pulling of

the viewer into the composition to generate embodied and emotive effects of assault and absorption.

Where are we at, then, in terms of understanding the figural provocations of baroque flesh? Italian philosopher Mauro Carbone is one of the few scholars to have picked up on the inherently baroque resonance of the *chiasm*. Although Carbone is not concerned with cinema nor with the embodied aesthetics of the baroque, he does acknowledge the definite parallels between Merleau-Ponty's 'being of the sensible' and the idea of a 'Baroque world' (Carbone, 'The Thinking', p. 127). As he details, Merleau-Ponty's thought expresses a quintessentially 'baroque configuration of the sensible—in which every taking [from the sensible] is simultaneously a being taken, and feeling is in reality a letting-be' (pp. 126–127).

For Carbone, as for me, what Merleau-Ponty bequeaths us is 'the philosophy of a baroque world' (p. 126). Although the passions are often thought of as inherently passive states of feeling (the 'passion that results from the feeling of being overpowered'), it is well worth remembering that 'passion' can signal an active devotion or agency (Lambert, *Return of the Baroque*, p. 29). Such embodied devotion 'is not passive but rather asserts our corporeal and affective adherence to others and the objective world', as well as to the material expressions of cinema (Sobchack, *Carnal Thoughts*, pp. 287–288). The doubled association of the passions as passive suffering and active devotion is highly relevant to *Trouble Every Day*. In the baroque flesh of art and film, we find ourselves spatially and affectively immersed 'in' passionate extremes of feeling such as horror, disgust, beauty, melancholy, and eroticism. Similarly, in Denis' cruel baroque film, we are passionately 'beside' ourselves as we experience its brutality and beauty as at once 'here' and 'there' in painful and pleasurable ways (Sobchack, *Carnal Thoughts*, p. 71).

In baroque cinema, there occurs a taking and a being taken, the hold is held and a shared sensuous being is inscribed across the bodies of both film and viewer. To adapt the words of Merleau-Ponty for *Trouble Every Day*, we might say that it is through its 'coiling up or redoubling' between bodies that I come to feel so deeply the sensible entity that is Denis' film as a redoubling or 'an extension of [my] own flesh' (*VI*, pp. 113–114).

3. Baroque Skin/Semiotics

Language is a skin: I rub my language against the other. It is as if I had words
instead of fingers or fingers at the tip of my words [...] The emotion derives from
a double contact [...] I enwrap the other in my words, I caress, brush up against,
talk up this contact, I extend myself.
– Roland Barthes (*Lover's Discourse*, p. 73)

[T]he eye in the painterly stage has become sensitive to the most various
textures, and it is no contradiction if even here the visual sense seems nourished
by the tactile sense—that other tactile sense which relishes the kind of surface,
the different skin of things.
– Heinrich Wölfflin (*Principles*, p. 27)

In this chapter I seek to re-embody semiotics for film studies and for the
baroque. This is because the contact that is exchanged between the film's
body and the viewer is a source of semiotic as well as sensuous significance
in baroque cinema. Rather than perpetuating a split between the word and
the world, studies of the skin and properties of signification, I prefer to
think of language and experience as always being in *chiasm* in an encounter
with baroque flesh. As Merleau-Ponty tells us, in this 'baroque world [...]
although meaning is everywhere figurative, it is meaning which is at issue
everywhere' ('The Philosopher', p. 181). Alternatively, we might approach
the forms and figurations of the baroque from their reverse, such that
'[w]hen we say that the perceived thing is grasped "in person" or "in the
flesh" [...] this is to be taken literally' (Merleau-Ponty, 'The Philosopher',
p. 167). Baroque flesh revels in figurative possibilities (the copy or artifice of
construction) as well as physical contact to achieve the art of entanglement.

Throughout this chapter, then, we will be returning to the importance of
analogy for the baroque and tracing its roots back to seventeenth-century
poetics. In this regard, I consider the close connection between ideas of the
infinite and the development of baroque poetic language. Given the broad
preoccupation with the infinite in seventeenth-century arts, language,
science, and philosophy, the historic baroque has often been conceived
as a world of shifting, scattered fragments that were unmoored from any
grounding 'centre'. By contrast, I argue that an urge towards connectiv-
ity and connection on the part of the baroque spurs the creation of new
artfully or artificially constructed wholes. The historic baroque allowed

shifting parts and fragments to be brought together again in dynamic, infinitely renewable combinations.[1] Baroque language is founded upon a simultaneous drive towards the copy (the figural) and contact (the literal). It foregrounds the figural artifice of language at the same time as it makes material contact with its participant.

Drawing on Gilles Deleuze, Mieke Bal, and Giuliana Bruno, in the second half of this chapter I stage a baroque texturology—a theory or philosophy of the image in which texture, surface, and sensuous contact become the meaningful sites and sights of our engagement. Bringing Deleuze's concept of the fold into dialogue with Merleau-Ponty's 'flesh', I argue that baroque flesh offers us a similarly mobile and materialist film-philosophy. Despite their established differences, the phenomenology of the 'flesh' and Deleuze's philosophy of the fold are both invested in materiality, in an intertwining of the interior and the exterior, and in the texturing of sensuous surfaces. Drawing on these two philosophers, baroque art history, and embodied film scholarship, I establish that baroque flesh turns the emotions 'inside out' by manifesting feeling upon the expressive outer coating or surface textures of the body, including those of the film's body.

Historically, the baroque conflation of surface/appearance with being/ substance can be traced back to seventeenth-century absolutism, especially at the royal French court of Versailles. After detailing the baroque history and impetus behind Versailles, I seek to demonstrate the close connections that exist between surface appearances, royal power, and luxury for the baroque. As it intermingles the past with the present, Sofia Coppola's costumed bio-picture *Marie Antoinette* (2006) plays out a similar nexus in her at once real and imagined Versailles. Rather than dismissing this film's attachments to the surface and surface-based display as superficial, I argue that characteristically baroque attachments to surfaces, surface-based display, and to a material-visuality persist in Coppola's film and its foregrounding of bodies living a luxurious life. The final analyses of this chapter bring the skin and the sign together by approaching the silent slapstick comedies of Buster Keaton as a cinematic continuation of baroque wit. With particular attention to *Our Hospitality* (Keaton and Blystone, 1923), *Sherlock, Jr.* (Keaton, 1924) and *The Navigator* (Keaton and Crisp, 1924), I liken Keaton's embodied engagements to a series of baroque tickles that are exchanged between film and viewer. Keaton's physically elegant comedies reprise the copy and the contact of baroque poetics by intertwining the literal with the figural and by making ingenious, carefully choreographed connections between different bodies, signs, and worldly phenomena.

As it manifests feeling as visible and sensible on the 'outside' surface of the film, the experiences of baroque luxury and baroque wit that I examine here solicit the sensitive surface, the affective inside, and the visual intelligence of their viewer. Best conceived through the 'flesh', 'the outside of the inside, the inside of the outside' reverse in a baroque cinema (del Río, 'The Body as Foundation of the Screen', p. 103). By way of conclusion, I turn to Walter Benjamin and others on the mimetic faculty to frame the copy and contact of baroque flesh as complementary with the cinema.

Chiasm: Language and Experience

While we are used to regarding language as primarily an auditory or visual phenomenon it can involve other bodily senses. Not only do we use language to express ourselves but writing is tactile as much as it is visual; the physical dynamics of speech and its reception are auditory, kinesthetic (achieved through the movement of mouth, tongue, and palate), olfactory (carried on the breath), and even gustatory (interrupted by burps and hiccups) (Classen, *Worlds of Sense*, p. 50). Language—our means of 'singing the world' to take up Merleau-Ponty's lovely phrase—is irreducibly incarnate (*PP*, p. 217).

In the quotation that inspired this chapter, Roland Barthes once described language as a sensitive skin that is stretched out between bodies. Like the unexpected tumults of being in love, he understands language as an unpredictable and embodied condition of the skin. In the 'flayed' entry of *A Lover's Discourse*, Barthes writes of the 'particular sensibility of the amorous subject, which renders [them] vulnerable, defenseless to the slightest injuries' (p. 95). Language, too, makes us responsive and vulnerable to others. As Bal also maintains, 'words can cause pain or harm and arouse sexual or other excitement', yet it is remarkable how often it is forgotten that 'bodily effects [...] form an integral part of linguistics' (*Quoting*, p. 152).

Alert to the material qualities of signification, Barthes is one of the few semioticians who repeatedly invoke the sensuality of signs.[2] For Barthes, language can rub, enwrap, caress, brush up against, or talk up another (*Lover's Discourse*, p. 73). As he reminds us, it is through language that 'I extend myself' and that our emotions derive from the 'double contact' between body and world (p. 73). Through the expansive 'skin' of inter-subjective communication, language turns intra-subjective experience 'inside out' by making it intelligible to others. Following on from Merleau-Ponty, we can approach 'flesh' as inherently semiotic. Thanks to the reversibility of perception, the lived body 'projects and performs its perceptual perspective

and situation and bears meaning into the world as the expression of that situation' (Sobchack, *Address of the Eye*, p. 41). How phenomenology understands the inherent significance of bodies' being-in-the-world helps us understand the sensuous conjunction of skin with semiotics.

Merleau-Ponty insists that we are 'condemned to meaning' because we are lived beings in the world, precisely because of and not in spite of our bodies (*PP*, p. xxii). Phenomenologists view the world that is given to us through perception as already meaningful, immanent, and 'given with existence' (Sobchack, *Address of the Eye*, pp. 41–42). From the first, we are immersed in that significance by inhabiting what Merleau-Ponty early on called the 'primacy of perception' and, later, the ontology of the 'flesh' ('The Primacy', p. 25). In his preface to Merleau-Ponty's *Signs*, Richard C. McCleary points out that a 'phenomenology of incarnate and carnal perception is inseparably a phenomenology of expression as well' ('Translator's Preface', p. xx). In this regard, Merleau-Ponty's phenomenology is as much a semiotic as it is an existential philosophy. This is because he grounds semiotics in the reversibly lived structure of the visual and the visible. 'All perception, all action which presupposes it, and in short every human use of the body is already *primordial expression*', Merleau-Ponty writes ('Indirect Language', p. 67). There is not 'a gesture, even one which is the outcome of habit and absent-mindedness, which has not some meaning', he continues, including those gestures that we unintentionally adopt in relation to particular situations (hunger, fatigue, boredom, arousal) (Merleau-Ponty, *PP*, pp. xx–xxi). Though involuntary, such gestures are imbued with meaning because they express 'a definite position in relation to the situation' (Merleau-Ponty, *PP*, p. xxi).

Merleau-Ponty's understanding of meaning as embodied but also endlessly renewable is refreshing, especially in comparison to the abstract structures and systems of signs that have traditionally framed semiotics.[3] By and large, semioticians have been reluctant to consider the importance of the body in the production of meaning. They have relied instead on linguistic or textual modes of interpretation that reduce embodied experience to properties of language (Howes, *Empire of the Senses*, p. 1). After the 1960s overwhelmingly textual metaphors dominated cultural interpretation. In the wake of the impact of structuralism, formalism, and semiotics, the privileging of culture as discourse, the empire of signs, and so forth ended up eliding the sensuous intelligence of the lived body. The ensuing poststructuralist or 'linguistic turn' of critical theory suggested that the world was a semiotic text that could be systematically deconstructed, if only we learnt to 'read' it correctly (Howes, *Empire of the Senses*, p. 1).

In Sobchack's film-phenomenology, the flaw of purely textual approaches to semiotics lies in the positioning of language as an irrecoverable absence. As the sign substitutes for the original referent, language is often conceived of as a fundamental negativity or 'loss, a vacancy, in experience' (Sobchack, 'Lived Body', p. 1054). But whereas semiotics sees 'only lack and substitution' in the relationship between language and experience, Merleau-Ponty 'sees [...] plenitude' and a regeneration of meaning that occurs in and through our embodied and enworlded being (Sobchack, 'Lived Body', p. 1054). Approaching the lived body as the originating, concrete, and necessary basis for all language, existential phenomenology argues that even 'the genesis of speech and writing occurs at the radical level of the lived-body' (Sobchack, *Address of the Eye*, p. 41).[4]

While semiotics has traditionally disavowed the elusive qualities of sensation, I appreciate the fact that lived, situated, and embodied experience is not an easy 'text' to be simply read, documented, or interpreted. According to cultural anthropologist David Howes, our '[s]ensory channels may not be modeled after linguistic forms of communication—a perfume is not the same as a sentence—but they are still heavy with social significance' (*Empire of the Senses*, pp. 3–4). Tensions between language and experience are to be celebrated rather than shunned because they highlight the lived body as the experiential site and underlying source of meaning. Following Howes, we could say that an experimental animation such as *Free Radicals* (Len Lye, 1958) with its tangible scratching onto the black leader, its kinetic, pulsating lines of movement, and its percussive drum beats and rhythms is definitely *not* the same as a sentence. Nor is the quiet glow and arrested sense of time that suffuses a Johannes Vermeer painting the same as the vibrant colour, spectacular *mise-en-scène*, and graceful sense of spatial traversal that marks a 1950s Hollywood musical. Nevertheless, the different forms and figural sensuality of these experiences will all be felt and synopsized in and through the lived body—a fact that has been too often dismissed in semiotics.

Film theory, too, has not been immune from bypassing the role of the senses in the production of meaning. As Sobchack points out, film criticism has erred on the safer, more 'objective' side of semiotics in its discussion of spectatorship.[5] It has reduced the sensuous correlation of film and viewer to a matter of representation or of psychic and/or cognitive processes of spectatorship, wherein until recently 'the spectator's [...] basic physiological reflexes [did] not pose major questions of meaning' (*Carnal Thoughts*, pp. 59–60). Sobchack is correct in her identification of the division between semiotics and sensation in much post-60s film theory. Here,

we would do well to recall how even the early semiotic work of Christian Metz had once flagged film as a techno-sensory machine. In his *Language and Cinema*, Metz refers to the fact that 'films have a meaning which is directly comprehended or "lived" by the spectator' before we engage in their conscious interpretation such as that of a generic system (p. 134). Although Metz asserts that this level of meaning is directly comprehended (and therefore not amenable to analysis?) and that film only attains further meanings in relation to larger textual systems, he does hint at the body as the all-important conduit between semiotics and sensation. While clinging to the structuralist need to divide film narrative into an 'ordered' series of signs or signifying statements, Metz realizes that such divisions are only possible 'because [film is] phenomenally ... a series of events' that unfold in the doubled time of film and viewer alike—as the 'time of the thing told and the time of the telling' (*Film Language*, pp. 26, 18).

Decades later, in his book *The Cinematic Body*, Steven Shaviro admirably takes on critics like Metz (together with semiotic and psychoanalytic film theory, in general). As he details, these strains of film theory have either isolated the image as a disembodied sign or linked it to an illusory 'lack' that can only signal absence or an absent-presence that dupes the viewer. Shaviro makes a powerful alternative argument for cinema's own material potency. Instead of notions of absence or lack, Shaviro suggests that cinema is imbued with an arresting presence that can instigate unsolicited physical responses in the viewer: 'the problem for the cinema spectator is not that the object is lost or missing, but that it is never quite lost, that it is never distant or absent enough' (*Cinematic Body*, p. 17).

Concentrating on a visceral, direct, and contagious stimulation of the eye, body, and the nervous system, Shaviro delves into the kind of embodied encounters with film wherein so-called film 'apparatus' theorists like Metz once refused to tread. Drawing on an alternative range of cinematic thinkers such as Deleuze, Shaviro's account of cinema-as-sensation edges towards a violent or tactile assault. For Shaviro, film is 'inescapably literal. Images confront the viewer directly, without mediation. [...] We respond viscerally to visual forms, before having the leisure to read or interpret them as symbols' (*Cinematic Body*, p. 26). In his consequent privileging of the literal over the figural, the assaults of cinema are not recoupable by or reducible to linguistic structures or conscious signification.

I welcome Shaviro's earlier attempts to re-inscribe cinema with the physical tremors and visceral excitations of the body. Nevertheless, in the recent push to re-embody film and media studies, semiotics has been abandoned for the pursuit of affect, embodiment, and sensation.[6] Shaviro

adopts (in reverse) Metz's claim that cinema is comprised of sensuous meanings that are first comprehended by the body, before they accrue an additional conscious or culturally constructed significance. Whereas Metz acknowledged the embodied resonance of film but bypassed it in favour of structuralist and semiotic analysis, Shaviro acknowledges that cinema contains conscious forms of signification that he then bypasses in favour of the rawness of sensation: 'affect, excitation, stimulation and repression, pleasure and pain, shock and habit' (*Cinematic Body*, p. 27). If Metz suggests that cinema produces semiotic meaning on top of or in addition to its phenomenological signification, Shaviro's counter-point is that cinematic sensuality short-circuits signification (*Cinematic Body*, pp. 32–33).

Similarly, in his essay 'The Autonomy of Affect', Brian Massumi also draws upon Deleuze to distance the immediacy of the skin from the conscious reflections of the sign. To quote Massumi: 'An emotional qualification breaks narrative continuity for a moment to register a state—actually re-register an already felt state (*for the skin is faster than the word*)' (p. 86; italics mine). Even within the sensuous 'turn' of film, media, and cultural studies, the split between the skin and the sign, language and experience, the literal and the figural continues. Divisions between perception, sensation, affect, feeling, and materiality from expression, narrative, language, and signification deny the embodied intelligence of the image (the fact that images can and do matter, cognitively), the meaning-full role of the senses, and the sensuality of signification.

These divisions simply do not hold for a cinema of baroque flesh, as I will demonstrate. In fact, the sensations of the body and the signs of semiotics need not so radically oppose each other as they do in Metz, Shaviro, Massumi, or in more recent strains of sensuous film scholarship.[7] Neither Massumi nor Shaviro are wrong in their foregrounding of the immediacy of feeling. The skin *is* faster than the word but sensation is not completely separate from language and signification, either (Montagu, *Touching*, pp. 151–152). I posit that the relationship between language and experience is an inherently renewable exchange that is akin to the *chiasmic* structure of the 'flesh'.[8]

How might the *chiasm* of language and experience take place in the cinema? According to Sobchack, long before 'we consciously and voluntarily differentiate and abstract the world's significance for us into "ordinary language", long before we constrain [Merleau-Ponty's] "wild meaning" in discrete symbolic systems we are immersed in language as an existential system' (*Address of the Eye*, p. 12). The film's body, too, 'perceives and expresses itself wildly and pervasively' before it articulates and organizes its

meanings 'more systematically as this or that kind of signification' such as a particular figure or trope, a set of generic patterns, directorial signature, the conventions of a particular film movement, and so forth (Sobchack, *Address of the Eye*, p. 12). While this might appear as if I am replicating Metz and Shaviro's claims—that the 'wild meaning' of perception precedes 'secondary communications'—this need not be the case if we situate the literal and the figural as always in *chiasm* in cinema. In these terms, 'the body and language (whether film language or "natural" language) do not simply oppose or reflect each other. Rather, they radically *in-form* each other in a fundamentally non-hierarchical and reversible relationship' (Sobchack, *Carnal Thoughts*, p. 73). An appropriately embodied take on semiotics as well as a formal and experiential structuring of sensation is needed if we are to come to terms with reversals between language and experience, and the fact that, '*to understand movies figurally, we must first make literal sense of them*' (Sobchack, *Carnal Thoughts*, p. 59). Similarly, as Peter Brooks glosses it, any 'semioticisation of the body is accompanied by the somatisation of story' (*Body Work*, p. 38). An intertwining of the literal and the figural or the skin and signification underpins baroque cinema, as it is founded upon copy and contact.

Baroque Poetic Language and the Seventeenth-Century Infinite

The historic baroque was a profoundly transitional period, shattering many previous conceptions of wholeness: geographical, astronomical, anatomical, and theological. It has already been amply documented that post-Copernican frameworks in astronomy were fraught with furious religious, artistic, and scientific debate, so I will not further rehearse those debates here.[9] Suffice to say that new technological inventions such as telescopes and microscopes, assisted by the newly pellucid clarity and power of lens production, put seventeenth-century European thinkers in touch with the infinite in a way that had never been seen before by opening up the formerly 'invisible' multiplicity of micro- and macro-worlds (Reeves, *Painting the Heavens*, pp. 176–177; Ndalianis, *Neo-Baroque*, p. 174).

In what follows, I am specifically concerned with how the seventeenth-century grasp of the infinite inflected baroque poetics for it 'is not too much to say that [a] sense of the infinite pervaded the entire Baroque age and colored all its products' (Martin, *Baroque*, p. 155). The infinite world view that gripped the seventeenth-century imagination is reflected in the popular literature of the age. First published in 1686, Bernard le Bovier de

Fontanelle's *Entretiens sur la pluralité des mondes* (Conversations on the Plurality of Worlds) proved to be an overnight sensation, tapping into the increasing belief in multiple worlds (Reeves, *Painting the Heavens*, pp. 8–9). Structured as a playful exchange between a man of letters and a cosmologically curious countess, Fontanelle employed the countess as a stand-in for the general public, couching his astronomical observations in the guise of casual conversation and proving 'that the Earth may be a Planet, the Planets so many Earths, and all the Stars, Worlds' (Fontanelle, *Plurality of Worlds*, p. 7). Fontanelle also drew upon microcosmic spectacles of Earth, teeming with life, to postulate the possibility of life on other planets.[10]

> Do but consider this little Leaf; why it is a great World, of vast extent, what Mountains, what Abysses are in it [...]. In the hardest of Stones, for example, in Marble, there are infinity of Worms which fill up the vacuums [...] you will find that the Earth swarms with Inhabitants. Why then should Nature, which is fruitful to an excess here, be so very barren in the rest of the Planets? (Fontanelle, *Plurality of Worlds*, pp. 88–89)

In his book, Fontanelle addressed a number of contemporaneous astronomical debates including the introduction of the telescope, the maculate nature of the moon's surface, the possibility of visiting the moon or other planets, and communicating with other-worldly inhabitants (Fontanelle, *Plurality of Worlds*, p. 7). At the same time, he imaginatively conjured up images of an elaborate cityscape lying just below the moon's surface where lunar inhabitants retired into great cavities—the kind of 'earthly' and mountainous caverns that had just been discovered by Galileo Galilei with the aid of the telescope (Huddleston, 'Baroque Space', p. 17; Fontanelle, *Plurality of Worlds*, pp. 82–83).

In his book *Barroco* (1974), Cuban writer Severo Sarduy notes the analogous spatial sensibility that is shared between the seventeenth-century arts and sciences. For Sarduy, the seventeenth century initiated a specific spatial trajectory that moved away from the enclosed, the circular, and the singular towards the open, the multiple, and the polycentric (Calabrese, *Neo-Baroque*, p. 44; Zamora, *Inordinate Eye*, p. 120). Drawing on Johannes Kepler's cosmology (which proved that the planets glided in elliptical orbits around the sun, not circles), Sarduy argues that a 'taste for elliptical form, provided with real centers and multiple potentials' infiltrated many different kinds of baroque artistic form from the curved architectural surfaces of Borromini to the poetry of Góngora or the energetic, spatially dispersed compositions of Caravaggio (Calabrese, *Neo-Baroque*, pp. 44, 11; Ndalianis,

Neo-Baroque, p. 176). For Sarduy, the 'step from Galileo to Kepler is from the circle to the ellipse, *from the form inscribed around the One to the form inscribed around the Many, the step from Classicism to the Baroque*' (qtd. in Zamora, *Inordinate Eye*, p. 120). Similarly, Umberto Eco links the openness, mobility, and the spatial dynamism of baroque forms to the seventeenth-century new sciences. As he states, by 'giving up the essential focusing centre of the composition and the prescribed point of view for its viewer, [baroque] aesthetic innovations were in fact mirroring the Copernican view of the Universe' (Eco, 'The Poetics', p. 157). Both Sarduy and Eco provide us with a useful spatial analogy for understanding the baroque preference for asymmetry, openness, polycentrism, and infinity, rather than the enclosure of the circle. Foregrounding shifting relations between parts and wholes, the One and the Many, the baroque urge is to 'displace and decentre, [to] amplify and include' (Zamora, *Inordinate Eye*, p. 120).

In his *Sade, Fourier, Loyola*, Barthes argues for a 'baroque semantics' that is 'open to the proliferation of the signifier, infinite and yet structured' (p. 99). Barthes' model of baroque language rejects dichotomies (subject and object, masculine and feminine, or real and unreal) and 'presents for interpretation a whole "hieroglyphics" which operates through the deciphering of series and correspondences between all the realms and forms of the universe' (Buci-Glucksmann, *Baroque Reason*, p. 140).[11] In another essay, 'The Spirit of the Letter', Barthes invokes a polysemic or pansemic 'baroque region'; here, the 'image-sign' becomes freed from a purely 'linguistic role (participation in a particular word), a letter can say everything [...] one and the same letter can signify two contraries' (p. 100). Unhinging indexical connections between a sign and its meaning, '[a]ny person, any object, any relationship can mean absolutely anything else' in the baroque (Benjamin, *The Origin*, p. 174). In baroque language, it is entirely possible for contraries to coexist happily.[12] The meaning of the sign is not predetermined by its referent: 'the sun here becomes dark' (Buci-Glucksmann, *Baroque Reason*, p. 140).[13]

Figurative language underwent a new phase of appreciation during the course of the seventeenth century. Poets drew upon a complex range of figural techniques such as metaphor, catachresis, allegory, doubled or polysemic meanings, metonymy, hyperbole, paradox, oxymoron, and antithesis to realize a 'trope-engendered world' (Bornhoefen, 'Cosmography and Chaography', p. 33).[14] In Foucault's account, if we remember, this was the era that put an end to resemblance by splitting words from things (*Order of Things*, p. 51; Bal, *Quoting*, p. 231). Discussing *Don Quixote*, Foucault describes how writing 'has ceased to be the prose of the world; resemblances

and signs have dissolved their former alliance' such that baroque 'words wander off on their own, without content, without resemblance' (*Order of Things*, pp. 47–48). We will return to Foucault's problematic dismissal of resemblance for the baroque momentarily. For now, let us stay with the notion of it splitting words or representations and things.

Based in classical Aristotelian theory, Renaissance poetics had preached that language ought to maintain a sympathetic resemblance to the world and an obvious correspondence between signs and experience (Donato, 'Tesauro's *Cannocchiale Aristotelico*', p. 114). By contrast, baroque poetics valorizes its own artificiality and 'self-reflects rather than reality reflects' (Bornhoefen, 'Cosmography and Chaography', p. 58). Seventeenth-century poets and scholars including the likes of the Jesuit rhetorician Emanuele Tesauro, Baltasar Gracián, Giambattista Marino, Matteo Pellegrini, and Cardinal Sforza Pallavicino aspired towards a new poetics (Mazzeo, 'Metaphysical Poetry', p. 222). They looked to the power of figural language to transform and re-make the world anew.

Baroque language is fundamentally generative in its creative renewal and replenishment of meaning. Its use of metaphor functions as much more than a simple rhetorical figure; rather, it 'becomes [a] significant form' in its own right (Donato, 'Tesauro's Poetics', p. 29). Poetic language created a 'universe of infinitely proliferating meanings' that was unconstrained by its referents (Donato, 'Tesauro's *Cannocchiale Aristotelico*', p. 113). Tesauro—one of the greatest advocates for tropology in poetics—suggested that there might be a certain kind of 'madness that inhabits the centre of [the baroque] system' (Donato, 'Tesauro's *Cannocchiale Aristotelico*', p. 113). For Tesauro, 'madness is the very definition of metaphor' in its baroque incarnation (qtd. in Donato, 'Tesauro's *Cannocchiale Aristotelico*', p. 113). Just as the baroque has been connected to the 'madness' of vision, so has baroque poetics been associated with the 'madness' of metaphor because of its flagrant dispersal of meaning.[15]

Through metaphor as well as other figural techniques the baroque poet re-wrote the world, embracing conceptual and spatial traversal and a reshaping of reality. The division of words (representation) from worldly things was precisely what Aristotelian guidelines had cautioned against through its avoidance of figurative tropes and by urging poetics to adhere to a strict proximity between language and experience (Barilli, *Rhetoric*, p. 70). In 'The Epistemology of Metaphor', Paul de Man suggests that one of the reasons that the history of figurative language has met with censure is because of the 'epistemological damage' that it incurs by annexing the figural to the literal (p. 39). This was not a concern for historic baroque poetics, as it deliberately sought to meld the literal and the figural.

Violating the connectivity between language and experience that had once guided the Renaissance, the warping of the word and the world by baroque poetics has been well captured by Saúl Yurkiévich. As he writes, the baroque

> wants to adapt the word to a complex and mutable apprehension of the world [...]. [I]t is about playing the game of the world so that what is happening in the world happens in a game, for the world to unfold in the game of words, for the words to account for their own unreachable displays. (Yurkiévich, 'Baroque Fusions', p. 112)

Essential to understanding baroque poetics is how its 'theoretical agenda praises figurative language as [...] the mode that best describes things' (Bornhoefen, 'Cosmography and Chaography', p. 44). In these terms, language is constructive rather than reflective of the world. Up to this point, I have been concentrating on the figural tendencies of the baroque and the centrality of the copy or artifice to its poetics. Let us now examine the equally pressing phenomenon of contact.

Commensurate with the analogical bent of the baroque, the seventeenth-century arts rendered concrete and tangible the intellectual 'abstraction' of infinity. Just as astronomers such as Galileo were proving that heavenly bodies contained terrestrial features such as laws of gravitation and motion, artists were analogizing the divine to the earthly by moving between multiple pictorial planes to connect other-worldly vistas and depictions of the infinite with the space of the beholder (Martin, *Baroque*, p. 155).[16] Artists like Cortona and Pozzo populated their ceilings with sky scenes, proliferating figures, and decorative motifs that literally overflowed the frame. Through their powerful sense of energy, kinetic movement, and vertiginous spatial expansion, these ceilings encourage us to connect or engage sensuously with their experiential vistas of infinity (Zamora, *Inordinate Eye*, p. 119). Similarly, baroque poetics used language to create artificial, mobile, and meaningful relations between parts and wholes. For the baroque poet, figural language could infinitely re-order the world.

For the baroque, it is a persistent convention that 'parts circulate and wholes are never fully defined' (Zamora, *Inordinate Eye*, p. 186). Rather than becoming lost in a maddening quagmire of shifting parts, though, the historic baroque arts employed 'association, accumulation, and [the] diffusion of elements' to create new, analogous, and artful connections between different bodies, signs, and phenomena (Zamora, *Inordinate Eye*, pp. 186–187). As Stafford points out, the analogical 'need to connect became

even more urgent in the destabilized world order ushered in by the New Sciences [...] Understanding emerged out of innovation, the continuous struggle to bind an elusive infinity to a finite imagination' ('Revealing Technologies', p. 5). We might add that the explosion of figural language on the part of the baroque partakes not only of analogy but also of the infinite and the baroque love of motion, whether semantic or visual. The seventeenth century used figural language to traverse (conceptual) space and to yoke disparate signs or elements together, allowing meaning to ludically multiply (Bornhoefen, 'Cosmography and Chaography', p. 65). As Zamora rightly observes, 'meanings [become] multiple and elusive [...] Signifiers are in motion and the motion itself is meaningful' (*Inordinate Eye*, p. 295).[17] While the baroque plays upon the distance between language and experience and the difference of one sign from another, it also tries to breach those very distances by binding an 'elusive infinity to a finite imagination' (Stafford, 'Revealing Technologies', p. 5). The baroque view of language does not only involve infinite motion and expansion; it makes contact between divergent signs. It is the *doubled* act of 'outreaching and combining' that characterizes baroque metaphor (Maiorino, *Cornucopian Mind*, p. 100).

The connection between the seventeenth-century infinite and baroque poetics can be ably demonstrated by Tesauro's 1654 treatise *Il cannocchiale aristotelico* (The Aristotelian Telescope), especially if we examine the ideas that are neatly contained in its frontispiece.

A number of characteristically baroque motifs appear in the frontispiece: fabrics and folds of drapery, beribboned banners, the intricate decoration of the trees and foliage, and the use of doubled 'framing' devices that contain still further symbols. Consistent with the seventeenth-century tradition of richly decorated emblem books, Tesauro's frontispiece conveys its discursive message through figural symbolism (Jay, *Downcast Eyes*, p. 47). In establishing his theoretical basis for baroque wit, Tesauro draws connections between three identifiable figures. On the left of the image sits a woman who represents *Poesis* (poetry). Her eye is affixed to a telescope, aimed towards the sun and steadied by none other than Aristotle. The Latin engraving at the bottom of the image explains that *Poesis* is studying spots in the sun. She is ascertaining evidence of the terrestrial affinity with the heavens, made perceptible through the telescopic lens. On the right hand side of the image is another woman, *Pictura* (painting). *Pictura* sits painting one of the ovular inserts with an anamorphosis of disguised letters. A conical catoptric device sits inside the painting, proclaiming its motto and its ultimate rationale—*omnis in unum* (meaning 'everything inside the one').

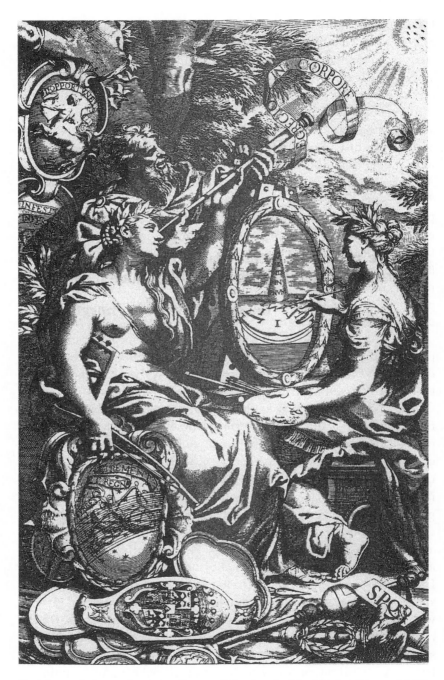

Fig. 6: Emanuele Tesauro, frontispiece *Il cannocchiale aristotelico* (The Aristolean Telescope) (1670 edition). Public Domain.

In his frontispiece, Tesauro suggests that the arts of painting and poetry have the power to transform the real into figured shapes and words. As Deleuze intimates, however, it is the cone that allows the 'real' to be recovered (*The Fold*, p. 126). The anamorphic cone that Tesauro includes can be read as the literal point of contact that baroque poetics makes with its participant. Baroque poetics translates the literal into the figural and the figural into the literal because it relies on (some)body to apprehend its words: 'the body in whom and for whom semiosis takes effect' (de Lauretis, *Alice Doesn't*, pp. 182–183). Weaving between mobile parts and wholes, baroque poetics sought to create renewable combinations of the word and the world that would surprise, delight, and move the body of its participant and it called upon the life of the senses to achieve that purpose.

In her study of Elizabethan and Renaissance poetics, Rosemond Tuve demonstrates that the historic baroque poet was not guided by the verisimilitude of the representation (*Elizabethan*, p. 12). Instead, their main criterion was what she calls 'sensuous vividness' and the ability to incite moments of wonder or delight (Tuve, *Elizabethan*, pp. 79, 90). The skill of the poet was measured by their giving 'over sensations bodily'; 'figurative language endeavors to arrest you, "to make you continuously see a physical thing, [so as to] prevent you from gliding through an abstract process"' (pp. 101–102). Nevertheless, what baroque figurality takes away with one hand it restores with the other by appealing to the literal flesh of its participant. The urge to copy becomes inextricable from wilful contact, as the poet 'brings into play the *infinite materiality* of images and bodies' (Buci-Glucksmann, *Baroque Reason*, p. 139).

Poetic language is therefore commensurate with the correlative structure that I claim for baroque flesh. In his analysis of Tesauro's treatise, Eugenio Donato is apposite:

> To appreciate fully the radicalism of Tesauro's semiology, it is important to note that the figurative nature of any representational system is symmetrical with respect to the painter and the viewer, the speaker and the listener, the reader and the writer. *If any ingenious intellect can use the materiality of letters, images, and words as a signifier for figurative meanings, it is only an equally ingenious intellect who can recognize them for what they are.* ('Tesauro's *Cannocchiale Aristotelico*', p. 111; italics mine)

Deleuze, too, has picked up on the copy and contact of baroque language that is emblematized by Tesauro's frontispiece. As he writes, the baroque introduces a new 'kind of story in which [...] description replaces the object,

the concept becomes narrative, and the subject becomes point of view or subject of expression' (*The Fold*, p. 127). The body of the participant must materially realize and also bear witness to the virtuoso transformations of the sign that have been undertaken by the poet.

By way of Tesauro, we can counter Foucault's dismissal of resemblance for the baroque and the overemphasis that Buci-Glucksmann and others have placed on the obscurity of baroque language. Like me, Buci-Glucksmann underscores the importance of the figural for baroque language. She suggests that the 'figure no longer "represents" the concept because the "concept" [...] is itself only a knot of words and images, a figured expression' (qtd. in Jay, 'The Rise', p. 322). In Buci-Glucksmann's schema, the 'rhetoric of the baroque is like its visual madness: anamorphosistic, undecidable and resistant to any plenitude' (Jay, 'The Rise', p. 322). While I appreciate the tangling of word and world that is invoked here, I have considerable qualms about the assumption that the baroque can lead only to obscurity, madness, or confusion, or that the baroque does not constitute its own formal system. What Buci-Glucksmann fails to consider is the flipside of the anamorphosis—the path from disorder to resolution. That path is precisely what Tesauro alludes to in his prominent inclusion of an anamorphic cone.[18] Just as an anamorphosis springs from shapeless illusion into the saliency of form, Tesauro hints at how baroque poetics is similarly invested in a moment of revelation that occurs through language. By drawing associations between the seventeenth-century sciences, language, and painting, Tesauro's frontispiece suggests that we might discover many subtle connections interknitting the diversity of the universe (Gilman, *Curious Perspective*, p. 70). For the baroque, this is the vital and inherently analogical idea that everything could be contained inside the one (*omnis in unum*) (Gilman, *Curious Perspective*, p. 70).

Tesauro allows us to retain the baroque proliferation of meaning without consigning its figural practices to madness and chaos. Through Tesauro, we can also contradict Foucault's suggestion that thought 'ceases to move in the element of resemblance' in the baroque (*Order of Things*, p. 51). I counter that resemblance (as it involved the art of analogy) remained alive and well in the historic baroque. The sensuous connectivity and connection between bodies that I claim for a cinema of baroque flesh has its genealogy in seventeenth-century language, especially its poetics of affinity and correspondence.[19] For the baroque, phenomena, signs, and bodies do not lead an isolated existence. Rather, they can be connected to one another through shifting webs of resemblance (*omnis in unum*). According to a particularly illuminating essay by Jan C. Westerhoff, the late sixteenth

and seventeenth centuries had a definite view of signification. Via Eco, he dubs this view 'pansemioticism' (Westerhoff, 'World of Signs', p. 633). Pansemiotics is the idea that every object or sign could signify or be related to other objects or ideas (whether abstract qualities like vice and virtue or literal events and historic affairs) (Westerhoff, 'World of Signs', pp. 633–634). Tesauro demonstrates just such a pansemiotic conception of the world in his frontispiece. He hints at how every object, word, painting, image, or sign and even earthly and heavenly space can be rhymed or related to one another (even if they appear dissimilar), if only we are willing to 'see' the world as the baroque poet does.

Unlike Foucault, I would insist that resemblance continued to inform both the visual arts and the poetic practices of the seventeenth century. His detailed viewing of *Las Meninas* aside, critics such as Horst Bredekamp and Svetlana Alpers have been quick to comment that Foucault's analyses in *The Order of Things* are primarily textual in nature (Bredekamp, *Lure of Antiquity*, pp. 109–110; Alpers, *Art of Describing*, p. 79). As a result, he does not consider how resemblance also played out as visually embodied experiences in the baroque. In Foucault's rejection of interpretation through resemblance, 'the centrality of the image to this new mode of knowing the world is never made clear' (Alpers, *Art of Describing*, p. 79). Furthermore, Foucault does not ever address the 'sensuous vividness' of seventeenth-century poetics or the fact that the baroque word calls upon our embodied vision and our sensuous intelligence (Tuve, *Elizabethan*, p. 79). And yet, a heightened intertwining of the word with the eye is exactly 'what happens in the baroque. Both externally and stylistically—in the extreme character of the typographical arrangement and in the use of highly charged metaphors—the written word tends towards the visual' (Benjamin, *The Origin*, pp. 175–176).

It was for good reason that Tesauro entitled his treatise *The Aristotelian Telescope*. This was not just a titular tribute to one of the foremost optical inventions of the times. As Buci-Glucksmann writes, it is 'characteristic of the whole figural realm [of the baroque that] the sudden perception of "dissimilar likeness" *telescopes reality*' (*Baroque Reason*, p. 157; italics mine). The explicit connection that Tesauro makes to the telescope points us towards the baroque as an art of analogy. Tesauro uses the newly expanded vision of the telescope as a stand-in for how baroque wit makes us 'see' the analogical connections that underpin the world. Like the telescope, wit allows the minds of the poet and their audience to regard the world anew by opening up alternative perspectives (Gilman, *Curious Perspective*, p. 80). We see what we normally would not because of either a technological (the

telescope) or figural (the poet) re-ordering of the world. In this regard, the visual understanding of metaphor during the seventeenth century becomes crucial. Metaphor provides the poet with a 'visually concrete language' that contradicts Foucault's stance on the distance and the divisiveness of the baroque (Tuve, *Elizabethan*, p. 101).

While the seventeenth century might have liberated the sign from its referent, it is not true to say that affinity no longer exerted a claim on the baroque. While seventeenth-century thought 'discards the analogic paradigm of signs and representation', as Buci-Glucksmann writes, the baroque poet sought to 'discover the role of correspondences' (*Baroque Reason*, p. 135). Baroque poetics continued to forge connections between diverse signs and to make material contact with its participant. Having established the copy and the contact of baroque language, let us now turn to the abiding baroque love of the surface.

Baroque Luxury

Blending historic subject matter with the re-imagined and the iconic, the opening shot of *Marie Antoinette* foregrounds its own artificiality. Set to the tune of 'Natural's Not in It' by Gang of Four, title credits of hot-pink and graffiti-like lettering introduce us to the last queen of France. Whereas the film's lettering evokes the signature font of the Sex Pistols and the rebellious spirit of British punk rock, the song's lyrics speak in counter-point to this, taking pleasure *in* popular consumption: 'The problem of leisure/what to do for pleasure/ideal love a new purchase/a market for the senses'.

The opening shot of *Marie Antoinette* appears de-contextualized from the film as a whole, though it functions more like an emblem or a frontispiece for what follows. That is, its images and sounds conceptually encode the film's main concerns with Antoinette's life at Versailles and the sensuous living of a luxurious lifestyle. Antoinette is seen reclining on a chaise, sur-rounded by multi-tiered cakes, while an anonymous attendant kneels to fit a delicate pair of pointed shoes on her feet. Too sated and sleepy to lift herself upright, Antoinette runs her finger across the icing of a nearby pink gateau before bringing it to her lips. She then turns and archly smirks at the camera before leaning back in utter self-satisfaction. The overt plushness, decadence, and social organization of power of the baroque is expressed to us here as an array of uneaten cakes and pastries, as a mixture of rich materials (satin, feathers, silk), sleepy movements, and bodily positions. Historically speaking, the film's emblematization of luxury, decadence, and royal power

is entirely appropriate to the age as '[e]conomics and the Baroque were antithetical', as Rémy Saisselin points out (*The Enlightenment*, p. 79).

In what follows, I will not be concerned with Coppola's creative blending of the past and the present in her rendition of the queen of France: her use of a predominantly American cast, the inclusion of a punk rock and New Romantic soundtrack, or the pair of blue Chuck Taylor All-Stars sneakers cheekily included in Antoinette's historic wardrobe. Confining itself to Antoinette's years spent at the royal French court of Versailles, *Marie Antoinette* includes little reference to the starving Parisians who spurred the French Revolution and no depiction of the queen's final end at the guillotine during the French Reign of Terror. As a number of scholars have commented, this is because Coppola is less concerned with historical accuracy than she is with crafting an 'impressionistic portrait of a young girl on the verge of becoming a queen' (Rogers, 'Historical Threshold', p. 83).

As Pam Cook observes, the film's flagrant mixture of 'authenticity and historical document against inventive remixing' may 'antagonize those who demand more substance to history' ('Portrait of a Lady', pp. 39–40). As she counters, however, 'style is substance' in *Marie Antoinette*. This is especially the case if we consider the film body's privileging of movement, music, colour, and *mise-en-scène* throughout, as well as the different material lures of fabrics, costumes, and surfaces. Feelings of luxury, surfeit, and gratification are paramount to the baroque flesh of this film. These feelings are expressed through the material-visuality of the film's body, as it occurs in tandem with that of our own.[20]

Cook is correct in identifying the importance that style-as-substance assumes in *Marie Antoinette*. Nevertheless, her almost apologetic defence of the film's affective import against the 'hard' facts of history need not be so absolute. In his book *Camera Historica: The Century in Cinema*, Antoine de Baecque details how filming Versailles has actually been a constant matter of negotiating French national history alongside its cinematic re-invention. As he writes, 'shooting Versailles often just means shooting the scene that will "sell" Versailles'; most commonly, by using the exterior of the palace or one of its famous interiors to sell the historic authenticity of the production (p. 78).[21] For this book, *Marie Antoinette* is historically apposite and indisputably baroque in terms of its embodied aesthetics of luxury.

As Saisselin contends, the baroque does not only refer to the art of Bernini or the architecture of Borromini but to an aesthetic that was forged out of a particular historic moment. It makes for a 'civilization that can be associated with the period of absolute monarchy, with an alliance of church and state to maintain the hierarchical structure of society, and even with economic

mercantilism' (*The Enlightenment*, p. 3). Similarly, Louis Marin argues that Versailles might not be the 'classical model of the royal palace' as is so often assumed ('Classical, Baroque', pp. 167, 172). For Marin, Versailles is best associated with the 'great baroque period' and baroque theatricalizations of power and representation that experienced a revival in France from around 1750 on (pp. 167, 172). As with this book, Marin is not concerned with fixing the baroque to a definitive chronology. Instead, he approaches Versailles as an instance of the historically specific and abiding 'baroque desire [for] the fantastic, the phantasmatic desire to show oneself as absolute power' (p. 170). Like Marin, Saisselin asserts that we can include that which 'the French see as their "classicism", as still within the Baroque moment because of [the] nonclassical traits belonging to such a moment—the court, religious enthusiasm, strong passions and a conception of the hero, the courtier, and the saint as dominant types' (*The Enlightenment*, p. 3). Following on from scholars such as Saisselin and Marin, I think we can extend the theatricality of power that typifies the baroque and its cinematic legacy into the age of Marie Antoinette, and beyond.

By examining *Marie Antoinette* in relation to the baroque resonance of Versailles, it is my intent to lay the historic and conceptual foundations for understanding baroque flesh as an intertwining of surface appearance with inner substance. As Walter Benjamin observes of the *Trauerspiel*, 'history becomes part of the setting' (*The Origin*, p. 177). History does indeed become part of the setting of *Marie Antoinette*, for Versailles is a crucial means of this film both embodying baroque luxury and figuring its attachments to the surface and to a material-visuality.[22] If, as de Baecque claims, Versailles and its chronicle are transformed into a 'cinematographic form of history' in film, what Coppola's *Marie Antoinette* contributes is a highly corporeal version of French history and the life of the queen that foregrounds Versailles as the site in which baroque luxury is imaged, imagined, and literally incarnated (*Camera Historica*, p. 100).

Before I examine *Marie Antoinette* in detail, we need to re-visit the historic frameworks that catalysed the baroque as a surface-driven aesthetic. There is little doubt that cultural production during the seventeenth century was galvanized by the socio-political demands of the era. For José Antonio Maravall, 'Counterreform, absolutism, and baroque went together' (*Culture*, p. 10). While Maravall's concern lies in the Spanish baroque, his analyses are applicable to the European baroque in general. While the Catholic Church was caught up in its own Counter-Reformation agenda, the increasing urbanization of European cities, together with the rise of social mobility, threatened prevailing monarchical-seigniorial interests

(Maravall, *Culture*, pp. 12–13).[23] Just as the church opted for sensual and/or emotive routes towards piety, royal and seigniorial powers turned to overt spectacles of power to circumvent political crisis and quell rebellion. For Maravall, the historic baroque represents a dedicated attempt by church, monarchy, and state to affirm the status quo; how successful they were in achieving that purpose remains a matter of dispute.[24] Nevertheless, in its appeals to the emotions, the senses, and a heightened theatricality, we can agree that the age strove to 'address the masses so as to bring them together, prompting their admiration' through ornamental effects and often spectacular techniques of attraction (Maravall, *Culture*, p. 92).

A tendency towards the grandiose in entertainment, and religious and political ceremonies sought to astound the urban set through hyperbolic theatricality—from urban fiestas and fêtes through to choreographed fountains, firework displays, opera, theatre, sermons, religious, and political rituals (Maravall, *Culture*, p. xix). As Ndalianis remarks of baroque artworks, these 'stand as monuments to their patrons [and] also monuments to spectacle itself' (*Neo-Baroque*, p. 171). Her distinction is of great interest because it suggests how deliberate stagings and choreographies of power inflected the development of baroque aesthetics. As John Beverley observes, '[t]heatricalisation, ceremony, allegorisation, ultra-refinement and charismatic exhibitionism are the very essence of aristocratic power itself' ('Going Baroque?', p. 32). Sensitive to the ways in which 'art and politics are not clearly separate disciplines and activities', Beverley astutely asserts that '[p]omp, or the *appearance* of power, is not separate from substance: power is representation' for the baroque (p. 32).

Appearance as substance, the material surface as depth, the inside as the outside—these ideas will take on a greater philosophical resonance with the baroque texturology of the next section. Until then, let us concentrate on the absolutist obsession with appearances that informs Coppola's film. In *Marie Antoinette*, life at Versailles is presented as a repetitive succession of different courtly rites and rituals and glittering surface displays. In the first scene of the film, Maria Theresa, Empress of Austria, warns a young Antoinette that 'the court of France is not like Vienna [...] all eyes will be on you'. This statement prefigures the highly visible and invisible place of Antoinette in many of the palace scenes that follow: the 'hand-over' or *remise* ceremony between Austria and France, the royal wedding, and her morning dressing and eating rigours. The emphases on the display, disciplining, and making of Antoinette-as-royalty cue us into the heightened function that surface appearances will accrue throughout, especially in terms of the film's highly expressive uses of bodily, decorative, and architectural surfaces.

The film's privileging of surface appearances echoes the biographical history of Marie Antoinette herself. As Judith Thurman observes, no other queen was 'more intent than Marie Antoinette on dressing for history' ('Dressed for Excess', p. 1). Antoinette's 'instincts for self-display' reflect a baroque compulsion to be seen as well as seeing, leading the eighteenth-century scholar Pierre Saint-Amand to gloss the tumultuous events of her life as a veritable 'series of costumed events' (qtd. in Thurman, 'Dressed for Excess', p. 4). The extravagant and surface-led history of Marie Antoinette is well suited to the conventions of the costume drama or bio-picture, where a sumptuous focus upon clothing, texture, and setting are abiding concerns (Bruzzi, *Undressing Cinema*, p. 35; Sadoff, 'Appeals to Uncalculability', pp. 43–44).

The importance of textural display is established early on, especially during the *remise* ceremony at the borders of France and Austria where we are informed that 'it is a custom that the bride retain nothing belonging to a foreign court'. During the symbolic removal of her dress, Antoinette stares out at us, impassively, while garments are pulled over her head and even bracelets removed from her wrists.[25] The vision of the camera lingers on the intricate detailing of her undergarments, travelling up her back, in close-up, to dwell on the interlacing of a flowered corset. Despite Antoinette's nakedness and the heavily curtained framing of her body, the scene is not eroticized. Rather, the film views Antoinette at a distance, with her body dimly silhouetted against the light. When the vision of the film moves in closer it is to concentrate on an elaborate wire hoop that is being fitted around her waist. Here, the film's body draws our attention to the sartorial sculpting of royalty and its theatricality. The *remise* sequence is highly theatrical in its framing of Antoinette's newly clothed body between the curtains of a temporary pavilion. As Thurman points out, Antoinette 'became Crown property at the moment that her new ladies redressed her' ('Dressed for Excess', p. 4). At the end of the hand-over ceremony, Antoinette re-emerges on the French side clad in a dress of pale blue satin that is offset against her now visibly whitened, powdered skin and hair, and fitted-out now as a French 'royal body'. When she walks towards the camera and pauses, symmetrically framed between the pavilion and its attendants, the suggestion is that she is on display for the French court as well as for us.[26]

Antoinette's brief liaison with Count Fersen aside, Coppola's lack of textural eroticism throughout *Marie Antoinette* is refreshing. In her discussion of the period piece or costume drama film, Stella Bruzzi highlights the importance of clothing. According to Bruzzi, the genre tends either to look

through or look at clothes (*Undressing Cinema*, p. 36). When it looks through clothes, it is usually to underscore the accuracy of costuming and thereby maintain claims to historic and/or literary authenticity. By contrast, when the costume drama looks at or foregrounds clothes it is usually to enact a textural eroticism such that clothes 'become essential components of a film's erotic language' (*Undressing Cinema*, pp. 36, 39). In a significant departure from this tradition, *Marie Antoinette* does not prioritize textural eroticism so much as the feeling of luxury by focusing on the making of royal bodies and their attendant privileges. Furthermore, while the film makes use of typical costume drama conventions such as clothing, setting, décor, and so on to capture its era of French absolutism (looking 'through' clothes), it uses textural expressivity to generate affective shifts in mood, tone, and atmosphere and project emotion on the sensuous surface of the film's body (looking 'at' clothes). The film's textural displays do not foster eroticism but other feelings such as insecurity, boredom, luxurious indulgence, surfeit, and foreboding. *Marie Antoinette* looks through clothing to capture the theatricality of the absolutist baroque and how power was bound up with appearances. At the same time, it looks at clothing and at the expressivity of texture to deploy its materialist aesthetic.

In this regard, it not merely by way of clothes that the film asserts the baroque history of Versailles. Rather, it is through its attention to surfaces and exteriors: costumed, human, decorative, and architectural. Framings of Antoinette either within or through reflective surfaces recur throughout. In her journey to the hand-over ceremony, the film's vision drifts between the inside and the outside of her carriage to watch Antoinette through its gilt-edged windows, drawing childish patterns on the glass. Returning to Versailles from a masked ball, close-up images of her hands, playing about in the air, are bathed in natural light. Accompanied by the song 'Fools Rush In' by Bow Wow Wow, the scene takes on a dreamy, atmospheric quality that is separate from life at Versailles for it is based in nature, and conveys subjective euphoria and intimations of love.[27] (She has just met Fersen, a 'breath' of fresh air, which the film's body expresses as the bluish chill of the morning light, with images of Antoinette leaning outside the carriage to take in the breeze.) Again, the film moves between the inside and outside of the carriage before returning to a close-up on Antoinette, re-framing her face through the windows as an object of display. In her earliest years at Versailles, the dauphine is seen as physically fixed in place by various ceremonial rituals or as a reflection that is contained within the many mirrored walls, halls, and surfaces of the palace. The film body's attention to the surface-based display of Antoinette is ripe with significance, if we

factor in the historic context of Versailles and its baroque linkages between luxury, wealth, and power.

In her study of seventeenth-century poetics, Bornhoefen asserts that for the baroque 'seeming *is* being' ('Cosmography and Chaography', p. 5). Likewise, Saisselin argues that the baroque (as a historic epoch and a specific mentality) can be identified as the 'conjunction of reality and appearance' (*The Enlightenment*, p. 6). Nowhere was that conjunction more prominent or perhaps necessary than at court, and Saisselin underscore its importance to Versailles in particular:

> This [baroque] psychology of appearance, or visibility was [...] the very essence of court life; it was important to be seen at court, to be noticed by the king. As Louis XV put it one day, noticing the absence of one of his courtiers: So-and-so must be sulking, since I do not see him. Thus the power of appearances, and the dependence upon the gaze of others.
> (Saisselin, *The Enlightenment*, pp. 31–33)

Not surprisingly, the conjunction of appearance with reality spawned equal parts anxiety and pleasure. This was an age that paid great attention to appearances, though it was also suspicious of them. As Saisselin writes, 'kings ought to look like kings, princes ought to look princely [...] and so on down the social scale' (*The Enlightenment*, p. 121). For the historic baroque, surfaces and exteriors were meant to be commensurate with inner being and with one's social status—an upstart social interloper or trickster should not *appear* more luxurious than those higher up. At Versailles, the cult of appearances was at once a form of power, a source of pleasure, a cultural currency, and a means to socio-political advancement.

Begun in 1669 under the reign of Louis XIV, the reconstruction of Versailles as the French royal residence and the official seat of government was incredibly expensive, taking decades and considerable manpower.[28] The world contained therein was also one of the most complex iconographic programs undertaken at the time (Martin, *Baroque*, p. 148; Ndalianis, *Neo-Baroque*, p. 51). Reflective of the baroque desire to display or be seen, the architectonics of power at Versailles represented the French monarchy as not just the 'absolute of political power' but also as the 'center of the cosmos in its entirety' (Marin, 'Classical, Baroque', pp. 168–170). Versailles deliberately staged monarchical as divine power, conflating Louis XIV (also known as the Sun King) with the mythological figure of the sun god Apollo. In 1674 André Félibien wrote that, 'since the Sun is the emblem of the King and since the poets confound the Sun and Apollo, there is nothing

in this superb residence that is not related to this divinity' (qtd. in Martin, *Baroque*, p. 149).

Rays of sunlight closely associated with Apollo and, by consequence, Louis XIV (the 'light of the world') appear throughout the palace. The image of the sun in splendour governs the design of the entire complex: it is evident in the long avenues that radiate out from the palace; it appears in the vast formal gardens of Le Nôtre; on the front gates; within the paintings and frescoes of interior decoration; and it adorned the courtly festivals, fireworks, music, and dancing that were held there (Martin, *Baroque*, p. 149; Ndalianis, *Neo-Baroque*, p. 51). There is little dispute that the image of the sun-in-splendour was an attempt to manufacture royal power as god-like and itself a divine birthright.[29]

There is, however, another baroque story to the history of Versailles. Alongside its staging of absolutist power, the court of Versailles was ensconced in ontological games that took pleasure in the shifting semblance of appearances. As it was practised in the *Galerie des Glaces* (Hall of Mirrors), the Sun King and his courtiers paraded, 'danced and postured in front of endless recreations of their masked selves' and one of the most extravagant mirrored interiors of its age. The inside and outside surfaces of the palace intertwined, as light emitted from the glass windows opposite in the *Galerie des Glaces* created a virtual 'arcade of light, transmitted and reflected' (Bornhoefen, 'Cosmography and Chaography', p. 3; Friedberg, *Virtual Window*, p. 109). While an attempt to outdo the *Salon de los Espejos* in Spain (another Hall of Mirrors), the *Galerie des Glaces* was a site of pleasure for its courtly participants. Embellishing the theatrics of Versailles proper, its mirrors functioned as 'spectacle and audience, endlessly confusing the representation with the representer until *all being must have seemed an intricate illusion, an infinity of appearances*' (Bornhoefen, 'Cosmography and Chaography', p. 3; italics mine). The baroque delight in surface-as-essence found a welcoming home within these mirrored halls.

For me, these connections between power, pleasure, surface, and appearance can be mobilized to identify a definite baroque sensibility to the display of Antoinette. These concerns will also help foreground Coppola's film as an encounter with baroque luxury. According to Saisselin, the baroque correspondence between reality and appearance had an outward manifestation in the guise of luxury. The 'luxury of ostentation was external glitter, visible show, and unmistakably baroque' (Saisselin, *The Enlightenment*, p. 103). If luxury was one of the foremost signatures of the historic baroque, it was thanks to its rampant culture of spending. In its pursuit of and desire to present luxury through visible signs of wealth, status, and

prestige, this was an era in which 'the aesthetic and the economic were inextricably mixed—a time when gold was specie as well as plate, exchange value as well as beauty, but sometimes also mere false glitter' (Saisselin, *The Enlightenment*, pp. 11–12). According to its eighteenth-century critics, luxury was the guiding passion of the baroque; society was considered to be virtually crippled by the pursuit of wealth. In contrast to the baroque, the Enlightenment drew firm distinctions between art and economics. It sought to penetrate rather than glorify appearances by distinguishing between art and luxury, taste and fashion, morality and aesthetics. It is for this reason that Saisselin asserts that revelry in 'luxury and spending may well be emblematic of a signal difference between the Baroque and the Enlightenment' (p. 37).

In *Marie Antoinette*, Coppola invokes the luxury as well as the representational posturing of Versailles. Luxury is brought to the fore during Antoinette's initial encounter with the royal French court at the palace. As a lengthy procession of carriages and horses crosses the frame, carrying Antoinette to her new home of Versailles, the film's body opens wide in a massive long shot to take in the sheer expanse of the grounds and the palace at the centre of the horizon. This impressive scale shifts upon Antoinette's arrival, as she is met by two crowded rows of the court. The expressions of the film's body become noticeably nervous, in sympathy with Antoinette's own response to the court. Its expressions here are quite unlike those of later sections: the vision of the camera stays close and darts between intimate shots of Antoinette and its own unsteady, roving perspective through a sea of what appear to be largely curious, disdainful, and unwelcoming faces. Antoinette's entry into the royal palace begins with an upturned view of its elaborately decorated and frescoed ceilings, descending to take in the hustle and bustle of servants and bowing courtiers below. The nervous vision of the film continues as she makes her way through the palace, passing from one splendidly furnished room to the next.

What the film's body fittingly expresses here is its ingénue awe at the splendour on show. Neither the character of Antoinette nor the sensible expressions of the film's body can be said to be fully 'at home'; they have not reached a baroque equilibrium with luxury nor have they begun to revel in it, as Saisselin claims.

The shifts in image scale continue, as our eyes are beckoned towards and flit between a series of glittering surfaces. The tinkling sounds of crystal chandeliers reverberate. A jewellery box is opened that reveals still more expensive contents within. A close-up of a fan is splayed across the frame, exposing yet another layer of patterning. The film's body directs its attention

Fig. 7: Baroque revelry in luxury and in surfaces in *Marie Antoinette* (2006). Columbia/American Zoetrope/Sony/The Kobal Collection.

vertically towards the ceiling or else it travels across the breadth of rooms to capture their size. The layering of luxury within the palace is matched by views of the stately gardens outside, replete with gushing fountains and their own vast geometric patterns. Opulence subtends all perceptual scales of the image. Just as Antoinette cannot resist the compulsion to run her hand along furnishings (as if to familiarize herself with this new luxurious world) neither can the film. The vision of the film's body lingers on and across the surfaces of Versailles as surely as Antoinette's hand does, trailing itself across newfound textures and materials in an effort to acclimatize itself with such surroundings. As Merleau-Ponty puts it, writing of the latent tactility of perception: 'things attract my look, my gaze caresses the things, it espouses their contours and their reliefs' (*VI*, p. 76). Similarly, the gilded baroque world that the film's body expresses in *Marie Antoinette* accords with the surfaces of a material-visuality.

Fully commensurate with baroque flesh, then, is how movement, materiality, decorative décor, surfaces, and textures function as highly charged repositories of meaning in this film. Antoinette's initial lack of power and insecurity at court is channelled through the surface expressions of the film's body. Rather than assuming the courtly importance of being seen, Antoinette chromatically rhymes, echoes, or blends into the film's background. At the beginning of the film, for instance, Antoinette's

costumes chromatically rhyme with the *mise-en-scène* such as with the blue-on-blue colours that predominate during her journey from Austria to Versailles. Rather than assuming the baroque importance of being seen, Antoinette's human exterior appears almost indistinguishable from other decorative surfaces such as the wallpaper or furnishings of the palace. After reading a scolding letter from her mother, Antoinette is framed against flowered wallpaper in a dress that mimics its patterns. As she slowly sinks to the floor, the film's body matches itself to the pace of her movements and moves into a close-up. The details of the wall are then brought into focus as elaborate bouquets. Not only does Antoinette look as if she were part of its floral decoration, when she turns to face the camera the distressed details of her face indicate that she is at risk of fading into the very background of Versailles. After furious whispers, asides, and demands for a royal heir from courtiers in the halls, Antoinette flees to a private room. Here, the film once again expresses materially resonant parallels between her dress, her flailing political position, and the décor of the *mise-en-scène*. In close-up, we watch Antoinette crying against gilt doors in a pale gold dress. The film then cuts to a medium shot in which she rests her head upon her knees in a corner. Portrayed as a crumpled pool of silk on the floor, Antoinette is strikingly and texturally analogized to the gathered gold fabrics of the curtains that she sits beside.

Expressive movement, too, is crucial to articulating Antoinette's precarious position at court. In one of the most stunning uses of the palace in the film, Antoinette stands against one of the enormous window bays of its balcony. Having recently been admonished by her mother for snubbing Louis XV's concubine, the camera then moves further and further away, re-configuring Antoinette as a lone fleck of colour against the immense exterior. The receding movements of the film are analogous to and in sympathy with Antoinette's own receding reputation at court, her steadily diminishing favour with the king and the imminent possibility of an annulled marriage. When the court physician visits Antoinette and Louis XVI to resolve the unconsummated marriage, the camera's intentional focus drifts away from the couple to fasten on the marital bed, where the real source of the 'problem' lies (Louis' delay in consummating their marriage).

At one point, the multiplicity and mobility of baroque vision (as a series of dynamic or proliferating centres) is assumed (Zamora, 'Magical Ruins', pp. 79–80). Seated with the court at dinner, the camera roves between Antoinette's face and the court as it circles about the table. The film's body conveys a complex and suitably baroque layering of voices and alternative points of view through its conjunctions of movement and sound. Overlaid

murmurings are heard: 'the countess is looking rather dour'; 'I suppose she's rather sweet for an Austrian'; 'I think she's delightful, she looks like a little piece of cake'. As the camera remains ambient throughout, the source of each voice is not readily apparent and a disjunction between sound and image occurs. As Anna Backman Rogers points out, the film's layered soundscape results in a 'seamless stream of gossip in hushed tones' in which Antoinette is at the centre of discussion but very much on the outside, echoing the ways in which gossip, rumour, and propaganda assumed a life of their own at Versailles and in the history of Antoinette herself ('Sofia Coppola').

Extending Rogers' analysis, I would point out that what needs to be underscored here is that, while many visible signs of wealth have been on show, neither Antoinette nor the film's body have engaged in revelry or pleasure in luxury, as would be commensurate with the baroque. For this reason, it is not only the character of Antoinette but also that of the film's body that seems outside or ill-suited to the sensibility of the French court. Boredom and monotony suffuse this film's portrayal of Antoinette's early years at Versailles. Little happens and long periods of waiting or dead time predominate as the same courtly rituals, gestures, and music repeat while only the fabrics or the food changes. Given its interest in the intensity of the passions, whether pleasurable or aversive, the impact of baroque flesh can be considered anything but boring.[30]

It is not until Antoinette begins to stage power through surface appearances, through spectacles of entertainment and through her own consumption—just as Louis XIV did at Versailles—that Coppola's film assumes an appropriately baroque guise of pleasure in luxury. As Saisselin and Ndalianis maintain, the baroque is dedicated to the pursuit of pleasure (*The Enlightenment*, p. 89; *Neo-Baroque*, p. 171). In historic terms, this state of affairs arose because the 'noble life' of the seventeenth century had an obvious 'love of luxury and pleasure' (Saisselin, *The Enlightenment*, p. 16). The historic baroque wedded luxury to an 'aesthetics of pleasure' and it pursued flagrant expenditure and wealth as the 'aesthetics of divertissement and pleasure', in and for itself (Saisselin, *The Enlightenment*, pp. 89, 104).

A pointed shift in the film's affective tone occurs with its fast-paced, rhythmic montage of Antoinette's spending and Antoinette's 18th birthday party, and by the exuberance of the film's body in these scenes as well. Played out to the song 'I Want Candy' by Bow Wow Wow, baroque pleasure and revelry in luxury is initiated by the film's pan across multi-coloured (Manolo Blahnik designed) shoes and through ensuing scenes of rampant expenditure. The film presents us with vibrant reams of fabric and ribbons,

all available for purchase; with images that focus on the splaying of beautifully decorated fans, laid one on top of the other and with jewels fitted around pale skin. Such luxurious wares are interspersed with elaborately decorated cakes, candies, and patisseries (with the colour palette of the film now reflecting the unrestrained palates of the bodies contained therein); granules of pink sugar or remnants of cream left on empty plates or lips; and champagne flowing into crystal glasses or bubbling over in stacked glass towers that reach to the ceiling.

The careless abandon with which a glass of champagne is knocked over as gambling chips simultaneously topple is telling of the kind of luxurious extravagance that Versailles has come to represent. And yet, Coppola's re-imagining of life at Versailles is not that far removed from its historic baroque circumstances. Here, we might take note of Saisselin's cogent analogy between cash flow and water flow to help distinguish between baroque and non-baroque spending (*The Enlightenment*, p. 13). For the baroque, entertainments were intransigent, ephemeral, and a pleasure for their own sake, as is befitting of an unrestrained flow of capital (Saisselin, *The Enlightenment*, p. 14). Baroque spending is about displays of power or taking pleasure for its own sake, as is reflective of an unchecked flow of capital—much like running water (*The Enlightenment*, p. 14). *Marie Antoinette* conjures up just such a baroque love of expenditure—lingering on the constant flow of champagne, the flow of silk dresses or other expensive fabrics across the floor, the depiction of fireworks and other spectacles of consumption, and the flow of bodies-in-movement that populate the film's frequent scenes of partying, gambling, and spending. Unrestrained pleasure in luxury gives way to imagery of surfeit and bloating. Such surfeit is realized in the aftermath of Antoinette's parties through the film's attention to forgotten plates of food, burnt-out candelabras, sleeping bodies, and languid movements, such as when Antoinette and her entourage lazily trail their fingertips across the lake of her private retreat.

Unlike those scholars who have claimed an ironic distance or commentary to the excessive consumption of *Marie Antoinette*, I would counter that we are invited to participate in its baroque embodiments of history and the living of a luxurious life through the sensible expressions of the film (Diamond, 'Sofia Coppola's', p. 212). From the up-beat tempo of the music, the energetic rhythms of film editing, the privileging of gesture and physical movement, and the film's own material-visuality, we are encouraged to feel the richness of Antoinette's life at Versailles, rather than watching it with the eyes alone (Cook, 'Portrait of a Lady', pp. 39–40; Rogers, 'Sofia Coppola'). Similarly, we feel the film's body's tangible impressions of surfeit, expressed

to us through its sleepy or lolling movements, indicative of those who know no restraint and have consumed too much.

Having approached Coppola's *Marie Antoinette* through its embodiments of baroque luxury, it seems fitting to conclude with Benjamin's baroque history as a kind of ruin. For Benjamin, 'history does not assume the form of the process of eternal life so much as that of irresistible decay' (*The Origin*, pp. 177–178). Benjamin's ideas resonate beautifully with *Marie Antoinette*. Coppola's film is, after all, situated on the cusp of revolution—in the passage from an absolutist culture that was nearing its end towards the Enlightenment (an alternative mentality that was totally at odds with the sensuality of baroque spending). The absolutist culture of hedonism and expenditure that *Marie Antoinette* depicts could not sustain eternal life but only hasten decay. The dissolution of royal French absolutism is signalled by the sensible expressions of the film's body, especially in terms of its affective shift away from baroque pleasure in luxury. The sombre tones, shading, and atmosphere that pervade Antoinette's last years at Versailles indicate as much. The end of the French monarchy is hauntingly crystallized by the film's final image, as it dwells upon the devastation of Antoinette's bedroom wrought by the revolution. The film's body is in quietude and utter stasis here, pondering a ruinous landscape of torn doors, curtains, and once gleaming chandeliers that are now smashed upon the floor. The inequitable expenditures and luxuries of life at Versailles did not last forever, though the baroque finds a renewed historicity and another depth of the surface in baroque cinema.

Skin-Deep: Baroque Texturology

The skin is comprised of three layers: the epidermis, the dermis, and its inner subcutaneous tissue (Freeman-Greene, 'Scratching the Surface', p. 14). These layers help mediate between the body's surface and its hidden but nonetheless perceptive interior. The epidermis of the skin is the largest, most sensitive of the human organs, responsible for registering the sensations of touch, temperature, weight, and pain (Montagu, *Touching*, p. 3; Benthien, *Skin*, p. 6). In his book *Touching: The Human Significance of the Skin*, Ashley Montagu documents the role of the skin as both an organ of sensation and as a source of communication. Touch, along with skin sensitivity, is the first of the senses to emerge during embryonic development. At eight weeks old, the embryo does not have ears or eyes yet its skin sensitivity is remarkably developed. This is a telling indication of the enduring sensuous significance that the skin bears throughout our lifespan (Montagu, *Touching*, pp. 1–2).[31]

As Montagu explains, contact through the skin is essential for new-borns. Stimulation of the skin through 'tender, loving care' satisfies the most basic demands of the kinesthetic and muscular senses; it activates the newborn's nervous system, respiratory centres, and the viscera, helping to improve the oxygenation of the blood (Montagu, *Touching*, pp. 81, 54, 69). Just as the newborn requires cutaneous contact for their healthy development (to be held, stroked, caressed, rocked, and reassured) so does our reliance on the skin continue into adulthood.[32] The 'closer' that we feel to another, the more we want to make tangible contact with them by connecting their skin to our own. We might shake the hand of a new acquaintance, a colleague, or our boss but to those nearest and dearest to us we hold them in an embrace, we kiss, and we offer up piggyback rides. For our pets, family, and lovers, we reserve the intimacy of the skin through the pleasurable, comforting warmth of touching our skin against another's physical surface.

This section is not concerned with the physiological specifics of skin as such, as these will surface in Chapter 4. Here, I want to use the site of the skin to lend texture to baroque flesh. In her book *Skin: On the Cultural Border between Self and the World*, Claudia Benthien notes that the skin occupies a dual register in culturally conceived notions of the self. Either the epidermis is viewed as a protective layer that envelops, hides, and shelters the self within or the skin is equated, metonymically, with the body and the self as a whole (Benthien, *Skin*, pp. 17–19). The fact that the self has been configured as either buried inside the skin or equivalent to its surface suggests that different meanings can be attached to this site, includ-ing those of aesthetics. As I have discussed, the historic baroque viewed surface appearances as equivalent to inner being and depth. Baroque flesh, then, needs to attend to a feeling self in which texture, materiality, and surface sensitivity are paramount. This is because baroque flesh intertwines subjective feeling with the expressivity of sensuous surfaces. This is not to imply that the baroque is 'superficial' in a pejorative sense, far from it. Rather, baroque flesh harnesses the sensuality of surfaces to express and engender feeling. Such surface sensitivity provides the baroque with a means of 'reaching skin-deep' (Bal, *Quoting*, p. 27). Reversals between the inside and the outside and surface and depth are yet another means by which the baroque lends concrete form to Merleau-Ponty's 'flesh'. By demonstrating the formal and the film-philosophical overlaps that connect the surface and the skin with feeling and with an emotional and subjective 'depth', I hope to arrive at the possibility of a baroque texturology that can be extended to cinema.

Many emotional experiences can be related to texture, and to the textures of the skin especially. In a lovely comment, Montagu observes that

> life's most intimate moments are associated with the changing textures of the skin. The hardened, armor like resistance of the unwanted touch [...] the exciting, ever-changing textures of the skin during love-making, and the velvet quality of satisfaction afterward are messages of one body to another that have universal meanings. (*Touching*, p. 211)

In her book *Touching Feeling: Affect, Pedagogy, Performativity*, Eve Kosofsky Sedgwick also underscores the close connections between skin, touch, texture and variations in feeling. As she asserts, if 'texture and affect, touching and feeling seem to belong together' that is because what they share 'in common is that *at whatever scale they are attended to*, [they] are irreducibly phenomenological' (Sedgwick, *Touching Feeling*, p. 21). Texture, in particular, reverberates on a tactile, visual, and emotional level and it can be felt across the bodily senses (pp. 15–16). While it usually inhabits the nebulous borders between vision and touch, texture is not 'coextensive with any single sense' such as when we can taste and hear the crispness of biting an apple or feel the audible crunch of eating crispy egg noodles (p. 15).

Touch, taste, and smell are all proximate senses but it is touch and the skin that are most commonly associated with the intimacy and intensity of feeling. Analogies, metaphors, figurations, and descriptions of the skin are often invoked in language to express the traits of an innermost, feeling self. If I feel too much, too keenly or too deeply, then I am said to be 'thin-skinned', 'touchy-feely', or a little 'touchy'. If I feel too little, I am purported to be 'thick-skinned' and immune to the depths or display of feeling. Through phrases such as you 'get under my skin' or you 'touch me to the quick' we convey how our strongest feelings are experienced as deep *inside* the skin, such that we feel an emotional state to our core (Montagu, *Touching*, p. 110; Benthien, *Skin*, p. 22). Such expressions are not mere figural decoration. Skin analogies help us 'express emotions and states of being that language is incapable of grasping directly' (Benthien, *Skin*, p. 211). In this regard, figural expressions and motifs of the skin are every bit as important as lived, literally embodied experience and a 'necessary form of knowledge and expression' (Benthien, *Skin*, p. 211).

Scholars such as Sedgwick, Montagu, and Sue Cataldi have all argued for the meaningful connections that subsist between skin, texture, and emotional experience (Sedgwick, *Touching Feeling*, p. 17; Montagu, *Touching*, p. 110; Cataldi, *Emotion*, pp. 89–148). For Sedgwick, to 'even talk about affect

virtually amounts to cutaneous contact' as the term 'touching' already implies a doubled meaning (the tactile/emotional) and that doubled register is equally present in the term 'feeling' (*Touching Feeling*, p. 17). Cataldi, in her *Emotion, Depth and Flesh*, offers us an even more appropriate inroad to the conjunctions of skin, surface, and texture with feeling in baroque flesh. By drawing upon Merleau-Ponty's 'flesh', she argues that both 'tactile and emotionally felt feelings overlap' and that they are in fact reversible (*Emotion*, p. 128).

As Cataldi remarks, we never just 'think' of textured qualities such as that of the slick or the smooth. This is because we have already lived and felt texture through the sensitivities of the skin. Emotions, too, have varying textures or affective 'tones' to them that are suggestive of how feeling and atmosphere are palpably textured. Terror, for example, is 'chilling', whereas lust 'is steamy—hot, moist. Boredom is dry—stale and stifling. Serenity is smooth. Gratification has a plush, or lavish felt feeling to it. Anger is felt to be a "wearing thin" of patience. In fatigue, we are simply "worn out"' (Cataldi, *Emotion*, p. 133). Insofar as our descriptions of feeling foreground such skin sensitivity, the emotions themselves can be said to possess distinct textures. The 'texturally descriptive' and sensually enlivened mode of analysis that Cataldi opens up for the emotions is entirely apposite to my study of baroque flesh (*Emotion*, p. 132). The figural sensuality of baroque art and film renders subjective feeling visible and sensuously available to others, through its overt privileging of texture, skin, and different material surfaces. Baroque flesh makes for a highly materialist aesthetic.

On this front, the art historic work of Wölfflin is insightful. His considered attention to the textural appeals of baroque art and its sensuous renderings of skin, flesh, and fabrics pre-empts the texturing of feeling that I would claim for baroque flesh and for a baroque cinema. In the second quotation that opens this chapter, Wölfflin writes of how the baroque (or what he also labels the 'painterly' style) makes the eye highly sensitive to texture. In the baroque, vision, texture, and touch knot synaesthetically. Here, the visual is demonstrably nourished by the tactile sense as the baroque 'relishes the kind of surface, the different skin of things' (Wölfflin, *Principles*, p. 27). The historic baroque arts certainly delighted in creating heightened textural illusions. Take, for example, the exteriors of its church façades and architectural columns with their supple impression of movement via the use of advancing and retreating contours. Alternatively, consider the innately pliable and transmutating surfaces of baroque artworks: Bernini's use of cold and hard marble gives the impression of soft, yielding flesh that glows, faintly, like translucent skin (Martin, *Baroque*, pp. 48–50).

Bal evocatively describes baroque art as in love with its own 'sensuous textures, its luscious form[s], its veneration for the human body as flesh—sensuous and beautiful' (*Quoting*, p. 73). One need only think of the 'voluptuous movement of nude flesh' in Rubens or the sculptures of Bernini to realize that the historic baroque is a dedicated art of skin, surface, and texture (Martin, *Baroque*, p. 50). Similarly, Svetlana Alpers points to the fact that it is the 'surfaces, the materials of the world that [catch] the eye' in seventeenth-century Dutch art, with its intricate, fibrous rendering of 'apparel, the satins, furs, stuffs, velvets, silks, felt hats, feathers, swords, the gold, the embroidery, the carpets, the beds with tapestry hangings, the floors so perfectly smooth, so perfectly solid' (*Art of Describing*, p. 30). In this regard, the historic baroque arts set the stage for the kind of texturology that has since been reprised by baroque cinema.

In *The Fold*, Deleuze draws upon Wölfflin's art history to establish the baroque as a set of 'material traits' (p. 4). Alert to the mass, movement, and materiality of baroque forms, the philosopher advances what he calls a baroque texturology. According to Deleuze, any baroque 'conception of matter, in philosophy as in science or art has to go up to that point, to a *texturology* [...] matter is a buoyant surface, *a structure endowed with an organic fabric*' (*The Fold*, p. 115; italics mine).[33] Like his evocative figure of the fold, the concept of texturology is another testament to Deleuze's materialist appreciation of the baroque. It has since been adopted by Mieke Bal in her work on contemporary art and by Giuliana Bruno, in her exploration of film (*pellicule*) as at once a material surface, architectural site, and screen. In her book *Surface*, Bruno is not invested in a baroque cinema as such. Nevertheless, the rewards of drawing on Deleuze's philosophical engagements with the baroque soon become clear. This is because texturology, together with Deleuze's sensuous conceptualization of the fold, produces a 'textured philosophical fabrication. It has a palpable quality, a material culture, a tissue-like texture' that can find cinematic 'correspondence on the screen, in the material display of film' (*Surface*, p. 20). In Bruno's take on the 'fabrics of the visual', materiality manifests on the surface of the film image as well as in the body/mind of the viewer to generate 'reciprocal *contact*' between them as a tangible exchange (*Surface*, p. 3). If, as Bruno suggests, an artwork or film is not just a text but 'textural for the ways in which it can show the patterns of history'—wearing its own history like an outer coating, garment, or fabric—a baroque cinema of the senses is well suited to such textural displays for it wears its history on the surface of things (p. 5).

Like Bruno, I consider texturology to be a fine means of engaging with the textures of cinema. If we return to the baroque origins of Deleuze's

texturology, though, we might take particular note of how the philosopher frames the baroque as concerned with matter and with '*a structure endowed with an organic fabric*' (*The Fold*, p. 115). Rather than approaching the baroque as chaotic or maddening, Deleuze's texturology hints at the material-visuality of the baroque—a materiality that manifests on the outer cloth, fabric or surface coating of its aesthetic organization. Texturology also recalls Wölfflin's insightful thoughts on the baroque 'skin of things' (*Principles*, p. 27). Baroque flesh demands that we attend to its materialist aesthetic, to 'the image's skin' and to the 'surface as skin' as the sensuality of reaching skin-deep becomes a primary mode of engagement (Bal, *Quoting*, p. 30).

As Deleuze suggests, 'matter has not only structures and figures but also *textures*' (*The Fold*, p. 115). In *The Fold*, he then goes on to describe the baroque as privileging 'the texture enveloping the abstract structure', singling out Bernini and Caravaggio as artists who filtered their abstract structures (scenes of ecstasy and transcendence, death and martyrdom) into a baroque texturology (*The Fold*, pp. 115, 122).[34] As Deleuze is careful to point out, a baroque texturing of sensation is not about '*simply decorative effects*' (*The Fold*, p. 122). Rather, texture helps the baroque convey 'the intensity of a spiritual force exerted on the body, either to turn it upside down or to stand or raise it up over and again, but *in every event to turn it inside out and to mold its inner surfaces*' for our external apprehension (Deleuze, *The Fold*, p. 122; italics mine).

Deleuze and Wölfflin resonate well with one another here. Indeed, the art historian and the philosopher can be productively read side by side to help underscore baroque flesh as a textural phenomenon. According to Wölfflin, the baroque is expressive of 'the surface of things' and 'how objects feel' (*Principles*, pp. 33–34). He asserts how the baroque 'eye is first interested in the sensual life of the surface', so much so that 'the texture of [its] fabric is more important than formerly' (Wölfflin, *Principles*, pp. 38–39). This textural turn can be evidenced by one of the foremost signatures of baroque art and its innate love of textured surfaces: rich, undulating folds of stylized drapery.[35] In *The Fold*, Deleuze later makes use of the French term *pli* to evoke the figure of a pleat or twist of fabric as well as the vital origins of life.[36] His conceptualization of the baroque-as-fold is at once 'a materialist figure and a form [that bears] almost infinite conceptual force' (Conley, 'Folds and Folding', p. 170).

Inspired by the infinitesimal thought of the seventeenth-century philosopher Gottfried Wilhelm Leibniz, Deleuze identifies the baroque as a trans-historic operative function ('it endlessly produces folds') (*The Fold*,

p. 3). More specifically, Deleuze offers up his own definition of the baroque as 'the fold to infinity': the baroque 'twists and turns its folds, pushing them to infinity, fold over fold, one upon the other' (*The Fold*, pp. 122, 3). Significantly, for my purposes, the fold is not just an optical approach to the baroque. Deleuze himself intimates as much by positing that an optical baroque—even the baroque conceived as its own spectacular optic—is too restrictive. For Deleuze, 'the operative concept of the Baroque is the Fold, everything that it includes, and in all its extensiveness' (*The Fold*, p. 33). Bound up with a strong sense of movement in and through space, as this might accommodate the baroque 'in all its extensiveness', the fold makes for an innately sensuous philosophical concept. Unlike Buci-Glucksmann, Deleuze's fold captures how the baroque perceives and expresses the world through movement, materiality, dynamism, and inter-connection, thereby folding between matter and mind (Deleuze, *The Fold*, pp. 3, 34–35; Zamora, *Inordinate Eye*, p. 267).[37] The Deleuzian fold is at once a visual, spatial, and *textural* concept (Deleuze, *The Fold*, pp. 34–37). Deleuze insists upon the baroque as arresting movement, spatial traversal, and tactile dynamism and baroque aesthetics as a highly textural encounter, as Wölfflin had done previously. Together, the privileging of texture and of the surface in historic baroque art and Deleuze's philosophy of the baroque fold affirm just how important embodied vision, movement, and materiality is to any conception of baroque flesh.

Given my efforts in this book to explore the neglected parallels between Merleau-Ponty's philosophy and the baroque for cinema, it is not surprising to find that 'flesh' is sensitive to texture.[38] In *The Visible and the Invisible*, Merleau-Ponty writes that the 'flesh' '(of the world or my own) is not contingency, chaos, but *a texture that returns to itself and conforms to itself*' (p. 146; italics mine). Following on from Merleau-Ponty, Michel de Certeau elegantly asserts that the 'flesh' of the world is a 'mobile texture' that moves between 'seeing and seen objects. It is the stuff in which the inner folding, unfolding and refolding takes place' ('Madness of Vision', p. 25). Lest the connections to the tactile, textured folds of baroque form be missed, Merleau-Ponty even models the structural reversibility of 'flesh' as two sides of a fabric: most notably, as 'the finger of a glove [...] turned inside out' (*VI*, p. 263). More recently, Sobchack describes the ontology of 'flesh' as a contour in process and one that reconstitutes itself continuously (*Carnal Thoughts*, p. 99).

While their philosophical premises differ, Deleuze's concept of the fold and Merleau-Ponty's 'flesh' can be brought into dialogue. Both 'flesh' and the fold are steeped in movement, texture, and materiality, although Deleuze's fold differs from 'flesh' in that it is bound up with the immaterial, moving

between the sensible and the intelligible (*The Fold*, p. 3-4). According to Conley, what the fold expresses is 'the continuous and vital force of being and becoming' ('Folds and Folding', p. 180). For Deleuze, the baroque moves between two particular vectors or levels: what he calls 'the pleats of matter' and the 'folds in the soul' (inner mental life) (*The Fold*, p. 3). These two levels are considered separate but united by the 'fold that echoes itself, arching from two sides', like a seam or crease in the surface of a cloth (*The Fold*, pp. 4, 29). Though Deleuze is ultimately concerned with folding the soul or mind into matter, the sense of 'double belonging' that he articulates in *The Fold* is not radically dissimilar to the renewal and reversibility of 'flesh' (*The Fold*, p. 33).

If there are productive continuities to be found between Deleuze and Merleau-Ponty, these lie in Merleau-Ponty's later writings and in his unfinished *The Visible and the Invisible* especially. As I flagged in my introduction, it is here that Merleau-Ponty shifts from a subject-focused phenomenology towards ontology, couched in ideas of perpetual movement, transition, and materiality. Similarly, his language shifts away from subject–object dichotomies to embrace a definite 'two-foldedness' wherein terms such as intertwining, *chiasm*, enlacing, fold, fabric, encroachment, knotting, and divergence now predominate. As Leonard Lawlor notes, it is during this period that the philosopher 'conceives being not as subject but as infinity' through the infinite renewal and replenishment of sensibility ('End of Phenomenology', p. 28). In other words, we might assert that at this time Merleau-Ponty begins to conceive and articulate being as baroque more overtly.[39]

The two sides of Merleau-Ponty's ontology of 'flesh' are neither entirely separate nor completely unified. The seeing and the seen, the touching and the touched, and the sensing and the sensible are intertwined as two aspects of the same phenomena or field of possibility. As a mobile contour in process, 'flesh' moves like Deleuze's infinite baroque fold, like a reversible fabric or topological entities such as the Möbius strip. As a result, 'to move from "inside" and "outside" to "outside" to "inside" [is] one continuous motion. Outsides turn into insides and *vice versa*', in a way that Deleuze's philosophy later develops as a fold between mind, body, and matter (Cataldi, *Emotion*, p. 111). In Merleau-Ponty's 'flesh', the roles of subject and object 'are not two opposed domains to be somehow united, they are both aspects of the same flesh: the flesh seeing itself, turned upon itself, overlapping itself, *folded upon itself, reversible*' (Cataldi, *Emotion*, p. 111; italics mine). Remembering 'flesh' as this mobile and vitalist 'structure of reversibility', let us more closely explore how baroque art intertwines and reverses the

properties of the inside and the outside (del Río, 'The Body as Foundation of the Screen', p. 103). We can then better appreciate the significance of these sensuous reversals for a baroque cinema.

Historically, the baroque privileging of texture resulted from its desire to convey feeling on the material surfaces of the body. The 'inside' of the emotions reverses to become visible on the 'outside' of the artwork. Given that the historic baroque also functioned as an art of analogy, its use of texturology helped to incarnate the force and intensity of feeling for the beholder. In 1668 the French painter Charles Le Brun catalogued approximately twenty-two emotions or 'passions' (from the expression of pure love to jealously and horror, to name but a few), detailing how passionate feeling manifested itself on the face through different external movements (Martin, *Baroque*, p. 89; Meyer, 'Introduction', pp. 3–4). Le Brun's catalogue is indicative of the baroque urge to translate internal feeling into an immediately sensuous experience that can be shared by others. Similarly, artist Nicolas Poussin once commented that 'the lineaments of the human body serve to express the various passions of the soul and *to make outwardly visible what is in the mind*' (qtd. in Martin, *Baroque*, p. 86; italics mine). In a baroque texturology, the emotions are never a self-enclosed or invisible affair. Through different modes of corporeal display (tell-tale looks, heightened gestures, movement, bodily comportment, frontal address, facial aspects) as well as an attention to what Wölfflin calls the skin of things, baroque art fosters a structural circularity (*Principles*, p.27). Coiling feeling upon feeling and bodies upon bodies, the 'inside' becomes the 'outside' as the internal dynamics of emotion become available for our inter-subjective apprehension.

Bernini is one such artist who demonstrates baroque texturology at work, as convulsions of flesh, fabric, and folded drapery are one of Bernini's trademarks for the depiction of inner states of feeling (Boucher, *Italian Baroque Sculpture*, p. 138). In both his *Teresa* and his *Blessed Ludovica Albertoni* (Altieri Chapel, San Franceso a Ripa, Rome, 1671–1674), agitated, tactile folds of drapery convey the passionate internal feeling of ecstasy.

Lest the importance of skin and texture in the surfacing of an emotional depth be missed, consider the following description of the *Ludovica* by Giovanni Careri. As Careri writes, the sculpture stages 'movement from the depths to the surface' (*Bernini*, p. 74). This movement assumes the 'emblematic form of a flaming heart' on the sarcophagus and 'the emotional form of a colorful fabric' that moulds itself to the contours of the Ludovica's body (Careri, *Bernini*, p. 74). Both the emblem and the fabric, together, express 'the depths of the blessed's soul [as it is] brought to the surface' so

Fig. 8: Gian Lorenzo Bernini, *Blessed Ludovica Albertoni* (1671-1674). The Art Archive / Gianni Dagli Orti.

that her divinity can be sensuously communicated to and experienced by the beholder as well (Careri, *Bernini*, p. 74). As with the baroque semiotics that concern this chapter, Careri notes the all-important role of the skin and the sign in the passionate surfacing of Bernini's sculpture.

> [T]he emblem provides a conceptual representation of Ludovica's emotion, the drapery provides a very concrete one, transforming the depths of her soul into an extremely sensitive membrane full of folds and creases, covered by a sort of flushed epidermis streaked with a tangled network of veins. If the drapery represents the very depths of Ludovica's soul through a surface [...] it [also] represents the immaterial through the concrete. (*Bernini*, p. 75)

Here, the analogical impetus to create an embodied connection between the divine and the earthly is channelled through surface textures and the figuration of the emblem. The marbled skin of the *Ludovica* sensitizes and makes contact with the skin of the beholder, tethering the immaterial (the soul) to a physically concrete sensuality.

Similar reversals between the inside and the outside of the artwork are also enacted by seventeenth-century Dutch still lives, as evidenced by their common technique of 'flaying' worldly objects to better reveal their interiors. According to Svetlana Alpers, the still life explores the 'multiple surfaces' of objects to make them 'more fully present' (*Art of Describing*, p. 91). This tradition makes visible and textural the material make-up of different worldly phenomena, from edibles (cheeses, fruits, nuts, fish) to collectibles (shells, vessels, and watches). Through a peeled lemon, the still life shows us the hard outer rind of the fruit and the inner pulp to which it is attached. Cheeses are sliced into or pies presented with their fillings spilling out. Fish are cut open, simultaneously exposing the gleaming scales of their skin, their fleshy interior, and their tiny bones. Containers or glassware are toppled onto their sides and watches opened, revealing the mechanics of their working interiors (Alpers, *Art of Describing*, pp. 90–91, 163). Through the subtle play of light, we are encouraged to discern still further layers of texture by distinguishing the gleam of glass from the glint of jewellery or precious metals or the texture of a finely woven cloth as opposed to a crumbling pastry (Alpers, *Art of Describing*, p. 91).

The Deleuzian fold also testifies to an intertwining of the inside and the outside on the part of the baroque. For Deleuze, 'such is the Baroque trait: an exterior always on the outside, an interior on the inside' before going on to observe how the 'fold separates or moves between matter and soul, the façade and the closed room, the outside and the inside' in lived as well as aesthetic experience (*The Fold*, p. 35). Though not concerned with the fold between matter and mind, Merleau-Ponty's 'flesh' speaks to reversals between the inside and the outside that are also commensurate with a baroque texturology. As he writes, what 'we call a visible is, we said, *pregnant with a texture, the surface of a depth*, a cross section upon [the] massive being' that is 'flesh' (Merleau-Ponty, *VI*, p. 136; italics mine). Note well his description of a material or textured vision within the 'flesh' as well as its surfacing of a depth, for this is how I wish to approach the skin-deep sensitivity of a baroque cinema. Here, texturology becomes even more materially charged because it is channelled through the mutually embodied exchange of film and viewer.

Bearing this background in mind we can recognize another ontological affinity between cinema and the baroque—their reversals of the inside and the outside and between the realm of surface and depth. In the skin-deep sensibility of the baroque, the material make-up of worldly phenomena as well as subjective states of feeling will be made visible, sensible, and textur-ally available. In coming to terms with a baroque cinema of the senses we

must consider how reversals between the inside and the outside are enabled by the ontological dynamics of the medium itself. This is because subjective vision and feeling are *'directly* felt' and *'sensuously* available' to the viewer, through the inside-out as well as sensible entity that is Sobchack's concept of the film's body (*Address of the Eye*, p. 8). While the technological means by which insides and outsides reverse is different to the baroque of the past, the circularity of feeling that is exchanged between bodies, as well as the coiling up or folding back of the sensible that is particular to baroque flesh, remains.

Here, we would do well to remember Merleau-Ponty on the 'flesh': 'Start from this: there is not identity, nor non-identity [...] there is inside and outside turning about one another' (*VI*, p. 264). In baroque art and film, the inside of feeling manifests on the outside surfaces of the aesthetic expression. In turn, baroque flesh relies on the outside of its aesthetic expressions to solicit our affective inside. The baroque lends aesthetic form to 'flesh', whereby 'the inside of the outside and the outside of the inside' will intertwine and reverse (del Río, 'The Body as Foundation of the Screen', p. 103). Skin, texture, materiality, and the expressivity of the surface hold a very special lure for baroque flesh and its art of entanglement. Texturology and the turning of the emotions inside out is another means of the baroque achieving its sensuous exchange.

In coming to grips with the formal and film-philosophical possibilities of a baroque cinema of the senses, we cannot afford to cling to hermetic accounts of emotion and feelings that are closed off in their own introspective reality. For the baroque, the surface *is* the depth of emotion insofar as feeling will always be outwardly displayed. Likewise, Merleau-Ponty has argued for the inter-subjective communication of feeling through gesture, movement, physical behaviour, bodily comportment, and style.[40] As he cautions, we 'must reject that prejudice which makes "inner realities" out of love, hate, or anger, leaving them accessible to one single witness: the person who feels them' (Merleau-Ponty, 'The Film', p. 52). A phenomenological approach to feeling holds that I intuit (or perhaps analogize?) the 'sorrow in your weeping, the regret in your apology, or the delight in your laughter' just as I can discern 'the confidence in your stance, the gaiety in your step [...] or feel the love in your caress' (Cataldi, *Emotion*, pp. 93–94).

For phenomenology, as for the baroque, the emotions are 'living meanings' that are exhibited through corporeal display (Cataldi, *Emotion*, pp. 92–94). For film-phenomenology, cinema also conveys feeling through variations in its formal and embodied expressions. In his one essay on film as well as in his working lecture notes, Merleau-Ponty very clearly articulates cinema

as an emotive, gestural, and motorially expressive medium.[41] Here, internal states like 'dizziness, pleasure, grief, love, and hate are *ways of behaving*', he remarks, hinting at how the film's body communicates feeling through its own attitude, comportment, material textures, and purposeful movements (Merleau-Ponty, 'The Film', p. 58; italics mine). Given its skin-deep appeals, my model of baroque flesh also does not confine feeling to the abstraction of interior depths. Feeling in a baroque cinema will be lived inside and out because it gets 'expressed in our bodily attitude' as viewers and in the expressive attitude of the film's body as well (Merleau-Ponty, 'The Film', pp. 52–53).

Elena del Río, a sensuously alert film scholar, has also mobilized the site of the surface to further embodied film theory. For del Río, the surface of the film (or what she calls the 'surface-image') 'fittingly conveys the fact that the perception of the image is not a matter of mental abstraction, but rather of sensory and bodily contact' ('The Body as Foundation of the Screen', pp. 101–102). As it is correlatively realized by the viewer, cinema gets 'translated into a bodily response, body and image no longer function as discrete units, but as *surfaces in contact, engaged in a constant activity of reciprocal re-alignment and inflection*' (del Río, 'The Body as Foundation of the Screen', p. 101; italics mine). While the sensuality of surfaces is essential to how I conceive baroque cinema, it is now time for us to bring the skin and the sign together for baroque flesh by way of Buster Keaton.

Tickles: Baroque Wit

The agile, dexterous, and often incredibly lucky actions of the beautiful Buster Keaton present us with comedies of slapstick physicality that centre on nearly every part of the body but especially the skin. Slapstick refers to the violent styles of comedy that developed out of the stage circuits of the late nineteenth century such as vaudeville, circus, and the music hall. Many silent comedians, including Keaton, transitioned directly from stage to screen with slapstick becoming an enormously popular film genre during the twenties (Kramer, 'The Making', p. 200; Crafton, 'Pie and Chase', p. 108).[42] The origins of slapstick alert us to the fact that its comedy is born of the skin. The term itself derives from a circus prop that created a loud cracking or slapping sound when performers dealt each other blows (Kramer, 'The Making', p. 200; Crafton, 'Pie and Chase', p. 108). The auditory effect brought about by this real and/or staged slapping of the skin finds its parallels in the cutaneous jolting and tickling of the viewer.

As has been well established, slapstick was intimately connected to the industrialization of modernity.[43] Infused by 'a dramaturgy of mechanics' and a 'comedy of kinetics', Keaton's films are often explicitly structured around the newly invented machines and technologies of modernity: the steam engine of *The General* (Bruckman and Keaton, 1926); the ocean liner of *The Navigator*; the steamboat of *Steamboat Bill, Jr.* (Reisner and Keaton, 1928); the arrival of electricity in the two-reel *The Electric House* (Cline and Keaton, 1922); and, of course, cinema itself in *Sherlock, Jr.* (Perez, *Material Ghost*, pp. 99, 103; Trahair, *Comedy of Philosophy*, p. 64). In these terms, Keaton's films will often enact 'mechanical drama, a drama in which, if Buster is the protagonist, the machine is not only the main scene of action but the main force actuating the proceedings' (Perez, *Material Ghost*, p. 99).

In the remainder of this chapter, I want to argue for the role of the skin, the surface, and the sign in Keaton and for the baroque legacy or inheritance of his comedies. This is not to dismiss the importance of modernity in shaping slapstick. Rather, it is to suggest that baroque conjunctions of affect and artifice, copy and contact, the literal and the figural might have persisted in modernity. Furthermore, it could be argued that cinema's baroque texturology and its privileging of the surface was hastened by the modern era.[44] As Miriam Hansen observes, 'writings on the American cinema of the inter-war period stress [a] new physicality, *the exterior surface or "outer skin" of things, the material presence of the quotidian*, as Louis Aragon put it' ('Mass Production', p. 71; italics mine).

In considering Hansen's observations about the skin or materiality of modernity, I am strongly reminded of philosopher Henri Bergson's essay on laughter—an essay that has been applied to Keaton and to slapstick more generally (Carroll, 'Keaton'). This is because the world of slapstick comedy is imbued with what Bergson calls '*something mechanical encrusted on the living*' ('Laughter'; italics mine). For Bergson, the human body becomes inherently comic when it is imbued with a sense of automatism and takes on qualities of the machine. To quote Bergson: 'the attitudes, gestures and movements of the human body are laughable in exact proportion as that body reminds us of a machine' ('Laughter'). The body of Bergson's essay is absent-minded and weighed down by the laws of matter. As such, Bergson's mechanics of laughter is not entirely applicable to Keaton. Though Keaton instigates a 'mechanics of solids', his comedy is not based on absent-minded automatism but the mobile ingenuity of baroque wit (Shaviro, *Cinematic Body*, p. 118).

Like other modernist film critics of the thirties and forties such as Benjamin and Eisenstein, Siegfried Kracauer was fascinated by the tactile, kinetic,

and physiological properties of cinema. He believed that cinema comes into its own when it grasps materiality. For Kracauer, cinema redeems the world's reality. The more that a film adheres to what Kracauer calls cinema's 'basic layer' (the layer that is attached to the surface of things) the greater the 'resonance effect' will be, whereby the spectator dissolves into the very substance of the image (Hansen, 'With Skin', p. 452; Kracauer, *Theory of Film*, p. 158; Peucker, *Material Image*, pp. 3–5). For Kracauer, slapstick lies close to the surface of the world because it is in touch with its material dimensions. The basic conventions of slapstick (danger, catastrophe, and its nick-of-time prevention) foreground bodily 'shocks, movements, and gags' while still allowing 'material phenomena to retain their own centrifugal gravity' (Hansen, 'With Skin', p. 461). He admired slapstick as the 'paradigmatic genre of film', describing the entire purpose of slapstick as 'perform[ing] games in the material dimension' (qtd. in Hansen, 'With Skin', p. 457, 460).

Of great interest to this book is how cinema expresses the different surfaces of the world, intermingling the skin-like sensitivity of the film's body with that of our own. As Merleau-Ponty describes it, 'my perception of the world feels that it has an exterior; *I feel at the surface of my visible being that my volubility dies away, that I become flesh*, and that at this extremity [...] there is something else, or rather *an other who is not a thing*' (*VI*, p. 61; italics mine). Merleau-Ponty's words are indicative of how my body *feels* its own sensitive surface in contact with another. Similarly, when I watch Keaton's films, the surface of my being is addressed by the felt presence of another, not an inanimate 'thing'. In her film-phenomenology of touch, Jennifer Barker describes how the film's body is able 'to perceive the skin of the world [...] and address itself to the skin of the viewer' in such cinematically tactile encounters (*Tactile Eye*, p. 26). Watching the different permutations of Keaton's uncertain world unfold—a cinematic realization of the baroque motif of a world that is turned upside down—I undergo surprise, shocks, jolts, lurches, slaps, and tickles that arise from the intermingling of my surface with that of the film's body, as it is invested in and expressive of material surfaces.[45]

Let us examine the meeting of sensitive surfaces in *Sherlock, Jr.*, where Keaton plays a hapless movie projectionist and would-be sleuth. Having dreamt himself into the movie that he is projecting (a detective film, entitled *Hearts and Pearls*), Keaton becomes the consummate 'crime-crushing criminologist', Sherlock, Jr. Ensconced within this film-within-a-film scenario, Sherlock, Jr. must repossess the missing pearls and make his escape from the criminals. After Sherlock, Jr. runs down a busy city street, his trusty assistant rides past on a motorbike. Sherlock, Jr. promptly hops on the

handlebars and so begins an elaborate and very precisely timed chase sequence.

Unfazed by the chase, Sherlock, Jr. crosses his knees and comfortably leans back. After passing over a puddle, the motorcycle suddenly loses its driver. Sherlock Jr. continues to talk to his absent companion: 'Be careful or one of us will get hurt'. He rides through gaps in oncoming traffic and speedily skirts the corners of streets; he nearly collides with a pedestrian but remains steadfast. His driverless journey then takes him into the countryside. Shovels of dirt are thrown over him by a group of men digging a ditch. He rides through a drunken stag party and a tug-of-war game, literally pulling its players through nearby picnic tables. He crosses a river and a half-built bridge. Fortunately, two trucks arrive to fill in the bridge's missing gaps. Like a falling set of dominoes, the bridge collapses at one end so that Sherlock, Jr. effortlessly reaches the ground. Men at work flag him to stop but to no avail. He rides through their roadblock, the exact moment at which a dynamite explosion blows away the fallen tree in his path. He passes beneath the raised tires of a tractor: 'I never thought you'd make it' he comments, and we would have to agree. Sherlock, Jr. then narrowly misses an oncoming train and evades still more traffic, clenching his hands about his ears. Only then does he turn sideways to look directly out at the camera and at us, now realizing that the motorcycle has no driver. Having ascertained his dangerous position, the sequence draws to a close with the detective falling through the window of an abandoned house where 'the girl in the case' is being held captive. Through the momentum of his sliding fall across a table, he knocks the villain clear through the other side of the building and makes his escape with the girl.

According to Andrew Horton, Keaton's body is akin to a 'coiled spring', ready and waiting to spring into action and movement to meet the de-mands of his unpredictable and ever-changing world ('Introduction', p. 8). Alternating between stasis and movement is typical of Keaton. Fast or agile actions are played off against his 'unsmiling' face—though I have never found Keaton's face nearly as blank or emotionally expressionless as his 'Great Stone Face' nickname implies—in comedic scenarios that juxtapose 'slow thinking and fast action', as he realizes the danger to which he had previously been oblivious (Horton, 'Introduction', p. 7; Perez, *Material Ghost*, p. 101). The metaphor of Keaton's body as a coiled spring ably captures how I feel my own skin engaged here, through undulating states of tension, release, and relaxation. As violent as the many shocks and jolts that are visited upon the bodies of slapstick are their effect is not a sensory shattering of our bodily surface (Marks, *Skin of the Film*, p. 151; Shaviro, *Cinematic Body*, p. 53).

The textures of feeling in Keaton could hardly be described as traumatic or even unpleasant.[46] Contra Shaviro's suggestion of a tactile assault or violence to cinema, Laura Marks comments that a 'tactile visuality may be shattering but not necessarily so' (*Skin of the Film*, p.150). Similarly, though slapstick is violent and undeniably physical I do not experience Keaton's comedies as cinema's cinesthetic ability 'to tear me apart', as I did with *Trouble Every Day* (Shaviro, *Cinematic Body*, p. 103). Violence does not in itself do justice to Keaton.

Instead, the most apt embodied analogy that I would propose for Keaton's comedies is the tickle. Tickling involves correlative contact and it occurs on the surface of the skin. The tickle can arouse pleasurable, animated, or excited feelings because it stirs our bodies into laughter (Vasseleu, 'Touch', p. 158). Tickling is highly amenable to slapstick because it can be violent by turns as well. Being tickled, there is the corresponding fear of an attack of the giggles; of laughing so much or so hard that we might be unable to draw breath (Vasseleu, 'Touch', p. 158). Like slapstick, the tickle is a playful, funny, and pleasurable gesture but it harbours the potential for violence and aggression. As Cathryn Vasseleu points out, tickling incites a loss of (self) control: 'to be ticklish is to be uncertain, unreliable, delicately balanced, in unstable equilibrium' ('Touch', p. 158). This loss of control suits the unstable equilibrium of slapstick where we teeter on the edge of losing our balance through fits of laughter—just as Keaton teeters, precariously, on the motorbike, trying to regain his own balance in *Sherlock, Jr.* The textures of feeling that arise from a tickling of the skin (including pleasure, laughter, violence, aggression, and instability) are entirely appropriate to Keaton.

In the scenes from *Sherlock, Jr.* described above, the film's body expresses the surface or skin of modernity to us through its repeated staging of a narrowly averted clash between Keaton and other objects, machines, or people. In turn, our skin apprehends and anticipates the danger of a clash between materials that do not naturally belong together such as the vulnerable human body colliding with hard metal, dynamite, moving vehicles, and so on. According to Kracauer, cinema 'addresses its viewer as a "corporeal-material-being"; it seizes the "human being with skin and hair"' (qtd. in Hansen, 'With Skin', p. 458).[47] Kracauer effectively speaks to how film addresses the entire body of the viewer: 'material elements that present themselves in film directly stimulate the *material layers* of the human being: his nerves, his senses, his entire *physiological substance*' (qtd. in Hansen, 'With Skin', p. 458). As Kracauer writes, 'objective movement acts as a physiological stimulus' and it can prompt 'in the spectator such kinesthetic reactions as muscular reflexes, motor impulses, or the like'

(*Theory of Film*, p. 158). The potential collision of materials and machines in Keaton is therefore not only felt with the skin, it registers within our recessive insides. Keaton's winding, swerving movements in the chase scenes of *Sherlock, Jr.* solicit our proprioceptive sense of balance and bearing, thereby stirring our own capacity for movement in carnal sympathy with the image.

Disequilibrium helps convey the violence of slapstick but not necessarily the pleasure that arises from its tickles. For that, we must turn to the repetitive nature of such bodily action. Tickling necessitates repetitive contact with the skin, either through a light, gentle stroking or as a painfully recurrent groping or poking (Vasseleu, 'Touch', p. 158). Similarly, there is a rhythmic and rhythmically embodied repetition to Keaton. Time and time again, he narrowly escapes the imminent danger of connecting with another skin or surface. Alternatively, if he does make contact (such as when he falls through the window in *Sherlock, Jr.*) the result only enhances our laughter as events happily fall into place. My skin relaxes in response to the image only to tense up again during the next potential collision like the tension and release of a coiled spring. Tickled by the film's body in slapstick, our skin becomes alert to the different material textures of modernity and its approaching dangers for Keaton (even as we remain fully aware that dangerous contact is likely to be averted). Arguably, we laugh all the more in silent slapstick because the embodied repetition of Keaton's comedies assure us that his actions will win out in the end—either through his bodily dexterity, his ingenious insight, or plain dumb luck. Violent and laughable by turns, the film's body's attachment to the surface of the world makes repeated contact with the viewer. We laugh not only with our bodies at Keaton's comedies; we enjoy them with the surface of our skin. Comedy, as Tarja Laine observes, can prompt warm and relaxed skin sensations, a state of the skin that is entirely befitting of Keaton ('Cinema as Second Skin', p. 103).

What, then, of the specifically baroque nature of Keaton's comedies? This occurs through his foregrounding of the film's body, the dynamism of his use of signs, and through his cinematic reprisals of baroque wit. As I flagged earlier in this chapter, the seventeenth century was the grand age of wit. Baroque poetic practice can be usefully framed by the historic concept of *ingegno* (meaning ingenuity, genius, or wit) (Overesch, 'Neo-Baroque', p. 61; Bornhoefen, 'Cosmography and Chaography', pp. 56, 87). Wit demanded 'a quickness of mind in *seeing resemblances between dissimilar things* and capturing these insights in unusual metaphors or engaging paradoxes' (Gilman, *Curious Perspective*, p. 68; italics mine). In this regard, *ingegno* refers to the poet's ability to create a witty resemblance, affinity,

and correspondence between things. *Ingegno* encapsulates both the visual and the analogical bases of baroque poetics.

Tesauro, especially, lauded wit for its 'capacity to produce a vision of the repressed, and previously unseeable, via poetic language' (Bornhoefen, 'Cosmography and Chaography', p. 56). Understood as a 'particle of the divine mind', Tesauro describes how *'ingegno* of non-entity forms entity' (qtd. in Bornhoefen, 'Cosmography and Chaography', pp. 86, 26, fn. 20). Mario Perniola extends the poetics of wit beyond just metaphor, invoking the multiple conceptual movements of baroque wit. He includes activities like discerning similarities amongst dissimilar things; revealing differences in things that appear similar; transforming an object into its exact opposite; creative hyperbole; making and unmaking exaggerated statements; paradoxes, wordplay, riddles, enigmas, and anagrams; allusions; and inferring unforeseeable and sudden solutions to difficult problems (*Enigmas*, pp. 116–117). Visual metaphors, the revelation of similarity between things and solving a difficult problem/situation are baroque witticisms that are highly relevant to Keaton. *Ingegno* thus finds an appropriate cinematic incarnation in Keaton's slapstick.

Before we examine the specifics of Keaton's baroque poetics, let us first of all examine his revelations of the film's body. As Henry Jenkins comments, there can be little 'doubt that Keaton wants us to be acutely aware of the experience of watching a movie unfold' ('This Fellow', p. 47). Cinematic self-reflexivity is evident not only within Keaton's doubling of media (the obvious film-within-a-film premise of *Sherlock, Jr.*) but in the transformative power of film editing and 'film language' (Jenkins, 'This Fellow', p. 47). For instance, in *Sherlock, Jr.* the projectionist steps through the screen and struggles to gain a firm foothold amidst its resulting transitions between scenes of mountains, lions, and seas. Alternatively, one need only consider the amazing special effects sequence of a town being swept away by a cyclone in *Steamboat Bill, Jr.*, or the upside-down camera that closes *The Navigator* to realize just how much Keaton loves drawing our attention to the non-human perceptions and expressions of film through the inclusion of overt technological displays.

Alongside these displays of the film's body, we watch Keaton himself (always minus a body double) as he performs incredible stunts and feats for the camera and unfolds his own human skill and prowess in continuous time and space. At the same time, we watch the film's body show us its own non-human and technological prowess. Through special effects sequences such as editing tricks or the doubling of a sleeping Keaton in *Sherlock, Jr.*, the film's body shows us here what it can do. In Keaton's comedies, we often

find ourselves addressed and engaged by two substantially different but nonetheless virtuoso and performing bodies. When the detective escapes his attackers by deftly diving into a small suitcase filled with ties in *Sherlock, Jr.* it is not only Keaton's physical elegance that makes his escape possible but that of the film's body. Through the expressivity of its trick editing, Keaton's body is able to disappear completely, as if vanishing into thin air.

As Norman M. Klein asserts, the baroque is best characterized by 'artifice [as it] invades the natural' as the 'audience senses, as if by miracle, how the natural and artificial merge and divide' (*Vatican to Vegas*, p. 40). A baroque intertwining of nature and artifice is re-staged in Keaton insofar as the film's body exploits realism (continuous long takes, the avoidance of close-ups, minimal cuts) at the same time as it expresses an unmistakably cinematic 'hallucination' (Perez, *Material Ghost*, pp. 101–102). Without labelling this conjunction baroque as such, Perez and Jenkins also pick up on this merger. To quote Perez: 'Keaton's cinema stems in large measure from the way he combines [...] the actual and the apparitional [...] he took to film as a medium both real and unreal' (*Material Ghost*, p. 102). Similarly, Jenkins affirms that 'Keaton wants us to be fully aware of the camera manipulation, to recognize that the camera can make us see things that could not possibly occur' ('This Fellow', p. 47). Such technological displays alert us to the presence of baroque flesh in Keaton as a deliberate gesturing towards the film's body. As with the historic baroque, our 'sensing the fake' or hearing the whir of machinery behind the illusion creates a self-reflexive reprisal of artifice invading the natural (Klein, *Vatican to Vegas*, p. 31). In Keaton's baroque cinema, revelations of artifice are no less affective or laughable in their embodied impact.

According to Buci-Glucksmann, filmic '[e]ffects—technical artifices, hyperbolic exaggerations of seeing, filmic citations re-filmed—permanently generate affects [...] [the] cinema lives, *practicing as its own visual syntax the great baroque rhetorical figures derived from Gracián or Tesauro*' ('Baroque Eye', p. 32; italics mine). The syntax of baroque poetics is certainly evident in Keaton, where the literal and the figural hilariously reverse. Whereas the seventeenth-century poet harnessed metaphor to make the written word veer towards the visual, Keaton invokes the written word, figural expressions, and visual metaphors to realize his gags (Benjamin, *The Origin*, pp. 175–176). In *Sherlock, Jr.* the projectionist approaches the world a little *too* literally. After he finds a stray dollar in the trash, its former owner appears to reclaim it. The projectionist asks her to 'describe' it, surreptitiously checking his newfound dollar against her gestures as to its size and shape. After he is wrongfully accused of theft, the projectionist consults his detective manual.

It instructs him to 'shadow your man closely' so he chases after the sheik/ villain, hot 'on his heels'. The sheik bends down to the pavement and the projectionist arches his back to accommodate him. When the sheik smokes and tosses a cigarette, the projectionist mimics his actions. They trip: first one, then the other, each stopping and starting at the same time. Keaton apes every single movement of the man in front, creating a 'literal and physical' shadowing of another (Trahair, *Comedy of Philosophy*, p. 94). The sweet but naïve projectionist is, however, not quite so physically adept as the real-to-life Keaton. He soon finds himself caught out, trapped on a train carriage, and drenched by a water tower ('as a detective he was all wet').

As Lisa Trahair rightly comments of Keaton's humour, 'words operate like objects and images, images and objects like words' (*Comedy of Philosophy*, p. 96). When Keaton is not taking the world at its word, he is sensuously concretizing any number of figural expressions and metaphors. He 'replaces the figurative with the literal, or obliterates the distinction between the two so that one metamorphoses into the other and *vice versa*' (Trahair, *Comedy of Philosophy*, p. 95). In *Our Hospitality*, Willie McKay fantasizes about his late father's estate. Arriving in Rockville, he finds his inheritance in the form of a dilapidated shack. We then cut to the image of a palatial home, promptly exploding. Willie's hopes are 'shattered' as his dreamed-of inheritance falls down around his ears. Fleeing the Canfield house in a girl's dress, Willie escapes his pursuers through his quick-witted assemblage of a horse, a dress, and an umbrella. Affixing the dress and the umbrella to the rear end of a horse, Willie temporarily distracts the Canfield men, effectively making them a 'horse's ass'. In *The Navigator*, spoilt rich boy Rollo Treadway finds himself (and the girl that he wants to marry) adrift at sea on a deserted ocean liner. Rescued by a submarine, the film closes below deck. Treadway's girl gives him an appreciative kiss. Her kiss causes Treadway to fall back upon the steering wheel, an action that simultaneously causes the submarine to topple and the camera to swirl upside down and around as well—the intimation being that Treadway (and the film itself) have fallen 'head over heels' in love.

Through his persistent use of metaphor—a comedic technique that belongs to what Noël Carroll calls the visual style of humour that is the 'sight gag' in slapstick—Keaton enlaces the visual with the verbal, also animating our skin into laughter through highly calculated appeals to the sign (Carroll, 'Notes on the Sight Gag', p. 32).[48] Despite its constant mutations Keaton's world can, at any moment, give way to a precision of 'the strictest order' (Perez, *Material Ghost*, p. 100). According to Perez, Keaton is the 'geometrician of slapstick' (p. 100). For me, Keaton's sudden resolutions of order from disorder continue the analogical world view of the baroque in

film.[49] Beset by cannibals in *The Navigator*, Treadway tries to circumvent their attack by lighting a tiny cannon. With the wick fast running out, he repeatedly tries to extricate himself from its strings. Everywhere he moves, the cannon trails behind him. When he eventually falls onto the deck of the ship, he successfully places himself out of danger. The cannon fires, its shot passes over his head and hits one of the cannibals climbing aboard. Relieved, Treadway gives the cannon an appreciative pat. In *Sherlock, Jr.* the detective is trapped on a rooftop with the sheik making his getaway below. Sherlock, Jr. runs to the end of the roof to grab hold of a gate that lies against the edge of the building. Jumping from the roof, he allows himself to fall. He is then neatly deposited in the back seat of the sheik's car. Everything works out for Keaton in the end, through 'adaptation gags' that prompt our laughter because they are much like a puzzle or a tricky problem that has just been 'ingeniously solved' (Carroll, 'Keaton', p. 219).

Although he took his fair share of pratfalls, Keaton's body could be a 'means of soaring, of surmounting the obstacles in his way and achieving his objectives' (Perez, *Material Ghost*, p. 104). Conjoining the forces of gravity and grace, Keaton's body is undeniably elegant—even when he can no longer fight against a gravitational pull to earth and he slips, tumbles, or falls. Recalling the renewable combinations of signs in baroque poetics, Keaton's films forge necessary, surprising, and witty connections across an unpredictable and infinitely changeable world. During the climax of *Our Hospitality*, Willie finds himself at the top of an immense waterfall, tied by a long rope to a stray log. His girl is trapped in the water, too, caught in the rapids and hastening towards a dangerous fall. Just before she hits the waterfall's edge, Willie devises a makeshift pendulum. He combines the weight of his body with the log and the rope. Leaping through the air, Willie grabs his girl with not a moment to spare. They hang together, like a trapeze act in mid-air, before Willie swings them to the safety of a nearby ledge. Keaton counters 'the waterfall by means of a machine, the pendulum, into which he incorporates' himself with nothing less than the 'exactitude' of an acrobat (Perez, *Material Ghost*, p. 103).

Keaton's body is not at all stupidly encumbered by the mechanical, as the body is in Bergson's account of slapstick. Instead, he adeptly makes contact between shifting parts and wholes to form new, artful combinations of the material and the mechanical. Like the poet who creates linkages between shifting signs, fragments, and phenomena, so too does Keaton endeavour to make meaningful connections across a world in flux.

According to Ernest B. Gilman, *ingegno* performed in poetic language what seventeenth-century artists were expressing in visual terms (*Curious*

Fig. 9: Ready to spring into analogical thought and action, Buster Keaton in *The Navigator* (1924). Metro-Goldwyn/The Kobal Collection.

Perspective, p. 78). Just as the techniques of linear perspective were being warped or altered by the visual arts, baroque language ruptured the indexical clarity of signification (Gilman, *Curious Perspective*, p. 1). Interestingly, *ingegno* was actually understood in explicitly visual terms. It was another form of 'good looking' in which visually loaded metaphors invited their participant 'to think connections which language does not actually say' whereby an analogical 'relatedness is seen' and affirmed (pp. 101, 122). For Tesauro, vision was essential to wit because 'watching with the eye and contemplating with the intellect are two analogous models of cognition' (qtd. in Donato, 'Tesauro's Poetics', p. 23).

Similarly, Keaton stages analogous revelations that make us 'see' the enlacing or inter-relatedness of his baroque world (*omnis in unum*). Combined, a log of wood, a rope, and a human body can indeed function like a pendulum. In *The Navigator*, Treadway must undertake some underwater repairs to the ship. He reveals to us how a lobster's claws can be like a pair of pliers or how the pointed snout of a swordfish can be like a weapon, used to fend off attacking fish. Later on, a deep-sea diving suit will become a handy and life-saving flotation device: the girl flips the

suited-up Treadway onto his back in the water and paddles them both away. For Tesauro, successful metaphors were best gauged by their novelty. The more unique the connection that could be made between signs, the greater was the *ingegno* of the poet and their ability to arouse wonder, delight, and surprise (Donato, 'Tesauro's Poetics', p. 23). Keaton makes just such unique, associative, and delightfully laughable connections, through his filmic reprisals of *ingegno*.

As I have detailed, the ability to take ideas or signs apart and knot them back together in potentially infinite combinations was crucial to baroque poetics. Tesauro even couched poetics as a kind of physical and mental dexterity:

> This marvelous dexterity, which suggests for Tesauro the agility of a juggler, is the essence of metaphor—here not configured so much as a figure of speech as a habit of mind, a kind of mental acrobatics that gives grace and speed to [...] thought. [...] The ingenious mind must train itself to experience ideas dynamically, their parts in constant motion, like a juggler's balls, not filed neatly into categories. (Gilman, *Curious Perspective*, pp. 76–77)

Whereas Perez likens Keaton to 'a consummate acrobat', I prefer to think of Keaton as the baroque poet of slapstick (*Material Ghost*, p. 99). His gags make contact with the sensitivity of the skin (the literal) while ingeniously juggling shifting relations of bodies, signs, and phenomena (the figural). A vital proponent of 'good looking', Keaton grants grace and speed to the embodied intelligence of sight and a 'heightened perceptual acuity [that] reminds us of the sensuality of the intellect and [...] responsive flesh lodged within visual experience' (Stafford, *Visual Analogy*, p. 161). At once a slapstick comedian and a baroque poet, Keaton's wit makes us see and feel the analogical connections that knit between things.

As Maria H. Loh remarks, seventeenth-century audiences 'were open to the type of aesthetic experiences [that were] based *on sharp, associative lateral thinking*' ('New and Improved'; italics mine). In *Sherlock, Jr.* the brakes of the car fail and the detective ends up driving straight into a river. Unperturbed by this turn of events, he places his hand outside the window to signal a turn. He spins the car around, lifts the car hood to create a sail, and sits with his girl to admire the view on the river as they gently float by. As the *ingegno* of Keaton's comedy powerfully reminds us, we only 'become aware of thinking in those kinesthetic moments when we actively bind the sights, savors, sounds, tastes, and textures swirling around us to

our inmost, feeling flesh' (Stafford, *Visual Analogy*, p. 58). By way of his wit, his bodily grace, and his ingenious insight, we participate in Keaton's sudden 'flashes' of sensual intelligence—the fact that a car can indeed be analogized to or perceived as a sailboat. Keaton's ticklish comedies are predicated on copy and on contact. At the same time as I am attuned to their cinematic artifice and I appreciate their figural expressivity, I feel a cutaneous tensing or apprehension as a result of their play of surfaces as well as pleasure in his films that occurs through looseness, warmth, elasticity, or uplifting of the skin. Intertwining the sign with sight and cutaneous sensitivity with analogical insight, Keaton is truly the baroque poet of slapstick.

Summation: Cine-Mimesis

In baroque cinema, as I have considered, the film's body and our own intertwine and reverberate (despite our material differences) because 'to feel one's body is also to feel its aspect for another' (Merleau-Ponty, *VI*, p. 245).

According to Walter Benjamin, the 'mimetic faculty' can be traced back to the ways in which ancient human beings understood their surroundings through sympathetic relations ('On the Mimetic Faculty'; Benjamin and Tarnowski, 'Doctrine of the Similar'). Entertaining the 'law of similarity', the ancients discerned pattern, similitude, affinity, reciprocity, and interplay across the universe and connected the microcosm to the macrocosm (Benjamin, 'On the Mimetic Faculty', p. 333; Hansen, 'Benjamin and Cinema', p. 329). A comet blazing across the sky, for instance, could be read as a portent of earthly disaster that foretold 'the fate of kings, nations and crops' while natural objects such as animal entrails or stars divulged hidden secrets for their interpreters (Stafford, *Visual Analogy*, p. 11; Benjamin, 'On the Mimetic Faculty', p. 336). For this book, mimesis—the 'gift of seeing resemblances'—is a wonderfully cogent concept by which to frame the art of analogy and the relevance of baroque flesh to cinema (Benjamin, 'On the Mimetic Faculty', p. 333).[50]

As Benjamin and other scholars such as Hansen and Marks have detailed, mimesis is very much an embodied mode of perception. It is a form or practice that transcends the subject–object dichotomy through interconnection; it also signals a mode of cognition that invokes kinesthetic, somatic, and tactile sensations (Hansen, 'Benjamin and Cinema', p. 329). For Benjamin, 'modern man contains only minimal residues of

the magical correspondences and analogies that were familiar to ancient peoples' ('On the Mimetic Faculty', p. 334). Nevertheless, he did detect the persistence of mimesis in a number of crucial arenas. In an earlier draft of his essay 'On the Mimetic Faculty', he asserts that the mimetic has 'disappeared from certain areas, perhaps in order to pour forth into others' (Benjamin and Tarnowski, 'Doctrine of the Similar', p. 66). In children at play, he points out that the 'child plays at being not only a shopkeeper or a teacher but also a windmill and a train' ('On the Mimetic Faculty', p. 333). Interestingly, Benjamin proposed that the mimetic also continues in language (as a veritable 'archive of nonsensuous similarities, of nonsensuous correspondences') and hinted at its resurgence through the machines of modernity such as photography and film (Benjamin, 'On the Mimetic Faculty', p. 334; see also Hansen, 'Benjamin and Cinema', p. 330).

As Marks nicely glosses it, mimesis is indicative of an immanent 'way of being in the world, whereby *the subject comes into being not through abstraction from the world but compassionate involvement in it*' (*Skin of the Film*, p. 141; italics mine).[51] If cinema can justly be considered a mimetic medium, it is because of the sensuous sympathy that connects film and viewer. As Shaviro points out, we are 'brought into intimate contact' with film 'through a process of *mimesis* or *contagion*' (*Cinematic Body*, p. 52).[52] Marks concurs, asserting that 'our experience of cinema is mimetic, or an experience of bodily similarity to the audiovisual images we take in' (*Skin of the Film*, p. xvii). Extending cine-mimesis further, though, I want to stake out a baroque cinema that is invested in the *chiasm* between language and experience, in the sensitivity of the surface and the skin as well as signification.

In these terms, the cultural anthropologist Michael Taussig is helpful as he draws our attention to the inherently doubled nature of mimesis. To quote Taussig: 'Here is what is crucial [...] namely the two-layered notion of mimesis that is involved—a copying or imitation, and a palpable sensuous connection between the very body of the perceiver and the perceived' (*Mimesis and Alterity*, p. 21). The two-layered nature of mimesis can be extended to a cinema of baroque flesh. This is because mimesis 'describes a language that draws close enough to its object to make the sign ignite', whereby the sign halts at the body of the reader, viewer, or participant wherein it is sensuously re-made and correlatively realized (Marks, *Skin of the Film*, pp. 141, 138).[53]

As this chapter has demonstrated, we are compassionately, literally, and figurally involved with the baroque flesh of art and film. Through

my examples of baroque luxury and baroque wit in film, I have sought to develop how baroque cinema privileges the skin and the sign in its very texturology, such that language and signification are not sacrificed in the pursuit of sensation. Baroque flesh foregrounds the copy or artifice of construction at the same time as it seeks out sensuous contact. A cine-mimetic intertwining of the literal (the skin) and the figural (the sign) is crucial to a baroque cinema of the senses, as an aesthetic category of film that demands an appropriately embodied semiotics.

4. One Hand Films the Other: Baroque Haptics

I would like to think that the story of the baroque composition, and the flaunted taste for delirious profusion, is a—calculated but embarrassed, playful and elusive—response to the *aporias* of tact.
– Jacques Derrida (*On Touching*, p. 131)

There is double and crossed situating of the visible in the tangible and of the tangible in the visible; the two maps are complete, and yet they do not merge into one. The two parts are total parts and yet are not superposable.
– Maurice Merleau-Ponty (*VI*, p. 134)

For Christine Buci-Glucksmann and Martin Jay, the baroque signals a particular scopic regime that harks back to the deeply visual culture of the seventeenth century (*La folie*, pp. 72–73; *Downcast Eyes*, p. 43).[1] Adopting a phrase that is taken directly from *The Visible and the Invisible*, both situate the baroque as a celebrant of the 'madness of vision'. Buci-Glucksmann, in particular, uses Merleau-Ponty's madness of vision as a synecdoche for the multiplicity and mobility of vision that is instigated by the baroque. Let us, however, return to the original passage to consider its implications for baroque flesh. To quote Merleau-Ponty: 'There is a sort of madness in vision such that with it I go unto the world itself, and yet at the same time the parts of that world evidently do not coexist without me' (*VI*, p. 75). Merleau-Ponty's madness of vision speaks to a reciprocal intertwining between bodies, between bodies and art, or bodies and the world that is typical of 'flesh'. That intertwining is not exclusive to vision. Merleau-Ponty himself extends the structural reversibility of 'flesh' to touch, sound, and sensibility in general (*VI*, pp. 75, 144).

While the notion of a cinematic baroque has helped contribute to the perceptual and aesthetic variety of film, the film-philosophical resonance between Merleau-Ponty's thought and the embodied experiences of a baroque cinema have yet to be fully explored. To date, the baroque of film and media studies tends to be conflated with spectacular or hyperbolic models of vision and with a cinema of technological display. Buci-Glucksmann, for instance, frames the cinema of Chilean director Raúl Ruiz through what she calls the 'baroque eye of the camera' ('Baroque Eye'). Whereas

film-phenomenology understands film as a visual and sensible subject, Buci-Glucksmann reduces Ruiz's baroque cinema to the singular, visible function of the camera eye. Furthermore, she understands the baroque eye of the camera as 'a mechanical and artificial eye' that locates us insides its 'deceitful perplexity' and a 'multi-faceted vision that is multiple, double, anamorphic, reflective' ('Baroque Eye', p. 32). The danger of such an overriding emphasis on the ocular is that it ends up anaemically restricting baroque flesh to vision—as if vision occurred in isolation from the rest of the lived body or were separate from other bodies' being-in-the-world. Delimiting the baroque to the visual is at odds with many of the experiences of baroque flesh that I have detailed: its knotting of sensation, its stirring of the passions, its co-extensive space, or its attraction to material textures, skin, and the surface. Any conception of baroque cinema needs to consider the longstanding sensuality of this aesthetic and its art of entanglement. Baroque flesh always engages our embodied perception, no matter how 'maddening' its vision might become.

This chapter supplements the commonplace association of the baroque with the eye by instead exploring its tactile potential. As the last avenues of our sensuous exploration of the baroque and a baroque cinema, touch and texture prove to be vital components of baroque flesh. In physiology, the sense of or relating to touch is taken from the Greek term *haptein* (meaning to fasten) (Marks, *Skin of the Film*, p.162; Barker, *Tactile Eye*, p. 37). Following on from the film-phenomenological work of scholars such as Sobchack and Barker, I want to approach cinematic tactility as mutually shared between film and viewer. Like Sobchack, I am not using touch as a licence for the poetic interpretation of film nor as a neatly evocative metaphor for film spectatorship, although representational modes of tactility will play their own part. Touch should be taken both literally and figuratively here, as a tangible experience that indicates our 'capacity to *feel* the world we see and hear onscreen' as well as indicative of cinema's sensuous 'capacity to "*touch*" and "*move*" us offscreen' (Sobchack, *Carnal Thoughts*, p. 66; italics mine).

How might cinema touch or move us in a baroque fashion? To answer this question, I want to reprise Merleau-Ponty's image of one hand touching the other and adopt the tactile gesture of 'one hand filming the other' to understand a baroque haptics. Unlike current film-phenomenology, what follows will analyse how touch might be given over to a baroque aesthetics of expression. One hand filming the other should not be construed as privileging cinematic tactility in the hand. The film's body does not have 'hands' as such although its tactile effects are palpable. Extending on the doubled sensations of 'flesh', this chapter will examine the tactile

doubling of a baroque cinema. Unlike Barker, it is not my intention to give a comprehensive account of the many different ways in which tactility can occur in film. I am interested only in the baroque resonance of touch and how it is realized in historic, aesthetic, and cinematic guises.[2]

After first of all considering the broad range of experiences that are associated with the touching and the touched, I move on to consider the rapport that exists between the baroque and the haptic. Much of the discussion of the haptic in contemporary film theory has relied on the work of the art historian Aloïs Riegl and his *Late Roman Art Industry* (1901), especially given Deleuze's mobilizations of Riegl, and Laura Marks' influential re-working of Riegl, Deleuze, and others in her account of a 'haptic visuality' (Riegl, *Late Roman Art*, p. xx).[3] Reconsidering what constitutes a haptics of perception in art and film, this chapter re-visits Riegl, Deleuze, and the work of Laura Marks from an alternative standpoint: the baroque. Seeking to expand on current discussions of the haptic, the baroque haptics that I develop has been inspired, alternately, by Merleau-Ponty, by Walter Benjamin, and by another early art historian who was a contemporary of Riegl, Heinrich Wölfflin.

After laying the foundations of the haptic appeals of historic baroque art, I next turn to Jonathan Caouette's *Tarnation* (2003)—an experimental digital documentary, produced on basic iMovie software—to ground the baroque haptics of film in specifics. Tactile-but-thinking acts of ordering, gleaning, pilfering, creating correspondence, retrieval, and assemblage figure strongly in *Tarnation*, combining to weave together textural patterns of experience. Such tactile-but-thinking acts help indicate the overlooked intelligence of sensation and the ways in which touch functions as a kind of 'outer brain', as Merleau-Ponty once claimed (*PP*, p. 369).[4] Connecting the multiple media fragments of *Tarnation* to the collecting traditions of the seventeenth century (collections that were housed in *Wunderkammers*, *Kunstkammers* or the *Wunderschrank*), I detail how the baroque habit of perceiving, expressing, and thinking by way of analogy rears its head again here.[5] In its tactile-but-thinking effects and its digital assemblage of elements, *Tarnation* reprises both the analogical bent of consciousness and forms of 'good looking' in film.

As an affiliate of baroque flesh, *Tarnation* demands from us a somewhat different model of the haptic in film. Rather than moving horizontally along the image, a baroque haptics can move between surface and depth. It is hastened by tactile, mobile, and successive perceptions and it is filtered through shifting masses of detail. It occurs through densely laden or overlapping surface effects, textures that convey to us the passing of time and

a dispersal, dismemberment, or spatialization of the image or images. This latter effect, especially, is endemic to the mobile, energetic, and aggregate structures that characterize the baroque and a baroque cinema.

Touching-Touched

Touch is a modality of sensation that cannot auto-effect. Incapable of sensing in itself, touch requires the presence of another surface, object, or body (physiological, technological, or inanimate) to press against and be pressed against in return. Touch also happens to be a reflexively intimate encounter. While I cannot always see myself seeing or hear myself hearing, touch involves the experience of our own bodily state, touching and mingling with that of another body, material surface, or thing. As Susan Stewart observes, touch is a sensation that therefore lends us considerable information about the stakes of our own embodiment. This is because it involves 'the perception of our own bodily state as we take in what is outside that state' (Stewart, *Poetry*, p. 162). A transitive phenomenon, touch bears 'on ourselves as well as on objects [...] To be in contact with an object means to be moved by it—to have the pressure of its existence brought into a relation with the pressure of our own bodily existence' (Stewart, *Poetry*, p. 164).

As we know, Merleau-Ponty captures the two-sided interplay of touch well. In his recurring example of one hand of the body touching the other, we undergo transient shifts between feelings of subjectivity and objectivity and sensations that are localizable as well as those that are dispersed. In effect, we become both the touching and the touched. Grounded in the sentience of our bodily being as the touching subject, we are simultaneously displaced from that intentional focus or desire by serving as the touched object as well, experiencing 'a confirmation of our state of being and alienation from it at once' (Stewart, *Poetry*, p. 163). Mutuality—coupled with feelings of direct or at least immediate proximity—is the structural constant of all tactile experience.

Unlike sight or hearing, touch pertains to proximate if not direct regions of sensation. As philosopher Jacques Derrida puts it, touch 'gives nearby [...] if the two other senses, tasting and smelling, do this also, it is no doubt because of their affinity with touching, because they partake in it, or lie near it, precisely, near the sense of nearness, proximity' (*On Touching*, p. 95). In his book *On Touching—Jean-Luc Nancy*, Derrida describes touch as having 'as its object more than one quality—in truth, it potentially has *all* sensible qualities' (*On Touching*, p. 47). This statement is not intended to imply that

touch predominates over the other senses or that we should replace the common cultural elevation of sight with the tactile. Like Merleau-Ponty, Derrida offers us a useful definition of touch that is inter-sensory in scope as well as being particular to the tactile register.

According to Derrida, touch is foundational to *any* concept of sensation. While it might be possible for us to survive without seeing, hearing, tasting, and smelling, the same cannot be said of touch. As Derrida puts it: 'no living being can survive for an instant without touching, which is to say without being touched. *Not necessarily by some other living being but by something = x*' (*On Touching*, p. 140; italics mine). Similarly, Merleau-Ponty points out how the 'body stands before the world and the world upright before it, and between them there is a relation that is one of embrace', then hastens to add that, 'between these two vertical beings, there is not a frontier, but a contact surface' (*VI*, p. 271). Perception-as-contact is indicative of the embodied reciprocity and relationality that is inherent to Merleau-Ponty's philosophy. In his terms, how we engage with the world or with aesthetic experience is more akin to intimate contact than it is to keeping one another 'at arm's length'.

If such intimate contact has underlined the philosophical and the film-phenomenological pursuits of this book, it is because it is commensurate with the baroque and with how baroque flesh foregrounds bodies as existing in reversible contact with each other in the aesthetic experience. Like Merleau-Ponty, Derrida also invokes the phenomenological epithet of *In der Welt Sein* (being-in-the-world) to underscore the importance of contact (Merleau-Ponty, *VI*, p. 222; *PP*, p. xiv). As he states, 'for a finite living being, before and beyond any concept of "sensibility" touching means *"being in the world"*' (Derrida, *On Touching*, p. 140; italics mine). For Derrida, Merleau-Ponty, and for the baroque, then, there is no world without touching and, likewise, no being-in-the-world without having been touched—not by the tactile *per se* but by the reciprocal contact that exists between body and world.

Intriguingly, Derrida goes on to list an astonishing range of acts belonging to the 'tactile corpus' of the French philosopher Jean-Luc Nancy (*On Touching*, p. 70). These include:

> skimming, grazing, pressing, pushing in, squeezing, smoothing, scratching, rubbing, *stroking*, palpating, groping, kneading, massaging, embracing, hugging, *striking*, pinching, biting, sucking, wetting, holding, letting go, licking, jerking, looking, listening, smelling, tasting, avoiding, kissing, cradling, swinging, carrying, weighing. (Derrida, *On Touching*, p. 70; italics mine)

Here, I italicize striking and stroking to emphasise the '[c]ontradictory injunctions' at the 'heart of touch', thereby hinting at what Derrida calls the *aporia* or problem of touch and its multiplicity (*On Touching*, pp. 76, 131). Via Nancy, Derrida associates touch with the bodily acts of 'looking, listening, smelling, [and] tasting' (*On Touching*, p. 70). Here, it would seem logical to assume that Derrida is arguing that touch is unique or even privileged amongst the senses. However, that conception of touch would be the result of grouping the senses according to entirely separate strains of phenomena: as if colour or light only affected the eyes, temperature were only discernable by touch, sound audible just to the ears and so on. From the previous chapters of this book, we know that this is not the case. The critical isolation of the senses from each other cannot begin to address the inter-sensory transfer of bodily and aesthetic phenomena (colour, shape, sound, smell, tactility, and so on) as they are distinguished and blurred across the sensorium. Derrida, like other philosophers of touch or visual tactility—and here I would include Merleau-Ponty, despite their differences—does not restrict touch to the hand or even to the skin.[6]

For the purposes of this book I appreciate Derrida's inter-sensory descriptors of tactility. Not only do they recall Merleau-Ponty on embodied perception; they help indicate how neither the hand, the skin, the tingling edges of the fingertips, or tiny follicles of hair on the body can claim the ownership of touch. According to Stewart, 'the entire surface of the body is touch's instrument' (*Poetry*, p. 162). And yet, touch does not belong solely to the realm of cutaneous sensations, either, for the haptic can be extended beyond the body's surface. As Jennifer Fisher and Barker both detail, the haptic includes tactile, kinesthetic, and proprioceptive modes of touch (Fisher, 'Relational Sense'; Barker, *Tactile Eye*, p. 37). To quote Fisher: the haptic 'functions by contiguity, contact and resonance. The haptic sense renders the surfaces of the body porous, being perceived at once inside, on the skin's surface, and in external space' ('Relational Sense'). Despite its frequent categorization as a proximal sense, Fisher usefully implicates the haptic in distal perception as well. This is because the haptic helps us to 'elucidate the energies and volitions involved in sensing space: its temperature, presences, pressures and resonances' (Fisher, 'Relational Sense'). Fisher's comments are reminiscent of Merleau-Ponty. As he writes, 'tactile perceptions gained through an organ are immediately translated into the language of the rest [...] we can, in recollection, *touch an object with parts of our body which have never actually been in contact with it*' (*PP*, p. 369; italics mine). In these terms, the haptic can be extended to an atmospheric plane of feeling that is distinct from literal physical contact and used to gauge

the 'affective charge' or 'felt dimensionality' of any given spatial context (Fisher, 'Relational Sense'). Inside the skin, in terms of our proprioceptive relationship with space, the haptic sense also perceives 'the visceral workings and felt intensities of our interior bodies' (Fisher, 'Relational Sense'). Touch belongs not only to the outer surfaces but also the inner recesses and felt dimensionality of the body, as well as how those sensitivities are engaged by the aesthetic experience.

While Derrida and Nancy's tactile corpus conveys the sheer range of what might fall under the domain of touch, it is very much a collection of verbs that privilege activity and the body who is *doing* the touching. That focus on activity is problematic because touch is a reversible exchange between the touching and the touched. Due to its structural constants, the touching will be correlated with the touched in any tactile encounter—regardless of whether that contact takes place between two bodies in the world, between the film's body and our own, or animate and inanimate matter. As Barker also indicates, whenever 'any two bodies, two skins, or two surfaces are pressed up against each other, the question of *who* or *what* is doing the touching becomes difficult to answer unambiguously' ('Tactile Eye', p. 11).

In her inspirational essay 'What My Fingers Knew: The Cinesthetic Subject, or Vision in the Flesh', Sobchack captures the ambiguity of the touching and the touched in cinema as a sensuous reversal of the literal and the figural. Detailing her own response to scenes from *The Piano* (Campion, 1993), Sobchack reflects on how this film spurred a tactile exchange between herself and the image that '"sensitized" the very surfaces of [her] skin—as well as its own—to *touch*' (Sobchack, *Carnal Thoughts*, p. 61). Paying particular attention to the film's fleshy and visually ambiguous opening, Sobchack argues that it was her own fingers that reflexively '*comprehended* that image, grasped it with a nearly imperceptible tingle of attention' (*Carnal Thoughts*, p. 63).[7] Prior to her more reflective recognition of the opening images as involving fingers that belonged to the film's character, Ada, she understood 'those fingers [as] first known sensually and sensibly as "these" fingers' such that they were felt, spatially, as 'both offscreen and on—subjectively "here" as well as objectively "there", "mine" as well as the image's' (Sobchack, *Carnal Thoughts*, p. 63). In Sobchack's reading, her own pre-reflective and physical comprehension of the image is a testament to our innate bodily responsiveness to cinema as it is forged out of a common carnality.

Whereas Derrida concentrates on the activity of touch, Sobchack's film-phenomenology continues in Merleau-Ponty's stead. She elevates neither the active nor passive components of touch but foregrounds the reversibility

and ambiguity of tactility at the cinema. Challenging an ontological split between the subject and object of perception, 'the sense of touch makes nonsense out of any dualistic understanding of agency and passivity' (Sedgwick, *Touching Feeling*, p. 14). Interestingly, Sobchack's identification of a primary sensing of cinema is bound up with the feeling of space. An ambient spatiality is especially evident in the following passage where Sobchack writes of how the figurally erotic touch that is exchanged between the film's characters of Baines and Ada awakens literal sensations of the skin, appealing to her own bodily capacity for touch and tangibility. At this moment, she describes that

> I feel not only my 'own' body, but also Baines' body, Ada's body, and what I have elsewhere called the 'film's body'. [...] textural and textual meaning [are] everywhere—not only in the touching but also in the touched. Objectivity and subjectivity lose their presumed clarity. (Sobchack, *Carnal Thoughts*, p. 66)

While primarily concerned with our pre-reflective and reflexive engagements with film, the value of Sobchack's account of cinematic touch for baroque flesh lies in its exchange between the literal and the figural and its spatial/sensuous continuum. Furthermore, her account of cinematic touch does not only occur through ambiguous or non-figurative imagery or just through the representational bodies of film characters but also through the sensuous expressivity of the film's body. At the point of contact, film and viewer, on-screen and off-screen bodies, intermingle in an ambient spatial scenario in which the positions of the touching and the touched are in flux and can reverse.

Let us return to Derrida, who connects tactility to movement by writing of touch enacting a serialized 'multiplicity without the horizon of a totalisable unity' (*On Touching*, p. 69). Within the sense of touch, we encounter fluctuating combinations of the fragment and the whole that are also apposite to the baroque. Many different permutations belong to the overarching sensation of touch (Derrida, *On Touching*, p. 69). The caress, for example, can easily lend itself to motions of skimming, grazing, and pressing. Caresses might become blows or vice versa. The caress might turn into a kiss, as well as everything that is exchanged between the lips, tongue, and teeth. Kissing can lead to biting, biting to tasting, and tactile sensations of pleasure to pain or pleasure in pain and back again, as we have felt through the baroque flesh of *Trouble Every Day*. In fact, the sense of touch harbours the potential to be so physically variegated that it is an

elusive sensation to pin down. Not only are there tricky distinctions to be made between the dual components of the touching–touched, tactility varies according to a range of experiential factors.

Touch possesses an extraordinary range of physical nuances, ranging from the subtle pitter-patter of rain falling on skin to physically overwhelming pain. It is the sense that discerns the tangibility of temperature (cool to the hand, hot to the touch), weight and pressure (a light touch, a heavy hand), the impact of intent and reciprocity (an unexpected slap to the face versus that of an invited caress), and the surface effects of feeling different textures (honeyed, rough, smooth, viscous, velvety, silky, syrupy). As if touch were not already complicated enough, it moves back and forth along incremental gradations of an affective continuum. Touch might elicit feelings of intense pleasure; it might make for an unremarkable melding into the background; it might be experienced as niggling discomfort, as surface irritation, as jolting shock or searing pain. We might note the association with temperature here, too, for the physiological components of touch can occur in isolation or as a combination of different experiential qualities. In short, touch is never singular. There is no one modality of touch that adheres to any one incarnation.

At this point, already, touch has revealed considerable variation in terms of how we might physically experience this sense. This is because the haptic overflows the containment of touch into fixed or singular categories, prompting synaesthetic (and cinesthetic) exchange along the way. It is little wonder that Derrida, after Aristotle, once invoked the *aporia* of touch. In the quotation that heads this chapter, Derrida describes touch as a 'flaunted taste for delirious profusion'—a profusion that is suggestive of the baroque (*On Touching*, p. 131). It is to the connections between the baroque and the haptic that I now turn.

Haptic Visuality and the Baroque

From Derrida's delirious profusion or *aporia* of touch to Buci-Glucksmann's madness of vision or Tesauro's madness of metaphor, much critical thinking on the baroque foregrounds mobility, multiplicity, and spatialized dispersal. The philosopher Jacques Lacan points to a kind of madness or delirium of movement that is inherent to baroque form. Writing of historic baroque churches in Europe, Lacan describes the baroque as 'everything attached to the walls, everything that is crumbling, everything that delights, *everything that is delirious*' (*On Feminine Sexuality*, p. 116; italics mine).[8] It is

this rampant proliferation that I am most concerned with in developing a distinctly baroque haptics. Through its strong sense of proliferation, its accumulation of detail, and its delirious multiplicity of images, spaces, and figures, the baroque sensuously yokes space, movement, and time together to a haptic end.

Movement, space, and time are essential phenomenological components to touch as they are to baroque flesh. As Merleau-Ponty tells us, 'the movement of one's own body is to touch what lighting is to vision', as it will 'bring about the patterning of tactile phenomena, just as light shows up the configuration of a visible surface' (*PP*, pp. 367–368). Movement is implicated in the sense of touch because touch requires time to occur and reveal patterning. Art historian Richard Shiff can help us think through the conjunction of touch, time, movement, pattern, and space for baroque flesh. Shiff makes an important temporal distinction between vision and touch in his discussion of the haptic canvases of Cézanne—one of the painters Merleau-Ponty reveres most when it comes to capturing the tactility of perception in art. According to Shiff, artworks that incline towards the tactile will be perceived in a piecemeal fashion, 'touch by touch, just as a canvas surface is painted', whereas a visual encounter is grasped more like 'an instantaneous survey' ('Cézanne's Physicality', p. 134). Tactile artworks are particularizing because they involve serialized, successive apprehension on the behalf of the beholder (pp. 134, 138). By contrast, visual apprehension of an artwork is instantaneous because it is offered to the eye in one coordinating glance (p. 138). Though Shiff does not discuss it, tactile, procedural, and piecemeal modes of perception in art are highly relevant to baroque art. This is because its haptic effects elicit our serialized perception through texture, restless movement, and the overt spatialization of time.[9]

The haptic resonance of baroque flesh is there to be had—if only we are willing to expand our focus beyond vision and consider the broader sensuous appeals of the baroque. Despite the prevailing association of the haptic with surfaces and with the surface of the body, the sense of touch and the haptics of art and film can also occur through depth and movement in and through space (Marks, *Skin of the Film*, p. 162; Fisher, 'Relational Sense').[10] In his *The Origin of German Tragic Drama*, Benjamin observed that one of the foremost characteristics of the baroque is its translation of time into space. This effect is achieved through highly spatialized narrative structures that draw attention to the unfolding of time. Although he is writing of seventeenth-century German theatre, Benjamin's ideas can be extended to baroque imagery.[11] As he indicates, 'what is vital is the transposition of the original temporal data into a figurative spatial simultaneity. This leads us

deep into the structure of the [baroque] dramatic form' (*The Origin*, p. 81). In a tellingly tactile turn of phrase, he then goes on to state how '*chronological movement is grasped* and analyzed in a spatial image' (Benjamin, *The Origin*, p. 92; italics mine). What Benjamin usefully suggests here is that the baroque produces spatial aggregates that are haptically perceived or 'grasped' by their participant in the figuring of time-as-space.

Let me establish the interpenetration of touch and vision in baroque flesh further. Film scholar Laleen Jayamanne asserts baroque perception as the following: 'baroque point-of-view would say why be simple when you can be complex' (*Toward Cinema*, p. 163). This take on baroque vision also pertains to its haptic effects. The baroque preference for complexity creates an aesthetic of dense proliferation or spatialization, as is evidenced by the baroque's wilful multiplication of different pictorial planes, spaces, objects, figures, surfaces, and images (Jayamanne, *Toward Cinema*, p. 163). Similarly, Martin Jay glosses the baroque scopic regime as an 'overloading of the visual apparatus with a surplus of images in a plurality of spatial planes' (*Downcast Eyes*, pp. 47–48). Such visual overloading and spatial multiplicity also yields tangible effects. Jay himself intimates as much, writing that the baroque 'is *more haptic or tactile than purely visual, more plural than unified*' ('The Rise', p. 318; italics mine). Because of its unrestrained proliferation of detail, the baroque often cannot be grasped in one instantaneous or all-encompassing survey. Instead, the baroque courts the embodied eye to move, haptically, between multiple figures, materials, and modes of decoration, roving across serialized images or between many spatial planes. Too much to take in with one glance, the baroque spurs a successive or serialized unfolding of the artwork in time that is very similar to Shiff's account of tactile art. As with touch proper, baroque haptics requires movement, space, and time to unfold its design or pattern.

Consider Annibale Carracci's elaborate ceiling frescoes for the Farnese Gallery, a coved hall of about 60 by 20 feet (Palazzo Farnese, Rome, 1597–1608). Its haptic effects stem from its complex layering of images, together with its juxtaposition of different materials and decorative modes. In the Italian *quadratura* tradition, illusionistic architecture is used to extend real architectural settings into imaginary space. Working in the vein of *quadratura* decoration, Carracci matches a painted architectural framework on the vault of the ceiling with stucco herms and atlantes figures that appear to be holding up the weight of the entablature. Medallions of simulated bronze appear (replete with a feigned ancient patina) alongside flesh-coloured youths with garlands and *quadri riportati* (*trompe l'oeil* decoration, housed in gilt-framed paintings) of love scenes from Ovid. Humans,

mischievous putti, and mocking satyrs are interspersed throughout, sitting
on the painted architecture or on the edges of the *quadri riportati* frames.
Crowding an immensity of detail into a relatively small space, we engage
with the gallery through a successive build-up of mobile looks (Dempsey, '*Et
Nos Cedamus Amori*', pp. 367–368). It is easy enough, for instance, to miss a
peeing putto next to one of the medallions or the satyr who appears about to
hurl a basket of fruit at us from behind one of the *quadri riportati*. Vision is
inflected by touch as the embodied eye is impelled to 'shift [its] focus from
quadro riportati, to architectural framework, to medallions to figures along
the borders' (Ndalianis, *Neo-Baroque*, pp. 90–91). Without labelling these
multi-layered effects haptic as such, Wölfflin's comments on the Farnese
Gallery resound with tactile possibility. As he writes: '*the eye remains in a
perpetual state of unrest*' for each image 'overlaps another image' such that it
'seems as if removing one will only reveal another' amidst Carracci's 'masses
of interpenetrating and overlapping forms' (Wölfflin, *Renaissance*, p. 64).

Alternatively, in the illusionistic dome painting, temporal progression in
space rather than formal or spatial overlap is crucial. Such effects remain
premised on the baroque artwork seeming to unfold in time and across
space. For example, Norman M. Klein has linked seventeenth-century dome
decoration to the kinesthetic movement, dizziness, and sense of balance
that it stirs within the body of the beholder. An embodied negotiation
of the dome is essential to achieving what he calls a baroque 'scripted
space' (Klein, *Vatican to Vegas*, p. 35). Significantly, the dome enacts an
unfolding story within a sensuously scripted space: '[w]hen the sky was
askew on a ceiling, it operated like an animatic, a five-minute stroll towards
revelation, from pride to humility, from hubris to prayer' (Klein, *Vatican to
Vegas*, p. 53). Dome decorations such as those of Andrea Pozzo or Pietro
da Cortona provided their beholder with a 'tangible path to God', as if one
were 'float[ing] inside the skin of these domes' (Klein, *Vatican to Vegas*,
p. 50). In the baroque dome, the eye is inseparable from the movement and
balance of the body beneath it. If the historic baroque dome could open
up a sensuous portal to the normally invisible divine, its effect—as with
all baroque flesh—would remain doubled and correlative. Portals to the
divine could only be entered through the literal movement of the beholder,
as its scripted space 'invites you to move in many directions' and to inhabit
the 'tangible space below' the dome (Klein, *Vatican to Vegas*, pp. 41, 45).

Through the transference of time into space, its crafting of scripted
spaces, serialized movement or the overloading of detail and overlapping of
images, historic baroque art can be considered a definite affiliate of the art
of touch. How, then, does touch or the haptic inflect baroque cinema? In his

book *The Cinema Effect*, Sean Cubitt outlines how the Hollywood baroque creates elaborately detailed, architectonic worlds that 'diminish the role of narrative' in favour of mobile traversal and the camera's 'exploring [of] the diegesis' (p. 225). The cinematic worlds of the Hollywood baroque transform 'narrative premise into pattern', resting upon the 'intrinsically decorative structuring of narrative, the extrusion of elaborations and fugal variations on basic premises' rather than linear, self-enclosed modes of narration (*Cinema Effect*, p. 223). While Cubitt is correct about the spatialization of the image/narration that occurs in baroque cinema and its privileging of movement, he never goes on to address the sensuous signification of a baroque cinema or what the compulsion to become space might mean at the level of the body.

To arrive at the haptics of a baroque cinema it is necessary for us to turn to film scholars whose work is more explicitly invested in the relationship between cinema, the body, and sensation. Laura Marks' *The Skin of the Film* and *Touch* provides us with a fine place to start. As she writes, the evocation of the proximate senses in film 'invite the viewer to respond to the image in an intimate, embodied way, and thus facilitate the experience of other sensory impressions as well' (*Skin of the Film*, p. 2). Like me, Marks turns to philosophers invested in the body as well as repressed and/or neglected histories of visual culture to open up film and film spectatorship along an embodied continuum. Her influential account of 'haptic visuality' is of special interest to us in terms of its implications for a baroque cinema of the senses. According to Marks, haptic visuality implies a mode of vision that can indeed be tactile, 'as though one were touching a film with one's eyes' (*Skin of the Film*, p. xi).

In her *The Skin of the Film* and *Touch*, Marks' conception of haptic visuality brings together art history with the philosophy of Deleuze and Félix Guattari. More particularly, she draws on what they call 'smooth' or 'nomad' space and its immediate relations to establish how haptic visuality operates in film (*Skin of the Film*, pp. 476, 493; *Touch*, p. xii). Rather than carving out space through the optical abstractions of maps, signs, geographical bearings, and compasses, Deleuze and Guattari describe nomadic space as involving 'step by step', close-range, and 'tactile relations' (*A Thousand Plateaus*, p. 493).[12] Unlike the optics of 'striated space', nomad/smooth space is 'a space of affects, more than one of properties. It is *haptic* rather than optical perception' and born of 'sonorous and tactile qualities' such as gusts of wind, 'the desert, steppe, or ice' (p. 479). Tracing the etymology of the term haptic back to the early art history scholarship of Aloïs Riegl, they understand nomad space as haptic, amorphous, and implicitly non-representational.

The nomad art that arises from this space creates the 'object of a close vision par excellence and the element of a haptic space (which may be as much visual or auditory as tactile)' (pp. 479, 493). In their reckoning of nomad art as abstract, Deleuze and Guattari invoke the aesthetic coupling of 'close vision-haptic space' to establish its tactile or, more precisely, haptic qualities in Riegl's sense. This is because nomad art 'does not establish an opposition between two sense organs' but instead suggests how the 'eye itself may fulfill [a] non-optical functioning' (pp. 492–493).

Returning to Riegl's work via Deleuze and Guattari, Marks advances an immediate, 'close-up and tactile way of looking' in film whereby 'the eyes themselves function like organs of touch' (*Skin of the Film*, pp. 168, 162). Before moving on to her account of haptic visuality, it is important to spend time with Riegl to discover what exactly his foundational concept of the haptic in art history entails. In his book *Late Roman Art Industry*, Riegl first distinguished between *haptisch* (tactile) and *optisch* (optical) qualities of art. He located the tactile as belonging to ancient art and the optical as beginning with late Roman and early Christian art (Riegl, *Late Roman Art*, p. xx). The difference between these two regimes lies in the former's elevation of the surface or the materiality of the surface plane over and above the representation of figures within space. According to Riegl, the planar tendencies of ancient art tried 'to avoid the representation of space as a negation of materiality and individuality' (pp. 23–24).

The ancients' privileging of the haptic over the optic and the surface over impressions of depth can be demonstrated by the following example. If we look at an ancient Egyptian statue or a relief from a distance, it will appear to possess 'a flat and absolutely lifeless impression'. However, as we move into proximity with the artwork, its 'planes become increasingly lively, until eventually the fine modeling can be felt entirely, when one lets the tip of the fingers glide over them' (Riegl, *Late Roman Art*, p. 24, fn. 2). The haptics of Egyptian art spurs a tactility of perception, urging the beholder to glide their eyes-as-fingertips across its flat, detailed surfaces. While our perception of the artwork 'has to be optical to a certain degree, it is *nahsichtig*' or haptic for Riegl, and 'Egyptian art expresses [*nahsichtig*] in almost its purest form' (p. 25).[13] By contrast, figurative art brings with it a predominantly optical engagement. This is because later traditions of art distinguish between figure and ground, encouraging the beholder to perceive 'figures in space' (Riegl, *Late Roman Art*, p. xx; Marks, *Skin of the Film*, p. 166). By depicting figures in space, 'individuals are isolated thus dissolving the previous tactile connection to the surface' (Riegl, *Late Roman Art*, p. 26).

Significantly, Riegl himself posits a correlative relationship between artwork and beholder that is open to the mutuality of touch. As Rolf Winkes notes, Riegl sees 'the beholder and the work of art [as] moving toward an ideal situation where they become part of the same time. Until this is reached, a work of art is not finished' (qtd. in Riegl, *Late Roman Art*, p. xxiv). For Riegl, whether or not an artwork could be considered haptic or optic or else a combination of both, as I will get back to, depended on the position of the beholder. In his terms, the beholder could be *nahsicht* (near), *fernsicht* (far), or *normalsicht* (somewhere-in-between) in relation to the work (Lant, 'Haptical Cinema', pp. 48, 63). A shift from the tactile towards the optical meant a corresponding shift in the spatial positioning of the beholder. To engage with the work through 'tactile perception the beholder needs to be close to the object, that is *Nahsicht*, while for an optical perception, the view from a distance, the *Fernsicht*, is best suited' (Riegl, *Late Roman Art*, p. xx).

As with much recent embodied film scholarship, Marks' haptics is premised upon cinema as a mutually embodied encounter or dynamic 'exchange between two bodies—that of the viewer and that of the film' (*Skin of the Film*, pp. 149–150).[14] In *The Skin of the Film* and *Touch*, she tethers that embodied exchange to haptic visuality (*Skin of the Film*, p. 162; *Touch*, pp. 2–3). While a painting, film, or example of video art might be suffused with haptic images, 'the term haptic *visuality* emphasizes the viewer's inclination to perceive them', she maintains (Marks, *Skin of the Film*, p. 162).

The distinction between the haptic as a formal component of the work and a predisposition of the viewer is a subtle but important one. Again, it highlights the relationship between film and viewer as founded on mutuality as well as difference. Given my established stance on the doubled or correlative structure of baroque flesh and its aesthetics of reversibility, I think we can claim haptic visuality for the viewer of a baroque cinema as well. A baroque cinema of the senses will offer us haptic compositions that are enabled by cinema's own mobility, its multiplication or dispersal of detail, its spatialization and heightened texturing of the image. This is, however, but one side of its doubled structure. Baroque cinema also relies on our haptic visuality to complete its embodied and sensuously intelligent effects. The movement of the film's body into or out of the depths of the image as well as across its material surfaces will be felt within and/or on the surface of our bodies, as well as in our proprioceptive or 'keyed' relations to the affective feeling of space (Bal, *Quoting*, p. 151). Baroque cinema reignites the haptic, successive, and piecemeal mode of perception that Shiff identifies in tactile art—conventions that are intrinsic to baroque art and film as well.

Let us return to Marks' appraisal of haptic visuality as a style of looking that is at once sensuously proximate and abstract because of its sheer proximity. To quote Marks: a haptic visuality 'tends to move over the surface of its object rather than to plunge into illusionistic depth, not to distinguish form so much as discern texture. *It is more inclined to move than to focus, more inclined to graze than to gaze*' (*Skin of the Film*, p. 162; italics mine). Given that baroque flesh is undeniably grounded in an embodied aesthetics of movement, texture, surface, and materiality, it bears striking affiliations with this passage. While I am indebted to Marks' thoughts on haptic visuality in film, I want to adjust her account to suit the sensuous significance of the baroque and a baroque cinema. For Marks, the haptic in film 'bypasses identification and the distance from the image it requires' by inviting a look 'that moves on the surface plane of the screen for some time before the viewer realizes' what it is they are beholding (*Touch*, p. 8). While baroque haptics can and indeed does traverse the surface of the image it can, just as easily, move us into or out of its sensuous depths. For Marks, as for Deleuze and Guattari, the haptic is steeped in the non-representational qualities of smooth/nomad space and in the 'creative power of non-figurative representation' (*Touch*, p. 6).[15] The baroque haptics that I put forth is instead amenable to and inclusive of so-called 'identification', figurative form, signification, and representation. In this regard, it is both informed by and distinct from haptic visuality and explorations of the haptic in film theory that have since gathered under Marks' model, especially those that seem to stringently divorce a cinema of haptic sensation from genre, narrative, or figuration.

Shifting the critical and aesthetic ground of what might constitute a haptics of perception is in keeping with the dialectic between the haptic and optic. As Marks herself insists, few works are 'entirely haptic' but rather 'stress the relationship between optical and haptic, their potential to dissolve and resolve into one another' (*Touch*, p. 12). Similarly, Deleuze and Guattari hint that 'there are still other kinds of space that should be taken into account' in addition to smooth/nomadic space and the striated (*A Thousand Plateaus*, p. 500). As they write, 'smooth space is constantly being translated, transversed into a striated space; striated space is constantly being reversed, returned to a smooth space' (p. 474). In these terms, the haptic and the optical should not be conceived of as a strict dichotomy but as a dynamic flow, passage, combination, or mixture.

In the pursuit of a baroque haptics for film, I should note that the haptic potential of cinema does boast some interesting critical precursors to Marks. While concerned with the haptics of early film history, the work of Noël Burch and Antonia Lant is suggestive of both the spatiality and tactility of

baroque flesh. Neither Burch nor Lant link haptic visuality to the kind of up-close, proximate, and intimately embodied style of looking that is Marks' contribution to film theory. Instead, they foreground movement into or out of the frame; an oscillation or overlapping between effects of surface and depth, near and far, or expulsion and recession; depictions of inanimate flatness versus the vibrancy of 'living' forms, and an interpenetration of the haptic and the optic that is highly relevant to baroque flesh.[16] Re-visiting Burch and Lant alongside Marks' haptic visuality, what follows returns to baroque art history and its properties of touch to forge an alternative conception of the haptic for baroque cinema.

In his *Life to Those Shadows*, Burch argues that cinema was 'deeply *split* where the representation of space and volume is concerned' prior to World War One (p. 163). Alongside other contemporaneous 'flat' or planar media entertainments (strip cartoons, chronophotography, chromolithographs, zoetrope strips), Burch suggests that the early cinema was initially indifferent to three-dimensional depth (pp. 163–164).[17] The surface-driven sensibility of early film can be seen in the cinema of Georges Méliès, in whose films the fixed camera, lighting, painted backdrops, and the frontal placement of actors lends a perceptual flatness to the image (Burch, *Life to Those Shadows*, pp. 164–165). Despite its flatness and planarity, Burch does not link the haptic effects of early cinema to the tactility of the surface. Rather, he understands 'haptic space' as an immersion into or a potential inhabitation of the image (p. 162). Such an effect echoes the sensuous movement or absorption of the viewer within the image that I discussed as co-extensive space in Chapter 2. Unlike Marks, Burch's understanding of haptic cinema entails a depth-full spatiality, 'such that a viewer believes he or she could touch the photographed objects and actors, as if they existed in real space' (Lant, 'Haptical Cinema', p. 71). With the rise of a more convincing spatial volume to cinema in the 1910s viewers were offered 'tangible proof of the three-dimensionality of "haptic" space' (Burch, *Life to Those Shadows*, p. 181).

> Rather like a conjurer putting his wand in the hat to show that it is empty, French directors [began to use] characters to show that none of the space visibly represented is on a painted backdrop, that it can be entered and touched, is 'haptic', to use the technical term psychologists of perception have derived from the Greek word for touch and juncture. (Burch, *Life to Those Shadows*, pp. 172–173)

Reaching toward or into the screen to grasp its sensuous 'depths' is noticeably different from haptic visuality, where our eyes will linger across, brush

up against, or horizontally caress the surface of an abstract or indeterminate image (Marks, *Skin of the Film*, pp. 127, 169). Such a film-phenomenological grasping and its tangible entry into the screen is, however, very relevant to the baroque topographies of the image that I have established, helping alert us to the baroque's propensity for the haptic in film.

From a slightly different tack, Antonia Lant's essay 'Haptical Cinema' is also reminiscent of baroque spatiality. Lant proposes a tactility of vision that is different again to Burch and to Marks. For Lant, early cinema exploits spatial layering and an enlacing of flat with volumetric forms. In Méliès, she points to the enlacing of designed surfaces with the illusion of a spatial penetration into the image (Lant, 'Haptical Cinema', p. 46). Time and time again, Méliès plays a trickster or cinematic magician who makes seemingly inanimate figures and paintings come to life. Alternatively, his trademark giggling skeletons will appear quite flat in form (as white bars painted on black cat suits) but then suddenly transform through dissolves 'into plump bodies of flesh' (Lant, 'Haptical Cinema', p. 47). Unlike Burch, Lant reads into Méliès' films a fascination with the illusion of movement and of depth that was newly afforded by cinema. This fascination takes the form of an alternation between surface and depth, between animate and inanimate, near and far, or expulsion and recession that can be extended to early film history more generally. Painted flats, sets or Egyptian bas-reliefs offset against the moving flesh of actors or the coming to life of paintings via trick effects was very much a performative display of cinema and its unique 'power to animate the surface', to oscillate between the planar and the volumetric (Lant, 'Haptical Cinema', p. 55).[18]

Significantly, for my purposes, Lant does not confine haptics to the surface or even to an alternation between surface and depth. Rather, she connects the haptical to movement into or out of the frame. Her understanding of the haptic accords with co-extensive space, as it might be experienced through 'motion into or out of the screen, forward and back' (Lant, 'Haptical Cinema', p. 47). While Lant never links 'spatial swallowing and rushing' and movement 'across the surface of the screen' as well as a 'probing into its depths' to the baroque, I think we can certainly extend such effects to its cinematic incarnation ('Haptical Cinema', pp. 49–50). Furthermore, Lant's integration of spatial movement with the movement between surface and depth allows for a *fluctuating* combination of touch with vision that is amenable to baroque flesh.

In their respective discussions of the haptic potential of film, Marks, Burch, and Lant all open up the possibility of an embodied engagement with film that is not delimited to just psychic and/or narrative identification with film characters but with the embodied expressivity of cinema itself. Marks,

for one, also takes issue with Riegl's teleological assumption that the haptic died out with the rise of figurative space in art. As she maintains, 'haptic representation [...] continued to be a viable strategy in Western art, although it is usually relegated to minor traditions' (Marks, *Skin of the Film*, p. 168). What Marks does not comment upon (and what is truly remarkable for the purposes of this book) is how many of her 'minor traditions' in art history can be explicitly connected to the baroque (*Touch*, p. 6). In this regard, the work of Mieke Bal, Naomi Schor, Svetlana Alpers, and even Riegl will help us develop a specifically baroque-oriented haptics.

Naomi Schor's study of the detail, for example, unpacks the sensuous history of ornamentation, its longstanding association with tropes of effeminacy or decadence, and its implicitly gendered discussion (*Reading in Detail*, p. 5).[19] According to Schor, the attention that is demanded by ornamentally laden or highly decorative arts tugs at the eye of the beholder, instigating a tactile 'break in perception' (p. 17). In arts such as that of the Dutch tradition or the ornamental style, the proliferation of minute, polycentric, or centrifugal elements fractures perspectival unity. Here, an array of many 'fine details' lie 'just beneath the range of immediate perception or just outside the field of perception altogether, in the shadowy, corporeal realm of the tactile' (Schor, *Reading in Detail*, pp. 20, 28). Not only is ornamentation, multiplication, and aesthetic dispersal favoured by the baroque, Schor herself goes on to note that the baroque is 'the school of the studied detail par excellence' (p. 47).

In *The Skin of the Film*, Marks also invokes Mieke Bal's concept of the navel painting as another instance of haptic visuality that is tactile but gender-neutral.[20] Bal, as we know, is one of my key critical affiliates in formulating baroque flesh. Her navel readings are suggestive of the sensuous function of the detail in baroque art and the correlative structure of the baroque, generally.[21] According to Bal, the navel painting will trigger 'textual diffusion, [and a] variation and mobility of reading' (*Reading*, p. 23). As indicated by the teasing features of Velázquez's mirror, Caravaggio's wound, or the nail, hole, and shadow on the wall of Vermeer's *Woman Holding a Balance* (c. 1664), the navel painting relies upon the physically arresting nature of the detail to prompt a 'burst of speculative fertility' and further hermeneutic questioning (Bal, *Reading*, pp. 2–3). For Bal, the 'navel, then, is a metaphor for an element, often a tiny detail, that hits the viewer, is processed by him or her, and textualises the image on its own terms' (*Reading*, pp. 22–23).

As Bal describes it, the tactile shock or start of awareness that occurs on the part of the beholder is not divorced from our semiotic interpretation of the work; if anything, the physicality of the detail furthers it. In these

terms, the navel painting participates in the 'imaginative construction' of the haptic image though its appeals occur through figurative rather than more abstract imagery (Marks, *Touch*, p. 16). In this regard, its visual tactility does not only 'invite a small, caressing gaze' (Marks, *Skin of the Film*, p. 169). I would add that the navel painting harbours definite baroque connotations and not simply because it is applied by Bal to seventeenth-century European art. Rather, the navel painting involves a sensuality, mobility, and reciprocity of meaning that is typical of baroque flesh. Destabilizing meaning in its arresting tactility, the detail absconds with interpretation and opens it up in multiple directions and meanings for the beholder.

Also deserving of our consideration is Svetlana Alpers' book *The Art of Describing: Dutch Art in the Seventeenth Century*. According to Marks, this work articulates another chapter in the history of haptic visuality whereupon the eye 'lingers over innumerable surface effects instead of being pulled into centralized structures' (*Skin of the Film*, p. 169). Alpers' goal is to elucidate the differences between northern European art and that of the south: 'northern mapmakers and artists persisted in conceiving of a picture as a surface on which to set forth or inscribe the world rather than as a stage for significant human actions' (*Art of Describing*, p. 137). The ambient, aggregate, surface-driven, and highly decorative tradition of northern Dutch art—what Alpers calls the 'art of describing'—boasts its own culturally distinct logic. Alpers reveals that logic to be different to the perspectivally framed, fixed, singular, and depth-full 'narrative art' of the Italian *istoria* tradition (*Art of Describing*, pp. xix, xx, xxv; Friedberg, *Virtual Window*, pp. 38, 64–65).[22]

> We might summarize the well-established contrast between north and south in the following ways: attention to many small things versus a few large ones; light reflected off objects versus objects modeled by light and shadow; the surface of objects, their colors and textures, dealt with rather than their placement in a legible space; an unframed image versus one that is clearly framed; one with no clearly situated viewer compared to one with such a viewer. (Alpers, *Art of Describing*, p. 44)

While the baroque partakes of figuration-in-space and perspectival depth it is also prone to flatness and materiality, eminently textural effects, a material-visuality and what Wölfflin calls the sensuous 'life of the surface' (*Principles*, p. 38). While Northern Dutch art harbours aesthetic conventions that are distinct from the Italian Renaissance this is not to suggest that the Dutch sensibility is divorced from the European baroque, including that

of the Italians. Through detailed surfaces and textures and its privileging of materiality and movement, the Dutch art of describing has definite affiliations with historic baroque art. Despite Alpers' geographic and formal separation of the northern and southern European arts, both expressed 'certain seventeenth-century ways of understanding the world' (*Art of Describing*, p. 22).

As Anne Friedberg demonstrates, Dutch art is unlike the Italian tradition of the Albertian 'open window' (the rectangle or framed window that Leon Battista Alberti offered as his influential descriptor of painting) (*Virtual Window*, p. 64). It does, however, bear a striking affiliation with Italian baroque art. What the art of describing and the baroque share in common are their attitudes towards the frame and towards the beholder. To quote Alpers, the Dutch model 'was not a window on the world like the Italian model of art but rather, like a map, a surface on which is laid out an assemblage of the world' (*Art of Describing*, p. 122). As with the porous spatiality of the baroque, Dutch art 'de-emphasizes the frame' (Friedberg, *Virtual Window*, p. 272, fn. 50). Whereas the baroque creates a continuum between bodies through co-extensive space, Dutch art presents the image as 'spread out on the pictorial surface' and gestures towards 'a world that continues beyond the canvas' (Alpers, *Art of Describing*, p. 27). Both aesthetics resist the strictures of the frame. Both engender a haptics of perception by hastening the embodied eye of the beholder to move across an aggregate collection of views.

Similarly, baroque aesthetics have long been embedded in the tactile lures of immanence, texture, and a material-visuality. Alpers herself proposes a connection between Dutch art and the Italian baroque because of their shared 'attentiveness to descriptive presence' (*Art of Describing*, p. xxi). According to Marks, the Dutch art of describing 'invites the sort of [haptic] look that would travel along textures of detail' (*Touch*, p. 132). As established via Deleuze and other thinkers in the previous chapter, the baroque is heavily invested in materiality and an art that 'comprehends the textures of matter' (*The Fold*, p. 115). Deleuze lists Bernini and Caravaggio as two prominent baroque artists who dedicated themselves to an art of textures rather than (centralized) structures (*The Fold*, pp. 35, 115, 122). Building on these claims, I would point out that even lesser known artists like the Neapolitan François de Nomé expressed such baroque materiality. In de Nomé, ghost-like statues and skeletal figures accompany his depiction of still or crumbling ruins and his hauntingly eerie and immense architectural landscapes. His paintings are best considered as events of texture that appeal to our skin and our fingers, as well as to our eyes. In fact, de

Nomé even employed the unusual technique of a thick *impasto* (where the paint, on closer inspection, resembles nothing so much as the drippings of a candle) for his aim was 'not to produce a reflection of reality but rather to produce in the viewer [...] a set of sensations' through the treatment of light, surface, and texture (Marandel, *François de Nomé*, p. 27; Zamora, 'Magical Ruins', p. 70).

Alpers points to Dutch artist Rembrandt van Rijn as another historic baroque painter who privileged painterly expressions of materiality, as is befitting of a baroque texturology. Such an investment can be evidenced by the glimmer of his painted helmets and swords, the glow of his painted jewels, or the density of his depiction of woven robes replete with finely interwoven threads of gold (*Art of Describing*, p. 225). To quote Alpers: 'Rembrandt [...] settles for the materiality of his medium itself. His paint is something worked at with the bare hands—*a material to grasp, perhaps, as much to see*' (*Art of Describing*, p. 225; italics mine). Furthermore, she observes how 'some of the most innovative and accomplished artists in Europe—Caravaggio and Velázquez and Vermeer [...] embrace an essentially descriptive pictorial mode' (*Art of Describing*, p. xxi).[23] By way of Alpers, we once again encounter the neglected touch of the baroque in art history.

Aside from the mobilization of Riegl for the haptics of smooth/nomad space or abstract imagery, there are important historic connections to be found between Riegl ('the great-uncle of tactile visuality') and notable critics of the baroque that suggest alternative paths (Marks, *Touch*, p. 231, fn. 6). Lant, for instance, alerts us to the fact that Riegl's work was a foundational influence on the art history of Wölfflin and on Benjamin ('Haptical Cinema', p. 47). In fact, Benjamin once referred to Riegl as 'a decisive influence' on nothing less than *The Origin of German Tragic Drama* (qtd. in Lant, 'Haptical Cinema', p. 48, fn. 7). I like to think that Benjamin worked through his own ideas about the baroque as a spatialization of time or as a texturing of time, encrusted on its ruins—all the while meditating on Riegl's fluctuating categories of the optic and the haptic or even a baroque version of Riegl's *Kunstwollen* and its tactile legacy.[24]

Riegl's optic and haptic categories would later inflect Wölfflin's comparative formalism in his own *Principles of Art History* (1915), especially in terms of the art historian's descriptions of the linear (classical) and the painterly (baroque) (Lant, 'Haptical Cinema', p. 67, fn. 85).[25] Significantly, Riegl himself understood the painterly as a combination of both the haptic and the optic ('the tactile-optical') (Riegl, *Late Roman Art*, p. 46). Wölfflin follows in this vein in his own discussion of the painterly or baroque—and it is this fluctuation, movement, or oscillation between the haptic and

the optic (the tactile-optical) that is of real consequence to us in pursu-
ing a baroque haptics for cinema. A baroque haptics does not only occur
through proximate surfaces or through 'images [that slowly] resolve into
figuration, if at all' as with Marks' haptic visuality (*Skin of the Film*, p. 163).
Returning directly to Riegl and to his category of the *normalsicht* position,
we discover a haptic intertwining of vision with touch that lends itself to
forms of figuration. This somewhere-in-between near and far relationality
between artwork and beholder 'ascertains equally both [the] tactile clarity
of the details and optical synopsis of the whole' (Riegl, *Late Roman Art*,
p. 29).

This interpenetration of the haptic and the optic is also evident in Wölf-
flin's evocative discussion of the painterly and its appeals to the senses. As
with the haptic in Riegl, the linear style in Wölfflin can be quite literally
grasped, touched, seized, fingered, and felt. For Wölfflin, the painterly
gives itself over to the eye at the same time as it heightens our awareness of
texture. In the linear style, the 'operation which the eye performs resembles
the operation of the hand which feels along the body' (Wölfflin, *Principles*,
pp. 21, 27). In the painterly style, the hand 'ceases to take hold of things'
because it strives for visual appeals albeit to an embodied (haptic) eye that
has become 'sensitive to the most varied textures' (Wölfflin, *Principles*,
pp. 21, 27).[26] As Marshall Brown also asserts, it is in his 'second baroque sense
of the tactile' and in the textured and mobile contours of the painterly that
Wölfflin finds a greater 'sensual richness' that 'relishes' the skin of things
(Brown, 'The Classic', p. 390). Though the figural sensuality of the painterly
or baroque might be channelled into the eye rather than literally into the
hand, it is no less haptic in its impressions of heightened texture, surface
movement, and energy.

Finally, in Merleau-Ponty's philosophy of 'flesh', there is the suggestion
of a non-coincident reversibility between touch and vision that is also
congruent with the baroque. As M.C. Dillon suggests, within his concept
of 'flesh', vision and touch are never superposable but they are reversible:
'for the most part, I can touch what I see and see what I touch' (*MPO*, p. 160).
In the second quotation that heads this chapter, Merleau-Ponty invokes
the crossing-over of touch and vision as a sensuous 'situating of the visible
in the tangible and of the tangible in the visible' without at all suggesting
that the two senses are the same (*VI*, p. 134). Extending the image of the
two hands touching to a reversibility between touch and vision, Merleau-
Ponty writes that 'there is encroaching, infringement, not only between
the touched and the touching, but also the tangible and the visible, which
is encrusted in it, as conversely, the tangible itself is not a nothingness of

visibility, is not without visual existence' (*VI*, p. 134). When I cannot *literally* touch what I see, the baroque will invoke touch through *figurative* appeals to our haptic visuality. The sensory orders of vision and touch will reverse, interpenetrate, and renew themselves in baroque flesh, wherein our vision is always embodied and the senses firmly entangled.

As Merleau-Ponty once remarked, 'the presence of the world is precisely the presence of its flesh to my flesh' (*VI*, p. 127). As I have outlined, the contact between bodies or between body and world that the philosopher speaks of can be extended to aesthetic experience. It is precisely because cinema involves a doubled address of the eye, a doubled spatiality, and a doubled embodiment that the two-sided interplay of touch is possible here. As Sobchack affirms, through the embodied 'address of our own vision, we speak back to the cinematic expression before us, *using visual language that is also tactile, that takes hold of and actively grasps the perceptual expression*' (*Address of the Eye*, p. 9; italics mine). Sobchack's words are indicative of the film-phenomenological consideration of film and viewer as two mutually embodied and enworlded subjects of vision that exchange contact.

However, just as there is no one mode of vision in cinema nor could we say there is a singular mode of touch—the kind of small, caressing gaze that Marks associates with lingering across the horizontal surface of an indeterminate image, as if brushing it 'with the skin of [our] eyes, rather than looking at it' (*Skin of the Film*, p. 128; see also *Touch*, p. 8). The reciprocally embodied, visually tactile relationship that Marks and Sobchack outline gives us pause for thinking about how cinematic tactility might occur in other aesthetic configurations. In this section I have justified alternative accounts of the haptic in art history and in film studies. If Marks' model of haptic visuality is not entirely that of baroque flesh, let us examine in more detail how a baroque haptics occurs in film.

Baroque Haptics and Cinema

A hybridized mixture of documentary, experimental film, digital database, personal archive, and life-as-performance, *Tarnation* announces itself as a highly personalized autobiography right from its beginning. The film opens with Caouette's mother, Renee Leblanc, singing an a cappella rendition of 'This Little Light' to the camera, clicking her fingers in time as she moves about the house. The film cuts to black, bringing with it an abrupt shift in atmospheric mood. When we next see Renee, she is in a hospital room. She is set against bleached-out, slowed-down footage and accompanied by

the mournful intones of the band Low: 'Mother close the door, I need your grace'. Renee's name appears in the film's title credits as the foremost star of *Tarnation*. Caouette's name, the names of his grandparents, and that of his lover then appear over sped-up footage of a train journey. Amidst these images of travel, the vision of the film halts to contemplate the faces of Caouette's different family members, especially Renee. The imagery becomes faster and faster, the soundtrack responding in intensity. The film fades to black again before fixating on images of clouds moving across a grey sky. The monochromatic haziness of the image expresses the sense of temporal decay that pervades much of the film's archival footage, although these images could easily be digitally washed out. In its representational uncertainty (clouds or pixels?), this image is one instance of *Tarnation* that does correspond with Marks' haptic cinema. The image solicits our embodied engagement with an ambiguous textured surface rather than film narrative or character. Material presence is prioritized over representation as the 'haptic image forces the viewer to contemplate the image itself instead of being pulled into narrative' (Marks, *Skin of the Film*, p. 163).

As is commensurate with baroque flesh, visual and material indeterminacy gives way to figuration: a re-enacted scene set in March 2002 featuring Caouette and his lover in their New York apartment. 'I was having the weirdest dream, it was about my mother', says Caouette upon waking. Caouette's face is the camera's intentional focus now: weeping, worried, and visibly ill with a fever. Renee has suffered a lithium overdose. We learn that the film's initial footage of Renee was taken after this event, which also caused her to suffer permanent brain damage. A close-up of Renee's face appears, slowly opening her eyes in a glowing black-and-white shot. As Caouette embraces his mother, the image dissolves around its edges. An old audio recording of Renee reading the 'Desiderata' poem of Max Ehrmann is played over Caouette's train journey back to Texas after the overdose. Suddenly, the images pixilate and fade into a close-up of static on a blank television screen. The face of Caouette-as-adolescent slowly comes into visible relief through the electronic flicker.

Given its iMovie genesis, Caouette's low-budget *Tarnation* has been lauded as a digital do-it-yourself—a prescient sign of events to come in the burgeoning of both digital filmmaking and user-generated content.[27] Initially produced on a miniscule budget of around $200 (US), the film is a digital reconstruction of the director's own troubled past and his familial history. In this regard, the film's haptic resonance is also compounded by its links with the documentary format. According to Marks, documentary has strong affiliations with the haptic—and interestingly, many of her examples

of haptic cinema do belong to documentary film and video. This is because the documentary film format maintains an almost fetishistic relationship to the real through its embodied connections with the profilmic event (Marks, *Skin of the Film*, pp. 79, 125). Similarly, Bill Nichols writes that documentary film claims a privileged indexical relationship to the real because it 'insists on the presence of the body' (*Representing Reality*, p. 232). Documentary strives to offer us 'evidence of a life as it was lived and experienced in the flesh, within the constraints of the historical physical body itself' (Nichols, *Representing Reality*, p. 233). Instead of furthering a sense of distance between film and viewer, the documentary can spur an ethics of reversibility as we are 'invited to mimetically embody the experience of the people viewed' on-screen (Marks, *Touch*, p. 8).

As Alphonso Lingis writes, to 'recognize another is not to identify a sensible essence or even a style in a succession of significant dealings with another; *it is to be touched by a body*' ('Bodies', p. 167; italics mine). In striving for recognition, sensuous empathy or cine-mimesis, the documentary format is well suited to baroque flesh. Bodies moving about the world will leave traces of their own presence, dismembering themselves by 'casting shadows, reflections, engendering profiles and perspective diminutions, leaving traces, [...], rustlings, footsteps, murmurings, coughs, sighs, echoes, winks, sweat, tears' (Lingis, 'Bodies That Touch Us', p. 167). Similarly, when *Tarnation* moves across its different media and materials it foregrounds the human lives that have been affectively dismembered through them.

As Lingis nicely proposes it, 'bodies touch us by dismembering' ('Bodies That Touch Us', p. 167). In its complexity and its formal dismemberment of the film's body, *Tarnation* touches us in a baroque fashion. This is not to say that the film is not moving in terms of its narrative, for much of the emotional impact of *Tarnation* stems from its powerful expressive rendering of Renee and Caouette's skewed psychic states. Retelling the past of Renee's adult shock treatments, it feels as if currents of electricity are passing through the film. The perceptions and expressions of the film's body become violently agitated, exploding across media by rapidly switching between and overlaying film and photography. The inclusion of shock therapy scenes from *Ciao! Manhattan* (Palmer and Weisman, 1972) is temporally and physically jarring in its repetitive movements back and forth. These scenes are intercut with video footage of Renee as a young woman. Photographs of her holding a baby Caouette erupt into bursts of colour, as the soundtrack bursts into static.

Like Renee, the film's body is incapable of sustained focus here. Its hallucinatory juxtapositions of the 'real' and the 'representational' parallel

Fig. 10: Formal and affective fragmentation combine in *Tarnation* (2003). Courtesy of the filmmaker.

her own disordered mental state. Similarly, the film attempts to document Caouette's development of a depersonalization disorder during his teens. This disorder automates the body, as if one were living it from the outside rather than experiencing it from within. The film's body stages this perceptive disjuncture as a literal fragmentation of the screen. Footage taken from one of Caouette's early horror films suddenly splits into four frames. The gestures of a teenage Caouette (silently screaming, clawing at the mirror, tearing his hair) repeat themselves in each frame, and are rhythmically matched to the offbeat soundtrack.

The scene becomes a musical montage of interior psychosis with variations in light intensity and washes of red that suffuse the split images. The alternation between a single image and its repetition across frames, together with the rapid blend of family videos work affectively to convey to us Caouette's own inability to concentrate. Throughout, we return to slow-motion images of Renee dancing. Through this motif, *Tarnation* makes visible and sensible to us Caouette's own need to connect with his absent or emotionally unavailable mother by making literal as well as figural sense of their past.

The final scene of Caouette as an adult, curled up against a sleeping Renee (now living with him in New York) is a poignant example of the ethics of reversibility that can occur in documentary (Marks, *Touch*, p. 8). The voice-over of Renee reading the 'Desiderata' poem is repeated. 'With all

its sham, drudgery and broken dreams, it is still a beautiful world', echoes her voice, first recorded in 1975 on audiotape, a tape that Caouette later found behind the family dryer. In this sense, the conclusion of the film is a touching testament to the psychic trauma and urge to survive that is mutually shared between Renee and her son.[28] There is a strong sense of stillness to the conclusion of *Tarnation* that stands out from this otherwise frenetic and fevered film. Having cine-mimetically embodied the traumatic experiences of Renee and Caouette, the film's body arrives at a kind of bodily and emotive catharsis. As Shaviro comments, *Tarnation* 'expresses and embodies a mode of being-in-the-world that is absolutely singular, rich, and strange, yet [...] completely comprehensible and recognizable to the spectator'. In its formal and affective sensibility, the film's world 'is also my own, the very same world I myself inhabit' and what I imagine I could be in and through the ethics of reversibility ('*Tarnation*').

While not disregarding this film's emotional impact, I am interested in how *Tarnation* resonates with a baroque haptics. In the work of Marks and Lant, Riegl's haptic and optical categories allow film and media studies to approach spectatorial relations as not only 'derived from [...] identification with a represented human figure, but rather [operating] at the level of design, suggesting an alternate avenue for discussing film figuration besides via narrative and plot' (Lant, 'Haptical Cinema', p. 64; see also Marks, *Skin of the Film*, p. 166; Marks, *Touch*, p. 5). While figuration, narrative, and plot will make their return in my discussion of the textural effects of this film, let us continue with baroque haptics in terms of its formal and formally embodied effects.

At this juncture, it is useful to return to Wölfflin's work on the painterly and Alpers on Dutch art. Both discuss the tactile conventions of seventeenth-century art, establishing a clear historic precedent for the kind of baroque haptics that I am pursuing with regards to *Tarnation*. Ascertaining the differences between the linear and painterly styles, Wölfflin distinguishes between the cult of the line and that of the mass. Each style produces a differently embodied mode of engagement. The linear style possesses clearly demarcated outlines. In the painterly/baroque style, 'seeing in masses' takes place; outlines will shift and mutate so that 'attention withdraws from the edges' (Wölfflin, *Principles*, p. 19). As is befitting of the open spatiality of baroque form, 'the depreciation of line as boundary takes place [and] painterly possibilities set in', Wölfflin states (*Principles*, p. 19). In the linear, the line separates and it isolates self-contained forms; in the painterly, there are instead 'unstressed boundaries which favor combination' (Wölfflin, *Principles*, p. 19). The linear style prompts our eyes to distinguish one form

from another. The painterly, by contrast, is bound up with the perception of an increasing internal complexity and with the sensuous impression of movement.

Wölfflin's understanding of the painterly style and its mobile, crowded, and aggregate compositions can be extended to *Tarnation*. We can easily identify such baroque traits at work here, as the film's body restlessly 'passes over the sum of things' and courts the haptic visuality of our embodied eye (Wölfflin, *Principles*, p. 19). Furthermore, the film's haptic effects occur through a similar combinatorial sensibility, as it is expressive of mobile, shifting, and visually tactile masses of detail. As Wölfflin assures us, 'the painterly style thinks only in masses' and *Tarnation* certainly reprises the aesthetics of a baroque mass (*Renaissance*, p. 31). In fact, Caouette's film is best described as a digital *assemblage* of media, materials, and memories.[29] The film itself is made up of masses of different media and mnemonic fragments. The backbone of the film is comprised of pre-existing foot-age—some 160 hours of stock tape that Caouette had shot of himself, his family, and friends across 20 years and over 200 personal photographs (pinned to a white wall, then filmed with a Hi-8 camera) as well as other media scraps that Caouette had been collecting since childhood (Silverman, 'Here's the Price'; Rich, 'Tell It'). The film's Hi-8 footage was then fed through iMovie to emulate the flickering that comes with the ageing of super-8 stock. In this regard, the film moves between, superimposes, and merges past and present media throughout. It spans digital video or a digital post-production/editing of the image, Super-8, Beta-Max and Hi-8 footage, text inter-titles, pilfered film and television clips, Caouette's early student films, staged re-enactments, old family photographs, performative monologues (featuring Caouette as a child and in drag, trying out different personas), and filmed confessionals. Sonically interwoven throughout are also answering machine messages, dictaphone audio-diaries, mini-cassette recordings, pop songs, and sampled tunes.

The digital assemblage of *Tarnation* yields a constant flux of images that are dispersed, fractured, and multiplied across every inch of the screen. These images alternate between varying speeds and tempos, switches in colour, and expressive shifts in emotion and/or atmospheric mood. The film's complicated layering of the image is matched at a sonic level. Audio recordings of Renee as she reads the 'Desiderata', recites the alphabet, or joins Caouette to chant a childhood song are played over the murmurings of an audio-diary from Caouette aged thirteen, interspersed with musical montages or set against the tune of Jimmy Webb's 'Witchita Lineman'. Evincing a recognizably baroque preference for formal complexity, the film

flagrantly multiplies frames, images, sounds, bodies, and media. The film's body dismembers its perceptions and expressions throughout, dynamically arranging, rearranging, layering, and fragmenting its masses of detail into a highly spatialized display.

Baroque flesh, as we know, is an aesthetic that couples sensation with self-reflexivity. As an instance of baroque cinema, *Tarnation* is not only a digital/haptic assemblage; it also functions as a compendium of film, video, and television history. The recurrent images of Caouette posturing through the years with his (film, video, digital) camera self-consciously recall Dziga Vertov's *Man with a Movie Camera* (1929) and its own 'database of film techniques', as these were enacted through montage and superimposition (Manovich, *Language of New Media*, p. xxx).[30] As Shaviro remarks, a 'formalist would call [*Tarnation*] a triumph of montage [...] a swirl of fragmentary images, unexpected leaps and associations' ('*Tarnation*'). Those associations veer from European modernist avant-garde techniques (montage, surrealist cut-up, and collage); American underground cinema of the 1960s–70s (Kenneth Anger, John Waters, Paul Morrissey); virtuoso split-screens (Brian De Palma); low budget queer confessionals (Sadie Benning); found-footage documentary; and even a musical rendition of David Lynch's *Blue Velvet* (1986), lip-synched to Marianne Faithfull tracks. Interspersing its archive of subjective memories and media materials with the inflections of film and other forms of popular culture, *Tarnation* effectively merges the 'real' of the documentary with an aesthetic of artistic/technological artifice. It thereby draws attention to itself as an obviously mediated production and an act of subjective re-construction (Klein, *Vatican to Vegas*, pp. 27–50; Shaviro, '*Tarnation*').

Consider the sequence in which Caouette relates to his family through the film, television, and music that he immersed himself in during his adolescent years. As archival footage of his grandmother recedes, Caouette's face emerges over a blank television screen. This is one of many repetitious pieces of footage used throughout the film. It is also an image that has been repeated from the beginning of *Tarnation*, framing popular film and media as an equally significant 'family' member. After tracking into the television set, a clip from the dream sequence of *Rosemary's Baby* (Polanski, 1968) begins. This is because Caouette had likened his grandmother to the film's actress Ruth Gordon while growing up. An image of Caouette as a boy appears—he is sleepily sprawled out on the floor and lit by the soft glow of a television screen. Close-ups of his face, the face of his grandmother, and footage of him play acting for the camera surface. The screen cedes to a series of zapping effects, as if switching between television channels

before it focuses on excerpts of Dolly Parton in *The Best Little Whorehouse in Texas* (Higgins, 1982). Clip sequences of *The Little Prince* (Donen, 1974) and the children's television show *Zoom* (PBS, 1972–1978) follow, as do the sounds of Roberta Flack and Michael Jackson. Inter-titles then explain how Caouette once imagined his life and its players as a rock opera. Joni Mitchell might play Renee; Louise Lasser could play Rosemary; Robbie Benson the role of Caouette himself, with other roles assigned to the various social workers, foster parents, and foster children of Caouette's youth. The inextricability of film, media, and subjective memory is not achieved through the inter-titles so much as the film's body's baroque medley of the real and the representational.

According to Buci-Glucksmann, baroque cinema manifests spatially as well as through self-reflexivity ('Baroque Eye', p. 33). Although she speaks only of the baroque 'eye' of the camera, she is worth quoting at length:

So: a baroque gaze [...] opens out, in which *a film is always several films, in a sort of arborescent, proliferating structure that respects no chronology,* no dramatization of the action, no Euclidian space: *everything cited, everything mixed, passing* [...] *through all the regimes of the image and of the visual* [...] in this gigantic combustion of forms, the cinema can [...] be a baroque palimpsest, a theatre of shadows, and memory. (Buci-Glucksmann, 'Baroque Eye', p. 33; italics mine)

In this regard, Caouette's film is commensurate with the kind of self-consciousness or 'hyper-mediacy' that is often labelled baroque (Bolter and Grusin, *Remediation*, p. 5). Why, then, do I not define baroque cinema as hyper-mediacy or formal artifice and leave it at that? As I have emphasised throughout this book, baroque flesh is a highly sensuous and topologically distinct aesthetic that couples sensation with displays of self-reflexive artifice. In and of itself, self-consciousness will not redress the evacuation of embodiment and the senses that pervades discussions of the baroque or a baroque cinema. Given its unabashed allusionism, its non-linear chronology, its arborescent images, and its combustions across media, *Tarnation* certainly corresponds with Buci-Glucksmann's claims for a baroque cinema. Nevertheless, what is missing from Buci-Glucksmann's baroque is the very *self*-reflexivity of it; that is, the sensuous dynamics of one body becoming entangled with another. In my take on baroque flesh, the hyper-mediacy and self-consciousness of the baroque and a baroque cinema must also be understood through its sensuous reversibility.

In *Tarnation*, for instance, subjective and culturally mediated memory becomes a convoluted film medley in which images and sounds repeat themselves, while continuously fragmenting, moving, and mutating. Shaviro, too, has picked up on how the film's images and sounds repeat themselves wilfully; vibrating, on-screen and off, like a musical motif ('*Tarnation*'). Although he does not link this sensibility to the embodied effects of the baroque, the repetition of images, sounds, and music in Caouette's film are suggestive of baroque musical 'themes [that] are intricately interwoven, varied, and rearranged into new formations' (Ndalianis, *Neo-Baroque*, p. 178). The repetition and variation of these motifs is at once sonic, visual, and haptic—recalling what Benjamin names the baroque translation of time into space (*The Origin*, pp. 81-92).[31]

While film and television clips alternate inside one framed image, another framed image suddenly appears below it. This image then expands to overwhelm the entire screen, to reveal the image of a dancing Renee in the family backyard that has been cut-up and repeated throughout. In close-up, this image slowly recedes into the background and exposes two more enframed images beneath it. One of these images contains documentary footage of Caouette's young son, wearing a cowboy hat, excitedly jumping up and down. Another image features pilfered film footage of an adolescent Caouette, lip-synching.

The three frames continue to alternate between archival footage of Caouette and his family and found footage excerpts. Individual sounds, unique to each frame, fade in and out. The screen then mutates into four separate frames, each with varying images and sounds, accompanied by the predominant musical soundtrack. Footage of Caouette as an adult then as a child appears, while the faces of his family are seen alongside the popular media excerpts. Significantly, the initial shot of a young Caouette watching television surfaces repeatedly. This is the central theme that is repeated and varied throughout. As Cubitt comments of the Hollywood baroque, here narrative gives itself over to a 'spatial orchestration of events [...] its reorganization of time as space' (*Cinema Effect*, p. 223). By way of *Tarnation*, we can put some baroque flesh on Cubitt's claims by adding that the reorganization of time-as-space is felt as its own kind of haptic visuality. To recall Benjamin, *Tarnation* presents the passing of time, self, and pop cultural history as a spatialized structure that boasts embodied effects. In a baroque haptics, the embodied eye must move through spatialized variations on a theme. That movement occurs along or across the film's surface, as well as into and out of the screen, prompting us to haptically 'grasp' the significance of the composition.

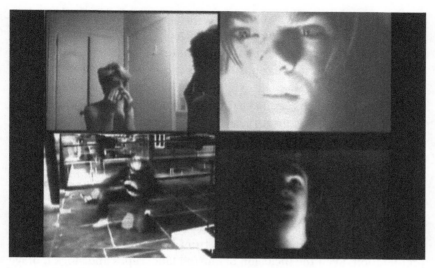

Fig. 11: Shifting masses of detail in *Tarnation*. Courtesy of the filmmaker.

The spatialization of time in *Tarnation*, as it is channelled into undulating images, is both sensuously compelling and unmistakably baroque. Through the film's baroque haptics, our eyes are led 'to and from' erupting clusters of detail and through the 'illusion of constant change' (Wölfflin, *Renaissance*, p. 31). Through its rhythmic, dense, and tactile layering of memory, media, and materials, the film revels in a heavily detailed, mutating, and overlapping surface. As Wölfflin tells us, the baroque is enamoured of 'restless surfaces' and 'endless change' (*Principles*, pp. 54, 62). Similarly, the surface of the image/screen of *Tarnation* continuously splits: images morph, multiply, and mutate; sounds modulate; and the film's body expresses a range of different psychic states that can sometimes swamp all objective stability. And yet, while *Tarnation* spurs the haptic movement of the eye by multiplying its points of intentional focus, it also remains the case that the images of the film are, for the most part, easily recognizable. In the baroque haptics of cinema, the embodied eye is inclined both to move *and* to focus.

To develop a baroque-oriented haptics for cinema fully, we would do well to remember the urge to become space through movement that is performed by the baroque. By way of Deleuze and Guattari as well as Riegl, Marks' account of haptic cinema pulls us in so close that we cannot clearly make the image out. This proximity means that we must feel the image with senses other than vision if we are to apprehend it (Marks, *Skin of the Film*, p. 159). The haptics of *Tarnation* work differently because of the film's baroque qualities. Herein, the categories of the optic and the haptic

combine and fluctuate. Recollecting Riegl, I would propose that *Tarnation* encourages the *normalsicht* position on the part of the viewer, or what I believe Wölfflin calls the painterly or baroque style. This somewhere in between the near and far positions, as it oscillates between the optic and the haptic, also highlights the nebulous border properties of vision and touch. Through its profusion of detail, its movement into and out of the screen and across the surface, and its splintering of one frame into many, *Tarnation* continues the piecemeal, serialized modes of (tactile) perception of baroque art. The tactility of its composite details is, however, coupled with the optical clarity of the whole (Riegl, *Late Roman Art*, p. 29). If *Tarnation* elicits our haptic visuality, then it does not do so through the use of proximate and/or optically indeterminate images. As a result, I do not experience the haptics of this film as a caress.

Instead, a baroque haptics arises from mobility, mass, volume, and proliferation. Even the inclusion of blurred landscapes and stock footage of the various streets and locations of Caouette's youth figures the film's fascination with movement and with mobile transition throughout. Given its sequential and mobilized dispersal of the image, the film reprises many of the aesthetic conventions that we have discussed as inherent to Dutch art. For instance, Alpers links Dutch art with 'sequential viewing' and with vistas that are 'successively viewed' (*Art of Describing*, p. 62). Alpers' comments are applicable to the baroque haptics that is set in motion by Caouette's film. Here, a 'single prospect [...] is sacrificed for an aggregate of aspects', through the film's formal suggestion of constant change, transfiguration, and transition (*Art of Describing*, p. 59). Often, a multiplicity of images, sounds, and media will be overlaid in the one frame or be seen as moving into newly emergent configurations. The film's conjunction of mass and complexity necessitates a highly sequential or successive mode of viewing. The overloading of the screen produces tactile and tangible effects upon our bodies because it relies on the embodied eye to move, kinesthetically, across the screen as well as into and out of the image if we are to apprehend such masses of detail. *Tarnation* courts the haptic eye of the baroque and it demands a tactile, mobile, and piecemeal perception to complete its digital assemblage. Unquestionably, it is an embodied eye that is excited by the tactile address of this film.

Through its conjunctions of the optic with the haptic, our vision is impelled to move and to focus. Rather than experiencing the haptics of a caress, my eyes often scan, skip, and skim this film, skittering across its baroque profusion of detail. In this regard, the haptic action of scanning or skimming is an appositely embodied metaphor for *Tarnation*. It is a haptics

of expression that is performed by the film's body as well, especially as it flickers and flashes between different photographs/media and effectively mimics the scanning that our own eyes must undertake. The film's body, too, must temporarily rest or re-focus its vision to absorb the overall effect. Roving between a myriad of details, film and viewer enact a fittingly haptic and recognizably baroque exchange that occurs through an aesthetics of movement, mass, volume, and proliferation.

According to Caouette, 'unlike professional editing systems, iMovie renders quickly [...] you can screen almost immediately what you have just *pieced together*' (qtd. in Bailey, 'I'll Be'). Of course, the piecing together of *Tarnation* is typical of digital storage and editing systems, where vast amounts of information can be stored and images or sounds uploaded, sorted, and elastically manipulated. As both Marks and new media scholar Lev Manovich discuss, the digital database returns us to a manual construction of images and is akin to painting-in-time. The origin of the image is 'less important than the decision to actualize it in a particular way' (Marks, *Touch*, p. 151; see also Manovich, *Language of New Media*, pp. 303–306). Even the title credits draw our attention to the film's manual albeit digital do-it-yourself foundations. Hand-scrawled titles—achieved through the Kid Print font of iMovie—conjure up the childhood that has left an indelible imprint on this retelling of a traumatized personal history. The use of this childlike text also highlights the subjective hand that is piecing together an obviously mediated account of its past by way of digital enunciation and the documentary format. And yet, what the manual construction and reconstruction of *Tarnation* offers us is not so much painting-in-time as a digital reactivation of the baroque art of analogy, once housed within wondrous historical collections.

Analogical Assemblages: Baroque Databases

The seventeenth century was renowned for its collecting practices, revealing a documentary-like impulse to archive the surrounding world at a time in which all of Europe seemed to be swept up in a shared passion for collecting. After the first science museums appeared during the sixteenth century, museums, libraries, gardens, grottoes, and galleries of art formed part of the general cultural landscape of the historic baroque (Findlen, *Possessing Nature*, p. 2). Polymaths assembled their collections inside *Wunderkammern* and *Kunstkammern* (chambers of wonder) or in the *Wunderschrank* (cabinet of wonder): a labyrinthine cabinet of various woods, with marble, ivory,

snakeskin, enamel, or tortoiseshell inlays (Stafford, 'Revealing Technologies', p. 7). Jesuit priest Athanasius Kircher was responsible for perhaps the most famous *Wunderkammern* of the seventeenth century—the *Musaeum Kircherianum*, in the Roman College of the Jesuits—although his formidable collection was not alone, as the collections of figures such as Ferrante Imperato, Fernando Cospiano, and Ole Worm attest (Stafford, 'Revealing Technologies', p. 6; Westerhoff, 'World of Signs', p. 642).[32]

Amassed across time and space from far-ranging locations, these collections housed a 'universal theatre' for their participant, akin to a compressed 'universe-in-a-box' ('Revealing Technologies', pp. 6–7). Baroque chambers and cabinets teemed with wildly disparate objects: paintings, miniature portraits, and other works of art, insects encased in amber, precious gems, crystals, automata, clocks, scientific and technological instruments, optical devices such as prisms and mirrors, petrified coral, seashells, religious relics, exotic spices, oddly shaped fruits and vegetables, ancient coins, scraps of wood, metal or stone, antique statues, animal remnants, coconut shells, and Egyptian mummies (Westerhoff, 'World of Signs', p. 644; Stafford, *Good Looking*, p. 75; Stafford, 'Revealing Technologies', p. 6). Art historian Horst Bredekamp notes how the collection of a *Kunstkammer* emulated the divine. Just as the Earth was thought to be the chamber or cabinet of God, the baroque collector crafted their 'world in a building [...] a microcosm and compendium of all extraordinary things' (*Lure of Antiquity*, pp. 72–73). Baroque collections were 'at one and the same time like time-lapse photography *and* microcosms of the world' (Bredekamp, *Lure of Antiquity*, pp. 72–73; see also p. 36).

A number of important features must be noted about these collections, especially in terms of their connections with the haptic, digital assemblage of *Tarnation*. Quite unlike their Renaissance predecessors, baroque collections were not interested in documenting the world in a linear, teleological fashion. Rather, they deliberately 'avoided classificatory systems based on linear sequencing' (Stafford, *Good Looking*, p. 31). Whereas Renaissance naturalists wanted to create an encyclopedia or compendium of the natural world, the *Wunderkammer*, *Kunstkammer*, and *Wunderschrank* resisted homogeneity. They revealed an interest in exotica, rarities, curiosities, and marvels whereby thousands of playful objects or devices were mixed up with scientific instruments (telescopes, microscopes) and with the phenomena of the natural world (Findlen, *Possessing Nature*, p. 35). Baroque collections were driven by the dialectic between nature and art, as evidenced by the countless ways in which artificial and natural phenomena were allowed to mingle alongside one another dynamically, thereby creating juxtapositions or striking

correspondences between them. An automaton might be placed next to a stuffed crocodile or popular alabaster paintings, whose 'natural' structure of stone was complemented by an artificial background of painted clouds (Findlen, *Possessing Nature*, p. 35; Westerhoff, 'World of Signs', pp. 644, 647).

Baroque collections yielded no immediate logic to their eclectic arrangements, though that was precisely their point. As Paula Findlen notes, the knowledge contained in these collections was 'consensual' and it had to be performatively puzzled out—shaped and re-shaped by those who entered the chamber or activated a cabinet's contents (*Possessing Nature*, p. 5). Stafford concurs, describing these collections as a veritable 'play-house of the world' ('Revealing Technologies', p. 6). The world on display here 'was not so much a static tableau to be contemplated as it was a drama of possible relationships to be explored' (Stafford, 'Revealing Technologies', p. 6). Significantly, for my purposes, the knowledge garnered within these collections derived from perceptions of affinity and the 'sensory structuring of common experience' (Stafford, 'Revealing Technologies', p. 11). Cabinets and chambers of wonder appealed to the embodied intelligence of their participant through tactile, sensory, and performative perception, exploration, and play. Activated by historic forms of 'good looking', baroque collections built 'visual bridges in order to emphasize the playfulness of nature through *the associative powers of sight*', forging a series of surprising or wondrous connections between seemingly unconnected objects (Bredekamp, *Lure of Antiquity*, p. 73; italics mine).

As I have demonstrated throughout this book, an analogical world view is fundamental to the baroque. The art and importance of 'good looking' can also be traced back to its historic collecting traditions, as these lead to bursts of analogical insight and speak to the intelligence of 'thought in and through images' (Bredekamp, *Lure of Antiquity*, p. 113). While Bredekamp underscores the 'visual structuring of [baroque] collections', Stafford points out that these cabinets and chambers were very much a 'voyage of tactile exploration' in which their participants were encouraged to *feel* their way through 'unfamiliar and familiar substances' (Bredekamp, *Lure of Antiquity*, p. 110; Stafford, 'Revealing Technologies', p. 12). The intertwining of vision with touch and the other senses was crucial. By opening the intricate compartments of a cabinet, smelling the scent of carefully crafted wood or other odours, fingering the cool textures of stones or gems, the user had to negotiate many 'competing sensations'.

Such inter-sensory negotiation involved placing 'distant things in contact with one another' and obliged the 'senses to converge in a kind of synaesthesia' (Stafford, 'Revealing Technologies', p. 6). Historic baroque collections

Fig. 12: Andrea Dominico Remps, *Cabinet of Curiosities* (date unknown). Alinari Archives.

turned upon both the embodied perception and analogical thinking of their participants. They were brought to life by way of analogical intelligence, sensory exploration, and tactile handling, with the user having to approach and feel each object as part of a constantly mutating whole.

Rather than chaos and disorder, such collections expressed what I have detailed as a baroque pan-semiotics. Here, signs and phenomena 'do not exist in isolation' but could be 'connected to one another through various intricately structured significations, not always discernable at first sight' (Westerhoff, 'World of Signs', p. 644). Nevertheless, there was a definite, underlying order to the collection. It was arranged in such a way as to allow for shifting, material relations to be enacted and explored. Diverse ephemera were brought into unexpected connections with one another, even if objects appeared to have little in common. Cabinets and chambers of wonder relied on their user to cross-reference, synthesize, and connect content into mutable constellations of meaning. One forged a personal order out of these collections by way of sensory handling and analogical appreciation. These bits and bytes of worldly data, centuries before the digital age, were also not based on linear sequencing or logic. Rather, objects had to be 'hyperlinked' or yoked together by the individual hand that ordered them, the embodied eye that perceived them, and an analogical intelligence that

could discern affinity or resemblance across the span of distance (Stafford, 'Revealing Technologies', pp. 6–7; Stafford, *Good Looking*, pp. 34, 74–75).[33]

Of particular interest to us is how the analogical assemblages of these collections reflect a baroque haptics that finds new life in film. While we do not physically handle the shifting media fragments of *Tarnation* as we would in a historic cabinet or chamber of wonder, its digital assemblage does help us work towards an alternative model of haptic visuality for film theory. As Sobchack once remarked of QuickTime, what best describes this film is 'some other rationale—and phenomeno-logic [...] *one more associative than hierarchical, more dynamic than static, more contingent than determined*' ('Nostalgia', p. 6). That phenomeno-logic lies in the art of analogy that is inherent to baroque flesh. Through the digital play land of iMovie (yet another 'World of Wonders in one closet shut'), *Tarnation* recalls for me nothing so much as Benjamin's productive thoughts on the collector.[34] As Benjamin comments, 'the collector's passion borders on the chaos of memories' ('Unpacking My Library', p. 60). This is because any sustained contemplation on the part of the collector will spur the spatialized dispersal of memory that is bound up with the very act of collecting.[35] '[I]n the life of a collector [there is] a dialectical tension between the poles of disorder and order', he writes, as is indicated by the scattering of memory that is associated with the collector's possessions as opposed to the ordering of the collector's catalogue (Benjamin, 'Unpacking My Library', p. 60). In another set of writings, Benjamin beautifully describes how the figure of the collector also 'takes up the struggle against dispersion'. Right from the start, the collector must create their own kind of order out of mnemonic scattering and the location in which things are found. The 'collector [...] *brings together what belongs together* [...] *keeping in mind their affinities*' (qtd. in Stafford, 'Leveling', p. 334; italics mine).

Expressive of the non-linear and associative tendencies of both collecting and memory, *Tarnation* makes visible, tangible, and sensible to us the 'invisibility' of subjective remembrance. Like Benjamin's collector, a seventeenth-century polymath, or the user of a historic baroque collection, the film's body brings together what belongs together. The film's digital assemblage jumps between, knits together, or overlays the various images, sounds, media, and texts that have been meaningful to *this* life: Caouette and his family. Expressive of subjective, associative, and mnemonic ordering, the film reveals to us how that photograph of Renee and her son might be related to the lyrics of that song or the recollection of that particular film/television clip, once viewed at a specific time and in a specific place but still connected to a larger whole. Re-activating the non-linear, eclectic

organization of the *Wunderkammer, Kunstkammer*, and *Wunderschrank* in digital forms, the film's body forges an analogical ordering and catalogue of sorts from out of a shifting array of different memories, media, and materials. *Tarnation* reveals how a baroque inheritance and mode of being persists, even within the radically different technological formats of the digital.

In this book, I have often embraced analogy as a means by which to speak to 'good looking', embodied intelligence, and the participatory perceptions of baroque flesh. In this, I am indebted to the media archaeological work of Stafford who has valuably argued for analogy as inherent to our consciousness and to our engagement with the visual arts and the 'intuitive ways we think simply by visualizing' (*Good Looking*, pp. 61; see also p. 23). Nevertheless, it must be acknowledged that Stafford tends to conceive analogy in optical terms. As she writes, analogy is driven by an 'optical necessity' that evidences or materializes formerly invisible connections by revealing a likeness or connection across particulars (*Good Looking*, pp. 3, 23). For the purposes of baroque flesh, analogy, especially in its incarnational effects, is best thought of as embodied rather than just visual. Stafford herself describes analogy in terms that reverberate powerfully with the haptic sense. If, for Stafford, 'the fragment, aphorism, ruin, grotesque and other shattered forms mark the allegorical composition', then actions of 'spinning, plaiting, and weaving capture the simultaneity of contraries, *the permeability and elasticity of intersubjective reciprocity*' that is the art of analogy (*Visual Analogy*, p. 82; italics mine).[36] In this light, analogy can be used to speak to the crossing-over of vision and touch that is so privileged by the baroque and the inter-subjectivity of its art of entanglement.

As Alpers notes of the Dutch art of describing, what we are presented with 'is not a linear argument but rather an associative display' that is complemented by our own mobile and materialist vision (*Art of Describing*, p. 62). *Tarnation* stages just such a succession of views while also expressing tangible connections between phenomena such as photographs or other personal remnants, snatches of pop music, or fragments of film and media history. In its digital re-construction of Caouette's familial life, the film's body weaves or plaits together what belongs together. Susan Stewart, in her work on the baroque, captures *exactly* the kind of visual tactility that occurs here. As she astutely claims: 'visual perception becomes a mode of touching when *comparisons are made and the eye is "placed upon" or "falls upon" relations between phenomena*' (Stewart, *Poetry*, pp. 164–165; italics mine). Such is the baroque haptics of *Tarnation*, for its analogical assemblage of media and materials makes analogical and tactile appeals to our haptic visuality. We, in turn, grasp or touch back that assemblage by

meeting this film with the embodied vision of a scanning or skipping eye that triggers our sensuous intelligence. Herein, cinematic tactility occurs on the part of both film and viewer—through the shared knitting together of many different details or media fragments that formulate *textural* patterns of lived experience.

As I suggested in Chapter 3, texture can involve the experience of multiple senses. If texture is felt most often at the juncture of vision with touch, then it is because 'touch moves and takes time [so that] pattern becomes apparent' (Stewart, *Poetry*, p. 145). In this regard, we can say that a mobile 'shuttle of perception' accompanies texture (Stewart, *Poetry*, pp. 161, 361, fn. 36). As it shuttles between proximity and withdrawal, *Tarnation* is a baroque film that fosters the *normalsicht* position on the part of its viewer—that somewhere in between near and far wherein the optic and the haptic combine. As a result, we alternate between a strong sense of intimacy with its images and a more comprehensive sense of distance. Detailed surfaces such as the film's archival footage, replete with accumulated grain, scratches, and projected wear-and-tear, will unexpectedly give way to snippets of found footage film clips or scenes of Caouette's own childhood role-play. Much of the film's dialogue is inaudible, whereas various songs and musical works assume pride of place. Specifics of the family history such as Renee's paralysis and hospitalization, her rape, or Caouette's foster care abuse are only narrated by text inter-titles, distancing us from these events. As viewers, too, we often need to take a perceptual 'step back' so that we can better synchronize ourselves with the film's baroque multiplication of media, images, spaces, and sounds. Orbiting between proximity and withdrawal, it is the mobile shuttle of perception (the near and the far, the haptic and the optic) that allows us to re-compose the many fluctuating details of *Tarnation* into an understanding of texture.

As it moves across the surface of the image and also into and out of the depths of the screen, the film's body performs a perceptual shuttling as well. According to Lant, the 'illusion of moving photographic pictures on a plane' in early film history and the cutting together of many 'diverse spaces against one another' often generated the palpable impression of a 'pressing out into and back into space' ('Haptical Cinema', p. 53). These techniques created movement between the haptic and the optical. Despite its now digital make-up, the film's body in *Tarnation* similarly presses itself out from the space of the screen such as when it absorbs the 'N-Square' effect of iMovie, where images can be repeated multiple times in the one frame. Alternately, the film's body will rush back into the space of the screen so as to gain a better feel for the positioning of diverse images against one

another or the metamorphoses of its static photographs into movement. In the baroque haptics of *Tarnation*, the traits of surface and depth, animated and static, near and far, propulsion and recession, the optic and the haptic combine and reverse.

In this regard, a baroque haptics in film stages shifts in perceptual scale to create a strong sense of texture. As Eve Kosofsky Sedgwick observes, we need to attend to texture across the micro and the macro for 'there is no one physical scale that intrinsically is the scale of texture' (*Touching Feeling*, p. 9). Texture is as present in an acre of trees that you see through an airplane window as it is in the rough bark of a single piece of wood (p. 9). Given its pronounced intertwining of the optic and the haptic, *Tarnation* expresses such varying degrees of scale. Despite its rhythmic repetition of various images, sounds, or pieces of media, the film's flotsam and jetsam of subjective and cultural memory does not yield a distinct overall shape. Rather, the film's analogical assemblage of fragments hastens our textural comprehension of Caouette's life, as it has been subjectively lived and experienced in the flesh. Perceiving the texture of this film once again interweaves our haptic and sensual experience with cognitive processes and an active, narrative hypothesizing. As Sedgwick details, I have not fully 'perceived a texture until I've instantaneously hypothesized whether the object I'm perceiving was sedimented, extruded, laminated, granulated, polished, distressed, felted, or fluffed up' (*Touching Feeling*, pp. 13–14; italics mine). The textures of baroque flesh therefore prompt us to ask: well, how did that object, artwork, film, or self get to *be* that way?

Summation: TEXXTURE

All materials possess a sense of texture, though some textures try to efface the processes of their own history. As Renu Bora has discussed, this can make for very different formal and affective experiences of texture. Whereas some textures erase their history to create the impression of smoothness, other textures are experientially 'thick', roughened, and dense with information about the passage of time and how they historically and materially came into being ('Outing Texture', p. 99). Such phenomena belong to what Bora calls 'TEXXTURE' (p. 99). TEXXTURE is indicative of 'what it means for something to occupy physical space': it conveys the bodily and the temporal substance of materials and the very 'stuffiness of [the] material structure' (Bora, 'Outing Texture', pp. 99, 101).

To close this chapter, we might say that it is the materiality and stuffi-ness of TEXXTURE that characterizes baroque flesh. As a sensuous and sensuously spatialized aesthetic, neither the baroque nor a baroque cinema is served well by purely visual accounts. Just as Benjamin once called our attention to the texturing of time in baroque ruins as well as the ghosts who continue to haunt them, TEXXTURE pervades the baroque haptics of *Tarnation*. As evidenced by the visibly dog-eared creases that mark Caouette's collection of old family photographs, the film's weaving between historic media fragments or its intertwining of culturally mediated footage with subjective memory, *Tarnation* testifies to the persistence of the past in the present.

Although the baroque involves multiplicity and mobility of vision, this chapter has considered the neglected formal and film-philosophical con-nections that have long united baroque aesthetics with the haptic sense. As Christopher Braider comments, as vital as the beholder's eye is to the baroque artwork, 'more fundamental still is the hand that frames the forms that put the eye to work' together with an equally 'baroque emphasis on *art as work*' (*Baroque Self-Invention*, p. 104, fn. 104). Through its visual tactility, its sensuous contact between bodies, its texturology and its cultivation of TEXXTURE, the baroque flesh of art and film reveals its own iteration of haptic visuality. As evidenced by *Tarnation*, 'one hand filming the other' is a two-sided exchange of tactility in film that demands from us the work of our own haptic, thoughtful, and analogical participation. A baroque haptics is imbued with highly mobile, spatialized, and visually tactile ap-peals—appeals to which our embodied eye and our analogical intelligence decisively respond.

Conclusion:
Or the Baroque 'Beauty of the Act'

> The chiasm, reversibility, is the idea that every perception is doubled with a
> counter-perception [...] an act with two faces, one no longer knows who speaks
> and who listens. Speaking-listening, seeing-being seen, perceiving-being
> perceived circularity (it is because of it that it seems to us that perception forms
> itself *in the things themselves*)—*Activity=passivity*.
> – Maurice Merleau-Ponty (*VI*, pp. 264–265)

In the above quotation, Merleau-Ponty captures the ontology of 'flesh' as
'an act with two faces' that is endowed with an inherent reversibility (*VI*,
p. 264). Like the mobile and replenishable field of possibility that is 'flesh',
the baroque hinges upon sensuous doubling. Baroque flesh entails a doubled
or reversible structure that enlaces, intertwines, knots up, encroaches upon,
or folds back the sensations of one body upon another to achieve the art of
entanglement. In the baroque flesh of art and film, the 'inside' of our embod-
ied perception exists in a correlative relationship with the 'outside' aesthetic
expression. Generating a heightened continuum between bodies, baroque
flesh takes great delight in a 'sensuous flipping' between the inside and the
outside of the work by drawing our attention to its own formal construction,
by reflecting upon its own perceptions and expressions or by foregrounding
chiasmic scenarios of the sensing and the sensible (Bal, *Quoting*, p. 142).

As I indicated in my introduction, the baroque has typically been invoked
as a stand-in for films that are stylistically excessive, idiosyncratic, visually
overwhelming, or technologically resplendent. As such, the very notion of
a cinematic baroque still tends to be conflated with a spectacular and/or
technologically-driven optic. As a result, the full range of its aesthetic and
embodied expressions and the ontological affinity that the baroque has in
common with cinema has been elided. This book has sought to redress that
scholarly gap by providing film and media studies with a new set of concep-
tual coordinates by which to understand the baroque and its relevance to
cinema: baroque flesh. By examining its various formal, film-philosophical
and embodied significances, I have argued that baroque cinema offers us
a cinema of the senses and an especially vivid aesthetic concretization
of Merleau-Ponty's ontology of 'flesh'. A cinema of baroque flesh emerges
when film activates the longstanding figures, forms, feelings, and motifs of

the baroque, intertwining the body, emotions, and the intelligence of the viewer into a literal and figural sensuality.

This conception of baroque flesh prompts an important question: is there a definite beginning or end in sight to baroque cinema? To answer this query let us turn to one final, tellingly baroque example in film. Playfully structured as a rhythmic succession of different theatrical 'acts', bodily actions and gestures, transmuting stages, and shifting worldly performances, Leos Carax's *Holy Motors* (2012) is a highly self-reflexive film that has excited much cinephilic attention. Transported around Paris in a white stretch limousine by his female driver, Céline, the mercurial character of Mister Oscar inhabits many roles throughout the course of this film: investment banker, decrepit female beggar, B-movie monster, hardened gangster, mournful lover, and family man. As viewers, we are privy not only to Oscar's performances but also to his 'private' moments behind the scenes in the limousine as it serves as his mobile dressing room. Within this highly mutable space, acting dossiers are read, wigs are brushed, and Oscar's costumes are changed. Make-up, rubbery masks, prosthetics, and fingernails are laboriously applied and then removed for the next performance. And yet, it is never made clear for whom Oscar acts. Does Oscar's driver, the mysterious organization known as the Agency, or the Man with a Birthmark coordinate the cameras? Are the sentient limousines of the film also performing? *Holy Motors* resists giving us answers to such questions, preferring instead to cultivate formal convolution and interpretive proliferation.

Given its multiple metamorphoses of the self, its overt allusions to film history and its propensity for enigma, Carax's film eludes neat interpretation. It does not however resist all conceptual fixity just as its hallucinatory transformations of film, body, and world exceed a surrealist poetic of cinema as dream. Rather, if we recall Merleau-Ponty on 'flesh' as an act with two faces, we might better recalibrate *Holy Motors* as an instance of baroque flesh in cinema. Here, the lures of sensation (such as the film's repeated emphases on bodily action, gesture, and kinesthetic movement) co-exist with a self-reflection on the medium of cinema itself, together with the mobility and multiplicity of meaning.[1]

During the opening act of *Holy Motors*, we are first introduced to Oscar as an investment banker and a loving father, leaving a lavish familial home for a day at work. Towards the film's conclusion, having died multiple times (including killing himself as the banker), Oscar appears spent and weary. He opens his last acting assignment for the day. The film then cuts to a shot of his limousine driving down a suburban street where his car pulls up outside a non-descript house. A seemingly endless stretch of similar homes and

streetlamps recede into the distance. An excerpt from the early chrono-photographic work of Étienne-Jules Marey suddenly appears, not for the first time, featuring a man who is repeatedly performing the same physical action. As the clock strikes the hour Oscar enters a suburban residence. The vision of the camera remains outside. It peers into the windows of the house to reveal the film's startling truth: tonight, the home that Oscar returns to sleep in contains a family of loving monkeys. For Oscar, this is but one stop in a potentially infinite series of future homes, families, and possible selves. During his last on-screen performance as the 'man in the house', the song 'Revivre' (relive) by Gérard Manset erupts. As Oscar makes his way inside, the film's body also performs a final twisting movement around the edges of the house before rising towards its upper-storey windows. There, it pauses to focus on Oscar and his monkeys as they look up into the night sky. All are absorbed by a vision that occurs off-screen. Both the character of Oscar and the visible and motorial expressions of the film's body hint at events still to come. Just as the closing song intones the words 'live' and 'relive', *Holy Motors* also gestures towards cinematic actions that have not yet been performed and a shared cinematic vision that has not yet been seen.

To my mind, this scene is a testament to the imaginative power, potential figuration, and experiential impact of film as inexhaustible—to cinema as an endless, 'holy' motor that keeps running, regardless of its technological bases. Similarly, in the revival and re-living of baroque flesh, there is a formal repetition that is continuous with the baroque of the past but there is a cinematic renewal. In her essay 'Incomparable Bodies', the French film scholar Nicole Brenez argues that cinema boasts its own distinct figures that exceed the properties of the lived body, generating bodies without any pre-existing model. By way of example, she invokes an early British film short, *An Interesting Story* (Williamson, 1904), in which a man is so absorbed by a book that he inadvertently falls under the path of a steamroller. He is then revived into life and liveliness by being blown up with the use of a bicycle pump. For Brenez, such figural plasticity indicates that he is 'truly the man of cinema' ('Incomparable Bodies', p. 8).[2] In the twenty-first century, Mister Oscar is brought back to life over and over again to perform what Oscar describes as 'the beauty of the act' that is cinema. In bringing together the baroque qualities of *Holy Motors* with Brenez's claims for the figural plasticity of cinema, we might begin to chart how baroque flesh has always been present in film history, perhaps with many more performances still to come.

As with *Holy Motors*, my examples of a baroque cinema in this book have alternated between silent film history and the contemporary. These

cinematic case studies are not exhaustive. If film and media studies were to pay closer heed to the sensuality, spatiality, and specific figures and forms of the baroque, we might uncover still further instances of a baroque cinema. As I have insisted, baroque flesh is amenable to the very ontology of film—*if* cinematic ontology is approached as a set of existential relations (perception and expression) and not as a question of cinema's technological make-up or indexicality. Baroque flesh is its own aesthetic category of film that can dynamically span different genres, creative formats, geographic confines, national cinemas, and historic periods. In *Cinema's Baroque Flesh: Film, Phenomenology and the Art of Entanglement* I have traced how baroque cinema develops many of the aesthetic qualities of the historic baroque (self-reflexivity, passionate feeling, co-extensive space, and the privileging of texture, materiality, and sensuous surfaces) while giving rise to a complementary mode of viewing that enjoins an embodied response in the viewer. Through its aesthetics of reversibility, baroque cinema is truly an act with two faces.

Interestingly, as I complete this book a number of new and exciting developments in baroque studies, film-phenomenology and sensuous film scholarship are emerging such as burgeoning work on the New World baroque of the Americas; the possibility of a baroque resurgence within the digital realm; further affirmations of the importance of Merleau-Ponty's own film-philosophy and further contributions to how cinema engages different bodily sense fields (Zamora, *Inordinate Eye*; Murray, *Digital Baroque*; Carbone, *Flesh of Images*; Quinlivan, *Place of Breath*). In bringing this book to a close, I hope that my model of baroque flesh might prompt scholars to consider the 'baroque world' that Merleau-Ponty's thought opens up and to come up with their own examples of baroque cinema, in line with the sensuous reversibility that is the formal and philosophical hallmark of the baroque ('The Philosopher', p. 181). I also appeal to film and media scholars to deliberate upon the tenets of contemporary embodied film theory or theories.

For instance, while adding to the many scholarly considerations of touch in film, I have endeavoured in this book to bring a baroque cinema of the senses into the orbit of 'good looking' by considering how it resuscitates analogical thought, art and practice. Art historian Giancarlo Maiorino puts the analogical impetus of the baroque beautifully when he writes that seventeenth-century Europeans 'did not affect a reality in which unity had broken down. If romantic minds found at the very core of life the diasparactive triad of ruin, incompleteness, and fragmentation, *their baroque ancestors would have sought ways for mending the pieces*' (*Cornucopian Mind*,

p. 124; italics mine). For Maiorino, as for myself, connectivity and connection is at the heart of a baroque world view. Maiorino even emblematizes the baroque urge to 'come together' as the outreaching design of Bernini's colonnade for Saint Peter's in Rome, as 'an architectural framework for [baroque] people whose human nature demands that they "step into living relations with one another"' (pp. 174–175).

In the cinematic framework that concerns this book, any consideration of baroque flesh must articulate the existential relations that connect the bodies of film and viewer. My exploration of the close connections between Merleau-Ponty's philosophy, film-phenomenology, and the baroque is a timely if overdue endeavour, especially in light of the rejuvenations of the body, affect, the emotions, and the senses in film theory that have been occurring for some time now. Bringing together work in embodied film theory with baroque studies has proved a productive coupling for this study—one that assists in identifying what a baroque cinema involves at the levels of film form and the body, while opening up different aesthetic modalities to a cinema of sensation. By drawing on the aesthetic, critical, and sensuous history of the baroque and considering its persistence in film, I have sought to develop a sensuously significant account of the cinematic baroque. Having attended to its mobility of vision, its use of heightened gestures, its face-to-face effects, its ingenious configurations of visual wit, its material-visuality, its stirring of the passions, its love of skin, and its connections with the haptic sense, there can be little doubt that baroque cinema makes for far more than just a spectacularly visuality.

A cinema of baroque flesh demands new kinds of embodied film theory from us that are more inclusive of the 'good looking' of sight, analogical insight, and our sensuous intelligence. Rather than relegating a baroque cinema of the senses to just pre-reflective embodiments or to aesthetic expressions of the maddening, the chaotic, the experimental, or the formless, the baroque cinema that I have advanced can make room for formal and experiential structure, for cinematic signification, and for conscious reflection, as well as sensation. In a cinema of baroque flesh, we discover how bodies are compassionately, passionately, pleasurably, and painfully intertwined in a literal as well as a figural sensuality. Given its investment in particular sensuous, spatial, emotive, and topological effects, the art of entanglement possesses its own clearly comprehensible set of figures, feelings, and forms. While a baroque cinema is born of sensation, its entanglements are never thoughtless. Such is the baroque 'beauty of the act'.

Notes

Introduction

1. Drawing on the work of the seventeenth-century philosopher Gottfried Wilhelm Leibniz (1646–1716), Deleuze's baroque 'fold' is a philosophical concept that brings together mind, body, and world. Deleuze visualizes baroque form and thought through its privileging of movement, materiality, and permanent permutation. See Deleuze, *The Fold*; Conley, 'Folds and Folding'.

2. Merleau-Ponty references the baroque in 'Eye and Mind', 'Cézanne's Doubt' and in his working notes on film in 'Sensible World'.

3. See Merleau-Ponty, *World of Perception*, pp. 93–101 and *Phenomenology of Perception*, pp. 376–377. All references to the latter text are now cited as *PP*. On Cézanne see Merleau-Ponty, 'Cézanne's Doubt' and 'Eye and Mind'.

4. See Merleau-Ponty, *World of Perception*, pp. 59–64 and 'Indirect Language', pp. 48–50.

5. As philosophy and as method, phenomenology foregrounds the importance of what it calls the lived body or *Leib* ('living body'). Unlike his predecessor Edmund Husserl, Merleau-Ponty rejected notions of being and perception modeled on a transcendental subject. One of the major contributions of his branch of existential phenomenology is its attention to the importance of the body as it is subjectively lived. As he writes, what prevents the body 'ever being [just] an object, ever being "completely constituted" is that it is that by which there are objects. It is neither tangible nor visible insofar as it is that which sees and touches'. Merleau-Ponty, *PP*, p. 105. For an explication of the lived body in existential phenomenology and the philosophical traditions that Merleau-Ponty reacted against, see Sobchack, *Address of the Eye*, pp. 32–50 and Leder, *Absent Body*, pp. 5–7.

6. See also Merleau-Ponty, *PP*, p. 379 and 'Cézanne's Doubt', p. 15.

7. See Merleau-Ponty, *The Visible and the Invisible*, 139. All references to this text are now cited *VI*. All references to *Merleau-Ponty's Ontology* are cited *MPO*.

8. Mobilizing Merleau-Ponty as well as Sobchack to understand cinematic tactility, Barker has provided a compelling film-phenomenological account of the varying modes of touch that are shared between film and viewer according to the sensory locales of the skin, the musculature, and the viscera. See Barker, *Tactile Eye*.

9. Merleau-Ponty himself intimates a 'break' with his earlier texts by writing of how the 'problems posed in [*Phenomenology of Perception*] are insoluble because I start there from the "consciousness"–"object" distinction'. Merleau-Ponty, *VI*, p. 200.

10. Dillon usefully divides Merleau-Ponty's thought into early, middle, and late periods. The early period (up until 1944) includes *The Structure of Behavior*

and centres upon psychological theory. The primacy of phenomena and perception belongs to the middle period (1945–58). It begins with *Phenomenology of Perception* and includes wide-ranging essays on art, politics, film, and *The Primacy of Perception*. The late period (1959–61) includes *The Visible and the Invisible* and the essay 'Eye and Mind'; we might also add *Signs* here, especially the essay 'The Philosopher and his Shadow' where Merleau-Ponty starts to use the term 'flesh'. See Dillon, *MPO*, p. 268, fn. 1.

11. The analogy between vision and touch is not without problems. French philosopher Luce Irigaray faults Merleau-Ponty for collapsing the intimate morphology of tactility (and its feminist implications) into vision. See Vasseleu, *Textures of Light*, pp. 66–72.

12. Husserl employed the doubled sensation of 'fingers touching fingers' to argue for differences between (digital) touching and seeing. By contrast, Merleau-Ponty implicates touch in vision and vision in touch. See Derrida, *On Touching*, pp. 162, 185–186.

13. Merleau-Ponty originally intended to entitle his work *The Origin of Truth*. See *VI*, p. 165, fn. 1.

14. In anatomic terms, *chiasma* refers to the crisscrossing of optic nerves at the base of the brain. In rhetorical terms, the *chiasmus* refers, in a pair of parallel phrases, to the second phrase reversing the grammatical order of the first: a phrase such as 'I cannot dig, to beg I am ashamed' is one instance. See the definition of 'chiasma' and 'chiasmus', *Merriam-Webster Dictionary*. Evans and Lawlor also point out that the *chiasm* can also be connected to the Greek *chiazein* meaning to mark with a *chi* (X), as in the sign of a cross. See Evans and Lawlor, 'Introduction', p. 18, fn. 2.

15. Here, I should comment on the terminology used in this book. I distinguish baroque cinema from its precedents by referring to the latter as baroque art, the baroque age, the seventeenth century, or the historic baroque. I rarely use the term 'neo-baroque' for film. This is because I strive to keep the historicity of the baroque alive in my conception of baroque flesh and to avoid situating baroque cinema as resulting from the post-classical, the postmodern, or the digital as some other scholars do. In this book, the perceptions and expressions of baroque flesh are ontologically inherent to cinema. I also differentiate between Merleau-Ponty's 'flesh', the flesh of the body and my discussion of baroque flesh by placing only Merleau-Ponty's concept in quotation marks.

16. For an overview of the cultural and ideological factors that led to the historic baroque see Maravall, *Culture*. On historic baroque aesthetics see Martin, *Baroque*.

17. Directors who have been labelled 'baroque' prove to be as varied as Sally Potter, Leni Riefenstahl, Raúl Ruiz, Roberto Rodríguez, and Quentin Tarantino. On Potter see Degli-Esposti, 'Sally Potter's *Orlando*'; on Riefenstahl see Peucker, *Material Image*, pp. 49–67; on Ruiz see Buci-Glucksmann, 'Baroque Eye'; Goddard, 'Towards a Perverse'; Jayamanne, *Toward Cinema*, pp. 162–170. On Rodríguez and Tarantino see Gabilondo, 'Like Blood for Chocolate'.

18. On the baroque and modernity see Buci-Glucksmann, *Baroque Reason*; Lambert, *The Return of the Baroque*. On the avant-garde baroque see Tweedie, 'Moving Forces'. On the baroque and surrealism see Caws, *The Surrealist Look*. On the 'Hollywood baroque' of Welles, Sirk, and Ray see Bonitzer, 'Partial Vision', p. 59; Schatz, *Hollywood Genres*, pp. 221–226; Andrew, *The Films*, pp. 70–77. On the neo-baroque see Calabrese, *Neo-Baroque*; Cubitt, *Cinema Effect*, pp. 217–244; Ndalianis, *Neo-Baroque*. On the baroque and new media art see Murray, 'Digital Baroque'. On the baroque of special effects and animation see Klein, *Vatican to Vegas* and *Seven Minutes*, respectively. On New World baroque see Zamora, *Inordinate Eye* and 'Magical Ruins'; Kaup, 'Becoming-Baroque'; Salgado, 'Hybridity'.

19. On the aesthetic experience as a correlative structure also see Dufrenne, *The Phenomenology*; Ngai, *Ugly Feelings*, pp. 38–88.

20. According to Ndalianis, shifts from the 'vertical' organization of studio-era Hollywood towards the 'horizontal' organization of the contemporary entertainment industry (transnational conglomeration and cross-media convergence) have hastened the neo-baroque. See Ndalianis, *Neo-Baroque*, 61. On the restructuring of the film industry also see Jenkins, 'Quentin Tarantino's'.

21. Obviously, the perceptive and expressive mechanisms of the cinema can alter. The mutoscopes and kinetoscopes of early film history boast different technological bases to contemporary digital cameras, digital playback devices, the internet, and so on. Nevertheless, the ontological dynamics of the 'film experience as a reversible structure correlating the activity of perception and expression and commuting one to the other' remain. Sobchack, *Address of the Eye*, p. 18.

22. On the anti-visualism of continental philosophy see Jay, *Downcast Eyes*.

23. See Marks' distinction between the optical and the haptic, although Marks herself is careful to insist on a flow between the two. See *Skin of the Film*, pp. 127–193 and *Touch*, p. xiii. The reconfiguration of vision as disembodied rather than a form of contact was itself a legacy of post-Enlightenment discourse. Deeply distrusted by the Enlightenment, the seventeenth-century baroque is an affiliate of what Marks calls haptic visuality, an alternate and older understanding of vision as 'embodied and material'. *Touch*, p. xiii.

24. As representative examples, see Mulvey, 'Visual Pleasure'; Baudry, 'The Apparatus'; Oudart, 'Cinema and Suture'. More recently, Eugenie Brinkema's *The Forms of the Affects* points out how film apparatus theories are partially responsible for the sensory turn of film and media studies as they are what the sensory turn sets itself up against.

25. The etymology of the 'baroque' varies according to its country of origin. The Spanish *barrueco-berreuco* refers to a node or misshapen pearl, while the Italian *barocco* signifies 'extravagance'. The French baroque can be connected to *barque* and *roc*, with evocations of movement and texture. See Maiorino, *Cornucopian Mind*, 49; Tweedie, 'Moving Forces', 23. The varying

etymologies of the baroque are suggestive of its aesthetic preference for diversity, movement, and materiality rather than uniformity. On the term 'baroque' as it emerged, retroactively, as a pejorative label for seventeenth-century aesthetics see Beverley, 'Going Baroque?'; Fleming, 'Element of Motion'.

26. Brinkema makes similar arguments for the intelligence and the significance of (film) form as having been lost amongst the recent spate of studies of affect, embodiment, and sensation. As she asserts, 'affect is not where reading is no longer needed'. Brinkema, *Forms of the Affects*, (p. xiv).

27. See Benjamin, *The Origin*. On baroque allegory and contemporary entertainment see Ndalianis, *Neo-Baroque*, pp. 49–69.

28. On the differences between analogy and allegory in critical theory see Stafford, *Visual Analogy*, pp. 8–55 and *Good Looking*, pp. 201–212.

29. See Deleuze, *Cinema 2*, p. 12.

1. Flesh, Cinema and the Baroque: The Aesthetics of Reversibility

1. Copies of paintings, sculptures, and architecture gave artists and the general public access to works that could previously only have been seen in situ or in rare, expensive print versions. See Ndalianis, *Neo-Baroque*, p. 46.

2. On the seventeenth century as an emergent mass culture see Maravall, *Culture*, pp. 79–103; Ndalianis, *Neo-Baroque*, pp. 43–46.

3. For Buci-Glucksmann, such 'madness' is the counterpoint to classicism and Enlightenment rationality.

4. See Gilman, *Curious Perspective*; Klein, *Vatican to Vegas*, pp. 21–67; on *quadratura* effects, see Sjöström, *Quadratura*.

5. On catoptrics and the Jesuits see Stafford, 'Revealing Technologies', pp. 25–28.

6. See Merleau-Ponty, *VI*, p. 75. I discuss the original passage further in Chapter 4.

7. While alluding to sensation, Buci-Glucksmann describes baroque art, theatre, and literature in predominantly visual terms. Furthermore, her work bears more in common with Lacanian notions of the gaze than with Merleau-Ponty's embodied philosophy. See also Buci-Glucksmann, *Baroque Reason*.

8. On the many divergent interpretations of this painting see Agamben, 'Notes on Gesture'; Alpers, 'Interpretation'; Foucault, *Order of Things*, pp. 3–16; Schmitter, 'Picturing Power'. As Brigitte Peucker observes, its discussion has also influenced film spectatorship debates through Jean-Pierre Oudart's work on suture. See Peucker, *Material Image*, p. 213, fn. 11; Oudart, 'Cinema and Suture'.

9. Palomino's biography *El museo pictórico y escala* is cited in Brown, *Velázquez*, pp. 241–264. See also Brown, *Images and Ideas*, pp. 88–110.

10. Palomino's assertions are supported by the 1686 inventory of the Alcázar,
 which describes how the prince's quarters were converted into the court
 painter's atelier (a position that Velázquez held) and that the decoration of
 this space consisted of copies after Rubens. See Brown, *Velázquez*, p. 241.

11. *Las Meninas* is the frontispiece for Michel Foucault's *The Order of Things*, as
 I will return to.

12. While we are encouraged to approach the mirror as the compositional
 centre of *Las Meninas*, it is not the precise geometric centre of the canvas,
 as that is located at Nieto's elbow. See Schmitter, 'Picturing Power', pp. 258–
 263.

13. On the baroque mirror see Jay, *Downcast Eyes*, p. 48.

14. Here, Marks is drawing upon Deleuze to invoke a mimetic relationship
 between the viewer's body and the image. I will return to the concept of
 mimesis at the close of Chapter 3.

15. Themes of reversibility are encased within the painting as well. Consider
 how its focus on attention is flipped around by depictions of inattention:
 the Infanta is not interested in the glass of water that is offered to her;
 the dog remains impassive to the foot that is placed on its back; and the
 widow's companion is not listening to her conversation. See Bal, *Reading*,
 p. 278.

16. As Sobchack asserts, all films are necessarily embodied, although this will
 occur in different degrees and ratios. See *Carnal Thoughts*, p. 62.

17. Merleau-Ponty has described how 'there is not just a unidirectional rela-
 tionship of the one who perceives to what he perceives. The relationship
 is reversed, the touching hand becomes the touched hand [...]. It is in no
 different fashion that the other's body becomes animate before me when I
 shake another man's hand or just look at him'. Merleau-Ponty, 'The Philoso-
 pher', pp. 166–168.

18. In addition to his well-known essay 'The Film and the New Psychology',
 Merleau-Ponty's writing on film also includes 'The Sensible World and the
 World of Expression'.

19. In this article Sobchack discusses the reversibility of perception and ex-
 pression in cinema in terms of its parallels with the lived body. Sobchack,
 'Active Eye'.

20. In formalist, realist, and psychoanalytic models of film theory, cinema has
 been likened to the metaphor of a picture frame, a window, or a mirror, re-
 spectively. Formalist theory privileges cinematic expression in its metaphor
 of the picture frame. By contrast, realists valorize the 'purity' of cinematic
 perception through the figure of the window. Both strains converge in their
 assumption that meaning at the cinema is 'located in the [cinematic] text
 as a significant object' alone. Within psychoanalytic or ideological film
 criticism, cinema is seen as neither perceptive nor expressive. Instead, it is
 considered refractive, reflexive, or reflective, and associated with the trope
 of the mirror. Here, the emphasis lies in the deceptive or illusionary nature

of the cinema and its duping of the spectator. Considered as a deception that is forced upon the spectator, film becomes an inherent distortion of all 'real' communication and any 'possibility of dialogic and dialectical communication is suppressed'. For Sobchack, these methods of theorization allow no recognition of the different ways in which the cinema rehearses very real and embodied modes of sense and significance. Sobchack, *Address of the Eye*, pp. 16–17.

21. For a detailed critique of ideological and Lacanian-inflected film theory from the standpoint of film-phenomenology see Sobchack, *Address of the Eye*, pp. 262–299; Marks, *Skin of the Film*, pp. 145–153, 188 and Marks, *Touch*, pp. 17–18.

22. See del Río, 'The Body as Foundation of the Screen', p. 103; Dillon, *MPO*, pp. 157–159.

23. Merleau-Ponty writes that the sensible is an 'open generality, a prolongation of the body's reserve' wherein 'reflection is not an identification with oneself (thought of seeing or feeling) but non-difference with self'. *VI*, p. 204.

24. See Merleau-Ponty, *PP*, p. 410 and 'The Philosopher', p. 168.

25. Lawlor rejects Merleau-Ponty's theorizations of generality and resemblance as he is discussing the relationship between Merleau-Ponty and Deleuze, whose philosophy of difference and of immanence 'confronts phenomenology [...] with its most powerful challenge'. Lawlor, 'End of Phenomenology', p.15. On Sobchack's concept of the film's body as distinct from Deleuze's approach see Sobchack, *Address of the Eye*, pp. 30–32; Marks, *Skin of the Film*, p. 150.

26. See Merleau-Ponty, *PP*, pp. 401–423; 'The Child's', pp. 96–155 and *VI*, pp. 78–83.

27. Elsewhere, Dillon points out how the ontology of 'flesh' sustains difference. The reversibility of one hand of the body touching the other is different to one hand touching an inanimate object or the reversibility between one body and another in the world. The 'isomorphism of reversibility in all its vicissitudes forms a unit by analogy', states Dillon, '*Écart*', p. 22, fn. 8.

28. Dillon writes that 'Husserl called this an analogical apperception to indicate that I attribute to the other's body there what I experience in my body here, that is, a field of sensation, a conscious life, a capacity for reflection, etc'. Dillon, *MPO*, p. 116. On the sense of recognition that is exchanged between one body and another as a 'coupling' see Merleau-Ponty, 'The Child's', p. 118.

29. Sobchack provides an extensive discussion of Merleau-Ponty's four-term system in relation to the film's body. Here I am interested only in its implications for a baroque cinema. See *Address of the Eye*, pp. 136–143.

30. On the painful vision of *Peeping Tom* see del Río, 'Body of Voyeurism'.

31. Merleau-Ponty suggests that 'flesh' is not something that we consciously enact. The 'feeling one sees, the seeing one sees, is not a thought of seeing or feeling, but vision, feeling, mute experience of a mute meaning' he writes. The 'flesh' precedes the consciousness of its own reflection as the primordial structure that makes meaning, reflection, and thought possible. *VI*, p. 249.

32. Again, we are alerted to parallels between the baroque and Merleau-Ponty, who writes that the 'round eye of the mirror' in such paintings gives voice to the 'labor of vision': the 'mirror appears because I am a seeing-visible [*voyant-visible*], because there is a reflexivity of the sensible: the mirror translates and reproduces that reflexivity'. Merleau-Ponty, 'Eye and Mind', p. 300.

33. Examples of doubled theatre include Vega's *Lo fingido verdadero*, Rotrou's *Saint Genest*, Corneille's *L'illusion comique*, Buckingham's *The Rehearsal*, Shakespeare's *Hamlet*, Gryphius' *Peter Squenz*, and Stieler's *Bellemperie*. See Bornhoefen, 'Cosmography and Chaography', p. 58.

34. See Kennedy, *Deleuze and Cinema*, pp. 180–192; Mulvey, 'Visual Pleasure'.

35. Here, I diverge from Sean Cubitt's reading of *Strange Days* where he argues that the neo-baroque artifice of 'Bigelow's world yields no truth, only emulations and betrayals'. From the perspective of baroque flesh, artifice and affect intertwine. In *Strange Days*, the body that we watch SQUID clips through is every bit as crucial as what we are watching. It is for that reason that we watch Iris' death through Lenny while Mace (the moral centre of vision) is the all-important conduit through which we view the LAPD's racist execution of the rap musician Jeriko One. Cubitt, *Cinema Effect*, pp. 236–237. For a different reading of the SQUID as belonging to the pre-subjective (whereby 'the vividness of what is happening takes precedence over the question of whom it is happening to') see Shaviro, 'Straight', p. 165.

36. See Saxton, 'Secrets and Revelations', pp. 9–10.

37. 'Remediation' is the term that Bolter and Grusin use to designate how no medium (or embodied self, for the matter) exists in isolation but draws upon, re-fashions, and re-forms past and present media through technological perceptions and expressions. See Bolter and Grusin, *Remediation*, pp. 4, 231–240.

38. The antithesis of fire-and-ice is a favourite trope of baroque poetics as it loves extreme sets of oppositions. See Maravall, *Culture*, p. 210.

39. On gesture, Caravaggio, and baroque art see Wittkower, *Art and Architecture*, pp. 48–50.

40. It is noteworthy that the historic baroque is also considered to be the privileged age of portraiture because of its association with artists such as Rubens, Rembrandt, van Dyck, and Velázquez. Their uses of gesture, vehement facial expressions, and frontal poses endow the image with an arrestingly physical presence. Portraiture is, of course, a form of painting that is premised on 'facing' and the sitter's presentation of his or herself for another. See Martin, *Baroque*, p. 91 and Fried, *Absorption*, pp. 109–110.

41. See also Barthes, 'The Face'. On 'facing' in film through a modernist framework see Peucker, *Material Image*, pp. 68–84, 87–103. On effects of frontality or 'facing' in the visual arts and their connections to neuroscientific research see Stafford, *Echo Objects*, pp. 75–104.

2. Knots of Sensation: Co-Extensive Space and a Cinema of the
 Passions

1. See Gunning, 'An Aesthetic', pp. 114–133.
2. On early cinema and the travelogue see Ruoff, *Virtual Voyages*.
3. Aristotle describes taste and seeing as different forms of touch in *De Anima*,
 thereby hinting at a synaesthetics of perception even within his hierarchy
 of the senses. See Stewart, *Poetry*, pp. 20–21.
4. On the inter-sensory effects of mescaline see Merleau-Ponty, *PP*, pp. 49–50
 and on the blind see Merleau-Ponty, 'The Film', pp. 49–50.
5. See also Calabrese, *Neo-Baroque*, pp. 131–143; Ndalianis, *Neo-Baroque*,
 pp. 77–107; Bonitzer, 'Partial Vision'.
6. On the shell as a trenchant emblem for the energy and serialized movement
 of the baroque see Maiorino, *Cornucopian Mind*, pp. 64–65, 125. On the spi-
 ralling, serpentine, and shell-like motifs that recur in seventeenth-century
 decoration also see Zamora, *Inordinate Eye*, p. 144; Shapcott, 'New Rococo',
 p. 39.
7. Lacan discusses the Borromean knot in Seminar 19, 9 February 1972. See
 Lacan 'Rings of String', *On Feminine Sexuality*, pp. 118-136.
8. As Deleuze writes, unfolding and folding actions are inherent to the ba-
 roque. See Deleuze, *The Fold*, p. 6.
9. The association of artistic movements with synaesthetic effects (the
 Symbolists, the Futurists, the Surrealists, and, as I will detail, the baroque)
 has led to the assumption that synaesthesia is an 'artistic' condition. I am,
 however, concerned with the latent synaesthesia of all perception and its
 relevance to the baroque. See Cytowic, 'Synaesthesia,' and Classen, *Color of
 Angels*, pp. 118–137.
10. See Marks, *Unity of the Senses*; Baron-Cohen and Harrison, *Synaesthesia*.
11. Incense marked a historic shift in taste as the newly found spices of Asia
 were imported to Europe and conjured up the 'taste' of paradise. See
 Schivelbusch, *Tastes of Paradise*.
12. On seventeenth-century theatre see Norman, 'Theatrical Baroque', pp. 1–11;
 Hagerman-Young and Wilks, 'Theatre of the World', pp. 36–45; Aercke, *Gods
 of Play*. On the spectacular mechanics of baroque theatre see Klein, *Vatican
 to Vegas*, pp. 67–96, 116–132.
13. The baroque unity of the arts pre-empted other interdisciplinary move-
 ments such as the *Gesamkunstwerk* of German Romanticism. See Lavin,
 Bernini, pp. 13–14, fn. 28.
14. On Bernini and the theatre see Lavin, *Bernini*, pp. 148–151; Klein, *Vatican to
 Vegas*, p. 29.
15. Teresa of Ávila's account of the transverberation is quoted in Lavin, *Bernini*,
 p. 107.
16. See 'ecstasy', *Merriam-Webster*.

17. Traditional imagery had depicted the saint kneeling, not reclining. See Lavin, *Bernini*, p. 113. On Teresa being depicted in a state of bodily orgasm see Lacan, 'On the Baroque', p. 76.

18. This term is taken from the noun *contrapposto*, referring to the dynamics of counterbalance between different parts of the body. It is entirely possible that the balance of media in the *bel composto* was thought of in relation to the body. See Lavin, *Bernini*, p. 10.

19. Bachelard articulates how childhood spaces are physically inscribed upon us: 'I alone, in my memories of another century, can open the deep cupboard that still retains for me alone that unique odor, the odor of raisins drying on a wicker tray'. Bachelard, *Poetics of Space*, p. 13.

20. On the presence rather than absence of cinema see Shaviro, *Cinematic Body* and del Río, 'Antonioni's *Blowup*'.

21. This is where the baroque flesh of this book diverges from the sensuous film scholarship of Beugnet, who approaches a cinema of the senses as the result of recent experimental/art filmmaking and as being bound up with the 'renewed interface between contemporary philosophy, film and film theory in particular'. Beugnet, *Cinema and Sensation*, p. 10.

22. On Eisenstein and synaesthesia see Smith, 'Moving Explosions'; Robertson, 'Eisenstein'.

23. Work in the cultural anthropology of the senses has contradicted the assumed precedence of vision in cultures outside the West, indicating much cross-cultural variation in the 'ordering' of the senses. On the anthropology of the senses see Classen, *Worlds of Sense* and *Color of Angels*; Howes, *Sensual Relations* and *Empire of the Senses*; Stoller, *Sensuous Scholarship*; Taussig, *Mimesis and Alterity*.

24. While deriving her title from Merleau-Ponty, Buci-Glucksmann's book is far more concerned with Lacanian readings of the gaze-as-absence than with approaching the baroque through Merleau-Ponty's notion of embodied being and perception as plenitude and renewal. Buci-Glucksmann, *La folie*.

25. On the minor affects (envy, irritation, anxiety, paranoia, and disgust) see Ngai, *Ugly Feelings*.

26. See Maravall, *Culture*; Martin, *Baroque*.

27. On Aristotelian theory in the Renaissance and the historic baroque see Ndalianis, *Neo-Baroque*, pp. 219–220; Lee, *Ut Pictoria Poesis*.

28. See Zamora, *Inordinate Eye*, p. 35.

29. On Loyola see Martin, *Baroque*, pp. 45–55; O'Malley, *Religious Culture*.

30. On the possibility of achieving transcendence-in-immanence see Merleau-Ponty, 'The Primacy', p. 16. For a discussion of transcendence and immanence in film, see also Sobchack, 'Embodying Transcendence'.

31. For a gloss on excess in film theory see Grindon, 'Role of Spectacle'; Charney, 'Historical Excess'.

32. See 'apprehension', *Merriam-Webster*.

33. Concerned with the pre-reflective body, the film-phenomenology of Sobchack and Barker is not interested in more conscious forms of narrative engagement or apprehension. Similarly, Beugnet's account sees the contemporary French cinema of sensation as distinct from narrative-driven modes of filmmaking. See Beugnet, *Cinema and Sensation*, p. 9.

34. Here, I appreciate the efforts of Barker's tactile film-phenomenology as it examines experimental and art cinema examples as well as commercial Hollywood. See Barker, *Tactile Eye*.

35. On the etymology and history of the passions see Meyer, 'Introduction'.

36. On Descartes and the passions see Summers, '*Cogito* Embodied'.

37. The distinction between the affects and the passions was a crucial one for Spinoza. While the philosopher distrusted what he once termed the so-called 'bondage' of the passions (as external forces that exert themselves upon us), he also admitted that the passions were a necessary part of the human condition. For Spinoza, we could (potentially) turn the passions into the body's capacity for action through the affects. Spinoza's suggestion of movement between physical states of activity and passivity is highly relevant to this chapter. For a discussion of Spinoza, affect, and *The Ethics* see Deleuze, 'Ethology'.

38. On the spatial proliferation of the baroque also see Barthes, 'Tacitus', pp. 99–102.

39. See Wittkower, *Art and Architecture*, p. 165. On Correggio see Sjöström, *Quadratura*, p. 35; Shearman, *Only Connect*, pp. 149–191.

40. On the iconographic program of these two ceilings and their artistic execution see Ndalianis, *Neo-Baroque*, pp. 84–93, 160–171.

41. On animation and the baroque see Klein, *Vatican to Vegas*, pp. 247–282 and *Seven Minutes*, pp. 162–171.

42. See Merleau-Ponty, *PP*, p. 294; see also Jay, *Downcast Eyes*, p. 307, fn. 143.

43. On Denis' cinema see also Beugnet, *Cinema and Sensation*, pp. 32–47, 78–87; del Río, 'Performing'; Met, 'Looking for Trouble'; Scholz and Surma, 'Exceeding the Limits'.

44. Morrey interprets the sensuality of Denis' film through Deleuze's philosophy of the fold. See also Walton, 'Enfolding Surfaces'.

45. On the physical realism of Caravaggio see Varriano, *Caravaggio*; Ndalianis, 'Caravaggio Reloaded'; Wittkower, *Art and Architecture*, pp. 45–56.

46. Morrey notes how Nancy employs the French verb *fouiller* in his essay as this boasts nauseous connotations of a skin-deep excavation, as in 'to dig in and root around'. 'Open Wounds', p. 17.

47. On disgust (a term derived from the Latin *gustus*, meaning to taste) as a visceral emotive state and as an inter-sensory experience see Miller, *Anatomy of Disgust*; on the cinesthetics of the horror film through its elicitation of disgust see Peucker, *Material Image*, pp. 159–192.

48. On the synaesthetics of our encounter with beautiful experiences see Scarry, *On Beauty*.

3. Baroque Skin/Semiotics

1. The philosophy of Gottfried Wilhelm Leibniz is indicative of the infinite, expansive, and analogical attitude of the historic baroque. His combinatorial thought argues that each unit or 'monad' (the name Leibniz gives to each subject, soul, or substance as a metaphysical point) can be brought into unified relations with a potentially infinite series (the Many). Leibniz believed that each monad expresses its own finite portion of the world, at the same time as it contains the entire world within. Leibniz espouses the baroque urge to 'come together' by arguing for the underlying connections between things. To quote Leibniz: 'each simple substance has relations which express all the others, and, consequently [...] it is perpetual living mirror of the universe'. See Leibniz, *The Monadology*, pp. 217, 237, 248. For a discussion of Leibniz see Deleuze, *The Fold* and 'On Leibniz'. On the relationship between Leibniz and Merleau-Ponty see Merleau-Ponty, *VI*, pp. 166, 222–223; Buci-Glucksmann, *La folie*, pp. 72–73. On Leibniz and analogy see Stafford, *Visual Analogy*, pp. 98–134.
2. Barthes is not the only semiotician to discuss the embodiment of language, though he is certainly one of the most prolific. See also Bal, *Quoting*, pp. 129–164; de Lauretis, *Technologies of Gender*, pp. 31–50 and *Alice Doesn't*, pp. 158–186; Sobchack, *Address of the Eye*, pp. 8–14, 41–43, 71–76 and 'Lived Body'.
3. Here I do not define semiotics as belonging to a particular object or discipline. This is because semiotics 'has something to say about objects in a variety of disciplines'; a semiotic approach 'is best indicated as a perspective, one that combines an awareness of the systematic nature of cultural expressions of all kinds with an interest in the "life" of signs'. Bal, 'Semiotic Elements', p. 585.
4. See also del Río, 'Alchemies of Thought', p. 64.
5. See also Andrew, 'Neglected Tradition', p. 627.
6. See Brinkema, *Forms of the Affects* for similar reservations.
7. Brinkema also identifies that Shaviro and Massumi divorce sensation and/ or Deleuzian intensity 'from all that signifies'. See Brinkema, *Forms of the Affects* p. 28. For a more recent instance of sensuous film scholarship that divorces the 'sensual affect of film' from mainstream 'representational functions and narrative functions'—functions that are also associated with spectatorial qualities of identification, distance, and rational detachment— see Beugnet, *Cinema and Sensation*, p. 27.
8. See also Butler, *Bodies that Matter*, pp. 67–68.
9. See, for instance, Baridon, 'Scientific Imagination'; Huddleston, 'Baroque Space'; Ndalianis, *Neo-Baroque*, pp. 137–140; Martin, *Baroque*, p. 145; Reeves, *Painting the Heavens*; Stafford, 'Revealing Technologies', pp. 4–5.
10. In his preface, Fontanelle asserts that 'to think that there may be more Worlds than One is neither against Reason, or Scripture [...] if God glorify'd

himself in making one World, the more worlds he made, the greater must be his Glory'. This was exactly the stance that the church itself adopted when it could no longer eschew the new cosmology. Fontanelle, *Plurality of Worlds* preface, no pagination; see also Ndalianis, *Neo-Baroque*, p. 237.

11. On the seventeenth-century imagination as 'essentially cryptographic' see Stafford, 'Revealing Technologies', p. 28.

12. On the importance of antithesis and dichotomy (for example, life–death, human–divine, fire–ice, light–darkness, reality–illusion) in baroque poetics see Overesch, 'The Neo-Baroque', pp. 45–47.

13. Consider Jorge Luis Borges' thoughts on Góngora. Borges describes how his poetry brings together and 'compares things that cannot sensibly be compared: for example, the body of a woman with crystal or the hair of a woman with gold. If Góngora had looked at these things, he would have discovered that they do not appear anything alike, but Góngora lives, as I said, in a verbal [and baroque] world'. Borges qtd. in Bornhoefen, 'Cosmography and Chaography', p. 32.

14. On baroque semiotics see Buci-Glucksmann, *Baroque Reason*, pp. 129–143.

15. Here, it is worth thinking about how the baroque (and its rebirth across different historic eras) may be the constant dialectic companion to classicism and/or rationalism. I am indebted to Sean Cubitt for these observations.

16. In his *Sidereus Nuncius* (Starry Messenger), Galileo detailed earth-like features upon the moon and its 'secondary light'. He argued that the moon's illumination came from solar light, bouncing off the earth (it is actually reflected directly off the moon's surface); his theories eroded former divisions between the celestial and terrestrial spheres and drew the earth into 'the dance of the stars'. See Galileo qtd. in Reeves, *Painting the Heavens*, p. 8.

17. Seventeenth-century language and the visual arts express a shared love of movement. As Zamora observes, 'Metonymic displacement impels the movement of Baroque narrative in the same way that it impels the eye over the animated surfaces of Baroque façades and frescoes'. Zamora, *Inordinate Eye*, p. 141. On movement and the seventeenth century see Fleming, 'Element of Motion'.

18. Taken from the Greek *ana* (to change) and *morphe* (to form or shape), an anamorphosis is a puzzle-picture whose perspective has been deliberately distorted. If seen from the front, it presents a visually entangled form. When the beholder moves to an oblique angle in relation to the image, the image appears to contract and reveal its hidden shape. Alternatively, in reflective or dioptic kinds of anamorphosis (such as the one included in Tesauro's frontispiece) a technological device (mirrored pyramids, cylinders, cones, or a faceted lens) is placed over the image to 'correct' its form. See Baltrušaitis, *Anamorphic Art*, p. 11.

19. On baroque metaphor as a means of connecting the world see Mazzeo, 'Metaphysical Poetry', pp. 221–234.

20. This term derives from Marks' work in *Enfoldment and Infinity: An Islamic Genealogy of New Media Art*, although I am interested in developing its affiliations with baroque flesh. See Marks, *Enfoldment*, p. 108.

21. Most films that are ostensibly set at Versailles, especially those with interior court scenes, are actually filmed elsewhere—at Vaux-le-Vicomte, the very site whose splendour so enraged Louis XIV that it led to the reconstruction of Versailles in the first place.

22. Although it is usually discussed as an instance of classicism, Versailles has also been seen as 'saturated with baroqueness': 'despite its classicist details […] [the] lack of restraint and proportion makes us lose ourselves there: "the grandeur turns into megalomania"'. Maravall, *Culture*, pp. 7–8. See also Zamora, *Inordinate Eye*, pp. 354–355, fn. 9.

23. During the baroque age, the threat that social aspiration posed to the established system (the feudal power and privileges of the nobility) was felt to be dangerously out of control. See Maravall, 'From the Renaissance'.

24. Like Bornhoefen and John Beverley, I disagree with Maravall's somewhat reductive account that the urban population of the historic baroque was simply manipulated by those in higher positions of cultural and economic power. See Bornhoefen, 'Cosmography and Chaography', p. 60 and Beverley, 'Going Baroque?', p. 38, fn. 9.

25. On the *remise* see Thurman, 'Dressed for Excess'.

26. For an ideological reading of the film as making over the female body and depicting Antoinette as an object that is exchanged within larger systems of power see Rogers, 'Historical Threshold'.

27. The natural light scenes in this film are quite different to the baroque aesthetics that predominate in its court scenes. On the transformation of baroque spaces into rococo and classical spaces and the potential movement between these aesthetics, see forthcoming work by Samuel Harvey on Sofia Coppola: Harvey, 'Return of the Rococo'.

28. By the eighteenth century, the financial maintenance of Versailles by Louis XVI and Marie Antoinette was a major problem. On the incredible expense of Versailles see Saisselin, *The Enlightenment*, pp. 12–14; Ndalianis, *Neo-Baroque*, p. 267, fn. 34.

29. The cosmological comparison of the prince with the sun is a common motif in the literature of this period. See Benjamin, *The Origin*, p. 67.

30. According to Renu Bora, boredom lacks any kind of affect (either the positive or negative kind). We physically feel a film to be boring because we experience it as a temporal 'blockage'. See Bora, 'Outing Texture', p. 117.

31. The skin and the brain are formed of the same membrane, the ectoderm, with both beginning their life as surfaces. See Benthien, *Skin*, p. 7.

32. On tactility as basic to our survival see Montagu, *Touching*, p. 187.

33. Deleuze's interests in the surface as a source of knowledge can be traced back to 'The Simulacrum and Ancient Philosophy', an appendix to *The Logic of Sense*. Using Plato's concept of the simulacrum to disrupt the Platonic

hierarchy between the real/original and the degraded copy, Deleuze maintains that any attempt to 'reverse Platonism' must avoid making distinctions between 'Essence-Appearance or Model-Copy'. Privileging the 'rising to the surface' of the simulacrum (as a figure that looks like or resembles something else), Deleuze argues that reality and representation and surface and depth are equally embodied. Attending to the 'surface of things' (skins, tunics, wrappings, envelopes, barks), we can discover how 'each sense seems to combine information of the depth with information of the surface'. For Deleuze, the simulacrum 'harbors a positive power which *denies the original and the copy, the model and the reproduction*'. It is suggestive of the intertwining between surface and depth that occurs in baroque flesh, wherein 'the surface element is related to depth, and what is apprehended when we touch the surface of the object is perceived as residing in its innermost depths'. Deleuze, 'The Simulacrum', pp.299-310.

34. On Caravaggio see Deleuze, *The Fold*, p. 159, fn. 32.

35. In another instance of the affect and artifice of the baroque, mastering the depiction of drapery and folds was essential to the artist's apprenticeship. The rendering of light, shade, movement, and texture was a sign of artistic virtuosity, 'allied to the study of nature, but a composed nature, an artificial nature, as it were'. Zamora, *Inordinate Eye*, p. 267.

36. See Conley, 'Folds and Folding'.

37. See also Leibniz, *The Monadology*, p. 231. After Leibniz, Deleuze's allegory of the Baroque House folds together 'pleats of matter' and 'folds in the soul' to reconcile the ontological split between body and mind. See Deleuze, *The Fold*, p. 29.

38. Textural descriptions are also evident in *PP*, where Merleau-Ponty writes that '[m]y body is the fabric into which all objects are woven, and it is, at least in relation to the perceived world, the general instrument of my "comprehension"'. Merleau-Ponty, *PP*, p. 273.

39. It is beyond the purview of this book to explore all of the continuities and differences between 'flesh' and the fold, though I do want to observe affiliations between Merleau-Ponty's 'flesh' (as a contour in process) and Deleuze's undulating 'fold', in particular that both employ textural metaphors of folds and fabric to achieve their respective aims. Merleau-Ponty himself first invoked the figure of the fold in *PP*: 'I am not, therefore, in Hegel's phrase, "a hole in being", but a hollow, a fold, which has been made, and which can be unmade' because of the lived renewal of perception and expression. Merleau-Ponty, *PP*, pp. 249–250. Deleuze makes reference to Merleau-Ponty's fold as *chiasm* as having 'a much stronger understanding of Leibniz'. Deleuze, *The Fold*, p. 146, fn. 28. For a more extended discussion of the relationship between Deleuze and Merleau-Ponty see Lawlor, 'End of Phenomenology'; del Río, 'Alchemies of Thought'; Butler, 'Merleau-Ponty'.

40. On feeling (anger, grief, suffering) as it is inter-subjectively understood through external bodily expressions see Merleau-Ponty, *PP*, pp. 214–215, 414–415; see also 'The Film', pp. 52–53.

41. In his lecture notes on film, Merleau-Ponty observes how 'true speaking' in the cinema involves non-verbal 'dialogue inscribed within the image' such as the stylistic expressions of camera movement, 'montage, editing, visual-sonorous rhythm', and so on; here is what 'makes the movement of a film and not the agitation of characters'. 'Sensible World', p.35.

42. See Jenkins, 'This Fellow', pp. 29–66.

43. See Jenkins, *What Made Pistachio Nuts*.

44. Bruno also argues for modernity as a set of surface effects. See *Surface*, ch. 3.

45. The historic baroque has been associated with 'the madness of the world', 'the world as a stage', or 'the world as a confused labyrinth'. Interestingly, Maravall connects these artistic themes to the figure of the comedian. Maravall, *Culture*, pp. 150–155.

46. On slapstick as a vehicle through which the sensory shifts of modernity could be playfully negotiated see Hansen, 'Mass Production', p. 71.

47. The German phrase *mit Haut und Haar* (meaning 'completely and utterly') also employs the skin as a synecdoche for the feeling self. See Benthien, *Skin*, p. 19.

48. On the importance of metaphor in slapstick see Trahair, *Comedy of Philosophy*; Carroll, 'Notes on the Sight Gag'.

49. The geometric harmony of Keaton also recalls Leibniz's notion of a divine 'universal harmony' that integrates the infinite and monadic structure of the world. See Leibniz, *The Monadology*, pp. 249–250.

50. On analogy as an inherently mimetic practice see Stafford, *Visual Analogy*, pp. 8–55.

51. See, for instance, Caillois, 'Mimicry' and Taussig, *Mimesis and Alterity*. The concept of mimesis has re-surfaced in recent neurological research on the embodied mind. See Stafford, *Echo Objects*.

52. On the relevance of mimesis to cinema see Bean, 'Technologies of Early Stardom'; Hansen, 'Benjamin and Cinema'; Jayamanne, *Toward Cinema*; Marks, *Skin of the Film* and *Touch*; Sobchack, *Carnal Thoughts*.

53. See also Benjamin, 'On the Mimetic Faculty', pp. 335–336.

4. One Hand Films the Other: Baroque Haptics

1. On baroque vision see Christine Buci-Glucksmann, *La folie*. Martin Jay maintains that baroque vision overlaps or competes with two other scopic regimes in Western modernity. These include the scientific rationalization of sight (emblematized by the monocular point of view of linear Renaissance perspective) and the Dutch 'art of describing' which is, alternatively, characterized by its horizontal spread of material details. See Jay, *Downcast Eyes*, pp. 45–49; Alpers, *Art of Describing*; Wollen, 'Baroque', p. 9

2. Here, I would direct the reader to tactile analyses of film in Steven Shaviro and Jennifer Barker. See Shaviro, *Cinematic Body*; Barker, *Tactile Eye*.

3. See Deleuze, *Cinema 2*, p. 12. On the combined influences of Deleuze and Marks on discussions of the haptic in film see Beugnet, *Cinema and Sensation*, pp. 65–68.

4. Merleau-Ponty is paraphrasing German philosopher Immanuel Kant: 'It is not consciousness which touches or feels, but the hand, and the hand is, as Kant says, "an outer brain of man"'. *PP*, pp. 268–369.

5. *Kunstkammer* and *Wunderkammer* collections overflowed entire chambers and rooms, whereas the *Wunderschrank* was a carefully designed cabinet of curiosity. On the *Kunstkammer* see Bredekamp, *Lure of Antiquity*. On seventeenth-century collecting see Findlen, *Possessing Nature*.

6. Philosopher Emmanuel Levinas, for instance, once wrote that the 'visible caresses the eye. One sees and hears like one touches'. Qtd. in Davies, 'The Face', p.257.

7. Sobchack concentrates her argument on two selected scenes: the film's opening where ambiguous, pinkish-red images give way to the protagonist, Ada, looking out through her fingertips and another scene where the character of Baines crouches beneath Ada's piano, caressing her exposed skin through a rent in her stocking. See *Carnal Thoughts*, p. 62.

8. Lacan's use of the French *délirer* ('to be delirious') also figuratively means to 'go nuts' or 'proliferate like mad'. Lacan, 'On the Baroque', *On Feminine Sexuality*, p. 116, fn. 37.

9. On the sequential or serialized artworks of the seventeenth century as they convey a passing of time in space see Maiorino, *Cornucopian Mind*, pp. 84–85. Similarly, Deleuze maintains that unfolding or unfurling is not the contrary of the 'fold' but inherent to its embodied and conceptual logic. See Deleuze, *The Fold*, p. 6.

10. See Barker, *Tactile Eye* on the latter. This link between surface and depth is also discussed in Bruno as atmospheric layering and as the stirring of emotion and thought in the mind of the viewer. See *Surface*, ch. 5.

11. Like the labyrinth poems alluded to in Chapter 1, Benjamin has related the baroque spatialization of time to seventeenth-century poetry. For instance, the 'Nuremberg poets' presented the graphic outlines of their poems as towers, fountains, orbs, organs, lutes, hour-glasses, scales, wreathes, hearts, and other shapes. See Benjamin, *The Origin*, pp. 94–95.

12. For instance, they describe the nomadic space of the Inuits as having 'neither perspective nor limit nor outline or form or centre'. Deleuze and Guattari, *A Thousand Plateaus*, p. 494.

13. Riegl borrowed the term 'haptic' from physiology (or what he describes as *nahsicht*) rather than using the term 'tactile' because the latter might be taken as too literal an experience of touch. This permeation of the optical with or alongside the tactile (without involving a literal or physical touch)

can also be related to baroque haptics. See Riegl, *Late Roman Art*, p. xx; Marks, *Skin of the Film*, p. 162.

14. For recent examples in film studies, see Quinlivan, *Place of Breath*; Chamarette, *Phenomenology*.

15. For Deleuze and Guattari, nomad art is emblematized by the freedom of the abstract line. Such abstraction has 'a multiple orientation and passes between points, figures and contours' instead of creating them, as with the figurative traditions of Western art. Deleuze and Guattari, *A Thousand Plateaus*, p. 496.

16. Marks herself understands these categories as inextricable. Given her interest in inter-cultural cinema and experimental film and video, however, she is more concerned with haptic embodiments than intertwinings of the optic with the haptic. See Marks, *Skin of the Film*, p. 163 and *Touch*, p. 3.

17. Burch himself admits that there was never a complete planarity to early film. Coloured hand tinting and smoke effects created effects of atmospheric depth, while even the movements of the actors lent a sense of depth to the representational space. I must, however, disagree with his assumption that haptic space put an end to tensions between surface and depth in film, especially as baroque flesh delights in using surface, materiality, and texture to express the depth of feeling. See Burch, *Life to Those Shadows*, pp. 170–172.

18. See Lant, 'The Curse'. Interestingly, Deleuze's own mobilization of Riegl in *Cinema 2* invokes the spatial dimensionality rather than the surface effects of the haptic. Discussing a 'touching which is specific to the gaze' in the films of Robert Bresson, he writes of how the 'hand doubles its prehensile function (of object) by a connective function (of space)'. Deleuze, *Cinema 2*, p. 12. See also Bruno, *Surface*, p. 249, fn. 8.

19. Decadence, luxury, splendour, and expenditure were precisely what Enlightenment critics of the baroque attacked, claiming they would lead to corruption and a crippling 'effeminisation of society'. See Saisselin, *The Enlightenment*, pp. 38–42.

20. Bal couples both the sensuality of the detail in art and its textual diffusion to the metaphor of the navel. For Bal, this bodily metaphor is democratic (both men and women have it) and it speaks to an anti-phallic semiotics, unlike Roland Barthes' pricking or piercing *punctum*. See Bal, *Reading*, pp. 1–24. On the *punctum* in photography see Barthes, *Camera Lucida*, pp. 26–27.

21. On *Doubting Thomas* see Bal, *Quoting*, pp. 31–32; on *Las Meninas* see Bal, *Reading*, p. 265.

22. *Istoria* derives from Leon Battista Alberti's influential Renaissance treatise *Della Pittura* (On Painting) (1435–36) where Alberti stressed the 'representation of significant human actions' and the importance of narrative, history, and story for painting. Alpers, *Art of Describing*, pp. 42–43. For the original source see Alberti, *On Painting*. On the historic persistence of the 'window'

metaphor in art, architecture, film, and digital culture see Friedberg, *Virtual Window*.

23. See also Alpers, *Art of Describing*, p. xxiii.

24. Riegl's *Kunstwollen* concept refers to the 'definite and purposeful' trend, taste, or artistic traits of an age. Qtd. in Lant, 'Haptical Cinema', p. 48.

25. The formal differences between the classical and the baroque are grouped according to the following well known pairings: the linear as opposed to the painterly; plane versus recession; closed form versus open form; multiplicity versus unity; the expression of absolute clarity versus relative clarity or complexity. See Wölfflin, *Principles*.

26. In an illuminating essay on the relationship between Deleuze and painting, Vlad Ionescu draws intriguing connections between Deleuze and the art history of Wölfflin. As he points out, the haptic in 'Deleuze is what Wölfflin calls the painterly quality of the Baroque' because both rest on 'perpetual modulation or local transition from one state to the other'. Ionescu, 'Deleuze's Tensive Notion', p. 59.

27. Despite the hyperbole that surrounded its release, the grassroots assemblage of *Tarnation* is indicative of what fans, digital filmmakers, and artists have been doing for years and what has now become standard practice in online culture. See Jenkins, 'Quentin Tarantino's'.

28. Unless otherwise noted, the specifics behind the film's production have been taken from Caouette's director's commentary on the DVD release of *Tarnation*.

29. Drawing on Deleuze, Jonathan Crary argues that an assemblage is 'a complex social amalgam in which its existence as a textual figure was never separable from its machinic uses'. He invokes the historic technology of the camera obscura as just such an assemblage because it functions as an epistemological figure, a used object/technology, and an arrangement of cultural practices. Just as the camera obscura is 'simultaneously and inseparably a machinic assemblage and an assemblage of enunciation', so too is *Tarnation* an assemblage. The baroque conventions that the film's body enunciates arise from its digital bases and machinic uses. Crary, *Techniques*, p. 31.

30. On the ways in which previously avant-garde techniques are now literally embedded within digital software see Manovich, *Language of New Media*, pp. xv–xxxvi.

31. In this regard, Caouette's 'rock opera' cinematically recalls the sensuous art of the historic baroque fugue. Made famous by the music of Johann Sebastian Bach during the seventeenth century, the fugue is based on a central theme or musical motif that is repeated, altered, and moved through varying cycles. See Ndalianis, *Neo-Baroque*, p. 69; Cubitt, *Cinema Effect*, p. 223.

32. On the precedents to Kircher and his collection see Findlen, *Possessing Nature*, pp. 17–47. On the repute of Kircher's gallery see Ndalianis, *Neo-Baroque*, pp. 149, 172–173.

33. On these collections as the historic precedents to the digital age see Bredekamp, *Lure of Antiquity*; Stafford, 'Revealing Technologies', pp. 6–20 and *Good Looking*.

34. This quotation is credited to British collector John Tradescant (1577–1638): 'As by their choice collection may appear, Of what is rare in land, in seas, in air: Whilst they (as HOMER's Iliad in a nut) A World of Wonders in one closet shut'. Qtd. in Findlen, *Possessing Nature*, p. 17, fn. 1.

35. Contemplating his library, Benjamin finds himself taken over by the memories attached to specific books and the various cities in which they were found. See Benjamin, 'Unpacking My Library', p. 67.

36. Given their connections to the baroque, I think we can add the *chiasm*, encroachment, or intertwining of Merleau-Ponty's 'flesh' and Deleuze's articulation of the new 'envelopments' that occur through the 'folding, unfolding, refolding' of the baroque fold to this list. See Deleuze, *The Fold*, p. 137.

Conclusion: Or the Baroque 'Beauty of the Act'

1. For an extended reading of Carax's film as baroque see Walton, 'Beauty of the Act'.

2. There are parallels with Deleuze's cinema books here, although Brenez's figural film theory constitutes its own mode of interpretation. See Brenez, 'Incomparable Bodies'; Martin, *Last Day*.

Bibliography

Aercke, Kristiaan. *Gods of Play: Baroque Festive Performances as Rhetorical Discourse*. Albany, NY: State University of New York Press, 1994.

Agamben, Giorgio. 'Notes on Gesture'. Trans. Liz Heron. In Giorgio Agamben, *Infancy and History: Essays on the Destruction of Experience*. London: Verso, 1993. 135–140.

Ahmed, Sarah, and Jackie Stacey, eds. *Thinking through the Skin*. London: Routledge, 2001.

Alberti, Leon Battista. *On Painting*. Trans. John R. Spencer. New Haven, CT: Yale University Press, 1956.

Alpers, Svetlana. *The Art of Describing: Dutch Art in the Seventeenth Century*. Chicago: University of Chicago Press, 1983.

——. 'Interpretation without Representation, or, the Viewing of *Las Meninas*'. *Representations* 1 (February 1983): 31–42.

Andrew, Dudley. 'The Neglected Tradition of Phenomenology in Film Theory'. In *Movies and Methods: An Anthology*. Ed. Bill Nichols. Vol. 2. Berkeley, CA: University of California Press, 1985. 625–632.

Askew, Pamela. 'Caravaggio: Outward Action, Inward Vision'. In *Michelangelo Merisi Da Caravaggio: La Vita E Le Opere Attraverso I Documenti*. Ed. Stefania Macioce. Rome: Logart Press, 1996. 248–269.

Bachelard, Gaston. *The Poetics of Space: The Classic Look at How We Experience Intimate Places*. 1958. Trans. Maria Jolas. Boston, MA: Beacon Press, 1994.

Baecque, Antoine de. *Camera Historica: The Century in Cinema*. Trans. Ninon Vinsonneau and Jonathan Magidoff. Columbia, NY: Columbia University Press, 2012.

Bailey, Andy. 'I'll Be Your Mirror'. *Filmmaker: The Magazine of Independent Film*, Spring 2004. <http://www.filmmakermagazine.com/spring2004/features/be_mirror.php> (accessed 11 April 2006).

Bal, Mieke. *Reading 'Rembrandt': Beyond the Word–Image Opposition*. Cambridge: Cambridge University Press, 1991.

——. 'Semiotic Elements in Academic Practices'. *Critical Inquiry* 22.3 (1996): 573–589.

——. *Quoting Caravaggio: Contemporary Art, Preposterous History*. Chicago: University of Chicago Press, 1999.

Baltrušaitis, Jurgis. *Anamorphic Art*. Trans. W.J. Strachan. Cambridge: Chadwyck-Healey, 1977.

Baridon, Michel. 'The Scientific Imagination and the Baroque Garden'. *Studies in the History of Gardens & Designed Landscapes* 18.1 (1998): 5–19.

Barilli, Renato. *Rhetoric*. Trans. Giuliana Menozzi. Minneapolis, MN: University of Minnesota Press, 1989.

Barker, Jennifer M. 'The Tactile Eye'. PhD. UCLA, Los Angeles, 2004.

——. *The Tactile Eye: Touch and the Cinematic Experience*. Berkeley, CA: University of California Press, 2009.

Baron-Cohen, Simon, and John E. Harrison, Eds. *Synaesthesia: Classic and Contemporary Readings*. Cambridge: Blackwell, 1997.

Barthes, Roland. 'Tacitus and the Funerary Baroque'. Trans. Richard Howard. In Roland Barthes, *Critical Essays*. Evanston, IL: Northwestern University Press, 1972. 99–102.

——. 'The Spirit of the Letter'. Trans. Richard Howard. In Roland Barthes, *The Responsibility of Forms: Critical Essays on Music, Art, and Representation*. New York: Hill and Wang, 1985. 98–102.

——. 'The Third Meaning: Research Notes on Several Eisenstein Stills'. Trans. Richard Howard. In Roland Barthes, *The Responsibility of Forms: Critical Essays on Music, Art, and Representation*. New York: Hill and Wang, 1985. 41–62.

——. 'Arcimboldo, or Magician and Rhetoriqueur'. Trans. Richard Howard. In Roland Barthes, *The Responsibility of Forms: Critical Essays on Music, Art, and Representation*. New York: Hill and Wang, 1985. 129–148.

——. *Sade, Fourier, Loyola*. Trans. Richard Miller. Berkeley, CA: University of California Press, 1989.

——. *A Lover's Discourse: Fragments*. Trans. Richard Howard. London: Penguin Books, 1990.

——. *Camera Lucida: Reflections on Photography*. Trans. Richard Howard. London: Vintage Classics, 2000.

——. 'The Face of Garbo'. In *Stardom and Celebrity: A Reader*. Eds. Sean Redmond and Su Holmes. Los Angeles: Sage, 2006. 261–262.

Baudry, Jean-Louis. 'The Apparatus: Metapsychological Approaches to the Impression of Reality in Cinema'. In *Narrative, Apparatus, Ideology: A Film Theory Reader*. Eds. Jean Andrews and Bertrand August. New York: Columbia University Press, 1986, 299–318.

Bean, Jennifer M. 'Technologies of Early Stardom and the Extraordinary Body'. *Camera Obscura* 48, 16:3 (2001): 9-57.

Benjamin, Walter. 'Unpacking My Library: A Talk About Book Collecting'. Trans. Harry Zohn. In *Illuminations* Ed. Hannah Arendt. New York: Harcourt, Brace & World, 1968. 59–67.

——. 'The Work of Art in the Age of Mechanical Reproduction'. Trans. Harry Zohn. In *Illuminations*. Ed. Hannah Arendt. New York: Harcourt, Brace & World, 1968. 219–253.

——. 'On the Mimetic Faculty'. Trans. Edmund Jephcott. In Walter Benjamin, *Reflections: Essays, Aphorisms, Autobiographical Writings*. New York: HBJ, 1978. 333–336.

——. 'One-Way Street (Selection)'. Trans. Edmund Jephcott. In Walter Benjamin, *Reflections: Essays, Aphorisms, Autobiographical Writings*. New York: HBJ, 1978. 61–94.

——. *The Origin of German Tragic Drama*. Trans. John Osborne. London: Verso, 1998.

Benjamin, Walter, and Knut Tarnowski. 'The Doctrine of the Similar (1933)'. *New German Critique* 17 (Spring 1979): 65–69.

Benthien, Claudia. *Skin: On the Cultural Border between Self and the World*. Trans. Thomas Dunlap. New York: Columbia University Press, 2002.

Bergson, Henri. 'Laughter: An Essay on the Meaning of the Comic'. ArcaMax Publishing, 2006. <http://www.arcamax.com/philosophy/b-1454-1-bprint - http://www.arcamax.com/philosophy/b-1454-6-bprint> (accessed 10 December 2006).

Beugnet, Martine. *Cinema and Sensation: French Film and the Art of Transgression*. Edinburgh: Edinburgh University Press, 2007.

Beverley, John. 'Going Baroque?' *Boundary 2* 15.3 (1998): 27–39.

Bolter, Jay David, and Richard Grusin. *Remediation: Understanding New Media*. Cambridge, MA: MIT Press, 1999.

Bonitzer, Pascal. 'Partial Vision: Film and the Labyrinth'. *Wide Angle* 4.4 (1981): 56–64.

Bora, Renu. 'Outing Texture'. In *Novel Gazing: Queer Readings in Fiction*. Ed. Eve Kosofsky Sedgwick. Durham, NC: Duke University Press, 1997. 94–127.

Bornhoefen, Patricia Lynn. 'Cosmography and Chaography: Baroque to Neobaroque: A Study in Poetics and Cultural Logic'. PhD. University of Wisconsin-Madison, Madison, WI, 1995.

Boucher, Bruce. *Italian Baroque Sculpture*. New York: Thames and Hudson, 1998.

Braider, Christopher. *Baroque Self-Invention and Historical Truth: Hercules at the Crossroads*. Aldershot: Ashgate Publishing, 2004.

Braudy, Leo. *The World in a Frame: What We See in Film*. New York: Anchor and Doubleday, 1977.

Bredekamp, Horst. *The Lure of Antiquity and the Cult of the Machine: The Kunstkammer and the Evolution of Nature, Art and Technology*. Trans. Allison Brown. Princeton, NJ: Markus Wiener Publishers, 1995.

Brenez, Nicole. 'Incomparable Bodies'. Trans. Adrian Martin. *Screening the Past* 31 (2011) <http://www.screeningthepast.com/2011/08/incomparable-bodies/> (accessed 15 September 2011).

Brinkema, Eugenie. *The Forms of the Affects*. Durham, NC: Duke University Press, 2014.

Brooks, Peter. *Body Work: Objects of Desire in Modern Narrative*. Cambridge, MA: Harvard University Press, 1993.

Brown, Jonathan. *Images and Ideas in Seventeenth-Century Painting*. Princeton, NJ: Princeton University Press, 1978.

——. *Velázquez: Painter and Courtier*. New Haven, CT: Yale University Press, 1986.

Brown, Marshall. 'The Classic is the Baroque: On the Principle of Wölfflin's Art History'. *Critical Inquiry* 9 (December 1982): 379–404.

Bruno, Giuliana. *Surface: Matters of Aesthetics, Materiality, and Media*. Chicago: University of Chicago Press, 2014.

Bruzzi, Stella. *Undressing Cinema: Clothing and Identity in the Movies*. London: Routledge, 1997.

——. 'Tempestuous Petticoats: Costume and Desire in *The Piano*'. *Screen* 36.3 (Autumn 1995): 257–266.

Buci-Glucksmann, Christine. *La folie du voir: De l'esthetique Baroque*. Paris: Editions Galilee, 1986.

——. *Baroque Reason: The Aesthetics of Modernity*. Trans. Bryan S. Turner. London: Sage, 1994.

——. 'The Baroque Eye of the Camera (Part 1)'. In *Raúl Ruiz: Images of Passage*. Eds. Helen Bandis, Adrian Martin and Grant McDonald. Melbourne: Rouge Press and Rotterdam International Film Festival, 2004. 31–44.

Burch, Noël. *Life to those Shadows*. Trans. Ben Brewster. London: BFI Publishing, 1990.

Butler, Judith. *Bodies That Matter: On the Discursive Limits of Sex*. New York: Routledge, 1993.

——. 'Merleau-Ponty and the Touch of Malebranche'. In *The Cambridge Companion to Merleau-Ponty*. Eds. Taylor Carman and Mark B.N. Hansen. Cambridge: Cambridge University Press, 2005. 181–205.

Caillois, Roger. 'Mimicry and Legenday Psychasthenia' (1936). Trans. John Shepley. *October* 31 (1984): 12-32.

Calabrese, Omar. *Neo-Baroque: A Sign of the Times*. Trans. Charles Lambert. Princeton, NJ: Princeton University Press, 1992.

Callahan, Dan. 'Buster Keaton'. *Senses of Cinema*, 2002. <http://www.sensesofcinema.com/contents/directors/02/keaton.html> (accessed 26 February 2006).

Calloway, Stephen. *Baroque Baroque: Culture of Excess*. London: Phaidon, 1994.

Carbone, Mauro. 'The Thinking of the Sensible'. In *Chiasms: Merleau-Ponty's Notion of Flesh*. Eds. Fred Evans and Leonard Lawlor. Albany, NY: State University of New York Press, 2000. 121–130.

——. *The Flesh of Images: Merleau-Ponty Between Painting and Cinema*. Trans. Marta Nijhuis. Albany, NY: State University of New York Press, 2015.

Careri, Giovanni. *Bernini: Flights of Love, the Art of Devotion*. Chicago: University of Chicago Press, 1995.

Carroll, Noël. 'Keaton: Film Acting as Action'. In *Making Visible the Invisible: An Anthology of Original Essays on Film Acting*. Ed. Carole Zucker. Metuchen, NJ: Scarecrow Press, 1990. 198–223.

——. 'Notes on the Sight Gag'. In *Comedy/Cinema/Theory*. Ed. Andrew Horton. Berkeley, CA: University of California Press, 1991. 25–42.

—— . 'Film, Emotion, and Genre'. In *Passionate Views: Film, Cognition and Emotion*. Eds. Carl Plantinga and Greg M. Smith. Baltimore, MD: Johns Hopkins University Press, 1999. 21–47.

Cataldi, Sue. *Emotion, Depth and Flesh: A Study of Sensitive Space*. Albany, NY: State University of New York Press, 1993.

Caws, Mary Ann. *The Surrealist Look: An Erotics of Encounter*. Cambridge, MA: MIT Press, 1999.

Certeau, Michel de. 'The Madness of Vision'. *Enclitic* 8.1 (1983): 24–31.

Chamarette, Jenny. *Phenomenology and the Future of Film: Rethinking Subjectivity beyond French Cinema*. London: Palgrave Macmillan, 2012.

Charney, Leo. 'Historical Excess: *Johnny Guitar*'s Containment'. *Cinema Journal* 29.4 (1990): 23–34.

Classen, Constance. *Worlds of Sense: Exploring the Senses in History and Across Cultures*. New York: Routledge, 1993.

—— . *The Color of Angels: Cosmology, Gender and the Aesthetic Imagination*. London: Routledge, 1998.

Conley, Tom. 'Translator's Foreword: A Plea for Leibniz'. In Gilles Deleuze, *The Fold: Leibniz and the Baroque*. Minneapolis, MN: University of Minnesota Press, 1993. ix–xx.

—— . 'Folds and Folding'. In *Gilles Deleuze: Key Concepts*. Ed. Charles Stivale. Trowbridge, UK: Acumen, 2011. 170-181.

Connor, Steven. 'Michel Serres' Five Senses'. In *Empire of the Senses: The Sensual Culture Reader*. Ed. David Howes. Oxford: Berg, 2005. 318–334.

Cook, Pam. 'Portrait of a Lady'. *Sight & Sound* 11 (November 2006): 36–40.

Crafton, Donald. 'Pie and Chase: Gag, Spectacle and Narrative in Slapstick Comedy'. In *Classical Hollywood Comedy*. Eds. Kristine Brunovska Karnick and Henry Jenkins. New York: Routledge, 1995. 106–119.

Crary, Jonathan. *Techniques of the Observer: On Vision and Modernity in the Nineteenth Century*. Cambridge, MA: MIT Press, 1994.

Creed, Barbara. *The Monstrous-Feminine: Film, Feminism, Psychoanalysis*. London: Routledge, 1993.

Cubitt, Sean. *Digital Aesthetics*. London: Sage, 1998.

—— . *The Cinema Effect*. Cambridge, MA: MIT Press, 2005.

Cytowic, Richard E. 'Synaesthesia: Phenomenology and Neuropsychology'. *PSYCHE* 2 (1995). <http://psyche.csse.monash.edu.au/v2/psyche-2-10-cytowic.html> (accessed 4 March 2008).

—— . *The Man Who Tasted Shapes*. Cambridge, MA: MIT Press, 1998.

Dastur, Françoise. 'World, Flesh, Vision'. In *Chiasms: Merleau-Ponty's Notion of Flesh*. Eds. Fred Evans and Leonard Lawlor. Albany, NY: State University of New York Press, 2000. 23–49.

Davies, Paul. 'The Face and the Caress: Levinas's Ethical Alterations of Sensibility'. In *Modernity and the Hegemony of Vision*. Ed. David Michael Levin. Berkeley, CA: University of California Press, 1993. 252–272.

Degli-Esposti, Cristina. 'Sally Potter's *Orlando* and the Neo-Baroque Scopic Regime'. *Cinema Journal* 36.1 (1996): 75–93.

Deleuze, Gilles. 'On Leibniz'. Trans. Martin Joughin. In Gilles Deleuze, *Negotiations 1972–1990*. New York: Columbia University Press, 1990. 156–163.

—— . 'Ethology: Spinoza and Us'. In *Incorporations*. Eds. Jonathan Crary and Sanford Kwinter. New York: Zone, 1992. 625–633.

—— . *The Fold: Leibniz and the Baroque*. Trans. Tom Conley. Minneapolis, MN: University of Minnesota Press, 1993.

———. 'The Simulacrum and Ancient Philosophy'. Trans. Mark Lester & Charles Stivale. In Gilles Deleuze, *The Logic of Sense*. Ed. Constantin V. Boundas. London: Continuum, 2004. 291–320.

———. *Cinema 1: The Movement-Image*. Trans. Hugh Tomlinson and Barbara Habberjam. London: Continuum, 2005.

———. *Cinema 2: The Time-Image*. Trans. Hugh Tomlinson and Robert Galeta. London: Continuum, 2005.

Deleuze, Gilles, and Félix Guattari, *A Thousand Plateaus: Capitalism and Schizophrenia*. Trans. Brian Massumi. Minneapolis, MN: University of Minnesota Press, 1987.

Dempsey, Charles. '*Et Nos Cedamus Amori*: Observations on the Farnese Gallery'. *Art Bulletin* 50 (1963): 363–374.

Derrida, Jacques. 'The Law of Genre'. In *Acts of Literature*. Ed. Derek Attridge. London: Routledge, 1992. 221–252.

———. *On Touching—Jean-Luc Nancy*. Trans. Christine Irizarry. Stanford, CA: Stanford University Press, 2005.

Diamond, Diana. 'Sofia Coppola's *Marie Antoinette*: Costumes, Girl Power and Feminism'. In *Fashion in Film*. Ed. Adrienne Munich. Bloomington, IN: Indiana University Press, 2011. 203–232.

Dillon, M.C. 'Merleau-Ponty and the Reversibility Thesis'. *Man and World* 16 (1983): 365–388.

———. '*Écart*: Reply to Claude Lefort's "Flesh and Otherness"'. In *Ontology and Alterity in Merleau-Ponty*. Eds. Galen A. Johnson and Michael B. Smith. Evanston, IL: Northwestern University Press, 1990. 14–26.

———. 'Preface: Merleau-Ponty and Postmodernity'. In *Merleau-Ponty Vivant*. Ed. M.C. Dillon. Albany, NY: State University of New York, 1991. ix–xxxv.

———. *Merleau-Ponty's Ontology*. Evanston, IL: Northwestern University Press, 1997.

———. *Beyond Romance*. New York: State University of New York Press, 2001.

Donato, Eugenio. 'Tesauro's Poetics: Through the Looking Glass'. *Modern Language Notes* 1 (1978): 15–30.

———. 'Tesauro's *Cannocchiale Aristotelico*'. *Stanford Italian Review* 5 (1985): 101–114.

Dorment, Richard. 'A Feast of Bourbon Excesses'. *The Age* 5 April 2008, sec. A2: 16.

Dufrenne, Mikel. *The Phenomenology of the Aesthetic Experience*. Trans. Edward S. Casey, et al. Evanston, IL: Northwestern University Press, 1973.

———. *In the Presence of the Sensuous: Essays in Aesthetics*. Trans. Mark S. Roberts and Dennis Gallagher. Atlantic Highlands, NJ: Humanities Press International, 1987.

Eagleton, Terry. *The Ideology of the Aesthetic*. Oxford: Blackwell Publishing, 1990.

Eco, Umberto. 'The Poetics of the Open Work'. In Umberto Eco, *The Role of the Reader: Explorations in the Semiotics of Texts*. Bloomington, IN: Indiana University Press, 1979. 47–66.

Edie, James M. 'Was Merleau-Ponty a Structuralist?' *Semiotica* 4 (1971): 297–323.

Eisenstein, Sergei. 'The Filmic Fourth Dimension'. Trans. Jay Leyda. In *Film Form: Essays in Film Theory*. Ed. Jay Leyda. New York: HBJ, 1949. 64–71.

Evans, Fred, and Leonard Lawlor. 'Introduction: The Value of Flesh: Merleau-Ponty's Philosophy and the Modernism/Postmodernism Debate'. In *Chiasms: Merleau-Ponty's Notion of Flesh*. Eds. Fred Evans and Leonard Lawlor. Albany, NY: State University of New York Press, 2000. 1–20.

Findlen, Paula. *Possessing Nature: Museums, Collecting, and Scientific Culture in Early Modern Italy*. Berkeley, CA: University of California Press, 1994.

Fisher, Jennifer. 'Relational Sense: Towards a Haptic Aesthetic'. *Parachute* 87 (Summer 1997): 4–11. <http://alcor.concordia.ca/~senses/Fisher.htm> (accessed 11 November 2005).

Fleming, William. 'The Element of Motion in Baroque Art and Music'. *Journal of Aesthetic and Art Criticism* 5.2 (1946): 121–128.

Focillon, Henri. *The Life of Forms in Art.* 1934. Trans. George Kubler. London: Zone Books, 1992.

Fontanelle, Bernard le Bovier de. *A Plurality of Worlds.* 1688. Trans. John Glanvill. London: Nonesuch Press, 1929.

Foucault, Michel. *The Order of Things: An Archaeology of the Human Sciences.* London: Tavistock Publications, 1970.

Freeman-Greene, Suzy. 'Scratching the Surface'. *The Age* 2 August 2008, sec. A2: 14–15.

Frey, Mattias. 'Michael Haneke'. *Senses of Cinema* (2003). <http://www.sensesofcinema.com/contents/directors/03/haneke.html> (accessed 3 June 2008).

Fried, Michael. *Absorption and Theatricality: Painting and Beholder in the Age of Diderot.* Berkeley, CA: University of California Press, 1980.

——. *Courbet's Realism.* Chicago: University of Chicago Press, 1990.

Friedberg, Anne. *The Virtual Window: From Alberti to Microsoft.* Cambridge, MA: MIT Press, 2006.

Gabilondo, Joseba. 'Like Blood for Chocolate, Like Queers for Vampires: Border and Global Consumption in Rodríguez, Tarantino, Arau, Esquivel, and Troyano (Notes on Baroque, Camp, Kitsch and Hybridization)'. In *Queer Globalizations: Citizenship and the Afterlife of Colonialism.* Eds. Arnaldo Cruz-Malave and Martin F. Manlansan IV. New York: New York University Press, 2002. 236–263.

Gilman, Ernest B. *The Curious Perspective: Literary and Pictorial Wit in the Seventeenth Century.* New Haven, CT: Yale University Press, 1978.

Goddard, Michael. 'Towards a Perverse Neo-Baroque Cinematic Aesthetic: Raúl Ruiz's *Poetics of Cinema*'. *Senses of Cinema* (2004). <http://www.sensesofcinema.com/contents/04/30/raul_ruiz_poetics_of_cinema.html> (accessed 5 April 2004).

Gombrich, E.H. *Norm and Form.* London: Phaidon, 1978.

Grindon, Leger. 'The Role of Spectacle and Excess in the Critique of Illusion'. *Post Script: Essays in Film and the Humanities* 13.2 (1994): 35–43.

Grosz, Elizabeth. 'Merleau-Ponty and Irigaray in the Flesh'. *Thesis Eleven* 36 (1993): 37–59.

——. *Volatile Bodies: Toward a Corporeal Feminism.* St Leonards, NSW: Allen & Unwin, 1994.

Gunning, Tom. 'An Unseen Energy Swallows Space: The Space in Early Film and Its Relation to American Avant-Garde Film'. In *Film before Griffith.* Ed. John Fell. Berkeley, CA: University of California Press, 1983. 355-366.

——. 'An Aesthetic of Astonishment: Early Film and the (In)Credulous Spectator'. In *Viewing Positions: Ways of Seeing Film.* Ed. Linda Williams. New Brunswick, NJ: Rutgers University Press, 1995. 114–133.

Hagerman-Young, Anita M., and Kerry Wilks. 'The Theatre of the World: Staging Baroque Hierarchies'. In *The Theatrical Baroque: European Plays, Painting and Poetry, 1575–1725.* Ed. Larry F. Norman. Chicago: Smart Museum of Art and University of Chicago, 2001. 36-45.

Hampton, Timothy. 'Introduction: Baroques'. *Yale French Studies* 80 (1991): 1–9.

Hansen, Miriam. '"With Skin and Hair": Kracauer's Theory of Film, Marseille 1940'. *Critical Inquiry* 19.3 (1993): 437–469.

——. 'Benjamin and Cinema: Not a One-Way Street'. *Critical Inquiry* 25 (Winter 1999): 306–343.

——. 'The Mass Production of the Senses: Classical Cinema as Vernacular Modernism'. *Modernism/Modernity* 6.2 (1999): 59–77.

Harvey, Samuel. 'The Return of the Rococo: the Films of Sofia Coppola'. PhD. University of Melbourne, Melbourne, forthcoming.

Hatherly, Ana. 'Reading Paths in Spanish and Portuguese Baroque Labyrinths'. *Visible Language* 20.1 (1986): 52–64.

Hoffman, Paul. *Essays on Descartes*. New York: Oxford University Press, 2009.

Hollinger, Karen. 'The Monster as Woman: Two Generations of *Cat People*'. *Film Criticism* 13.2 (1989): 36–46.

Horton, Andrew. 'Introduction: "Think Slow, Act Fast" – Keaton's Comic Genius'. In *Buster Keaton's Sherlock Jr.* Ed. Andrew Horton. Cambridge: Cambridge University Press, 1997. 1–28.

Howes, David. *Sensual Relations: Engaging the Senses in Culture and Theory*. Ann Arbor, MI: University of Michigan Press, 2003.

——, ed. *Empire of the Senses: The Sensual Culture Reader*. Oxford: Berg, 2005.

Huddleston, Robert S. 'Baroque Space and the Art of the Infinite'. In *The Theatrical Baroque: European Plays, Painting and Poetry, 1575–1725*. Ed. Larry F. Norman. Chicago: Smart Museum of Art and University of Chicago, 2001. 13–19.

Huston, Johnny Ray. 'I, Movie'. *San Francisco Bay Guardian Online*, 2006. <http://www.sfbg.com/39/02/cover_tarnation.html> (accessed 11 September 2006).

Ihde, Don. *Sense and Significance*. Pittsburgh, PA: Duquesne University Press, 1973.

——. *Bodies in Technology*. Minneapolis, MN: University of Minnesota Press, 2002.

Ionescu, Vlad. 'Deleuze's Tensive Notion of Painting in Light of Riegl, Wölfflin and Worringer'. *Deleuze Studies* 5.1 (2011): 52–62.

Jauss, Hans Robert. *Toward an Aesthetic of Reception*. Trans. Timothy Bahti. Minneapolis, MN: University of Minnesota Press, 1982.

Jay, Martin. 'The Rise of Hermeneutics and the Crisis of Ocularcentrism'. *Poetics Today* 9.2 (1988): 307–326.

——. *Downcast Eyes: The Denigration of Vision in Twentieth-Century French Thought*. Berkeley, CA: University of California Press, 1994.

Jayamanne, Laleen. *Toward Cinema and Its Double: Cross-Cultural Mimesis*. Bloomington, IN: Indiana University Press, 2001.

Jenkins, Henry. *What Made Pistachio Nuts? Early Sound Comedy and the Vaudeville Aesthetic*. New York: Columbia University Press, 1992.

——. '"This Fellow Keaton Seems to Be the Whole Show": Buster Keaton, Interrupted Performance, and the Vaudeville Aesthetic'. In *Buster Keaton's Sherlock Jr.* Ed. Andrew Horton. Cambridge: Cambridge University Press, 1997. 29–66.

——. 'Quentin Tarantino's *Star Wars*? Digital Cinema, Media Convergence, and Participatory Culture'. In *Rethinking Media Change: The Aesthetics of Transition*. Eds. David Thorburn and Henry Jenkins. Cambridge, MA: MIT Press, 2004. 281–312.

Johnson, Galen A. 'Introduction: Alterity as a Reversibility'. In *Ontology and Alterity in Merleau-Ponty*. Eds. Galen A. Johnson and Michael B. Smith. Evanston, IL: Northwestern University Press, 1990. xvii–xxxiv.

Johnson, Galen A., and Michael B. Smith, eds. *Ontology and Alterity in Merleau-Ponty*. Evanston, IL: Northwestern University Press, 1990.

Johnson, Mark. *The Body in the Mind: The Bodily Basis of Meaning, Imagination, and Reason*. Chicago: University of Chicago Press, 1987.

Jütte, Robert. *A History of the Senses: From Antiquity to Cyberspace*. Trans. James Lynn. Cambridge: Polity Press, 2005.

Kaup, Monika. 'Becoming-Baroque: Folding European Forms into the New World Baroque with Alejo Carpentier'. *CR: The New Centennial Review* 5.2 (2005): 107–149.

Kemp, Martin. *The Science of Art: Optical Themes in Western Art from Brunelleschi to Seurat*. New Haven, CT: Yale University Press, 1990.

Kennedy, Barbara M. *Deleuze and Cinema: The Aesthetics of Sensation*. Edinburgh: Edinburgh University Press, 2000.

Kitson, Michael. *The Age of Baroque*. London: Hamlyn, 1966.

Klein, Norman M. *Seven Minutes: The Life and Death of the American Animated Cartoon*. London: Verso, 1993.

——. *The Vatican to Vegas: A History of Special Effects*. New York: The New Press, 2004.

Kracauer, Siegfried. *Theory of Film: The Redemption of Physical Reality*. London: Oxford University Press, 1960.

Kramer, Peter. 'The Making of a Comic Star: Buster Keaton and *The Saphead*'. In *Classical Hollywood Comedy*. Eds. Kristine Brunovska Karnick and Henry Jenkins. New York: Routledge, 1995. 190–210.

Lacan, Jacques. *On Feminine Sexuality: The Limits of Love and Knowledge*. Trans. Bruce Fink. Ed. Jacques Alain-Miller. Vol. XX. New York: W.W. Norton & Company, 1998.

Laine, Tarja. 'Cinema as Second Skin: Under the Membrane of Horror Film'. *New Review of Film and Television Studies* 4.2 (2006): 93–106.

Lambert, Gregg. *The Return of the Baroque in Modern Culture*. London: Continuum, 2004.

Lant, Antonia. 'The Curse of the Pharaoh, or How Cinema Contracted Egyptomania'. *October* 59 (1991): 87–112.

——. 'Haptical Cinema'. *October* 74 Fall (1995): 45–73.

Lauertis, Teresa de. *Alice Doesn't: Feminism, Semiotics, Cinema*. Bloomington, IN: Indiana University Press, 1984.

——. *Technologies of Gender: Essays on Theory, Film, and Fiction*. Bloomington, IN: Indiana University Press, 1987.

Lavin, Irving. *Bernini and the Unity of the Visual Arts*. New York: Oxford University Press, 1980.

Lawlor, Leonard. 'The End of Phenomenology: Expressionism in Deleuze and Merleau-Ponty'. *Continental Philosophy Review* 31 (1998): 15–34.

Leder, Drew. *The Absent Body*. Chicago: University of Chicago Press, 1990.

Lee, Rensselaer W. *Ut Pictoria Poesis: The Humanistic Theory of Painting*. New York: W.W. Norton, 1967.

Lefort, Claude. 'Flesh and Otherness'. In *Ontology and Alterity in Merleau-Ponty*. Eds. Galen A. Johnson and Michael B. Smith. Evanston, IL: Northwestern University Press, 1990. 3–13.

Leibniz, G.W. *The Monadology and Other Philosophical Writings*. Trans. Robert Latta. Oxford: Clarendon Press, 1898.

Levin, David Michael. 'Visions of Narcissism: Intersubjectivity and the Reversals of Reflection'. In *Merleau-Ponty Vivant*. Ed. M.C. Dillon. Albany, NY: State University of New York, 1991. 47–90.

Lingis, Alphonso. 'Translator's Preface'. In Maurice Merleau-Ponty, *The Visible and the Invisible*. Evanston, IL: Northwestern University Press, 1968. xl–lvi.

——. 'Sense and Non-Sense in the Sexed Body'. *Cultural Hermeneutics* 4 (1977): 345–365.

——. 'Sensations'. *Philosophy and Phenomenological Research* 42.2 (1981): 160–170.

——. 'Bodies That Touch Us'. *Thesis Eleven* 36 (1993): 159–167.

Loh, Maria H. 'New and Improved: Repetition as Originality in Italian Baroque Practice and Theory'. *The Art Bulletin*, 2004. <http://www.findarticles.com/p/articles/mi_m0422/is_3_86_ai_n8680826/print> (accessed 11 April 2004).

Maiorino, Giancarlo. *The Cornucopian Mind and the Baroque Unity of the Arts*. University Park, PA: Pennsylvania State University Press, 1990.

Man, Paul de. 'Introduction'. In *Towards an Aesthetic of Reception*. Ed. Hans Robert Jauss. Minneapolis, MN: University of Minnesota Press, 1982. vii–xxv.

——. 'The Epistemology of Metaphor'. In *Aesthetic Ideology*. Ed. Andrzej Warminski. Minneapolis, MN: University of Minnesota Press, 1996. 34-50.

Manovich, Lev. *The Language of New Media*. Cambridge, MA: MIT Press, 2001.

Marandel, J. Patrice. *François De Nomé: Mysteries of a Seventeenth-Century Neopolitan Painter*. Houston, TX: University of Texas Press, 1991.

Maravall, José Antonio. *Culture of the Baroque: Analysis of a Historical Structure*. Trans. Terry Cochran. Minneapolis, MN: University of Minnesota Press, 1986.

——. 'From the Renaissance to the Baroque: the Diphasic Schema of a Social Crisis'. Trans. Terry Cochran. In *Literature among Discourses: The Spanish Golden Age*. Eds. Wlad Godzich and Nicholas Spadaccini. Minneapolis, MN: University of Minnesota Press, 1986. 3–40.

Marguiles, Ivone, ed. *Rites of Realism: Essays on Corporeal Cinema*. Durham, NC: Duke University Press, 2003.

Marin, Louis. 'Classical, Baroque: Versailles, or the Architecture of the Prince'. *Yale French Studies* 80 (1991): 167–182.

Marks, Lawrence E. *The Unity of the Senses: Interrelations among the Modalities*. New York: Academic Press, 1978.

Marks, Laura U. *The Skin of the Film: Intercultural Cinema, Embodiment, and the Senses*. Durham, NC: Duke University Press, 2000.

——. *Touch: Sensuous Theory and Multisensory Media*. Minneapolis, MN: University of Minnesota Press, 2002.

——. *Enfoldment and Infinity: An Islamic Genealogy of New Media Art*. Cambridge, MA: MIT Press, 2010.

Martin, Adrian. 'Ticket to Ride: Claire Denis and the Cinema of the Body'. *Screening the Past* 20 (2006). <http://www.latrobe.edu.au/screeningthepast/20/claire-denis.html> (accessed 13 December 2006).

——. *Last Day Every Day: Figural Thinking from Auerbach and Kracauer to Agamben and Brenez*. Brooklyn, NY: Punctum, 2012.

Martin, John Rupert. *Baroque*. London: A. Lane, 1977.

Massumi, Brian. 'The Autonomy of Affect'. *Cultural Critique* 31 (1995): 83–109.

Mayne, Judith. *Claire Denis*. Urbana, IL: University of Illinois Press, 2005.

Mazzeo, Joseph Anthony. 'Metaphysical Poetry and the Metaphysics of Correspondence'. *Journal of the History of Ideas* 14.2 (1953): 221–234.

McCleary, Richard C. 'Translator's Preface'. In Maurice Merleau-Ponty, *Signs*. Evanston, IL: Northwestern University Press, 1964. ix–xxxii.

Mecchia, Giuseppina. 'The Children Are Still Watching Us, *Cache/Hidden* in the Folds of Time'. *Studies in French Cinema* 7.2 (2007): 131–141.

Merleau-Ponty, Maurice. 'The Primacy of Perception and Its Philosophical Consequences'. Trans. James M. Edie. In Maurice Merleau-Ponty, *The Primacy of Perception: And Other Essays on Phenomenological Psychology, the Philosophy of Art, History and Politics*. Ed. James M. Edie. Evanston, IL: Northwestern University Press, 1964. 12–42.

——. 'The Film and the New Psychology'. Trans. Hubert L. Dreyfus and Patricia Allen Dreyfus. In Maurice Merleau-Ponty, *Sense and Non-Sense*. Ed. James M. Edie. Evanston, IL: Northwestern University Press, 1964. 48–59.

——— . 'Cézanne's Doubt'. Trans. Hubert L. Dreyfus and Patricia Allen Dreyfus. In Maurice Merleau-Ponty, *Sense and Non-Sense*. Ed. James M. Edie. Evanston, IL: Northwestern University Press, 1964. 9–25.

——— . 'The Philosopher and His Shadow'. Trans. Richard C. McCleary. In Maurice Merleau-Ponty, *Signs*. 1960. Evanston, IL: Northwestern University Press, 1964. 159–181.

——— . 'The Child's Relations with Others'. Trans. William Cobb. In Maurice Merleau-Ponty, *The Primacy of Perception*. 1960. Evanston, IL: Northwestern University Press, 1964. 96–155.

——— . 'Indirect Language and the Voices of Silence'. Trans. Richard C. McCleary. In Maurice Merleau-Ponty, *Signs*. 1960. Evanston, IL: Northwestern University Press, 1964. 39–83.

——— . 'On the Phenomenology of Language'. Trans. Richard C. McCleary. In Maurice Merleau-Ponty, *Signs*. 1960. Evanston, IL: Northwestern University Press, 1964. 84–97.

——— . *The Visible and the Invisible*. Trans. Alphonso Lingis. Ed. Claude Lefort. Evanston, IL: Northwestern University Press, 1968.

——— . *Phenomenology of Perception*. Trans. Colin Smith. London: Routledge Classics, 2002.

——— . *The World of Perception*. Trans. Oliver Davis. London: Routledge, 2004.

——— . 'Eye and Mind'. Trans. Carleton Dallery. In *Maurice Merleau-Ponty: Basic Writings*. 1964. Ed. Thomas Baldwin. London: Routledge, 2004. 290–324.

——— . 'The Sensible World and the World of Expression'. Trans. B. Bannon. *Chiasmi International*, 12 (2010): 31–37.

Merriam-Webster Dictionary <http://www.merriam-webster.com/> (accessed 20 October 2015).

Met, Philippe. 'Looking for Trouble: The Dialectics of Lack and Excess in Claire Denis' *Trouble Every Day* (2001)'. *Kinoeye* 3 (2003) <http://www.kinoeye.org/03/07met07.php> (accessed 3 June 2008).

Metz, Christian. *Film Language: A Semiotics of the Cinema*. New York: Oxford University Press, 1974.

——— . *Language and Cinema*. The Hague: Mouton & Co, 1974.

Meyer, Richard. 'Introduction: The Problem of the Passions'. In *Representing the Passions: Histories, Bodies, Visions*. Ed. Richard Meyer. Los Angeles: Getty Publications, 2003. 1–11.

Michelson, Annette. 'Bodies in Space: Film as "Carnal Knowledge"'. *Artforum* 7.6 (1969): 52–61.

Miller, William Ian. *The Anatomy of Disgust*. Cambridge, MA: Harvard University Press, 1997.

Montagu, Ashley. *Touching: The Human Significance of the Skin*. New York: Columbia University Press, 1971.

Morrey, Douglas. 'Textures of Terror: Claire Denis' *Trouble Every Day*'. *Belphegor* 3.2 (2004). <http://etc.dal.ca/belphegor/vol3_no2/articles/03_02_Morrey_textur_en_cont.html> (accessed 3 June 2008).

——— . 'Open Wounds: Body and Image in Jean-Luc Nancy and Claire Denis'. *Film-Philosophy* 12.1 (2008): 10–30. <http://www.film-philosophy.com/2008v12n1/morrey2.pdf> (accessed 3 June 2008).

——— . 'Introduction: Claire Denis and Jean-Luc Nancy'. *Studies in French Cinema* 12.1 (2008): i–vi.

Mulvey, Laura. 'Visual Pleasure and Narrative Cinema'. *Screen* 16 (1975): 6–18.

Murray, Timothy. 'Philosophical Antibodies: Grotesque Fantasy in a French Stoic Fiction'. *Yale French Studies* 86 (1994): 143–163.

——— . 'Digital Baroque: Via Viola or the Passage of Theatricality'. *Substance* 31.2–3 (2002): 265–279.

——— . *Digital Baroque: New Media Art and Cinematic Folds*. Minneapolis, MN: University of Minnesota Press, 2008.

Nancy, Jean-Luc. 'Icons of Fury: Claire Denis' *Trouble Every Day*'. *Film-Philosophy* 12.1 (2008): 1–9. <http://www.film-philosophy.com/2008v12n1/nancy.pdf> (accessed 3 June 2008).

Ndalianis, Angela. 'Caravaggio Reloaded: Neo-Baroque Poetics'. In *Caravaggio and His World: Darkness and Light*. Ed. Art Gallery of New South Wales. Sydney: Art Gallery of New South Wales, 2003. 72–77.

——. *Neo-Baroque Aesthetics and Contemporary Entertainment*. Cambridge, MA: MIT Press, 2004.

Newman, Kim. *Cat People*. London: BFI Publishing, 1999.

Ngai, Sianne. *Ugly Feelings*. Cambridge, MA: Harvard University Press, 2005.

Nichols, Bill. *Representing Reality: Issues and Concepts in Documentary*. Bloomington, IN: Indiana University Press, 1991.

Norman, Larry F. 'The Theatrical Baroque'. In *The Theatrical Baroque: European Plays, Painting and Poetry, 1575–1725*. Ed. Larry F. Norman. Chicago: Smart Museum of Art and University of Chicago, 2001. 1–11.

O'Malley, John W. *Religious Culture in the Sixteenth Century: Preaching, Rhetoric, Spirituality and Reform*. Aldershot: Variorum, 1993.

Oudart, Jean-Pierre. 'Cinema and Suture'. *Screen* (Winter 1978). <http://www.lacan.com/symptom8.articles/oudart8.html> (accessed 16 April 2008).

Overesch, Lynne Elizabeth. 'The Neo-Baroque: Trends in the Style and Structure of the Contemporary Spanish Novel'. PhD. University of Kentucky, Lexington, KY, 1981.

Palmer, Tim. 'Under Your Skin: Marina de Van and the Contemporary French *cinéma du corps*'. *Studies in French Cinema* 6.3 (2006): 171–181.

Panagia, Davide. 'The Effects of Viewing: Caravaggio, Bacon and *The Ring*'. *Theory and Event* 10:4 (2007).

Panofsky, Erwin. 'What is Baroque?' In Erwin Panofsky, *Three Essays on Style*. Ed. Irving Lavin. Cambridge, MA: MIT Press, 1995. 19–88.

Perez, Gilberto. *The Material Ghost: Films and Their Medium*. Baltimore, MD: Johns Hopkins University Press, 1998.

Perniola, Mario. *Enigmas: The Egyptian Moment in Society and Art*. Trans. Christopher Woodall. London: Verso, 1995.

Peucker, Brigitte. 'Effects of the Real: Michael Haneke's *Benny's Video* (1993)'. *Kinoeye*. 4 (2004). <http://www.kinoeye.org/04/01/peucker01.php> (accessed 3 June 2008).

——. *The Material Image: Art and the Real in Film*. Stanford, CA: Stanford University Press, 2007.

Quinlivan, Davina. *The Place of Breath in Cinema*. Edinburgh: Edinburgh University Press, 2012.

Rabinbach, Anson. 'Introduction to Walter Benjamin's "Doctrine of the Similar"'. *New German Critique* 17 (Spring 1979): 60–64.

Rascaroli, Laura. 'Steel in the Gaze: On POV and the Discourse of Vision in Kathryn Bigelow's Cinema'. *Screen* 8.3 (Autumn 1997): 232–246.

Reeves, Eileen. *Painting the Heavens: Art and Science in the Age of Galileo*. Princeton, NJ: Princeton University Press, 1997.

Reijen, Willem van. 'Labyrinth and Ruin: The Return of the Baroque in Postmodernity'. *Theory, Culture & Society* 9.4 (1992): 1–26.

Rich, B. Ruby. 'Tell It to the Camera'. *Sight & Sound* 15.4 (April 2005): 32–34.

Richir, Marc. 'The Meaning of Phenomenology in *The Visible and the Invisible*'. *Thesis Eleven* 36 (1993): 60–81.

Riegl, Aloïs. *Late Roman Art Industry*, 1901. Trans. Rolf Winkes. Rome: Giorgio Bretschneider Editore, 1985.

Río, Elena del. 'The Body as Foundation of the Screen: Allegories of Technology in Atom Egoyan's *Speaking Parts*'. *Camera Obscura* 37–38 (Summer 1996): 94–115.

———. 'The Body of Voyeurism: Mapping a Discourse of the Senses in Michael Powell's *Peeping Tom*'. *Camera Obscura* 15.3 (2000): 115–149.

———. 'Performing the Narrative of Seduction: Claire Denis' *Beau Travail*'. *Kinoeye* 3.7 (2003). <http://www.kinoeye.org/printer.php?path=03/07/delrio07.php> (accessed 17 January 2007).

———. 'Alchemies of Thought in Godard's Cinema: Deleuze and Merleau-Ponty'. *Substance* 34.3 (2005): 62–78.

———. 'Antonioni's *Blowup*: Freeing the Imaginary from Metaphysical Ground'. *Film-Philosophy* 9.32 (2005). <http://www.film-philosophy.com/vol9-2005/n32delrio> (accessed 10 January 2007).

———. 'Between Brecht and Artaud: Choreographing Affect in Fassbinder's *The Marriage of Maria Braun*'. *New Review of Film and Television Studies* 3.2 (2005): 161–185.

Robertson, Robert. 'Eisenstein, Synaesthesia, Symbolism and the Occult Tradition'. *Offscreen. com*, 2006. <http://www.offscreen.com/biblio/phile/print_img/eisenstein_synaesthesia/> (accessed 17 January 2007).

Rogers, Anna Backman. 'Sofia Coppola'. *Senses of Cinema*, 2007. <http://sensesofcinema. com/2007/great-directors/sofia-coppola> (accessed 14 January 2014).

———. 'The Historical Threshold: Crisis, Ritual and Liminality in Sofia Coppola's *Marie Antoinette* (2006)'. *Relief* 6.1 (2011): 80–97.

Rowland, Ingrid D. 'The Architecture of Love in Baroque Rome'. In *Erotikon: Essays on Eros, Ancient and Modern*. Eds. Shadi Bartsch and Thomas Bartscheaer. Chicago: University of Chicago Press, 2005. 144–160.

Ruoff, Jeffrey, ed. *Virtual Voyages: Cinema and Travel*. Durham, NC: Duke University Press, 2006.

Rutherford, Anne. 'Precarious Boundaries: Affect, *Mise-En-Scène*, and the Senses'. In *Art and the Performance of Memory: Sounds and Gestures of Recollection*. Ed. Richard Candida Smith. London: Routledge, 2002. 63–84.

Sadoff, Dianne F. 'Appeals to Incalculability: Sex, Costume Drama, and *The Golden Bowl*'. *Henry James Review* 23.1 (2002): 38–52.

Saisselin, Remy G. *The Enlightenment against the Baroque: Economics and Aesthetics in the Eighteenth Century*. Berkeley, CA: University of California Press, 1992.

Salgado, Cesar Augusto. 'Hybridity in New World Baroque Theory'. *Journal of American Folklore* 112.445 (1999): 316–331.

Sarduy, Severo. *Barroco*. Paris: Editions Du Seuil, 1975.

Saxton, Libby. 'Secrets and Revelations: Off-Screen Space in Michael Haneke's *Caché* (2005)'. *Studies in French Cinema* 7.1 (2007): 5–17.

Scarry, Elaine. *On Beauty and Being Just*. Princeton, NJ: Princeton University Press, 1999.

Schatz, Thomas. *Hollywood Genres: Formulas, Filmmaking, and the Studio System*. New York: McGraw-Hill, 1981.

Schivelbusch, Wolfgang. *Tastes of Paradise: A Social History of Spices, Stimulants and Intoxicants*. Trans. D. Jacobson. New York: Pantheon, 1992.

Schmitter, Amy M. 'Picturing Power: Representation and *Las Meninas*'. *Journal of Aesthetics and Art Criticism* 54.3 (1996): 255–268.

Scholz, Sebastian, and Hanna Surma. 'Exceeding the Limits of Representation: Screen and/ as Skin in Claire Denis' *Trouble Every Day* (2001)'. *Studies in French Cinema* 8.1 (2008): 5–16.

Schor, Naomi. *Reading in Detail: Aesthetics and the Feminine*. New York: Methuen, 1987.

Scott, John Beldon. *Images of Nepotism: The Painted Ceilings of Palazzo Barberini*. Princeton, NJ: Princeton University Press, 1991.

Sedgwick, Eve Kosofksy. *Touching Feeling: Affect, Pedagogy, Performativity*. Durham, NC: Duke University Press, 2003.

Seremetakis, C. Nadia, ed. *The Senses Still: Perception and Memory as Material Culture in Modernity*. Boulder, CO: Oxford, 1994.

Shapcott, Thomas. 'The New Rococo or Post-Modernist Lovesongs from the Age of Ugliness'. *Australian Book Review* July (1995): 36–41.

Shaviro, Steven. *The Cinematic Body*. Minneapolis, MN: University of Minnesota Press, 1993.

—— . '"Straight from the Cerebral Cortex": Vision and Affect in *Strange Days*'. In *The Cinema of Kathryn Bigelow: Hollywood Transgressor*. Eds. Deborah Jermyn and Sean Redmond. London: Wallflower Press, 2003. 159-177.

—— . '*Tarnation*'. *The Pinocchio Theory*, 16 October 2004. <http://www.shaviro.com/ Blog/?p=360> (accessed 11 September 2006).

Shearman, John. *Only Connect ... Art and the Spectator in the Italian Renaissance*. Princeton, NJ: Princeton University Press, 1992.

Shiff, Richard. 'Cézanne's Physicality: The Politics of Touch'. In *The Language of Art History*. Ed. Salim Kemal & Ivan Gaskell. Cambridge: Cambridge University Press, 1991. 129–180.

Shinkle, Eugenie. 'Digital Games and the Anamorphic'. *Refractory: a Journal of Entertainment Media*. 13 (2008). <http://blogs.arts.unimelb.edu.au/refractory/2008/05/22/digital-games-and-the-anamorphic-eugnie-shinkle/> (accessed 7 March 2008).

Silverman, Jason. 'Here's the Price of Fame: $218.32'. *Wired*, 2004. <http://www.wired.com/ entertainment/music/news/2004/01/61970> (accessed 9 September 2006).

Sjöström, Ingrid. *Quadratura: Studies in Italian Ceiling Painting*. Stockholm: Almqvist & Wiskell International, 1978.

Smith, Greg M. 'Moving Explosions: Metaphors of Emotion in Sergei Eisenstein's Writings'. *Quarterly Review of Film & Video* 21 (2004): 303–315.

Sobchack, Vivian. 'The Active Eye: A Phenomenology of Cinematic Vision'. *Quarterly Review of Film & Video* 12.3 (1990): 21–36.

—— . *The Address of the Eye: A Phenomenology of Film Experience*. Princeton, NJ: Princeton University Press, 1992.

—— . 'The Lived Body and the Emergence of Language'. In *Semiotics around the World: Synthesis in Diversity*. Eds. Irmengard Rauch and Gerald F. Carr. Vol. 1. Berlin: Walter de Gruyter, 1994. 1051–1054.

—— . 'Nostalgia for a Digital Object: Regrets on the Quickening of QuickTime'. 2000: 1–20. <http://demrg.english.ucsb.edu.conference/2000/PANELS/AFriedberg/nostalgia.html> (accessed 27 January 2007).

—— . *Carnal Thoughts: Embodiment and Moving Image Culture*. Berkeley, CA: University of California Press, 2004.

—— . 'Embodying Transcendence: On the Literal, the Material and the Cinematic Sublime'. *Material Religion* 4.2 (2007): 194–203.

Stafford, Barbara Maria. *Artful Science: Enlightenment Entertainment and the Eclipse of Visual Education*. Cambridge, MA: MIT Press, 1994.

—— . *Good Looking: Essays on the Virtue of Images*. Cambridge, MA: MIT Press 1996.

—— . *Visual Analogy: Consciousness as the Art of Connecting*. Cambridge, MA: MIT Press, 1999.

———. 'Revealing Technologies/Magical Domains'. In *Devices of Wonder: From the World in a Box to Images on a Screen*. Eds. Barbara Maria Stafford and Frances Terpak. Los Angeles: Getty Publications, 2001. 1–142.

———. 'Leveling the New Old Transcendence: Cognitive Coherence in the Era of Beyondness'. *New Literary History* 35 (2004): 321–338.

———. 'Working Minds'. *Perspectives in Biology and Medicine* 49.1 (2006): 131–136.

———. 'Hedonics: Pleasure, Pain and the Neurobiology of Feeling'. *n.paradoxa* 15 (2006): 49–54.

———. *Echo Objects: The Cognitive Work of Images*. Chicago: University of Chicago Press, 2007.

Stern, Lesley. 'I Think, Sebastian, Therefore … I Sommersault'. *Para*doxa*. 3–4 (1997). <http://www.lib.latrobe.edu.au/AHR/archive/Issue-November-1997/stern2.html> (accessed 13 July 2006).

Stewart, Susan. *Poetry and the Fate of the Senses*. Chicago: University of Chicago Press, 2002.

———. 'Remembering the Senses'. In *Empire of the Senses: The Sensual Cultures Reader*. Ed. David Howes. Oxford: Berg, 2005. 59–69.

Stoller, Paul. *Sensuous Scholarship*. Philadelphia, PA: University of Pennsylvania Press, 1997.

Stone, Harriet. *The Classical Model: Literature and Knowledge in Seventeenth-Century France*. Ithaca, NY: Cornell University Press, 1996.

Summers, David. '*Cogito* Embodied: Force and Counterforce in Rene Descartes's *Les Passions De L'ame*'. In *Representing the Passions: Histories, Bodies, Visions*. Ed. Richard Meyer. Los Angeles: Getty Publications, 2003. 13–35.

Taussig, Michael. 'Tactility and Distraction'. *Cultural Anthropology* 6.2 (1991): 147–153.

———. *Mimesis and Alterity: A Particular History of the Senses*. New York: Routledge, 1993.

Taylor, Kate. 'Infection, Postcolonialism and Somatechnics in Claire Denis' *Trouble Every Day* (2002)'. *Studies in French Cinema* 7.1 (2007): 19–30.

Thompson, Kristin. 'The Concept of Cinematic Excess'. In *Narrative, Apparatus, Ideology: A Film Theory Reader*. Ed. Philip Rosen. New York: Columbia University Press, 1987. 130–142.

Thurman, Judith. 'Dressed for Excess: Marie Antoinette, Out of the Closet'. *The New Yorker* (2006). <http://www.newyorker.com/archive/2006/09/25/060925crat_atlarge?printable=true> (accessed 3 June 2008).

Tomasulo, Frank P. 'Phenomenology: Philosophy and Media Theory, an Introduction'. *Quarterly Review of Film & Video* 12.3 (1990): 1–8.

Trahair, Lisa. *The Comedy of Philosophy: Sense and Nonsense in Early Slapstick Comedy*. Albany, NY: State University of New York Press, 2007.

Tuve, Rosemond. *Elizabethan and Metaphysical Imagery: Renaissance Poetic and Twentieth-Century Critics*. Chicago: University of Chicago Press, 1947.

Tweedie, James Andrew. 'Moving Forces, Still Lives'. PhD. University of Iowa, Iowa City, IA, 2002.

Varriano, John. *Caravaggio: The Art of Realism*. University Park, PA: Pennsylvania State University Press, 2006.

Vasseleu, Cathryn. *Textures of Light: Vision and Touch in Irigaray, Levinas and Merleau-Ponty*. New York: Routledge, 1998.

———. 'Touch, Digital Communication and the Ticklish'. *Angelaki: Journal of the Theoretical Humanities* 4.2 (1999): 153–161.

Walton, Saige. 'Enfolding Surfaces, Spaces and Materials: Claire Denis' Neo-Baroque Textures of Sensation'. *Screening the Past* 37 (2013). <http://www.screeningthepast.com/2013/10/

enfolding-surfaces-spaces-and-materials-claire-denis%E2%80%99-neo-baroque-textures-of-sensation/> (accessed 30 October 2015).

———. 'The Beauty of the Act: Figuring Film and the Delirious Baroque in *Holy Motors*'. *Necsus: European Journal of Media Studies* (Spring 2014). <http://www.necsus-ejms.org/beauty-act-figuring-film-delirious-baroque-holy-motors/> (accessed 30 October 2015).

Westerhoff, Jan C. 'A World of Signs: Baroque Pansemioticism, the *Polyhistor* and the Early Modern *Wunderkammer*'. *Journal of the History of Ideas* 62.4 (2001): 633–650.

Williams, Linda. 'Film Bodies: Gender, Genre, and Excess'. *Film Quarterly* 44.4 (1991): 2–13.

———. 'Corporealized Observers: Visual Pornographies and the Carnal Density of Vision'. In *Fugitive Images: From Photography to Video*. Ed. Patrice Petro. Bloomington, IN: Indiana University Press, 1995. 3–41.

Wind, Barry. *'A Foul and Pestilent Congregation': Images of 'Freaks' in Baroque Art*. Aldershot: Ashgate, 1986.

Wittkower, Rudolf. *Art and Architecture in Italy, 1600 to 1750*. Harmondsworth: Penguin Books, 1973.

Wölfflin, Heinrich. *Principles of Art History: The Problem of the Development of Style in Later Art*. 1915. Trans. M.D. Hottinger. New York: Dove Publications, 1922.

———. *Renaissance and Baroque*. 1888. Trans. Kathrin Simon. New York: Cornell University Press, 1967.

Wollen, Peter. 'Baroque and Neo-Baroque in the Age of Spectacle'. *Point of Contact* 3.3 (1993): 9–21.

———. 'Speed and the Cinema'. *New Left Review* 16 (July–August 2002): 105–114.

Woolf, Virginia. 'The Cinema'. In *The Captain's Death Bed and Other Essays*. London: Hogarth Press, 1950. 166–171.

Young, Iris Marion. 'Throwing Like a Girl: A Phenomenology of Feminine Body Comportment, Motility, and Spatiality'. In Iris Marion Young, *Throwing Like a Girl and Other Essays in Feminist Philosophy and Social Theory*. Bloomington, IN: Indiana University Press, 1990. 141–159.

Yurkiévich, Saúl. 'Baroque Fusions and Effusions (the Tumultuous Perceptions of the Emotions)'. *Point of Contact* 3.3 (1993): 110–113.

Zamora, Lois Parkinson. 'Magical Ruins/Magical Realism: Alejo Carpentier, François De Nomé, and the New World Baroque'. In *Poetics of the Americas: Race, Founding, and Textuality*. Eds. Bainard Cowan and Jefferson Humphries. Baton Rouge, LA: Louisiana State University Press, 1997. 63–103.

———. *The Inordinate Eye: New World Baroque and Latin American Fiction*. Chicago: University of Chicago Press, 2006.

Filmography

An Interesting Story (James Williamson, 1904)

Arrival of a Train at La Ciotat (Auguste and Louis Lumière, 1896)

Battleship Potemkin (Sergei M. Eisenstein, 1925)

Blue Velvet (David Lynch, 1986)

Caché (Michael Haneke, 2005)

Cat People (Jacques Tourneur, 1942)

Ciao! Manhattan (John Palmer and David Weisman, 1972)

Free Radicals (Len Lye, 1958)

Holy Motors (Leos Carax, 2012)

Ivan the Terrible, Part One (Sergei M. Eisenstein, 1944)

Man with a Movie Camera (Dziga Vertov, 1929)

Marie Antoinette (Sofia Coppola, 2006)

Nosferatu, a Symphony of Horror (F.W. Murnau, 1922)

Our Hospitality (John G. Blystone and Buster Keaton, 1923)

Pandora's Box (Lulu) (G.W. Pabst, 1929)

Peeping Tom (Michael Powell, 1960)

Psycho (Alfred Hitchcock, 1960)

Rear Window (Alfred Hitchcock, 1954)

Rosemary's Baby (Roman Polanski, 1968)

Sherlock, Jr. (Buster Keaton, 1924)

Steamboat Bill, Jr. (Charles Reisner and Buster Keaton, 1928)

Strange Days (Kathryn Bigelow, 1995)

Tarnation (Jonathan Caouette, 2003)

The Best Little Whorehouse in Texas (Colin Higgins, 1982)

The Birds (Alfred Hitchcock, 1963)

The Cabinet of Dr. Caligari (Robert Weine, 1920)

The Electric House (Edward F. Cline and Buster Keaton, 1922)

The General (Clyde Bruckman and Buster Keaton, 1926)

The Little Prince (Stanley Donen, 1974)

The Navigator (Donald Crisp and Buster Keaton, 1924)

The Piano (Jane Campion, 1993)

The Shining (Stanley Kubrick, 1980)

Trouble Every Day (Claire Denis, 2001)

Vertigo (Alfred Hitchcock, 1958)

Zoom (PBS, 1972–1978)

Index